ROOKWOOD

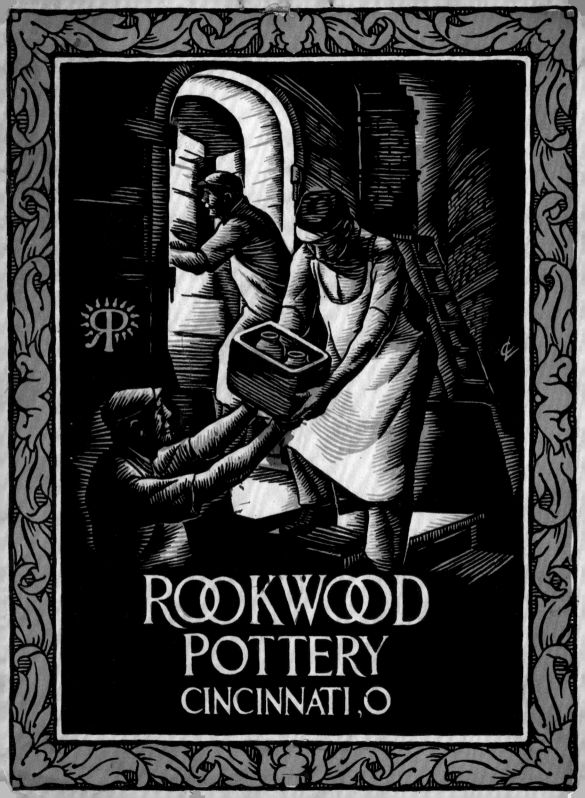

ROOKWOOD
POTTERY
CINCINNATI, O

Bob Batchelor

ROOKWOOD

THE REDISCOVERY AND REVIVAL OF AN AMERICAN ICON

—An Illustrated History—

ROCKPORT

Brimming with creative inspiration, how-to projects, and useful information to enrich your everyday life, Quarto Knows is a favorite destination for those pursuing their interests and passions. Visit our site and dig deeper with our books into your area of interest: Quarto Creates, Quarto Cooks, Quarto Homes, Quarto Lives, Quarto Drives, Quarto Explores, Quarto Gifts, or Quarto Kids.

First published in 2020 by Rockport Publishers, an imprint of The Quarto Group,
100 Cummings Center, Suite 265-D, Beverly, MA 01915, USA.
T (978) 282-9590 F (978) 283-2742 QuartoKnows.com

Rockport Publishers titles are also available at discount for retail, wholesale, promotional, and bulk purchase. For details, contact the Special Sales Manager by email at specialsales@quarto.com or by mail at The Quarto Group, Attn: Special Sales Manager, 100 Cummings Center, Suite 265-D, Beverly, MA 01915, USA.

10 9 8 7 6 5 4 3 2 1

ISBN: 978-1-63159-863-0

Digital edition published in 2020
eISBN: 978-1-63159-864-7

Library of Congress Cataloging-in-Publication Data available.

Front cover design: Beth Johnson
Back cover design: Landers Miller Design
Book Design: Rick Landers

Printed in China

To Maria Longworth Nichols Storer for breaking barriers and to Marilyn Scripps for stewarding the legacy. And, to the generations of artisans whose vision brought the art to life.

Contents

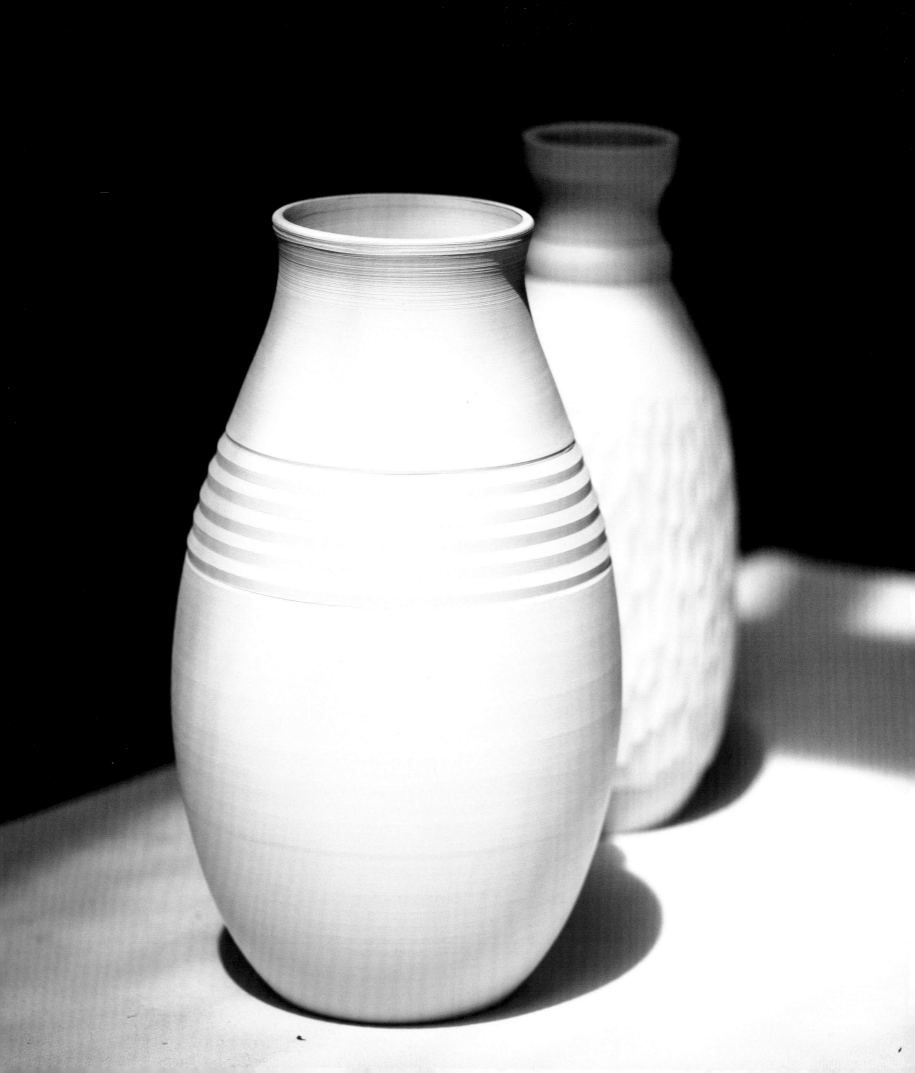

Foreword
by Marilyn Scripps

In the business world, there aren't many "firsts" that go on to also be symbols of durable longevity. But Rookwood Pottery proudly breaks that rule, just as Maria Longworth Nichols Storer broke the unspoken rule of her day when she became the first female owner of a large manufacturing firm in the United States.

From having a female-majority workforce (which is true at Rookwood to this day!) to having proprietary glazes and processes that have commanded the respect of the entire industry for generations, there is much that makes Rookwood Pottery stand out from its peers, as you'll see in the pages that follow.

Like many in the Cincinnati area, I feel a special connection to Rookwood. I distinctly remember the three Viking ships on the mantel of the Rookwood fireplace in my childhood home in Walnut Hills. As a young girl, I was captivated by the beauty of Rookwood pieces I saw on a trip to California. And I'm not alone. It seems everywhere I go, I meet people who tell me about special pieces they remember and how much they love Rookwood Pottery.

It's clear that Rookwood is admired by many, but Rookwood is about so much more than beautiful pottery and tile.

Rookwood is about leadership. Maria and her colleagues wanted to create artwork that would beautify people's homes in an era when home décor did not even exist for most people, so she blazed a trail that others still follow. And she wasn't content to simply *be* in that business; she demanded that Rookwood *be the best* in that business. This idea still drives us today as we create elegant, handcrafted products that set market trends for others to follow.

Rookwood is about quality. For more than a century, our products have stood apart from mass-produced tile and pottery because they are handmade by skilled craftspeople who strive every day to deliver exquisite artwork. In an era when many organizations aim for authenticity, Rookwood quietly exemplifies it with old-world attention to detail and excellence.

And Rookwood is about civic pride. Running any business involves an obligation to customers and employees, but with Rookwood there is an extra measure of gravity because stewarding a cherished business icon is a great responsibility. Rookwood is part of the reason Cincinnati is on the map for art lovers around the globe, and the fact that it is considered a world leader 140 years after its founding would not be possible if it were not lovingly embraced by its neighbors and admirers in Cincinnati. We value that relationship and, from our home in Over-The-Rhine, we intend to keep nurturing it for generations to come.

When people visit our factory today, I see the same sparkle in their eyes that I had when I stood in front of my mantel as a young girl. They relive treasured moments as if we are the curators of fond memories. *Rookwood: The Rediscovery and Revival of an American Icon* chronicles the unique ways that Rookwood is so much more than simply a creator of beloved art.

Marilyn J. Scripps
Entrepreneur, philanthropist,
preservationist, urban revivalist
Owner, Rookwood Pottery

Hand-carved art pottery in bisque, prior to being fired and glazed, reveals the intricate detail and beauty of clay.

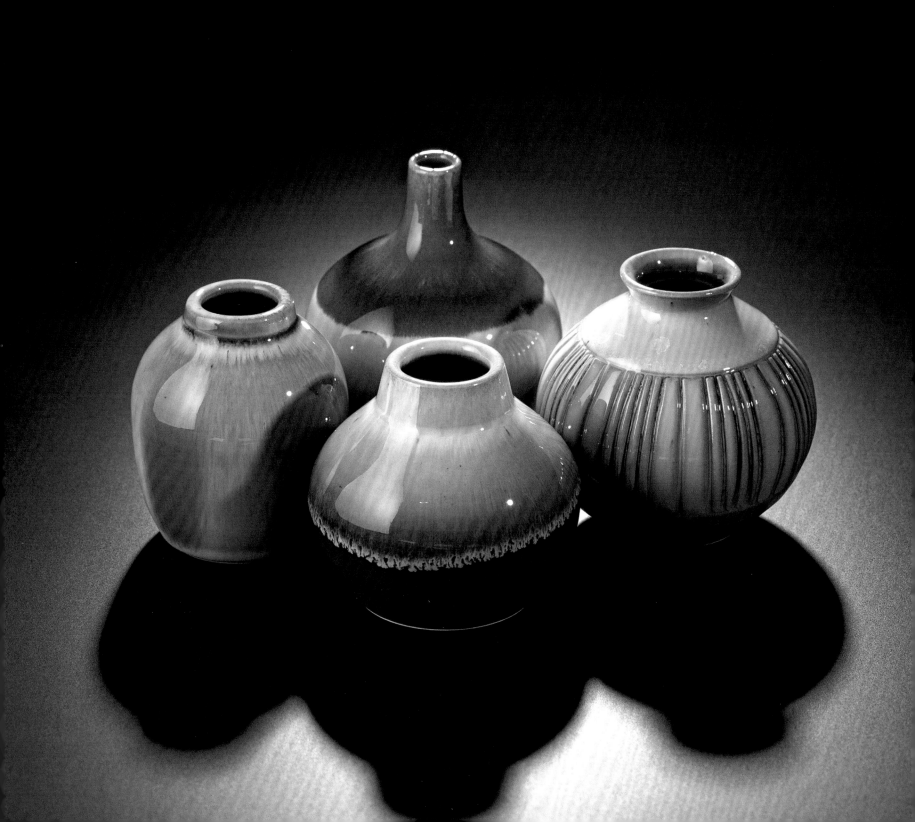

Preface

Although founded in 1880, Rookwood was launched on thoroughly modern ideas. As the first woman to establish a large manufacturing enterprise in the United States, Maria Longworth Nichols Storer created a nineteenth century version of a high-tech start-up. Rookwood's success depended on scientific innovations and technical advances, as well as recruiting talented artists and craftsmen essential in launching a new industry.

Imagine, then, as this pioneering startup grew, its artisans honed their craft to the point that in less than a decade, Rookwood had won international recognition as the finest ceramic art pottery in America—and, perhaps even more impressive, quickly gained on its European and Asian competitors, many of which had been making pottery for hundreds of years.

This global success story sprouted from the nation's Midwest heartland in Cincinnati, one of the mightiest of the many towns on the grand Ohio River. Rookwood became the crown jewel of the Queen City, its primary tourist destination, drawing countless visitors who wanted to experience the magic. An icon was born.

Maria's aims harmonized with a broader transformation occurring in American homes. She and others believed that a home filled with art would uplift people's lives spiritually and physically. The inspiration from home art would help people—and the nation—reach an elevated status.

Under the leadership of the business mastermind William Watts Taylor, Rookwood's fame spread as museums and art collectors bought its art pottery. The company next moved into architectural tile, filling many of the nation's premiere landmarks as American architecture grew grander and skyward.

Then as now, the real stars at Rookwood have been its artists and dedicated production workers. Long before "handcrafted" became a design trend, Rookwood artisans were adamant in utilizing the finest ingredients to make glazes and ceramics, creating one-of-a-kind designs, and employing expert craftsmanship. Each piece brought together the perfect harmony of exquisite color, unique form, and eye-catching design.

Rookwood: The Rediscovery and Revival of an American Icon features more than 300 images, photos, and illustrations that highlight the immaculate artworks produced. Yet no art is created without multiple hands crafting it. As such, *Rookwood* also provides readers with a deeper sense of past and current artists and leaders who enabled the company to achieve its international acclaim. Multi-archival research illuminates the cultural history influencing the company and its development.

Rookwood's story is uniquely American—an epic tale filled with hard work, exploration, grit, and success, but also struggles, failures, and devastation. Like great stories across time, the challenges were met with courage and ultimately led to rebirth and newfound accomplishment.

Now, more than ever, people are looking back at history not only to explore the past, but also to gain insight about how we might live fuller, more engaged lives. What is becoming clearer by the moment is that art is a critical, foundational facet of a well-lived life. This is the story of a great American company whose generations of artists and skilled production workers come to life in its pages.

Today's Rookwood art pottery is a master class in style, form, and glaze technique.

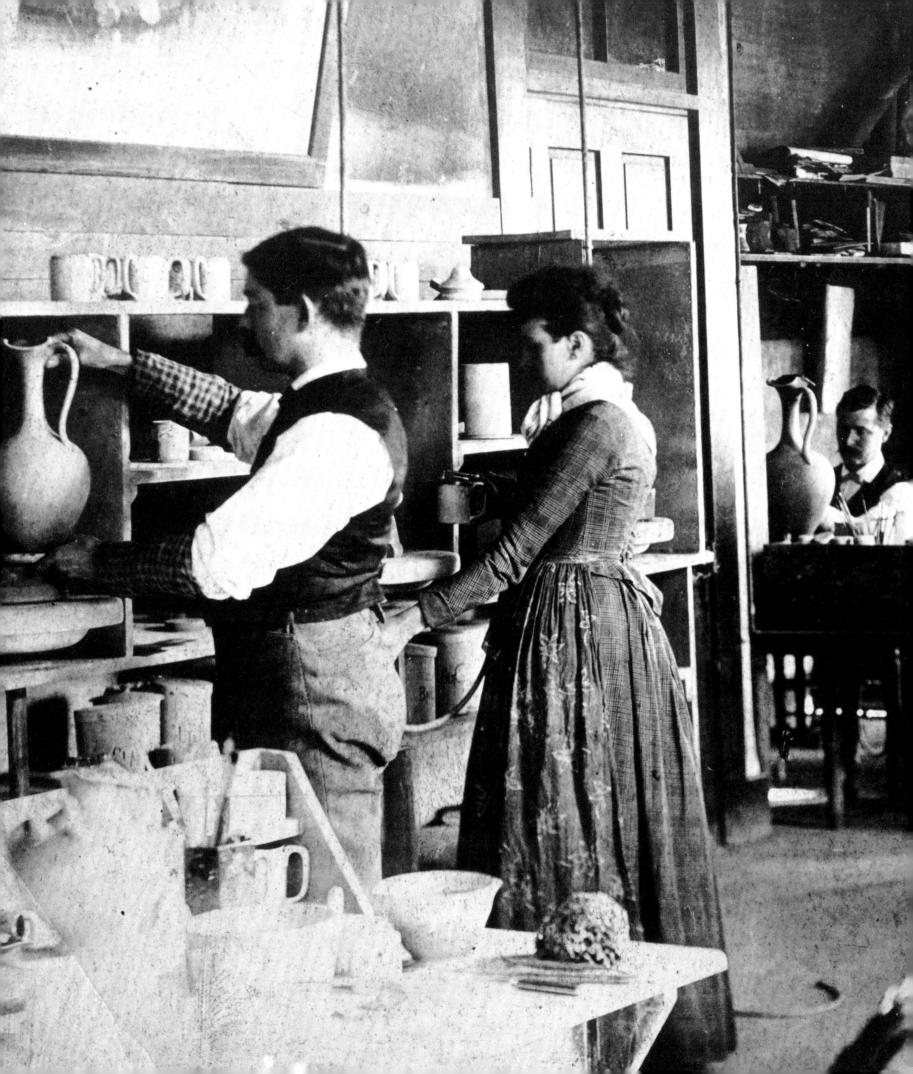

1 The Birth of American Art Pottery

In 1880, a fiercely determined young woman defied societal norms and founded America's first female-owned and female-founded manufacturing business in Cincinnati. Maria Longworth Nichols Storer named her burgeoning company Rookwood Pottery and set out to fulfill her vision of an American art pottery factory that could not only make "home art" to beautify and elevate people's everyday lives, but create artworks that would rival the best European and Asian ceramics in the world.

Thanksgiving Day, 1880

Maria Longworth Nichols Storer and two teenage workers emptied the first kiln at a small ceramics factory at 207 Eastern Avenue near downtown Cincinnati.

Close enough to the Ohio River where they could hear the water circle and swirl on the bank below, Maria and the boys delicately removed its contents, inspecting each piece for cracks and damage. Each kiln opening proved a surprise, the mysterious merger of heat and chemicals revealing some new wonder, just as potters had experienced for centuries.

Maria had christened the small studio "Rookwood" after her childhood home, about an hour's carriage ride away in fashionable Walnut Hills. She believed that the name conveyed an air of sophistication, similar to "Wedgewood," the renowned British ceramics firm that dated back to 1759. Maria had an affinity for the innumerable black ravens that roosted at her father's estate. She was drawn to art that featured slimy, scary, and otherwise grotesque creatures. "Rookwood" captured exactly what she wanted.

As the small group studied the wares, breathless in anticipation of what might emerge, little else from that day would be noted, let alone commemorated. What no one realized in the chaos of everyday life—amid the quick-moving dark water, sounds of hooves clicking on stone, and *clackety-clack* of trains clamoring near the cluttered building—was the thirty-one-year-old artist had just made history as the first female owner and founder of a manufacturing company in the United States.

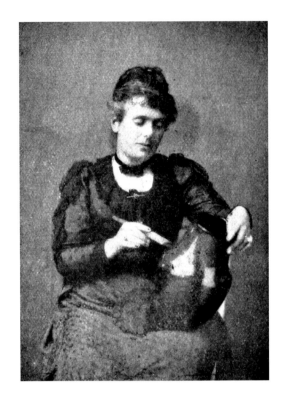

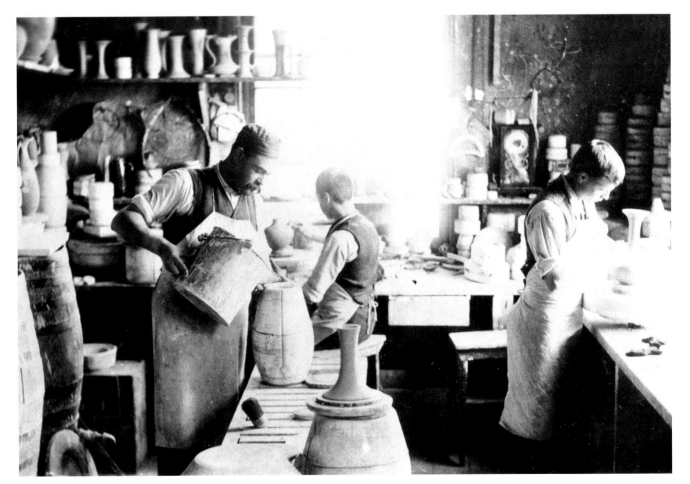

Above
Maria posing with a brush and vase.

Left
John Jacob Menzel (far left), foreman and master potter, with unidentified members of the slipcast department. Menzel created many shapes for Rookwood. His sons William Henry and Reuben Earl would also become Rookwood potters. Reuben Earl's career stretched from 1896 to 1959.

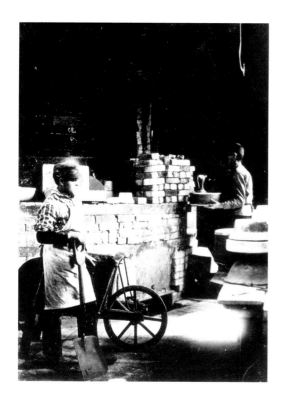

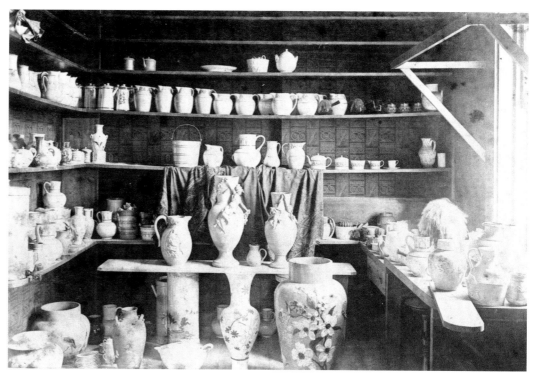

Some of those first pieces to emerge from the fire were hand-painted and turned into works of art while others remained utilitarian to meet the everyday needs of American families. However, the reaction of male business leaders in Cincinnati could not have been more negative. Adhering to decorum in late nineteenth-century America, they were offended that a woman would have the audacity to establish a business. As if the bad news flowed as freely as the mighty Ohio River, Maria faced even more stinging criticism from the local pottery community. Area potters predicted the worst for her upstart studio. They insisted that Rookwood was doomed.

What the naysayers had clearly underestimated, however, was Maria's spirit, vision, and commitment to launching her own business that would bring together art and commerce. Later looking back on the early history of Rookwood, she proudly exclaimed that at her studio, "the potter's wheel will be turned by woman-power." This enterprise, to its founder, would promote art and the creation of art by her and those she would hire to fulfill her vision of what Rookwood could someday become.

Proud of her city and determined to make the venture a success, despite the criticism, Maria explained:

My birthplace shall produce a pottery that shall smack of the soil . . . Its clay shall come from deposits in the Ohio Valley; its workers shall be graduates of Cincinnati's Art School. Its designs shall be original; individuality shall be the goal.

Top left
Rookwood production workers at the kiln in the Eastern Avenue factory.

Top right
Maria Longworth Nichols Storer's workspace at Eastern Avenue. She pushed the company toward art pottery, but this photo—taken by her father, art patron Joseph Longworth—reveals that Rookwood also pursued Maria's aim of creating "home art" to beautify the lives of American consumers.

Left
An illustration of the factory and studio at 207 Eastern Avenue, Cincinnati.

The First Woman of Manufacturing

In establishing a manufacturing enterprise, Maria realized that her efforts had to bring together the arts and industry. These linked designs would feed off one another, enabling the company to simultaneously create artwork, while also satisfying the marketplace. American art critics and cultural observers had been yearning for a homegrown pottery to wean the nation from its reliance on European ceramics. The young founder believed her enterprise could fill that gap.

Within two months of founding Rookwood, Maria wrote: "The main object of the Pottery is to advance the manufacture of artistic work as well as to make cheap ware pretty." Like artisans across the millennia, Maria and Rookwood would have to balance art and craft with shifting consumer demands and industry fluctuations.

Creating an industry from scratch was not easy or inexpensive. Initially, Maria relied on her father, Joseph Longworth, to provide funds to keep Rookwood operating.

One of Cincinnati's wealthiest men and a renowned American art patron (the family had donated at least $430,000 to the Cincinnati Art School and museum, a sum that equates to $130 million in today's relative income), Longworth served as a kind of angel investor for Rookwood, taking a risk on a manufacturing startup that showed promise, but could only survive if given time to establish a footing based on the skills and talents of its founder and the staff she assembled.

Within eight years of Maria founding the pottery, a reporter tried to make sense of the significance of her family to the city, explaining:

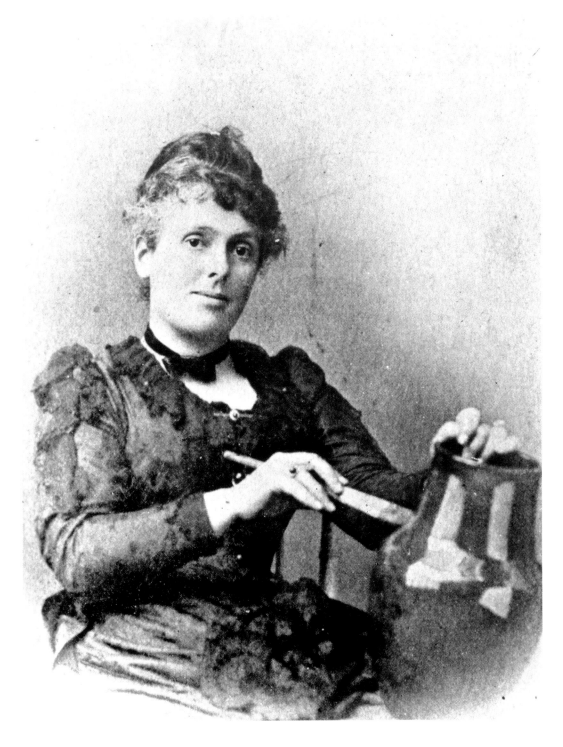

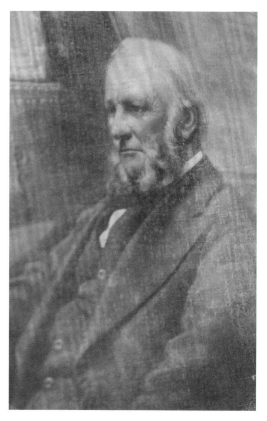

"The history of the Longworths in Ohio is the history of Cincinnati itself, especially in its artistic developments." While noting the family's role in creating the Cincinnati Art Museum and School of Art, the writer proclaimed: "The greatest of these, in practical results, is the pottery."

Although Americans have historically been drawn to rags-to-riches stories, many of the heralded business founders and entrepreneurs have either had money or been backed financially by others. Previous historians and art critics have often portrayed Maria as a woman of means who bulldozed others with her wealth. These characterizations, though, have severely undermined a different view based on the wherewithal it took for a woman to launch a business enterprise in 1880. Perhaps, instead of assessing Maria's wealth as a negative, we should instead focus on the tenacity, strength, and intelligence it took for her to stand in the face of decorum and pursue her aims.

Characterizations of Maria as a dilettante by her rivals and some early historians should be reimagined in light of new documentation and investigation into women's lives at the end of the nineteenth century. Deeper analysis leads to a fuller understanding and different perspective. Her early years learning the ceramics trade are an example of how one might reassess the young founder.

The first public announcement of her intention to found Rookwood, before the company even had a name, portrayed her as a "most enthusiastic and tireless" worker, arriving at the Dallas Pottery , a ceramics company founded by Frederick Dallas in 1865 and located on Cincinnati's Hamilton Road, "day after day for a year or more," where she "worked in clay and colors as steadily and hard as any artisan in the establishment." Obviously, the writer purposely meant to contrast her work ethic with the predominantly male workers there.

Maria's tenacity had served her well during the preceding years. Prominent ceramics scholar Edwin Atlee Barber, perhaps the era's greatest pottery historian, also noted that she had worked for two years at the Dallas Pottery, honing her skills and experimenting. Repeated challenges

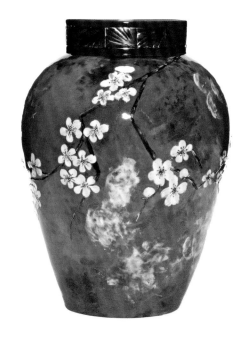

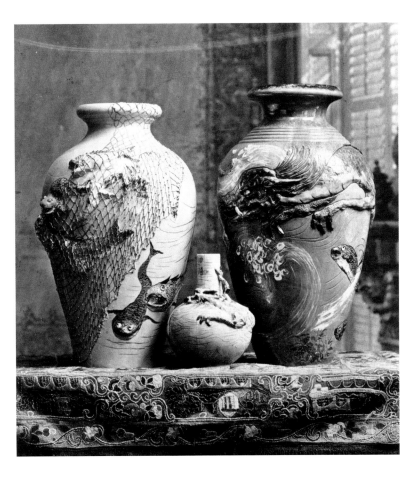

with kiln heat led to "the idea of building a place of her own."

Unlike many female members of the Cincinnati art scene, Maria did not readily join groups, preferring to chart her own course. Largely self-taught, she preferred to work alone or in small groups. As such, one historian notes, "Her attitude caused reactions of hostility or jealousy among the other women which must necessarily prejudice their evaluations of her work … usually negative or ambivalent." When assessing how the rough treatment from her rivals was sustained by later observers and writers, one might subsequently place more emphasis on a contemporary journalist's view, who explained, "Her wares have been much admired for the unique character of the decorative forms upon them, her fancy supported by a prolific inventive faculty."

Prior to founding Rookwood, Maria had demonstrated astute business acumen by charging women caught up in the ceramics craze to fire their wares in her kiln at the Dallas Pottery. She also sold her earliest pieces: "Of these, Tiffany in

New York has been a large purchaser." The funds Maria accumulated enabled her to purchase the engine for the first kiln at Rookwood.

To grow the young business quickly, Maria did what entrepreneurs and business leaders have always done: hired professionals and experts. In this case, she needed employees to cast and throw, as well as help her continue scientific efforts with glazes and experiments with kiln temperatures. Her own art would be unique and hand-painted, but she carried no illusion about the necessity of using molds to mass-produce pieces intended for everyday use.

"A specialty was first made of commercial ware for table and household purposes," Barber explained. The first year of production at Rookwood included "breakfast and dinner services, pitchers, plaques, vases, wine-coolers, ice-tubs, water-buckets, umbrella jars, and a variety of other patterns." Most were decorated in an ivory finish or underglaze of animal subjects primarily in blue or browns, with many carved and adorned in an interesting fashion.

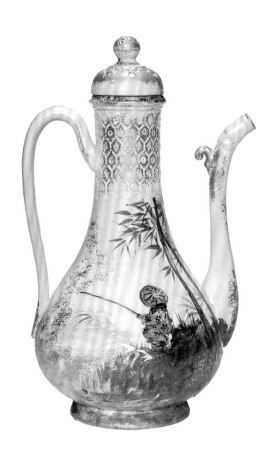

Five months after Rookwood debuted, observers were already writing about the little miracle on the banks of the Ohio River. From New York, Will M. Butler exclaimed: "Cincinnati has at last a genuine pottery, where work is produced that may justify claims to considerable attention." Certainly the idea of a female founder had electrified the media, but Butler saw the need for an American pottery that mixed art and industry. "Real beauty must always appeal strongly to a healthy mind; and the goods made at the Rookwood Pottery promise to be popular for this very reason.

"The showroom of the Rookwood Pottery looks more like the display window of a Fourth Street importer than that of an American manufactory," the journalist opined. "It is filled with vases, cups, mugs, pitchers, buckets, tubs, saucers, plaques, in surprising variety." Yet, the push to meet burgeoning consumer needs also had a role. Butler noted this idea, explaining that Maria "evidently believes in the appreciativeness of American taste, and has little fear of making a piece of ware that will be unmarketable by reason of its artistic excellence."

The accolades continued in a May 1881 essay published in *Harper's Weekly* by Elizabeth Williams Perry (published as Mrs. Aaron F. Perry). What the writer did not tell her readers, however, was that she was a long-time friend of Maria's, as well as a leading Cincinnati socialite. The national publicity gave Rookwood a significant boost and acted as validation for what Maria had accomplished.

Perry noted that pottery provided both "suitable work for women" and "a future of commercial importance for Cincinnati as a center of activity." As noted, Perry was no stranger to the Queen City art movement. She was also a close associate of businessman and civic leader Alfred Goshorn, serving as chair of the executive committee that helped organize fundraising efforts for the 1876 Philadelphia Centennial Exposition. The tight bonds between members of Cincinnati's elite certainly played a role in the article, the kind of civic support that the wealthy were expected to carry out in the late nineteenth century.

The *Harper's Weekly* article did more than promote Rookwood. It gave insight into the national craze around ceramic decoration and pottery, using the "women in Cincinnati" as a case study. These women, Perry wrote, were members of the "idle rich," who took up pottery "at the expense of what are called 'social dutes.'" For the magazine's editors, the pottery mania, like china painting before it, was equated with what they saw as female weaknesses, labeling

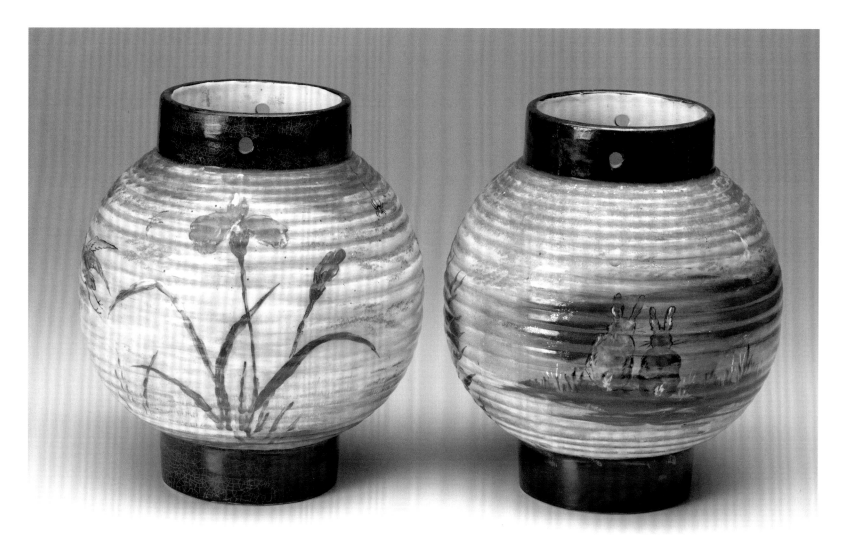

the trend a "mania" and joking that handling "dear old mother earth" did "not leave much room for hysteria."

Both Maria and her chief rival, M. Louise McLaughlin, had to overcome notions that their work was amateurish. The women longed to be taken seriously as artists, with McLaughlin taking the lead as an innovator by replicating the underglaze painting process, while Maria founded Rookwood and became the first female to lead a significant manufacturing firm.

Perry's article brought the region national acclaim. She acknowledged the women who led the movement, along with the handful of men working with them. Without identifying Rookwood by name—just six months after its launch—Perry exclaimed that its founding was "the crowning result of the six years' work by women, and the earnest of the future, is also inspired and executed by a woman."

Maria, she wrote, was the future of pottery, both as an industry leader and artist. Of the work, Perry explained, "the simplest article of household use shall combine the elements of beauty." Pointing to Maria specifically, the writer glowingly acknowledged: "The work ... is shown in vases of all sizes, and in wonderful variety of style, for her talents enable her to throw off work with uncommon rapidity." The outcome—long before anyone thought about the phrase—was female empowerment. "Mrs. Maria Longworth Nichols, by this use of time and money, practically opens a path in which unlimited work for women may eventually be found."

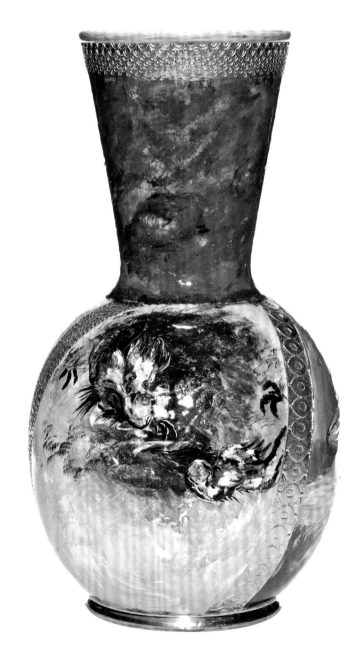

A monumental 1883 vase featuring dragons on two panels and a lonely pelican on the third by Maria Longworth Nichols Storer in her typical style focusing on mysticism, magic, and wonder.

Woman Power

Top
Many hands work to create each unique Rookwood piece of pottery across the production process (circa 1900s).

Bottom
Loretta Holtkamp, a skilled horticulturalist, was the kind of woman whom Maria indirectly empowered. The Mount Adams native joined the pottery in 1920, working for Sally Toohey as a decorator in the architectural tile department. In 1943, she moved to the decorating team, staying until she retired in 1954, thirty-four years in all.

Creating Rookwood Pottery fulfilled a dream that grew from Maria Longworth Nichols Storer's utter astonishment when she saw the Asian and European ceramic art exhibits at the 1876 Philadelphia Centennial Exposition. As one writer observed, Maria "conceived the idea of founding an industry in the west that should one day rank with the best of the old world."

But a woman founding a business? This was unheard of, not simply out-of-the-question, and ludicrous in the Gilded Age. Certainly it was not to be done by someone like Maria, a member of the wealthy, ruling class.

Although possessing untold resolve, Maria faced additional obstacles in attempting to implement her goal, from the physical exertion of running a factory to the repeated flooding of the Ohio River. Then there were snickers from male business leaders who scathingly criticized her aspiration. Maria was resolute. Her company would be "a regular, out and out, practical, enterprising pottery."

Although an audacious idea, building a new company and industry began with a focus on people. Maria told the *Cincinnati Gazette* that she "wished to exercise her own taste in the choice of forms upon which to work." Yet, Rookwood could not be a one-person operation, nor rely on the founder to be the sole creator. Maria had to find decorators who would—in time—produce one-of-a-kind masterpieces. The early Rookwood workforce included both men and women. However, the highly skilled female artists and painters she employed were almost revolutionary in that the pottery enabled artistic, creative females a place to launch and build careers.

Although it may seem odd to modern ears to label female employment revolutionary, in the late nineteenth century there were strict rules (legal and social) that dictated how females lived. Rookwood's very existence as a female-owned manufacturer employing other women broke delicate societal norms.

Rookwood gave women an opportunity for employment in an era in which they were expected to concentrate on managing their households and tending to their children. However, it would take years for the pottery—and society at large—to slowly change work culture. Many women at Rookwood left when they got married. Yet many others, such as Sallie Coyne and Lorinda Epply, established long and fruitful careers at the pottery.

Maria explained her idea, smacking of female empowerment: "Designs shall be original; individuality shall be the goal." Most importantly, she declared, "The potter's wheel will be turned by woman-power." A reporter visiting the factory in 1888 watched the enterprise in action and noted, "The big wheel, patiently turned by a woman's hand" invocative of Henry Wadsworth Longfellow's poem *Kéramos*: "Turn, turn, my wheel . . . these vessels made of clay."

Implementing Maria's ideas, Rookwood would create what she called "home art," or bringing a touch of luxury into people's lives. Establishing this new industry would not only create art pottery in America, but would open a door for female employment. Her goal, she told a local newspaper: "improving the quality and style of domestic ceramics."

On the Banks of the Mighty Ohio River

Quite unusual for a Midwestern city, Cincinnati had a history of supporting women in the arts. Sarah Worthington King Peter, daughter of Ohio's first governor, founded the Ladies' Academy of Fine Arts, the first arts society solely for women in the United States. For some women, the arts was a path away from the boredom and redundancy of childrearing, while others saw it as a way to bring art closer to home and hearth.

Historian Charles Frederic Goss called the women's movement, not only in Cincinnati, but nationally, a "great movement sweeping over the country like a tidal wave." In its wake, Maria and other women launched initiatives to "cultivate the arts themselves and to demand a far more general cultivation of them by their children." At the center of the movement was the 1876 Centennial Exhibition in Philadelphia.

Maria exhibited a collection of china paintings in the Women's Pavilion. However, her reaction to other exhibits had a more lasting consequence. She poured over the ceramic art from Asia and Europe, drawn mostly to the Japanese pieces. Maria had a revelation—she would launch a pottery studio in Cincinnati that might someday rival the work she had seen.

National newspapers and magazines were quick to realize that the Centennial Exhibition launched American artists into friendly competition with their overseas counterparts. Yet these publications were often derisive when they gathered that women led the interest and established much of the early excitement. Editors used thinly veiled phrases and code words to demean these efforts, for example,

calling the pottery movement a "wild ceramic orgy," "craze," and "hysteria."

Undaunted, Maria moved ahead with her idea. A later Rookwood booklet captured the founder's resolve, explaining that she possessed: "Enthusiasm of the artistic temperament coupled with fixity of purpose and financial resources." Creating a company from scratch, even with her father supplying the abandoned schoolhouse at 207 Eastern Avenue as a headquarters, required that Maria find additional resources.

Her work at the Frederick Dallas Pottery—almost like an extended apprenticeship—had taught her quite a bit about kilns and firing, but she needed someone with more expertise. Maria turned to Joseph Bailey, Sr., the superintendent at Dallas Pottery, but he would not leave, forcing her instead to offer a position to his son, Joseph Jr.

Still, the older Bailey oversaw the purchase of kilns, engines, raw materials, and other manufacturing aspects that would be costly and essential in launching the enterprise. Bailey's initial labors were conducted basically under-the-table because he promised Frederick Dallas that he would not abandon him. Instead he moonlighted to help Rookwood become operational. According to historian Kenneth R. Trapp, Bailey's "empirical knowledge of clay and pottery production were vital in transforming Rookwood from a fledgling, parochial enterprise into a pottery of international authority." Later, in July 1881, after Dallas died, Bailey joined the new pottery full time.

Historians have not determined the exact date that thirty-one-year-old Maria officially launched Rookwood. However, recently discovered archival records reveal that it took place sometime in 1880 between May 21 and September 14. The former marked the announcement in the *Cincinnati Daily Star* that the Women's Art Museum Association had put new artworks on display in the art gallery rooms at Music Hall. That article mentioned Maria's ceramics, but did not mention that she had launched a new pottery. On the latter date, the *Cincinnati Gazette* published a story about Maria's accomplishments and announced Rookwood, although she had yet to determine the name.

Over the next year, dozens of papers nationwide would republish the profile piece on Maria, with

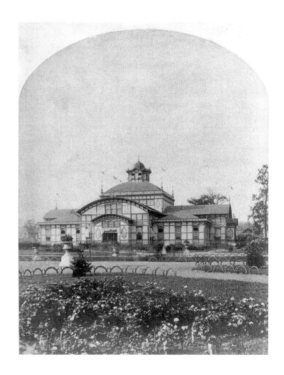

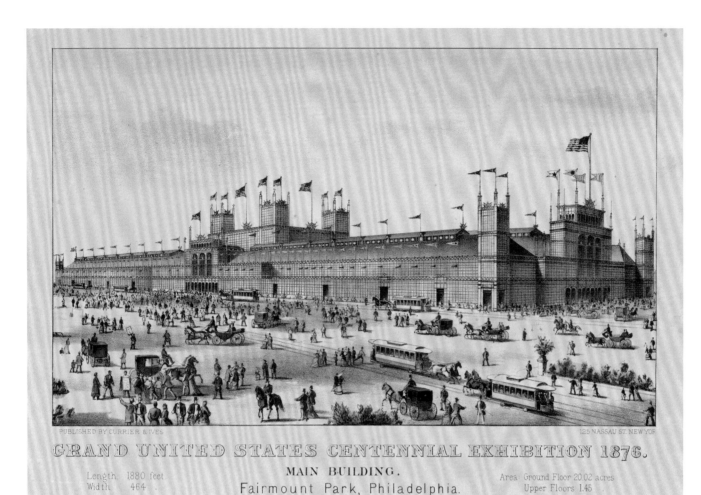

GRAND UNITED STATES CENTENNIAL EXHIBITION 1876.

MAIN BUILDING.

Fairmount Park, Philadelphia.

Length 1880 feet.
Width 464

Area: Ground Floor 20.02 acres
Upper Floors 1.45

PUBLISHED BY CURRIER & IVES

125 NASSAU ST. NEW YORK

Left
The Main Building at the 1876 Centennial Exhibition in Philadelphia, covering 20 acres and drawing spectators by the millions.

Below
The ceramics exhibit of London china merchant A. B. Daniell & Son, which represented three major English ceramic factories: Mintons, Royal Worcester, and Coalport. These exhibits had a significant influence on the female porcelain painters in Cincinnati.

Oppopsite
The Women's Pavilion at the 1876 Centennial Exposition, important because it was built after women were refused exhibition space in the Main Building. All exhibits showcased there were the work of women, including Maria and other Cincinnati female artists.

the new pottery at the heart of the story. These included major national media outlets such as the *Philadelphia Inquirer*, *St. Louis Post-Dispatch*, and the *New-York Tribune*. The idea that the plucky and determined (and wealthy) granddaughter of famed winemaker Nicholas Longworth would start her own pottery captured public fascination. The high-profile article helped establish Maria's national fame and spread word about her daring enterprise.

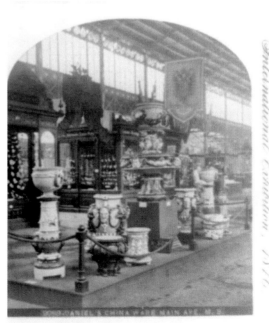

Although the precise list of contents in that initial kiln fired in November 1880 is lost to history, evidence exists that reveals it held a mix of Maria's hand-painted pieces, common wares meant for daily use, and some pieces decorated by female amateurs in the area. With the Baileys' knowledge of ceramic science and kiln experience, Rookwood had a huge jump-start in gaining a foothold as a business entity.

Maria focused her own work on the intricacies of decorating and creating unique grotesque styles on a variety of forms, but she also realized that everyday wares would help the company financially. In the early years, she suggested a number of utilitarian products, ranging from teapots and sugar bowls to bowls and pitchers designed for daily use.

The young business needed wares to sell, so Maria turned to friends—both personal and from the local art scene—to boost production. Many of these early figures were never considered official employees, but were essential in launching the factory, including Ferdinand Mersman, James Broomfield, Edward Cranch, and Henry Farny, who not only helped decorate, but created the first Rookwood trademark. Farny would later become one of America's most celebrated illustrators and painters creating artworks featuring Native Americans and their lives.

On May 10, 1881, a fire caused $300 in damage to the Eastern Avenue building, starting in the chimney and then spreading to the roof (the equivalent of $526,000 in our current economy). Although the fire was extinguished before the entire building was destroyed, the incident was a setback so early in Rookwood's history.

Despite the fire, Rookwood's development as a company necessitated hiring a team of decorators. Albert Robert Valentien (originally spelled "Valentine") demonstrated mastery of several art forms while a student at the School of Design at the University of Cincinnati (in 1887, renamed the Art Academy of Cincinnati). While still a teenager, he teamed up with fellow student John Rettig on numerous entrepreneurial ventures.

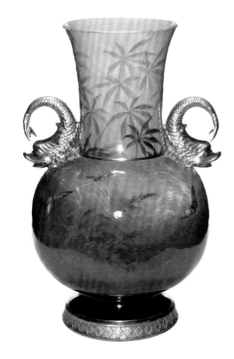

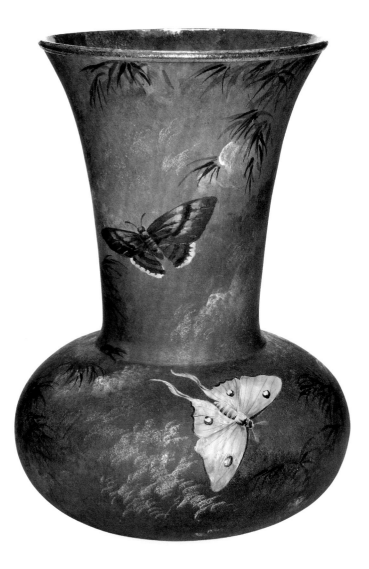

Above
A 2 foot (60.9 cm) tall Limoges-style vase features butterflies and impressive colors with golden dolphin handles and a gold-accented base by Albert Valentien (1883).

Left
Valentien liked painting butterflies and moths, the latter featured on this Dull Finish glaze vase from 1883. The glaze accentuates the gray nightfall backdrop, highlighted by fired-on gold highlights and patches of white enameling suggestive of moonlit clouds.

In spring 1880, realizing that refined Cincinnati women potters needed additional training, Valentien and Rettig offered a class in Limoges that drew sixty students (all female), who assembled to learn the style at the peak of the china-decorating craze. A reporter noted that the women "displayed a most praiseworthy zeal and industry." Several "developed rare talent and skill in this novel branch of art." Commentators hoping to propel Cincinnati to the status of one of America's great art centers exclaimed that the city must be the "acknowledged center" of the burgeoning pottery industry.

Maria officially hired Albert Robert Valentien in September 1881. Although just nineteen years old, the young man had already won wide acclaim. The previous June, a *Cincinnati Daily Star* article proclaimed that the young artist exhibited work "not excelled by those of any professional artist in the West." The following week, the newspaper noted that Valentien stood as a model for city art lovers "who have an interest in the progress of art culture in this city."

Valentien, who taught himself the Limoges style, had already shipped pieces to New York City that met with such popularity that he received a standing order for more product from dealers there. By some accounts, Rettig's faience eclipsed Valentien's, drawing even higher prices in New York.

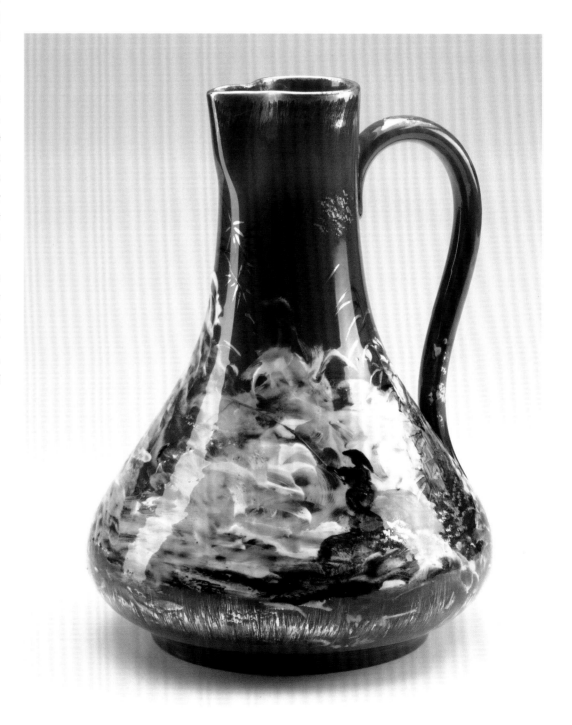

An 1882 Limoges-style pitcher that Maria hand painted and flecked with gold accents. The Asian fisherman casts his line into a murky sea, but the water, bamboo shoots, and sky are filled with sparkling gold.

Despite his young age, John Rettig gained considerable fame as a set designer, and important organizations such as the Masons hired him to decorate their headquarters. Valentien served as Rettig's partner in these projects. Soon they brought aboard other friends from art school, including Matt A. Daly.

In 1882, Daly joined Valentien and soon developed into one of Rookwood's most accomplished artists. Several more were hired, including William Purcell McDonald and Rettig, who worked as a decorator and modeler, as did his brother Martin. The decorating department expanded, adding Laura A. Fry, Fannie Auckland, Alfred Brennan, Harriet Wenderoth, and W. H. Breuer. Surprisingly, William Auckland, the lone thrower, was able to create the countless pieces later glazed or decorated.

Fry and Maria's friend, administrator, and fellow decorator Clara Chipman Newton also helped Maria create the Rookwood School of Decorative Art, an academy established with the express notion of using tuition dollars to offset the cost of running the factory. Launching an education center for teaching pottery-making had been one of Maria's original ideas and had frequently been mentioned in early articles about the company. It seems that the idea of women teaching other females how to create ceramics was more palatable than imagining that women could run a manufacturing-based business. In July 1881, a journal reported that workers were building a new 60 x 40 foot (18.3 x 12.2 m) facility next to the factory to house the academy.

Like the others, Valentien was instrumental in Rookwood's success because he not only excelled at decorating, but also designed numerous clay bodies and forms. He would become the company's chief decorator for nearly the next quarter century before retiring with his wife Anna (also a renowned Rookwood decorator) to California, where he would embark on a second career painting wildflowers, trees, and other plants, ultimately becoming one of the greats in this area.

Looking back on the early years, a company history noted: "Kiln after kiln brought experiences, and with them knowledge of the possibilities of the materials at hand." Over time, "The plant strove upward, gaining strength from concentration," leading to "the perfect fruit, fresh and new to the world's ceramics."

The early experiments with baked clay centered on natural materials found in Ohio and Indiana. This work led to trials on painting with slip, applying clay thinned with water and color to wet clay bodies. "The idea," explained one journalist, "was to produce a new pottery of native American clays by applying color decoration in the material itself before firing, to make body and decoration a homogenous mass in the first firing, and then to protect and enrich this biscuit with a glaze."

Top
The potters and production team at the Eastern Avenue factory included John Jacob Menzel (back row, far left) and Joseph Bailey, Sr. (standing third from right). The potters were instrumental in developing Rookwood's scientific and technical expertise.

Bottom
Members of the decorating team and others circa 1903. Several artists had been with Rookwood since its earliest days. Back row (from left): John Dee Wareham, Fritz van Houten Raymond (photographer), Albert Valentien, Sallie Coyne, Amelia Sprague, Stanley Burt (chemist), and O. Geneva Reed. Seated (from left): Sally Toohey, Anna Valentien, and Margaret Coyne (administrative staff).

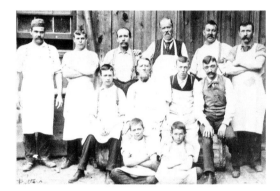

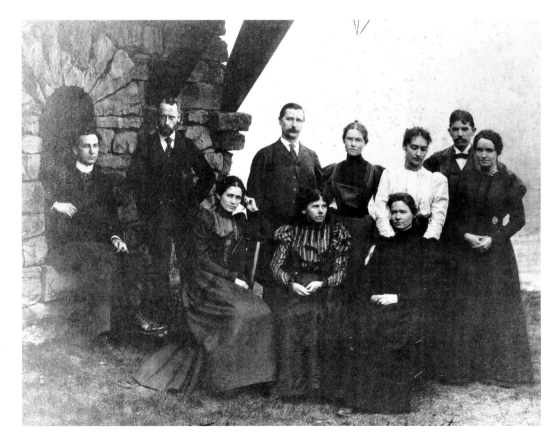

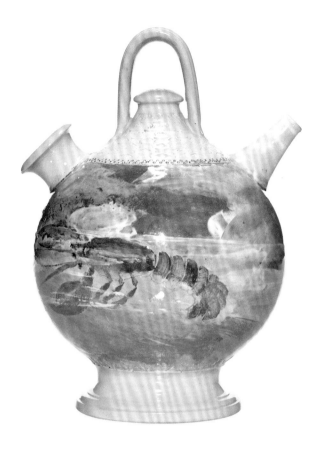

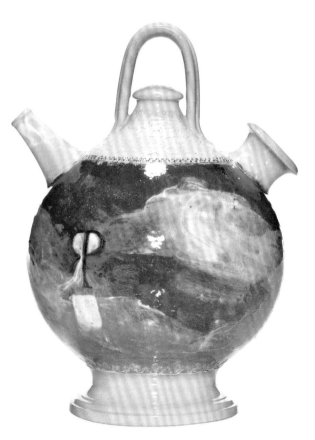

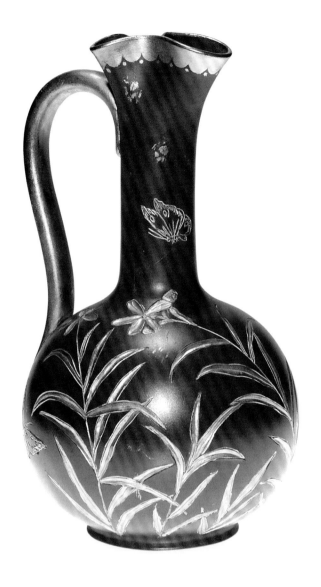

Left

This 1883 Spanish water jug is famous for many reasons, including as an example of an early depiction of the Rookwood RP logo, created by Alfred Brennan. The lobster is emblematic of the style of early decorators, similar to Maria's work. The work was part of Rookwood's internal museum. Brennan left the pottery in 1884, achieving a global reputation as a pen-and-ink and watercolor artist.

Top

Harriet Wenderoth incised this Dull Finish ewer (1882) with butterflies and flowers, colored them in gold, and added gold to the rim, handle, and neck.

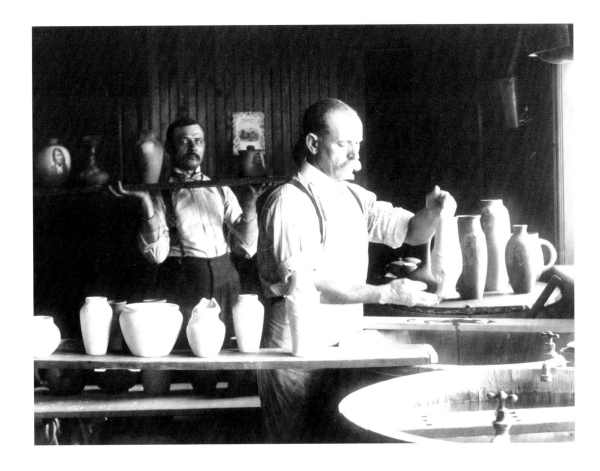

Left
Glazing pottery by hand at the Eastern Avenue factory. The glazes created by superintendent Joseph Bailey, Sr. helped establish Rookwood's growing reputation.

Below
Maria in 1886.

Maria slowly brought together a team of decorators and production experts to create Rookwood wares. Out of necessity, the little enterprise had to experiment with all the competing variations in the process of creating both practical and art pottery. These efforts ranged from putting processes in place for shapes that would be produced, pricing finished goods, and marketing the wares to creating a studio and factory culture and building infrastructure that enabled all the various pieces to run as possible. In an industry beset by products that emerged broken, faulty, or cracked, Bailey's influence was felt. "He never tolerated inaccuracies which his trained eye discovered in the molding of a vase or the placing of a handle on a piece of ware," said Newton.

Historian Edwin Barber placed the success on the shoulders of Rookwood's founder, saying, Maria "was the conception of a talented woman . . . who devoted her rare abilities and her abundant means to the realization of an idea . . .

particularly gratifying, both to the founder herself and the community."

The first two years of Rookwood's existence set a tone for the accolades that would come later—which no one could have imagined at the time. Like today's tech entrepreneurs, Maria led the efforts both managerially and creatively. That constant juggle, while creating something that no woman had ever done before, would become familiar to leaders in many of America's most innovative industries today. Just as women today juggle parenting duties and work life, Maria found a way to balance long days at the pottery company with childrearing. She took her son Joe and daughter Min to the factory. Her niece lamented that Aunt Ia (Maria's nickname) "rarely came home at lunch."

No less an authority than W. P. Jervis, one of America's leading pottery critics—and himself a potter—proclaimed that in contrast to the European ceramics industry, which was funded by monarchies and royal families, "It was a woman

who in America dared to leap into the breach and give us an art." The results, he exclaimed, were "a revelation . . . something entirely new." Jervis noted:

The harmony of color, the restraint in decoration and the luscious softness of the glaze gave to the painting the appearance presented by a pebble under limpid water. So charmed was the eye that another sense was involuntarily called into play: you feel compelled to touch it.

Maria also merits additional credit for prompting Rookwood's early marketing and publicity efforts. The female porcelain decorators in Cincinnati had used the media in its fundraising push for the 1876 Philadelphia Centennial Exposition and many local accomplishments, so Maria understood the value of public relations as third-party validation and a way to raise awareness.

Later in life, Maria lightly derided the "gratuitous advertising" the company received because she was a woman business founder. Taken in context, her remarks seem to be an attempt to credit others with Rookwood's achievement, rather than for onlookers to think it was a one-person operation. Yet then, as now, the media often looks to the founder and that person's vision as the defining aspect, particularly when successful.

The marketing efforts began with the first kiln. Maria had been in contact with Edward Atkinson, a Boston lecturer who took an interest in the young company. She sent ceramic wares to Briggs & Co., a retailer in that important city, which in turn lent pieces to Atkinson for his presentations. In addition, Maria continued working with Tiffany & Co. in New York City, and sold pieces in Cincinnati. A Rochester, New York, newspaper declared: "She has accumulated quite a handsome sum of money received from the sale of her vases. Of these, Tiffany in New York has been a larger purchaser."

What might be most astounding is that Maria had no blueprint for creating Rookwood. No

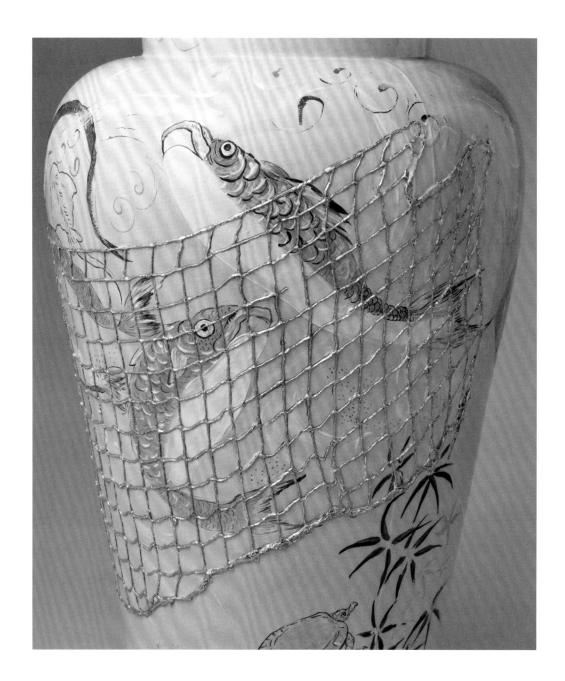

Above
One of Maria's signature designs, this large Aladdin vase (circa 1880) stands 30 inches (76.2 cm) tall and shows fish caught in a golden net, while a playful turtle swims below.

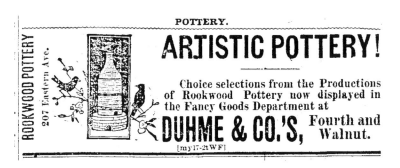

Left
The May 17, 1882 *Cincinnati Enquirer* ad for Duhme & Co., Rookwood's luxury goods retailer in the Queen City.

Oscar Wilde Visits the Queen City

In 1882, Oscar Wilde, the "priest of the beautiful" and "high priest of the aesthetes," made three tour stops in the Queen City of the American West. He received the same reaction as, if you can imagine today, Bruce Springsteen and the Rolling Stones somehow melding together and being topped with Beyoncé. Area newspapers published more than 500 stories about the English writer. Ever flamboyant and controversial, young Wilde blew across America to raise interest in the Gilbert & Sullivan play *Patience*, a British spoof on the era's pretty young things—individuals such as Wilde himself. The money and fame flowed as fast as the Ohio River, though, so Wilde set out to conquer the new world.

On February 20, Wilde stopped in Cincinnati on his way to Louisville, spending the morning with Maria. He told a reporter: "Today I drove to the Rookwood pottery, with Mrs. George Ward Nichols, and inspected its work very closely." When asked his opinion, he frankly rejoined, "Some of it was very good, and much of it indifferent." However, "On the whole I was very much pleased, as it showed what can be done for art." Though Wilde wasn't wild about Rookwood, the reserved praise made for good news fodder.

During the tour, some crowds turned on Wilde, deriding him for having long hair and wearing "knee-breeches," but the thousand people who attended when he returned two days later "largely represented the wealth and culture of the city." He did not impress the *Cincinnati Enquirer*, which criticized Wilde for everything from his pants ("horribly ill-made") and voice ("nasally") to his looks ("ugly, ungainly-looking man").

Maria sat in the audience, along with her sometimes friend/foe M. Louise McLaughlin. The Rookwood founder must have been aghast when Wilde called out Rookwood, exclaiming, "I saw some work at Mrs. Nichols' pottery that looked as if the one who decorated it had had five minutes to catch

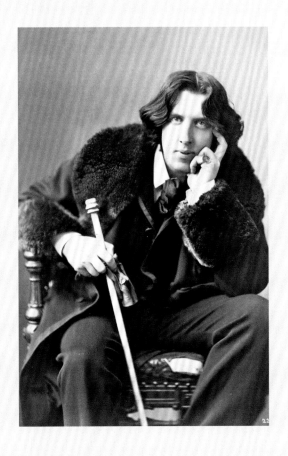

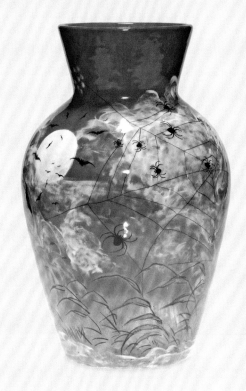

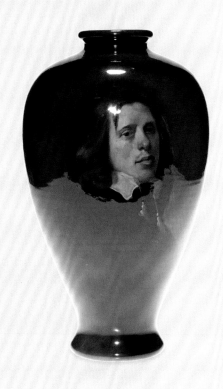

a train, and had decorated two vases within that time." More to her liking, he counseled instead that American artists replicate the Japanese master who "selects the scene, rejects some facts, and retains others with a perfect self-control." Yet Wilde also praised McLaughlin, calling her work "most beautiful and delightful."

One can only imagine Maria's reaction, but unquestionably her personal interest in grotesque renderings, such as skittering spiders and scurrying crabs, stood as the antithesis of what Wilde considered beautiful, a plainer style without overt ornamentation. Was the February afternoon the next day particularly chilly? Maria scored points among the local elites, hosting Wilde for lunch as Cincinnati's leading citizens jostled for a meeting with the young man, who would be destined for both greatness and an early death at forty-six in 1900.

female had ever established a large-scale manufacturing operation, and much of the male-dominated business establishment wrote her enterprise off as an amateurish collection of women looking for a way to pass the time between social engagements.

Certainly the financial picture remained grim for some time. Extant company records and research by previous writers reveals that the young firm's financial outlook was directly tied to the angel investor status of Joseph Longworth from the founding through his death in December 1883. Frequently, the company barely had money in reserve to pay its overhead and payroll, but this seems more out of a lack of oversight than neglect.

Maria also used her personal checking account to pay for the pottery in an era in which women (and most men) were not taught the ins and outs of modern record keeping. Edward Cranch, a retired lawyer and talented illustrator who decorated many pieces in the early years, helped with bookkeeping, as did Bailey, who kept the owner abreast of financial conditions when she traveled.

The costly enterprise ran at a loss of approximately $2,000 per year in 1882 and 1883 ($3.3 million annually today, based on economy cost comparison), despite sales of about $16,000 ($26.5 million today). Gauging what these figures meant in the early 1880s, one might consider that a semiskilled to skilled industrial worker earned about $1.38 to $4.00 per day. Unskilled workers, servants, and others earned considerably less, perhaps as low as $0.40 to $0.60 daily. Rookwood employees—as well as workers at other potteries in Ohio—earned about $2 per day based on a sixty-hour workweek. Rent in Cincinnati ran about $10 per month for a four-room apartment, but smaller places and rooms were much less expensive.

Although Rookwood's losses seem heady by today's standards, the shortfall is a pittance compared to what many technology companies generate and lose each year. One might liken Rookwood's launch as comparable to the creation of a new Silicon Valley industry, say

semiconductors, rather than the continuation of an established business.

Although the financial challenges proved a hurdle, Maria and her father were able to make up for the shortcomings. Demonstrating the kind of leader she was, Maria gave employees a Christmas bonus in 1882, withdrawing $30.50 in coins to disburse with the year-end payroll (about $8,500 today, based on relative income valuation).

Despite the losses, Maria and the production team continued the focus on making art. The effort began to take shape, and within a few years, Rookwood had produced handcrafted pieces that forced art critics to take notice. Perhaps more important for the company's long-term success, the science and experimentation took hold and became foundational within Rookwood's internal culture.

There are no existing company records or documentation that definitely prove that the "art over profit" idea was Maria's alone, but she believed in this goal, willing to back it with her considerable fortune. "In the beginning," she explained, "when it was not a matter of importance whether it paid or not, a great many new things were tried and experiments made, in search of improvement in material and effect." At every turn, while acknowledging the need to gain "financial solidity," Maria's overall aim was "artistic progress."

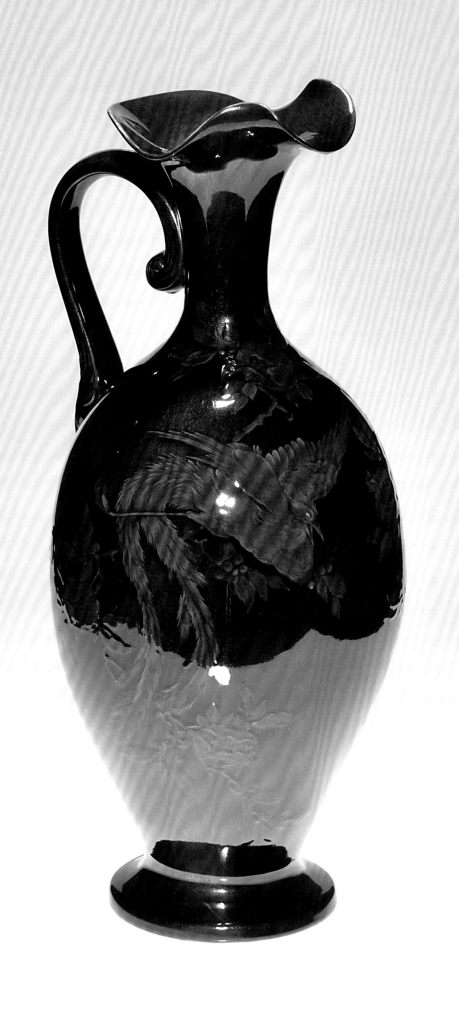

2 The World's Foremost Design Studio

Maria Longworth Nichols Storer envisioned Rookwood as America's answer to the celebrated art pottery made in Europe and Asia. Moreover, she believed her company might utilize new technology and artistic ingenuity to exceed the traditional stalwarts. Rookwood transformed from startup to powerhouse under the leadership of William Watts Taylor, Maria's handpicked business partner. By 1900, Rookwood won top honors at several international expositions, essentially establishing itself as one of the world's premier art pottery studios.

A rare Standard Glaze with Goldstone ewer painted by Valentien (1888). More than 20 inches (50.1 cm) tall, it features a firebird swooping through a flowering tree. Dark Standard Glaze and Goldstone won Rookwood widespread fame and international acclaim.

"Commerce Prostrate and Homes Laid Waste. The Queen City of the West Prone and Helpless."

Cincinnati Enquirer, February 15, 1883

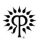

The lights across Cincinnati flickered, and then in a flash, the city went dark. What had begun as a hard rain turned into a deluge, with much of the region submerged under 66 feet (20 m) of water. When the sun came up the next morning, according to one newsman, "only the dark picture of destruction and death from the broad expanses of waters is presented to their view."

The next spring, floodwaters again overtook the Queen City, cresting at 71 feet (22 m). Eastern Avenue—on a makeshift island in the Fulton neighborhood—was basically cut off from the city as the railway lines were overrun and people downtown took to boats either as a means of escape or in hopes of rescuing those stranded.

The Rookwood factory flooded, with the basement taking a hard hit. The kilns behind the building were swamped too, as were many of the supplies and raw materials in storage sheds. The successive natural disasters would shut down the factory at a time when it had begun to generate sales momentum with retailers stretching across the East Coast and Midwest. The floods also showed how precarious the Eastern Avenue location would continue to be.

Maria could hardly have believed that her company would so quickly outgrow its head-

quarters, but the factory was cramped, dirty, and more than a little dangerous, as the repeated floods had revealed. Too many pieces were being damaged or destroyed in transport up and down the dark stairs between the kilns and the decorating studio and throughout the plant. Something had to be done about the space! However, before imagining a new factory, Rookwood had to transform as the company progressed from a small shop to a thriving enterprise.

Several months after the devastating 1883 flood, Maria made a significant change in the way Rookwood would be managed. She hired her longtime friend William Watts Taylor to run the operation. Taylor, one of Cincinnati's leaders in the arts community, had been working at his father's merchant house for nearly twenty years by that time, taking over when his father died in 1869. Although a businessman by trade, like so many Queen City executives, he believed that a thriving arts scene was essential for creating a great American city.

Like many company founders, Maria found that the managerial processes were not what fueled her creatively. As the factory expanded, formal business needs exceeded what she, Clara Chipman Newton, and other advisors who provided

guidance could provide. As Maria's lifelong friend (and, at one time, considered a suitor before her marriage to George Ward Nichols), Taylor had a relationship with her built on trust. That rapport gave him the motivation to institute solid business practices that enabled growth.

Past observers have suggested that Taylor came from out of the blue and had no experience in running a company like Rookwood. However, this characterization is not accurate. As a local business executive, Taylor—like Maria—had long been a fierce promoter of the arts in the Queen City. As a matter of fact, it was Taylor who, according to Maria, "happened to be with me the first time I stopped" at the Dallas Pottery. On that initial visit, they met Joseph Bailey and struck up a relationship with the master potter. One can imagine Maria's wheels already fixing on the notion of someday creating her own pottery.

No stranger to the arts scene, Taylor had notably served as secretary of the Cincinnati Industrial Exposition of 1872. Managed and marketed by Alfred Goshorn, advertisements for the month-long fair decreed it the "largest exposition ever held in the United States," comprising some 8 acres of indoor space.

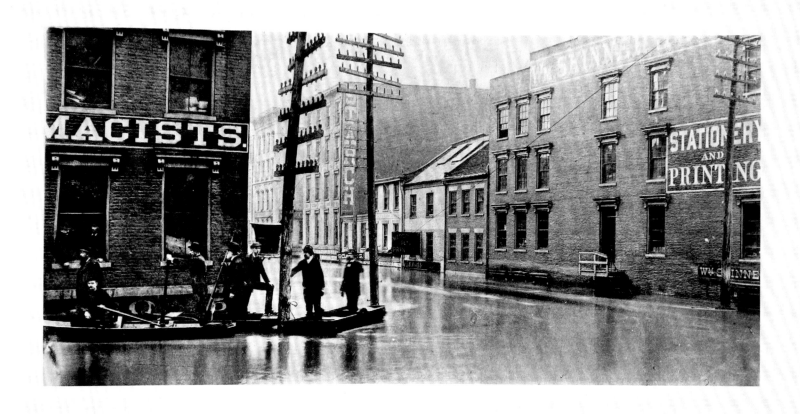

Above
The 1883 and 1884
floods left Cincinnati
decimated and put the
fledgling Rookwood Pottery
in repeated jeopardy.

Right
The Queen City, without
electricity, launched door-
to-door rescue efforts to
save people trapped by
the 1884 flood.

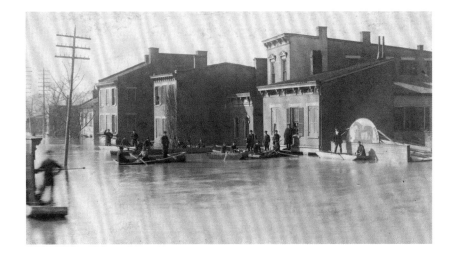

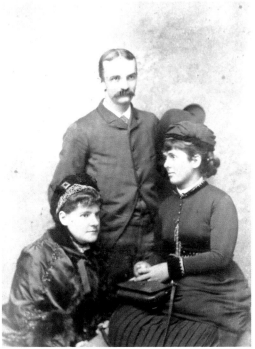

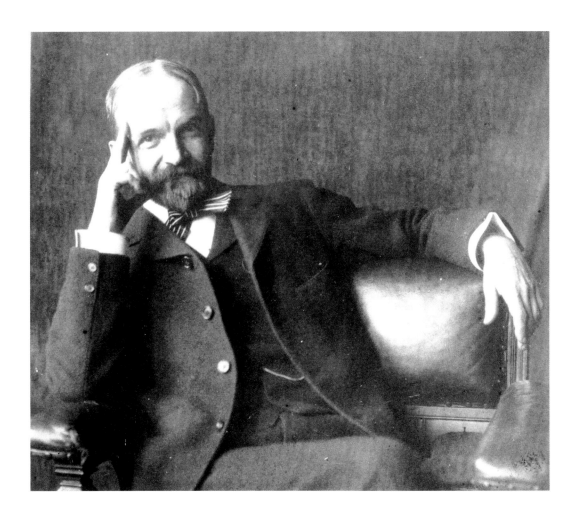

Top left
William Watts Taylor, Maria's handpicked manager, digs into work at the factory.

Top right
William Watts Taylor, center, with Maria on the right, and her sister-in-law Susan Walker Longworth. Susan's son Nick would become Speaker of the U.S. House of Representatives and marry Alice Roosevelt in one of the era's fairytale romances.

Right
William Watts Taylor, the Cincinnati business leader and arts patron who would lead Rookwood to international acclaim.

Goshorn's role is intriguing, because he was a close friend and confidante of Maria's first husband, George Ward Nichols (who tragically died of tuberculosis on September 15, 1885). The Cincinnati Exposition had been a financial and artistic success, which established Goshorn's international reputation. More importantly, the event provided the springboard for him to be named Executive Director of the Philadelphia Centennial Exposition. He pulled both male and female leaders from Cincinnati into the international art and culture scene. Given his significant role in the successful Cincinnati Exposition, Taylor would have basked in this glow as well.

The recommendation to hire Taylor could have come from a number of sources, including Goshorn, Maria's husband George Ward Nichols, or her father Joseph Longworth. Possibly she could have made the decision herself, based on their long friendship. No matter the route to Rookwood, Taylor quickly proved himself indispensable. As a seasoned executive, he had a strong eye for detail and a pulse on what types of products would sell. He even possessed an artistic flair, frequently suggesting or designing new pottery shapes based on his consumer instincts and many visits to retail shops and museums.

Taylor began a process that transformed Rookwood from a founder-led operation into a business enterprise. Many startups across history have not made this transition well, limping along for years attempting to determine who is in charge. Clearly Maria did not want to remain the day-to-day manager of operations, so she turned the firm over to her handpicked successor. As Taylor built the organization, Maria moved on to obligations and interests outside the pottery.

As a result, Taylor's influence on the Rookwood's ensuing success and global accolades cannot be understated. Yet, like Maria, Taylor has not received much attention from business or art historians, while much less accomplished leaders have been routinely praised.

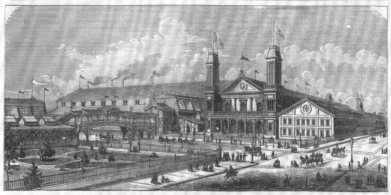

An illustration of the Cincinnati Industrial Exposition of 1872 in *Harper's Weekly*.

A Scientific Endeavor: Glaze, Form, and Decoration

In the early years, Maria kept a close eye on the blossoming Cincinnati art scene, as well as the students trained in the city. Getting Valentien into the pottery was a coup and his early work demonstrated that blossoming prowess. To build out the decorating staff, Maria could handpick from among the most talented, providing them with a steady paycheck and a canvas on clay for fulfilling their artistic dreams. What emerged sometimes fell in line with Maria's own fascinations—grotesques and wild creatures, from scampering crabs to witches on broomsticks to painstaking renderings of wildflowers and an array of floral designs.

In Rookwood's first three years, Maria would hire a cadre of artists, all trained at the School of Design and with an impressive array of talents. Some of the early decorators were innovators in their own right, including Laura Fry, who joined Rookwood in 1883. Fry had learned the Limoges painting style and taught it to students, while Clara Chipman Newton taught different types of painting, including the Cincinnati technique created by M. Louise McLaughlin. In July, searching for a new way to apply colored slip, Fry developed a mouth atomizer that enabled decorators to spray slip using their mouths. One historian claims Fry's invention "revolutionized faience."

The growing decorating staff focused its efforts primarily on hand painting the surface of different clay bodies. For inspiration, Rookwood assembled a deep library of photographs, books, and images. They also traveled around the city and region searching for examples in museum and private collections. From these, they created in styles reminiscent of the Japanese mania that had fueled Maria's work, as well as European styles spanning the continent.

As the world grew more mechanical in the late nineteenth century, Rookwood relied on traditional means, which fascinated observers. Historian Edwin Atlee Barber noted, "The workmen of this factory have all been especially trained ... no machinery is used save the primitive potter's wheel" for the decorative wares. The lone thrower's "graceful creations have obtained a world-wide celebrity." Most writers had fewer words for the production pieces, which were created using slip poured into molds, just has had been done for more than a century. The art pottery—then, as now—seemed to always grab the headlines.

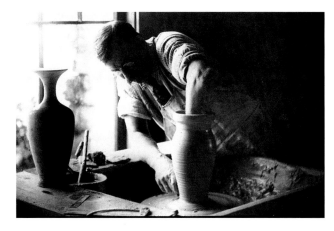

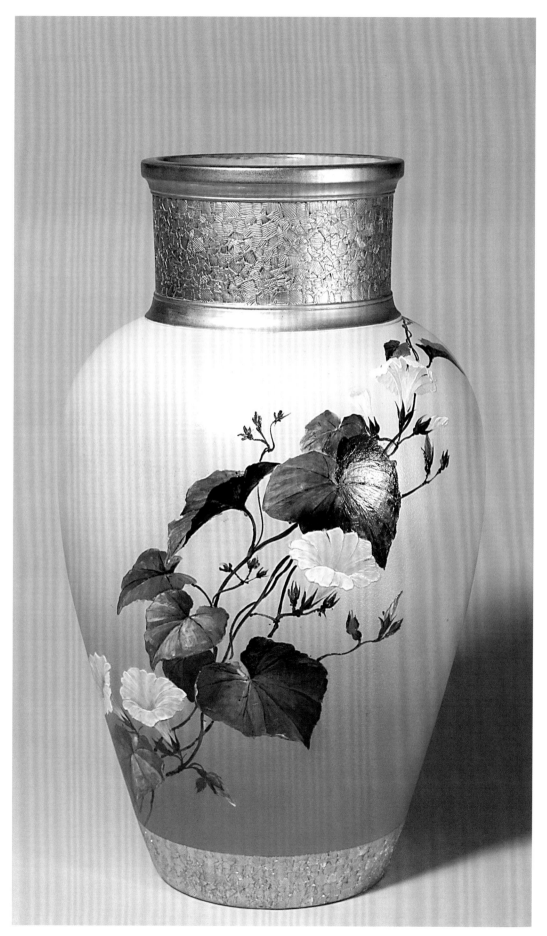

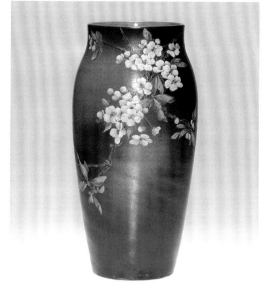

Taylor proved to be a personable, take-charge leader. When the factory returned to speed after the 1884 flood, he began supervising production operations. Walking the shop floor, he visited with the chemists and production supervisors, which ensured that he had the latest information directly from the source. He learned about glazes and kiln temperatures through these discussions, which gave him insight on products that could be fired with less breakage, one of the costly elements when making ceramics. Combining these points with the sales data he crunched, Taylor made critical decisions about what products to produce in great volume and which shapes had to be discontinued.

Rookwood lore claims that nearly every kiln ever fired in the factory had an experimental or research element. The process of constantly testing in decorating and glazing resulted in a distinct Rookwood style that emerged. Although expensive to produce under the guidance of the industry's initial chemists and craftsmen, the output led to a series of glaze lines that would catapult Rookwood to international acclaim. Repeated tests were necessary because the mysterious chemical transformations often made it difficult or impossible to know exactly how an experiment might turn out.

In addition to Joseph Bailey, Karl Langenbeck joined Rookwood as a ceramic chemist. He kept meticulous records of clay types, mixes, glaze reactions, and recipes in an effort to standardize output. Historian Herbert Peck explained that this period is marked by "almost endless experiments." Although Langenbeck would only stay at Rookwood until late 1885, he profession-alized research efforts. After leaving Rookwood, Langenbeck would go on to a stellar career as one of the top authorities in ceramics.

In December 1885, Maria applied for a patent on "chromatic ornamentation of pottery," which was granted in April 1887. The effort to infuse color across the work inspired and frustrated Maria and Rookwood chemists, but it would ultimately provide the fuel to propel the company ahead of rivals.

Walter S. Christopher, a young chemist and doctor who specialized in pediatrics, served as a consultant at Rookwood, focusing on glaze chemistry and clay composition from December 1885 to 1886. His notebook is filled with experiment after experiment, and also notes that demonstrate the challenges inherent in glaze research. On October 30, 1886, in an entry "Experiment on Bubbling Yellow Glaze," Christopher laments: "What constitutes complete firing of biscuit? What are the changes which take place from clay to biscuit?" Bubbling was Christopher's constant nemesis in the research. In another experiment, the doctor concluded, "Over the formal decoration the glaze was perfect, but on the backgrounds it had a fine dull metallic luster, which was not at all pleasing." Taylor, however, was pleased with the chemist's work and continued to use him off and on as a consultant.

After four years of tinkering, testing, and trialing, Rookwood's glaze engineers had created three glaze lines—Cameo, Dull Finish, and Standard—that would serve as the foundation of its products.

Called "Ivory ware" before Taylor changed the name in 1887, Cameo played a critical role in the pottery's production pieces, as it was primarily the traditional white, china-like look that would be most at-home to consumers who were used to porcelain everyday ware. The production team soon mastered Cameo, turning it into a consistent moneymaker. The success with Cameo gave Rookwood the funds and time necessary as the research team continued to refine the fancier glaze lines, which were more expensive to create and prone to breakage.

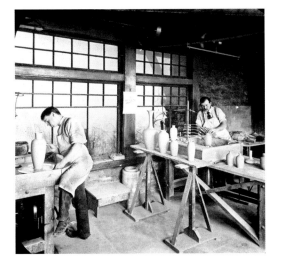

Over time, however, Cameo got pushed aside as other glaze lines were created and marketed. By 1892, Rookwood moved away from the basic glaze because its overall fortunes had changed significantly. Taylor no longer needed to lean on the traditional, porcelain-like glaze line as Rookwood grew more experimental and was lauded for that innovation.

The Dull Finish Glaze used a smear technique to apply a thin glaze that left the vessel looking as if no glaze had been applied at all. The result, however, gave decorators a muted canvas that enabled bright white, pinks, and blues to seemingly burst from the piece, particularly when accented with gold. The delicate hand-painted illustrations—usually of flowers—made the Dull Finish works seem dainty or fragile, but it was part of the illusion of the glaze line.

The mysterious elements of the firing process, clay composition, and glazes sometimes led to breathtaking results. The king of early colors emerged with the Standard glaze line. After its introduction, Rookwood received critical acclaim. In international competitions, judges were flabbergasted by its dark, rich, and deep tones in assortments of brown. The recognition led to consumer demand for Standard pieces of art pottery to the point that Standard became synonymous with Rookwood for many people.

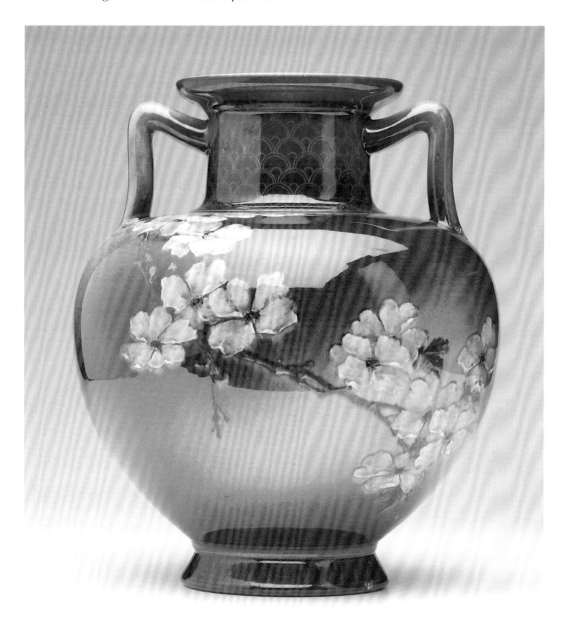

Matt Daly (1888) Standard Glaze urn (13 x 10½ inch [33 x 26.7 cm]) featuring branches of yellow dogwood with a gently tooled underglaze design encircling the collar.

Rookwood excelled based on its hand-painted pieces and glaze lines. In early 1888, a reporter deemed Rookwood "exquisite," noting one piece for "its color, a symphony in dull green and gray," while another "has a glaze so brilliant that it might have been polished for a hundred years." The "controlling idea," the writer noted, "has been to apply art to simple things and to common materials . . . originality has been encouraged and quality has never been sacrificed to quantity."

The dedication to research resulted in new glazes, which then led to increased sales. By late 1885, Taylor's efforts had brought Rookwood near even, financially, through dedication to operational efficiency and sales analysis. He also picked up marketing efforts, beginning a coordinated outreach campaign to museums. The most obvious target was the Cincinnati Art Museum, which had a growing, important ceramics collection. Rookwood "deposited" works there, which kicked off a relationship that would last for thirty-five years.

Taylor's continued attention to financial details paid off when Rookwood achieved profitability by late 1888. According to Herbert Peck, "Although exact figures are not available, it was probably almost enough to reimburse Mrs. Storer for all the losses sustained during Rookwood's first five years in business." In retrospect, this is a remarkable accomplishment, given the way the pottery grew in complexity in Taylor's first five years. To make what might be estimated to be some $10,000 in profit could hardly be understated ($14 million today, based on economy cost comparison).

In 1894, the experimentation led to another batch of glazes. After five years of work, the company introduced three glaze lines: Aerial Blue, Iris, and Sea Green. For Taylor, the research had to then line up with public demand. Unfortunately, consumers did not respond to Aerial Blue, forcing Rookwood to drop the line after about a year. Sea Green and Iris, in contrast, were not only popular, but used to create magnificent, award-winning pieces.

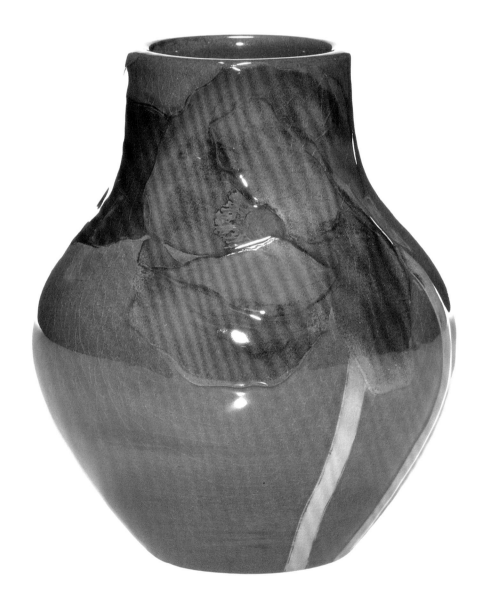

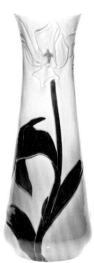

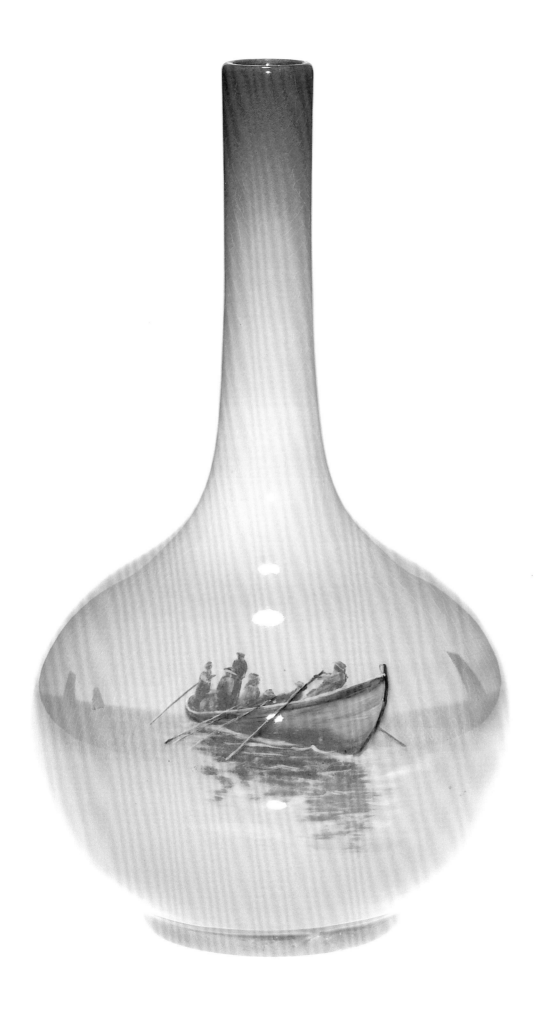

Left
Aerial Blue Glaze never caught on with buyers, but collectors adore it. This rare Aerial Blue vase painted by Amelia Sprague (1895) features men on a fishing boat and other vessels in the distance.

Opposite left
An experimental 5½ inch (14 cm) Black Iris Glaze vase with carved and painted poppies created by Harriet Wilcox (1900). One of the 2,292 Rookwood pieces the Cincinnati Art Museum acquired through Taylor's "loan" system.

Opposite top right
Kitaro's 1900 Art Nouveau tulip vase was created using Iris Glaze, but layered to create dimension. This piece was part of Rookwood's loan system with the Cincinnati Art Museum, an association that helped each institution grow in importance in the early twentieth century.

Opposite bottom right
John Dee Wareham's skills as a decorator and designer are highlighted in this Sea Green vase (1899). The cobalt coloring on the stems and leaves is rare, difficult to replicate in the late nineteenth century.

Native American Portraits

GEORGE HIBBEN

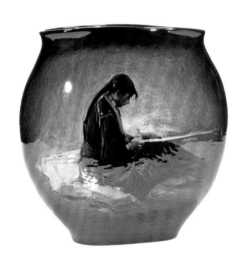

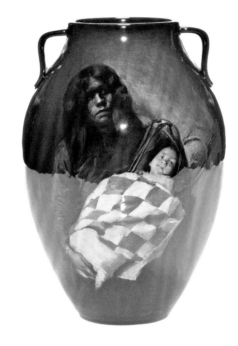

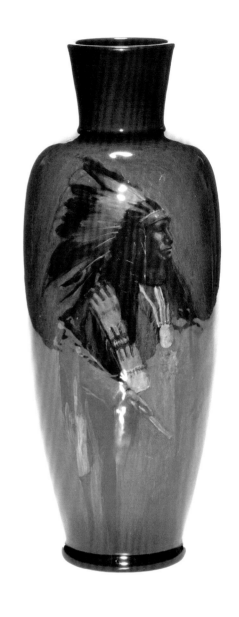

Designs trends are often linked to societal influences or color trends. In the mid-1880s through 1910, Rookwood's Standard Glaze took the art world by storm, demonstrating that ceramics could be created in deep, rich shades of brown. Standard Glaze added depth to the decoration underneath, accentuating the power of Rookwood's decorating department as painters.

Native American portraits grew popular based on the fascination of the settling of the West and traveling Wild West shows, such as the one run by William "Buffalo Bill" Cody. Sporadically, beginning with Henry Farny in 1881—who would later gain great fame based on his work portraying Native Americans and the American West—then more decisively in the late 1880s, Rookwood artists used Native American portraits on vases, mugs, and plaques.

The premier Native American portrait artist was Grace Young. Matt Daly, William McDonald, and Olga Geneva Reed stand out, but Young's talent for portraiture and painting set her apart. "Masterful," explains art curator Anita J. Ellis. "Each composition offers a different mood, whether it is dramatic, sympathetic, dark, light, somber, pleasant, tonal, colorful, simple, or complex."

Like all Rookwood wares, Native American portraits were produced out of a complex mix of decorator inspiration, sales potential, marketing, and larger societal influences. When the nation moved from sentimentality to an era invigorated by expansion and technology in the early twentieth century, the fad faded.

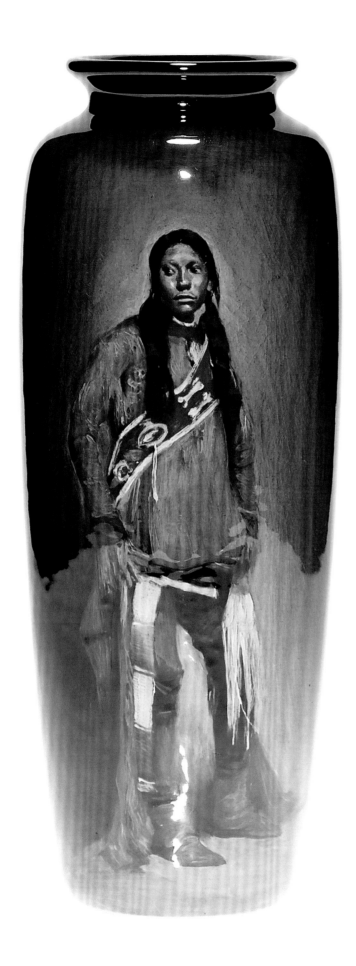

Opposite left to right
An 1899 Native American vase decorated by Grace Young, this portrait is rare for Rookwood because it features a young woman, rather than the usual, formal male posed in tribal garb. In addition, she is engaged in daily work, which is noted on the base: "Fox of Hawk Bead Work." Young could have seen the image in a photograph or from an 1896 staged encampment of Sioux at the Cincinnati Zoo.

This Grace Young two-handled vase (1900) features a portrait of a Native American mother and baby, who is wrapped in a woven checkerboard-patterned blanket. Darkness hides the mother, while baby is bathed in light. This piece was probably on display at the 1900 Paris Exposition.

A full standing portrait of Chief Black Bird of the Sioux, complete with head-dress, that was painted by Grace Young in 1900. Her artistry is on full display in a piece just under 13 inches (33 cm) tall.

Left
Characteristic of Grace Young's detailed portraits, this Standard Glaze 1900 vase is of Suriap, a Ute male.

Above
In her studio painting a portrait on clay, Grace Young is herself the picture of careful observation and concentration.

Worldwide Acclaim

In the late 1800s, commentators lamented that a truly "American" art movement had not fully emerged. Given the young nation's growing economic and military prowess, critics believed that American art should compete with the grand history of European culture and the opening Asian markets, tying these ideas closely to democracy and the nation's youthful vigor versus the antiquated Old World. As a result, U.S. officials supported American artists, companies, and organizations to participate in international expositions that served as the gathering place for the world's best arts, industry, and ideas.

Although Americans felt their democratic spirit served as a springboard to greatness, European commentators viewed the nation as a backwoods outpost lacking culture. The idea of America as a vast cultural wasteland filled with dirt farmers and tobacco-spittin' cowboys was not far from the norm. Consequently, Americans had a cultural inferiority complex, while Europeans considered themselves superior, but cast a wary, ever-watchful eye overseas.

Taylor recognized the importance of winning local and regional honors, but understood that the world's fairs had the potential to increase international exposure in a way that returned much more than it would cost to participate. In one fell swoop, Rookwood could debut its scientific advancements in glaze lines, while highlighting the decorating team's work by showcasing its top pieces.

Winning awards also translated into additional marketing opportunities, press coverage, and intensified interest from art collectors and aficionados, including museum curators. The latter, Taylor anticipated, would snap up Rookwood wares for display, thus expanding the firm's growing footprint.

One of the key components of Taylor's push was to take shape in the form of Kitaro Shirayamadani, who joined Rookwood's decorating staff in 1887. Maria had dreamed of a Japanese artist working at her pottery and Kitaro fulfilled these visions and more. He quickly proved to be a relentless worker and effortlessly delicate in hand-painting ceramics. Kitaro

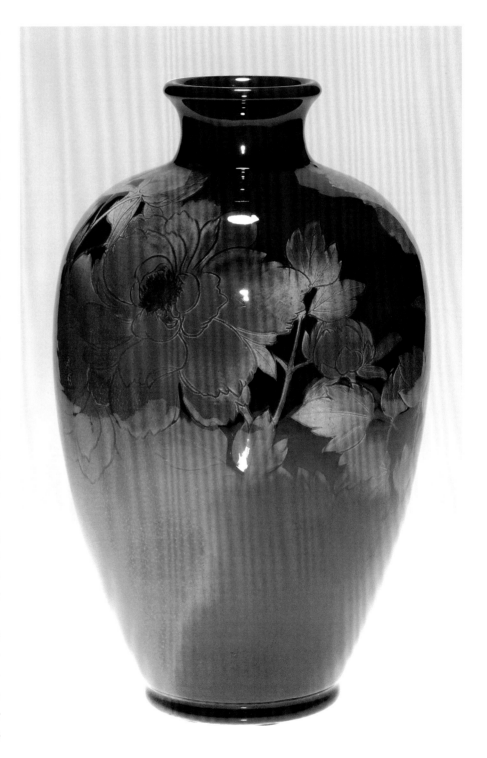

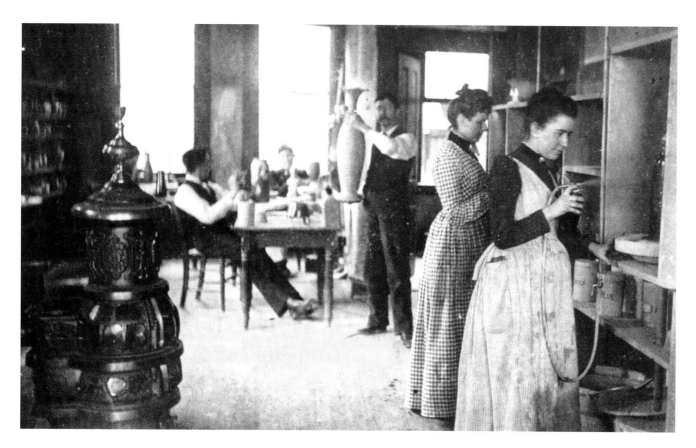

also added to Rookwood's understanding of clay bodies, adorning pottery with metal, and became expert in glaze chemistry.

Rookwood's first international award came at a London exhibition in late 1887. The "Special Mention" gave the firm a marketing boost. Within a month—just in time for holiday shopping— Duhme & Co., which sold Rookwood in downtown Cincinnati, placed a newspaper ad quoting the London judges, who called Rookwood "among the most original and beautiful modern developments of ceramic art." Retailers, spurred on by Taylor, continued to use subsequent Rookwood accolades in their marketing efforts.

Taylor aggressively established relationships with leading pottery writers, as well, such as Edwin Atlee Barber, a pioneer in ceramic scholarship and later an advisor and curator/director of the Pennsylvania Museum of Art in Philadelphia. Barber's power cannot be understated; potteries vied for inclusion in his books and rushed to send samples. Of the forty-five potteries competing for his attention, however, "none facilitated and encouraged more significant support for the Museum's collections than Maria Longworth Nichols," says one pottery scholar, making an important point about Maria's role in marketing in the 1880s and 1890s (usually seen to be Taylor's purview alone).

In Barber's monumental and groundbreaking history of American pottery, he gave Rookwood a prized position, proclaiming: "It is safe to assert that no ceramic establishment which has existed in the United States has come nearer fulfilling the requirements of a distinctively American institution."

Moreover, he singled out Maria, explaining, "The founding of this factory was due to the intelligent and well directed efforts of a woman." Maria, he said, "Possessed of rare and versatile talent . . . has since produced a great variety of pieces, original in conception, artistic in treatment, and bold in execution." Ironically, though, despite Rookwood's international renown, Maria being a female founder, Barber said, would elicit "a peculiar interest for American collectors and patrons of art."

One of Rookwood's first national successes had come in the 1888 ceramics exhibition held at the Pennsylvania Museum of Art. Taylor sent eighty-three pieces, which won two gold medals. At its conclusion, benefactors in Philadelphia purchased the two main prizewinning vases and a third that showcased Rookwood's impressive Tiger Eye Glaze. These acquisitions set in motion the creation of a large permanent Rookwood collection overseen by Barber, who aggressively selected the best pieces from ensuing years.

The next competition would be overseas. American officials pressed manufacturers to exhibit at the 1889 Exposition Universelle in Paris, hoping that a good showing would expand international trade and solidify its longstanding relationship with France. Despite the encouragement, Rookwood was the only ceramics company to heed the call. The pottery was displayed at a booth handled by Davis Collamore and Co., a New York City retailer headquartered at Broadway and 21st Street that sold Rookwood along with European and Asian imports.

Taylor launched a plan to publicize Rookwood in Paris, corresponding with the retailer and others in an attempt to mold the judge's sentiment in Rookwood's favor. His efforts began by selecting deliberately artistic pieces.

Several of the stunning art pieces featured the Tiger Eye and Goldstone Glazes, both known internally at Rookwood as happy accidents. The glazes were difficult to replicate and, as a result, were costly, yet possessed undeniable beauty. What stood out on the Tiger Eye pieces were the mysterious gold striations and flecks that seemed to shimmer from deep within. These glazes basically transformed attractive pottery into works of art.

For Taylor, the simple equation equated to whether the Tiger Eye wares would separate Rookwood from its European competitors. What happened next was almost too good to be true! Tiger Eye was so unlike anything that the judges had seen before, they assumed Rookwood perpetrated some kind of fraud. They demanded that the pottery prove it could consistently create this

The gold medal awarded to Rookwood in 1889.

level of artwork. Frenzied missives between Collamore officials in Paris and Cincinnati led to several additional pieces sent overseas.

Rookwood became the talk of the exposition, drawing large crowds eager to see its unique glazes and decorating styles. Much to the surprise of American and European art pundits, Taylor's gamble paid off—the turmoil ultimately led to Rookwood earning a gold medal.

News of the award resulted in notable sales to European galleries and museums, and also to the French government, which bought Rookwood to display at the Musée des Arts Décoratifs in the Louvre's western wing. Also many wealthy Americans who were in Paris bought pieces to decorate their mansions back in the United States. Not surprisingly, several European potters bought Rookwood wares to study and copy what the company had achieved in its relatively short history.

According to art historian Kenneth R. Trapp, "It is something of a miracle that Rookwood was given the gold medal in its first international competition." The Europeans, Trapp asserts, did not want to award the gold medal to a small American firm, but the sensation forced their hands. Assessing its success, Rookwood asserted that originality and technical merit were at the foundation: "An individuality that grew out of a combination of fresh impulses in pottery with sound processes of manufacture and decoration."

Always balancing the divide between art and commerce, Taylor wasted no time using the win in company advertisements. Within weeks of the gold medal notification, Rookwood ads exclaimed that its artistic pottery was "an appropriate gift for Christmas." The award remained a part of Rookwood advertising across the ensuing decades.

Below
Research notes for exhaustive Tiger Eye experiments conducted by Walter S. Christopher in late 1886. Brought in by Taylor, the young chemist spent a year trying to replicate the formula.

Winning international acclaim helped Rookwood spread awareness, but many art critics still weren't sure how to interpret the ceramics craze. Slowly, they began writing in more positive voices about the role women played. A newspaper story in February 1890 by Eliza Putnam Heaton focused on "rare and beautiful things in the ceramic world." She lauded Maria for establishing Rookwood "whose exhibit at the French Exposition was pronounced remarkable, and was bought up eagerly by French potters for imitation." Rookwood "color effects" and "artistic feeling," the reporter noted, "are not surpassed anywhere."

The 1889 commendation marked a turning point for Rookwood. In one fell swoop, the company gained an international reputation. Moreover, the recognition almost immediately boosted sales. After teetering for nearly a decade, Rookwood's financial picture turned around.

With Taylor at the helm and a seemingly bright future ahead, Maria Longworth Storer decided to retire from active management. Six months after her first husband passed away, she married her former suitor, Cincinnati lawyer and politician Bellamy Storer. The new power couple turned their attention to his political aspirations, life in Washington, DC, and a future in diplomacy.

As a result, Maria gifted Rookwood to Taylor. His managerial prowess enabled her to turn her energy toward supporting Bellamy and helping guide his career. The partnership between Maria and Taylor, though, had been instrumental. "The direction, without which all this must have been aimless, has come mostly from Mrs. Storer and Mr. Taylor, though others have from time to time helped with friendly criticism," a company document outlined. The two leaders represented the interlocked arms of the pottery—the artisanship of the decorating team and the factory focused on making household wares for daily use.

Taylor would quickly have to come to terms with these frequently competing divisions,

but perhaps no one outside Maria was more committed to Rookwood's long-term success. Although not having Maria's innate artistic ability, Taylor had shown deep interest in marrying artistry and production. For example, he had designed hundreds of body forms for the hand-thrown and slipcast teams to test. The Rookwood Shape Book, the bible of shape designs across the firm's history, is filled with Taylor's handiwork, everything from original ideas to metallic and museum pieces he and his wife had seen and believed could be replicated in clay.

Taking over as owner, Taylor moved to formalize Rookwood as a corporate entity. In late April 1890, he and a small group of eight men—including Maria's husband Bellamy Storer—met to incorporate as The Rookwood Pottery Company. They capitalized the new company $60,000 (equivalent to some $81 million today), divided into 600 shares of $100 each.

Taylor was named president and treasurer, controlling 380 of the 490 issued shares (77.5 percent). The other board members

received 5 or 10 shares. In an odd move that has never been fully explained, Bellamy Storer was named vice president of the new entity, which might reveal that the "gift" from Maria came with some strings attached. Furthermore, Bellamy's cousin Albert G. Clark, who was a noted city arts booster, served as secretary. Next, a subcommittee then created bylaws and the group voted to spend $40,000 to purchase the company assets, including patents, trademarks, and factory property.

The financial picture was rosy after the 1889 Paris win. In 1891, some 11,300 pieces were sold, which reaped the company $52,365. There would be no dividend issued, however, because Taylor had a vision that was about to come to life—moving to a new home.

Rookwood had achieved a great deal from its cramped home base on Eastern Avenue, situated between the railroad tracks and Ohio River. Modifications to the basic layout and expansion were made when possible. Ultimately, however, space on Cincinnati's Eastside was limited. The factory was hemmed in and the floods of 1883 and 1884 showed the location's vulnerability.

William Watts Taylor was a man of unique and diverse talents. When the board of directors approved his long-awaited plan of moving the pottery, he hired architect H. Neill Wilson, a former Cincinnati resident operating out of Pittsfield, Massachusetts. In actuality, though, Taylor designed the new factory and studio. He chose a location almost the exact opposite of Eastern Avenue. The new home would be on the top of a grand bluff overlooking downtown in Mount Adams.

Ground broke in early 1891, including new oil-burning kilns that would replace the coal-fired ones that powered Eastern Avenue. The proposed building would have two floors on top of a working basement that housed machinery to drive the equipment and a clay storage facility. The ground floor featured salesrooms and a lab and office for Bailey. The top floor housed Taylor's office, payroll, and the decorating department. The senior artists (Albert

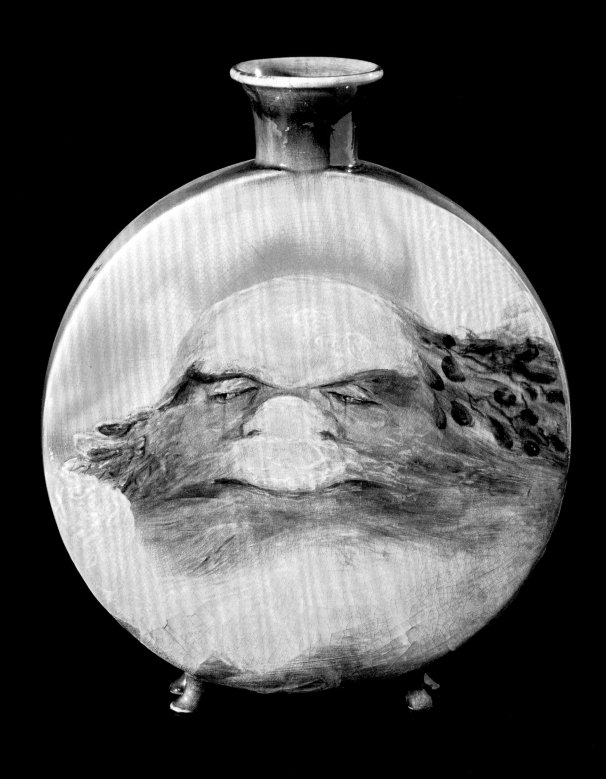

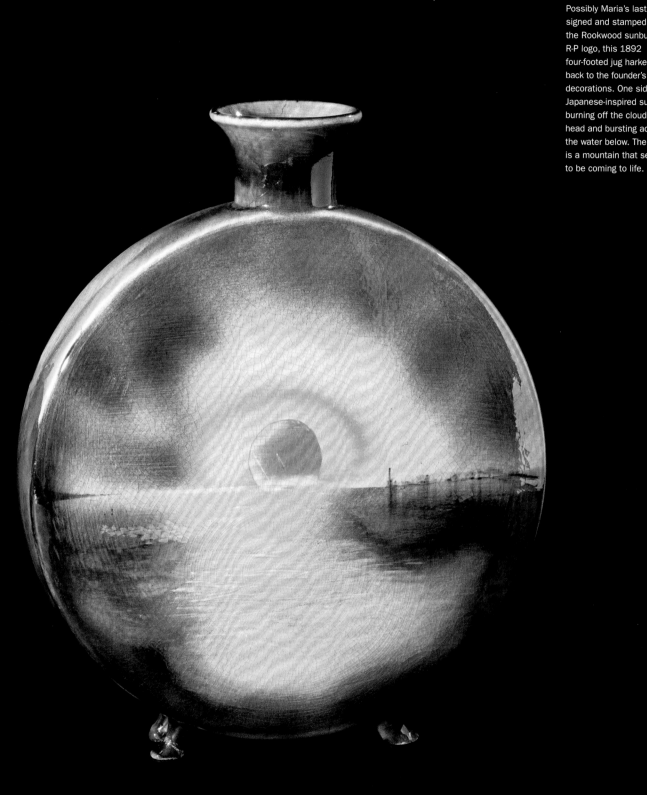

Left
Possibly Maria's last piece
signed and stamped with
the Rookwood sunburst
R-P logo, this 1892
four-footed jug harkens
back to the founder's earliest
decorations. One side is a
Japanese-inspired sunset
burning off the clouds over-
head and bursting across
the water below. The other
is a mountain that seems
to be coming to life.

and Anna Valentien, Matt Daly, William McDonald, Grace Young, Kitaro Shirayamadani, Artus Van Briggle, Amelia Sprague, and Sally Toohey) had private studios. The rest of the decorating team shared an open-office bullpen area.

In 1892 the new factory opened, looking to visitors like a grand vision of an English countryside manor, with a tower jutting up the bluff. From its large windows looking over the ridge, the Queen City and Kentucky unfolded below.

The increase in space enabled Taylor to add nine new decorators, increasing the department to twenty-four. A larger factory also facilitated production of more wares. For the year ending in 1893, revenue climbed some 20 percent to $64,630. The marketing and manufacturing processes led to greater awareness and sales. According to Barber: "Today its exquisite ceramic creations may be found in almost every home of culture and refinement and in every prominent art museum in the land."

The 1893 Chicago World's Fair played a significant part in expanding Rookwood's footprint. Fair organizers displayed its wares across five different exhibits, demonstrating the company's prestige in art pottery circles. Taylor, hoping to capitalize on the spectacular aura of the exposition, paid for company employees to visit the Windy City, providing new or renewed inspiration.

Rookwood won "Highest Award," the only designation at Chicago, and quickly responded by placing the commendation in advertisements and marketing materials. After the 1889 Paris successes, the Chicago Fair served as a kind of punctuation mark. More importantly, European museums and buyers across the nation continued gobbling up pieces.

In 1898, Rose Kingsley, an art critic writing for London's *Art Journal*, who had visited the factory in Cincinnati, proclaimed: "Out of the clary of Storer's native place, she has developed the most original and beautiful art industry in the United States." The critic pinpointed what set Rookwood apart from its American competitors, explaining, "The actual glaze of Rookwood is comparable only to the finest Chinese and Japanese."

In less than a decade since its founding, Rookwood would enter the twentieth century safely arguing that it stood as the top pottery in the world. The leadership transition from Maria Storer to William Watts Taylor had gone smoothly, enabling the company to gain its footing. As Maria moved away from daily operations, Taylor's smart leadership acted like a rocket, allowing the decorating team to grow into its full power. Overcoming the early bumps, Rookwood had shown the world that the gem in the crown of the Queen City could conquer the world.

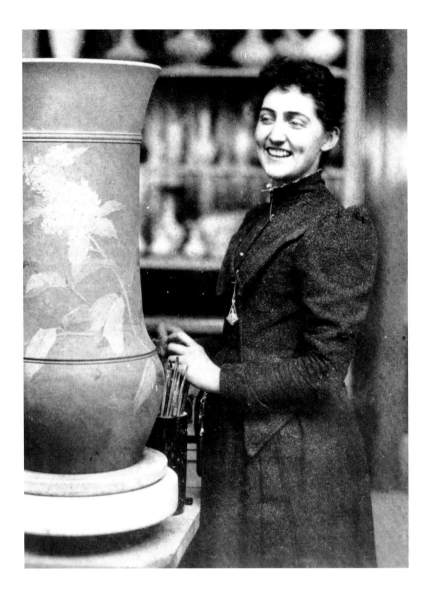

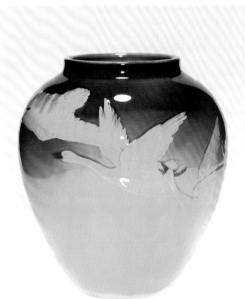

Scale background

Above
Amelia Sprague joined the decorating team in 1887, only seventeen years old. Her work was widely praised and was purchased by a museum in Germany.

Left
A bulbous vessel by Amelia Sprague in Sea Green Glaze decorated with five white geese in flight (1899).

Rookwood and Electroplated Metal

RILEY HUMLER

Valentien painted this Standard Glaze ewer (1894) with finely decorated fish swimming in a shimmering greenish sea. Gorham added a stunning silver overlay with seashells, crab, coral, and kelp.

Around 1891, Rookwood began sending finished pieces to Gorham Manufacturing Company in Providence, Rhode Island, to be enhanced with silver overlay done by electroplating. Gorham was a premiere manufacturer of sterling silver objects, including dinnerware, and had used electroplating to enhance glass and ceramic objects. Keep in mind, the 1890s were the height of Victoriana and "guilding the lily" was in vogue.

Electroplating was developed in Italy in the early 1800s and less than 100 years later, Gorham had become adept at the process. Rookwood, apparently wanting to add some sizzle to its products, began a relationship with the company that lasted into the early twentieth century.

In all, more than 2,500 Rookwood pieces were electroplated at Gorham over a fifteen-year period. Each has the usual Rookwood marks on the ceramic portion, while the silver features Gorham touch-marks and the notation "R" followed by a number. Included were vases, ewers, and bowls, including complete seven-piece sets of tankards and mugs. Most were in Rookwood's Standard Glaze, but the occasional Iris Glaze piece is found. Rookwood subject matter of flowers, portraits, and creatures were used, including some rather scary vignettes based on popular literature of the time, such as Palmer Cox's *The Brownies*. All in all, overlay from this period is considered garish by some, but pleasantly Victorian by others.

One challenge with the addition of silver was unrest among some artists at Rookwood who chafed at the overlaying of silver, often thought to be artistically incompatible with their original decoration. Some of Gorham's silver overlay does

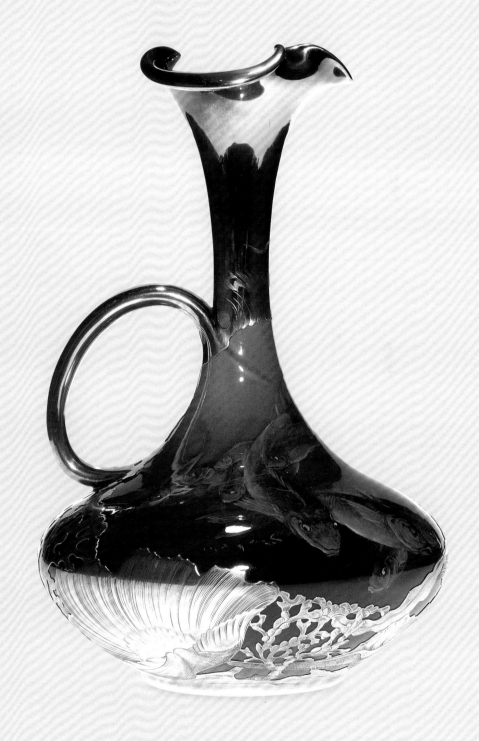

conflict a bit with the Rookwood decoration, but in fairness, Gorham often did an excellent job of matching its design to what the artist had produced. To no avail, Rookwood and Gorham continued "guilding the pottery" for several years, moving to an art nouveau aesthetic after 1900. By 1910, the partnership dissolved—the end predicated more on popular tastes than the unhappiness of Rookwood's artists.

Gorham was not the only electroplater to work with Rookwood. The Alvin Silver Manufacturing Company of New Jersey is another occasionally seen and several pieces with woven silver wire have been encountered, perhaps done in Japan.

Rookwood, having survived, or perhaps prospered, through the sales of its wares enhanced by Gorham electroplating, must have realized the potential involved and decided to have another go at the process. This time the overlay was done as a well-thought-out part of the process, rather than as a fancy add-on.

To add some background: In 1894, Kitaro Shirayamadani returned to Japan for a visit and brought with him E.H. Asano, a worker in bronze. Asano was hired by William Watts Taylor to add bronze mounts to vases and lamps. We do not have a record of whether these were to be electroplated or simply mechanically added.

Herbert Peck notes, "In the metal work department experiments were continued by Asano. As difficulties were encountered in working the harder metals satisfactorily, it was decided to import hard metal castings from Japan and to make only soft metal fittings at the pottery." An early Rookwood lamp had a bronze dragon base, almost certainly brought back from Japan.

Asano probably knew about electroplating, information he seems to have passed on to Shirayamadani, but his small metal department at Rookwood was closed down in 1897. Asano then went to work with Maria Longworth Nichols Storer, who grew fascinated with metalwork and produced many art museum–quality pieces for the next several decades.

Following Asano's departure, Rookwood produced many important pieces, including vases and lamps with deeply carved leaves, stems, limbs, or dragons, most often done by Shirayamadani. These are thinly electroplated with copper or silver to enhance the carved areas. An example is the most valuable Rookwood vase sold at auction, a Black Iris piece with both copper and silver electroplating in the carved areas.

At that time Rookwood artists were using electroplating as part of their work, and not in opposition to it. Most of these pieces were done by Shirayamadani or John Wareham, both of whom were masterful carvers and became masters at the plating process, thanks to Asano. The first example noted was done in 1897, but the majority were made between 1898 and 1900, many made expressly to show at the 1900 Paris Exposition (Paris World's Fair). By 1901 the process fades into history.

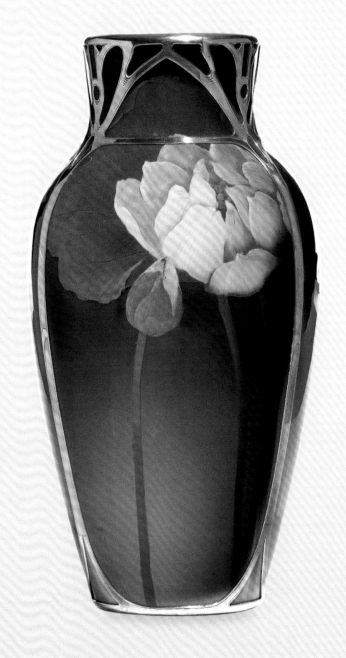

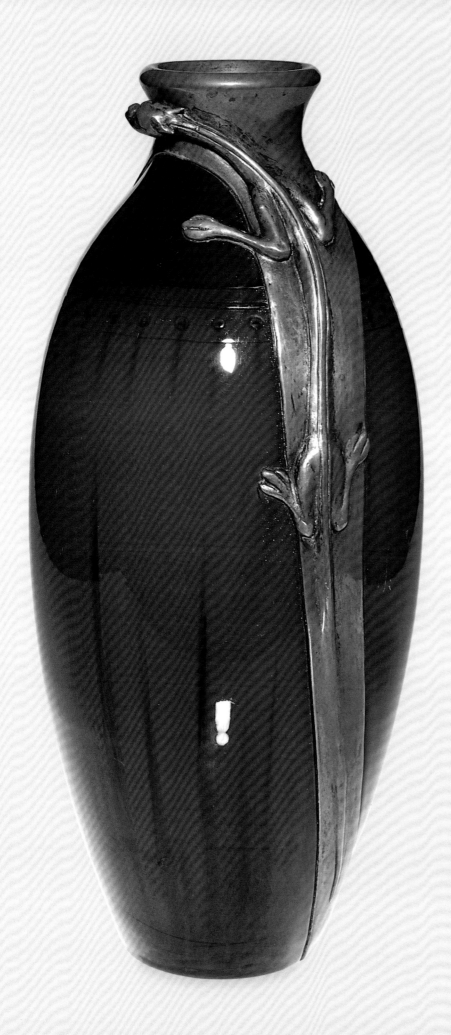

Above
A rare Standard Glaze vase carved, painted, and electroplated by Kitaro Shirayamadani (1898). The copper at the top presents pronounced fish and seaweed. To create the piece, the artist painstakingly carved the details in the clay, colored and glazed the rest, and then electroplated the area with copper. This piece was most likely showcased at the 1900 Paris Exposition.

Left
A rare Mahogany Glaze by Shirayamadani (1899) showcases a carved, electroplated dragon. The beast's long copper tail swirls down the side and to the base. This piece was most likely on display at the 1900 Paris Exposition (Paris World's Fair).

Opposite
A 1902 Iris Glaze with lotuses and Gorham sterling silver overlay painted by Olga Reed.

Mark Twain: Rookwood Aficionado

"Twins of Genius"—This is the tagline Mark Twain devised when he hit the road with fellow author George Washington Cable in 1884 and 1885. Poor Cable . . . whenever anyone toured with Twain, they were certain to play second fiddle. The title alluded to "twins," but Twain was the head genius and the star attraction. Like today's musicians, he hit the road to support a new piece of work, a forthcoming novel called *Adventures of Huckleberry Finn*.

In nineteenth-century America, a Mark Twain lecture was just about a sure thing (akin to an Ed Sheeran or U2 tour today). Already a true megastar, the follow-up novel about Huck would soon push him into the upper pantheon of literary greats. The novel's critical and commercial success would transform Twain from *a* beloved to *the most* beloved American author.

Twain's star was on the ascent in 1885. The publishing house he owned also published Ulysses S. Grant's memoirs in 1885, which became a surprise bestseller and would become one of the highest-grossing books of all time. When the "Twins of Genius" pulled into the Queen City, it was a major intellectual and social event.

Like most distinguished visitors to Cincinnati, Twain and Cable made a visit to the Rookwood factory and studio on Eastern Avenue to see Maria and her establishment. Unlike many sightseers who had simply heard about the woman-owned pottery and wanted to get a glimpse, Twain had a series of personal connections to Rookwood.

Twain's ties to Rookwood began with artist Henry Farny, the designer of the first Rookwood logo. The noted artist had a long association with Twain. Attorney Pitts H. Burt also knew the author, receiving an early copy of *Adventures of Huckle-berry Finn* from him a couple months after the Cincinnati tour stop. Burt had a close friendship with William Watts Taylor and helped around the pottery, including designing a significant number of early shapes. His son, Stanley Gano Burt, had a long and distinguished career as a scientist, researcher, and superintendent at the pottery. Twain had also been longtime comrades with the members of the Stowe family, well known in that era as Rookwood collectors.

The visit was a rousing success! In a letter home to his wife Livy, Twain reported on the several pieces that he sent her, expressing his delight: "The *red* pottery is a *new* invention—just out of the kiln." The red pottery he referenced was most likely the Standard Glaze, which would soon win Rookwood worldwide acclaim. Twain also mentioned a "rough piece of rock" that he sent back, a sample of what "Mrs. Nichols's wonderful house is being built of." Although a somewhat mysterious note, certainly the rock tied Twain even closer—himself seriously interested in home architecture, based on his sprawling Hartford, Connecticut, mansion—to Maria's Rookwood estate.

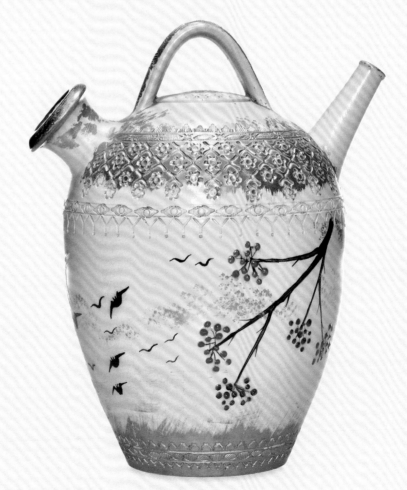

Left
An 1882 Spanish water jug decorated by Rookwood founder Maria Longworth Nichols Storer, featuring her precise, incised design and painted bats, enhanced with gold. A near-exact version of this vessel is at Mark Twain's Connecticut home.

Opposite
An 1885 illustration of Mark Twain lecturing from *Puck* magazine, calling him "America's Best Humorist."

"MARK TWAIN,"
America's Best Humorist.

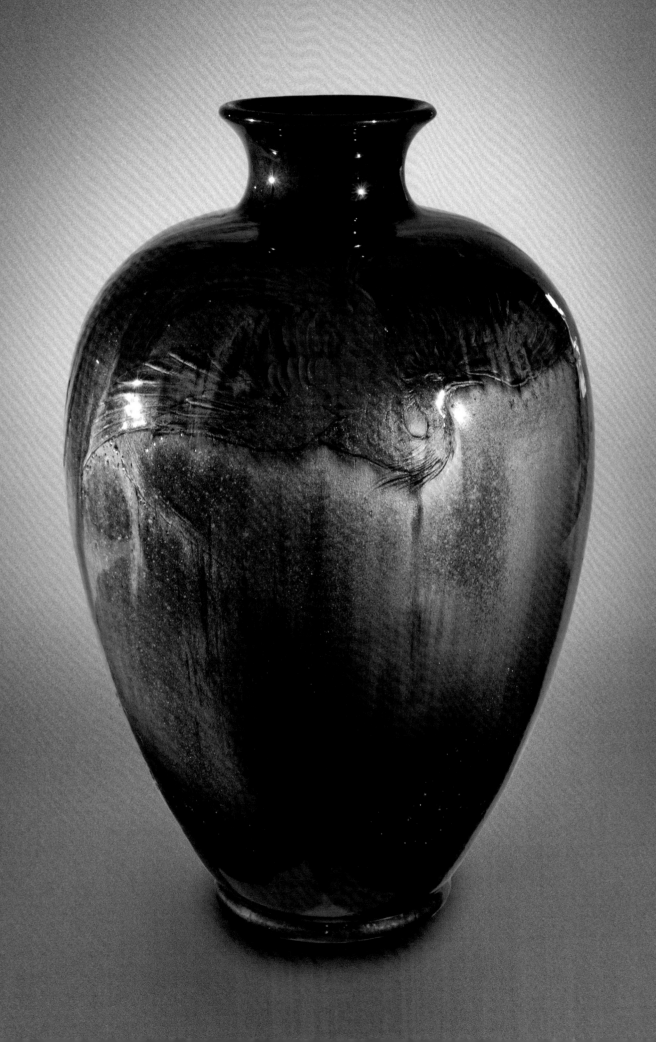

3 Melding Art and Industry in the Twentieth Century

Rookwood's top honor at the 1900 Paris World's Fair was a stunning achievement, solidifying its place atop American art potteries. Yet the company was unwilling to rest on its global reputation. Rookwood aggressively searched for new markets, most notably architectural faience, a burgeoning marketplace as American technology and industrial might pushed buildings skyward and stretched its urban centers. Rookwood adapted to the new world by introducing stunning glazes, technical innovations, and new ways to expand its consumer and architectural trajectory.

Arguably the finest Tiger Eye still in existence, this 17 × 11 inch (43.2 × 27.9 cm) vase by Matthew Daly (1900) features the deep, spectacular Tiger Eye shimmer and two cranes painted under the glaze. This vase helped Rookwood gain acclaim at the 1900 Paris Exposition.

The entire world seemed to be preparing for the 1900 Paris World's Fair.

With approval from the board of directors, William Watts Taylor authorized $7,000 to be spent on the exhibit, an investment representing 50 percent or more of the net profit of a strong financial year. Paris would be Rookwood's roll of the dice—a gamble Taylor and the board willingly took.

The decorating department ramped up the metal overlay work headed by Kitaro Shirayamadani, with early results conveying that this should be a major push for the pieces on display. Pointing to the critical nature of the event, Taylor went to Paris in February 1900 to oversee the installation, not returning until the end of the summer. It was not an easy task, he reported to board member Albert Clark. "I have had a rather hard time here getting our exhibit into shape and am not through yet." However, he noted, "We are making a fair amount of sales

and I think our exhibit shows well against those from elsewhere."

In Cincinnati, Taylor had hired a new photographer, Fritz van Houten Raymond. His first order was to create pictures of pieces to send to the City of Lights as a kind of advance marketing campaign. A Chicago photography studio also staged photos of the decorating department and individual artists to give Paris fairgoers a behind-the-scenes look at the vaunted pottery.

Rookwood was an immediate hit once the Paris Fair opened, standing out not only among potteries, but among all American exhibitors. In a report to the board, Taylor reported that the Iris Glaze sold best, but included that all glazes were popular. After some wrangling with the jury, Taylor appealed the decision of gold medal, getting the award bumped up to grand prix. He also nominated Valentien and superintendent Stanley Burt for individual prizes—the longtime decorator receiving a gold, while Burt

Left
1930 Sanborn Insurance Map that shows the entire Rookwood factory and studio complex in Cincinnati's Mount Adams neighborhood.

Top right
Stanley Gano Burt led the scientific advancements at Rookwood and developed many glazes that won the pottery worldwide praise.

Bottom right
Kitaro outside the Rookwood studio with fellow decorators, including (left to right): Elizabeth Brain, Edward Diers, Irene Bishop, and Edith Noonan, circa early 1900s.

Opposite
Two Rookwood employees work in the large kiln at the Mount Adams factory.

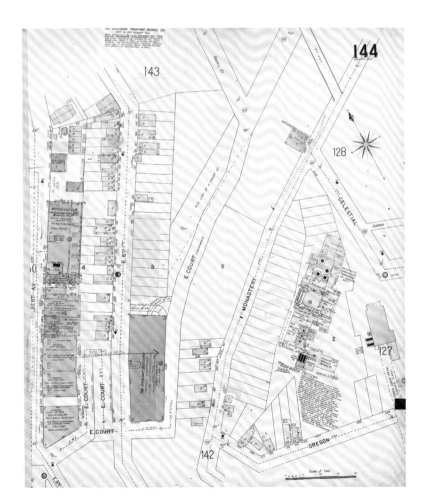

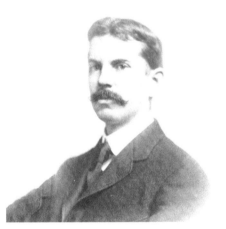

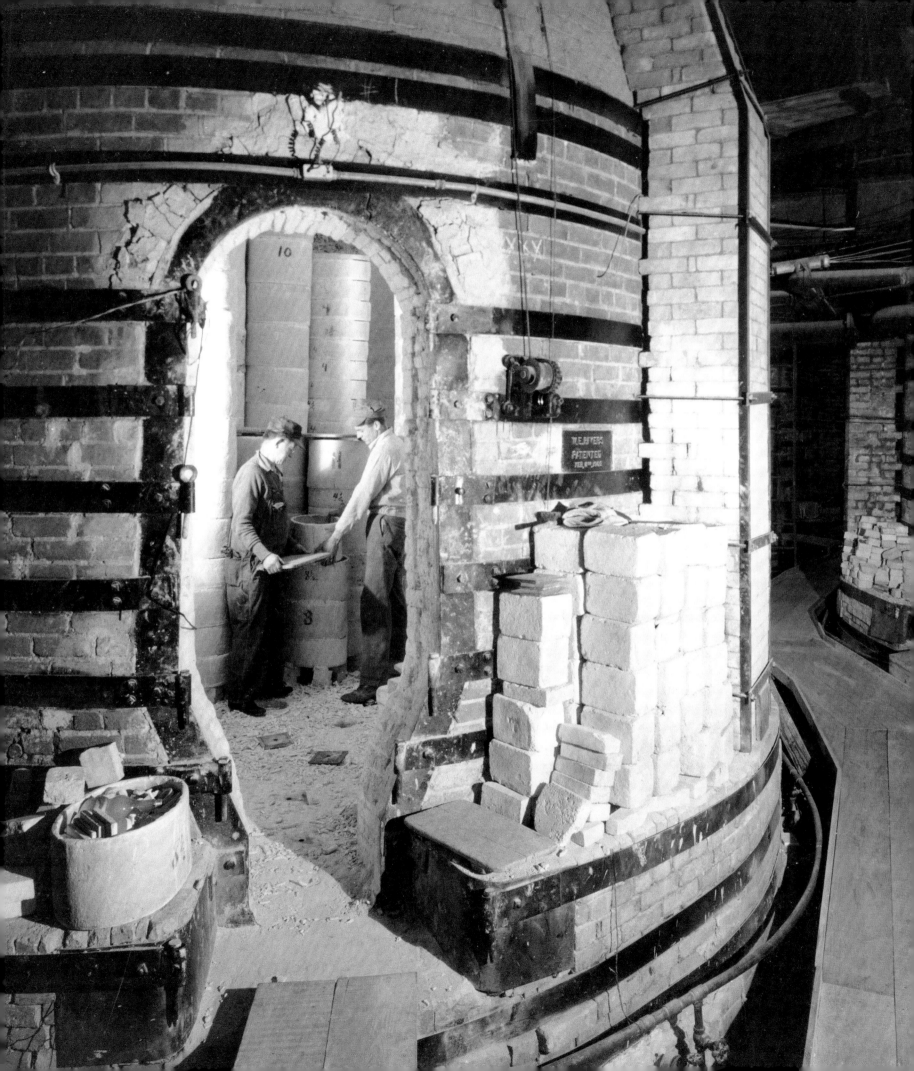

earned silver (the highest achievement a person in production could be awarded). In a stunning display of Rookwood's status in the art world, Taylor received a special Chevalier of the Legion of Honor, awarded by French President Émile François Loubet.

The Grand Prix Medal at the 1900 Paris World's Fair captured the world's imagination. Sales directly at the exposition topped $10,400, basically paying for the exhibit and effort. More importantly, Taylor exclaimed, "It is no exaggeration to speak of Rookwood as being now classed among those potteries which hold the highest rank in the world."

In the high-profile *Scientific American* magazine, writer Waldon Fawcett proclaimed Rookwood had created "as artistic ware as has been turned out on this side of the Atlantic." What set the studio apart, he explained, was that its wares were "most thoroughly representative of American ideas and methods in pottery work." From what seemed like humble origins from the outside grew an entire industry and discipline. An article such as this one in *Scientific American*, praising the company, made for promotional gold and certainly created awareness among new consumer groups.

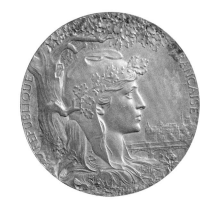

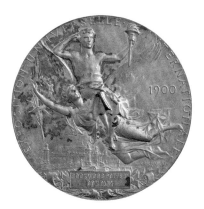

Left
The Grand Prix Medal awarded to Rookwood at the Paris Expo.

Bottom left
A 14½ inch (36.8 cm)-tall Standard Glaze vase by Matt Daly (1899) carved in sharp relief with large yellow tulips and long green stems on a golden yellow-to-brown background. From the Cincinnati Art Museum Collection.

Bottom right
Edward Diers painted this 4 inch (10.2 cm)-tall Sea Green vase, then given a bronze overlay in the shape of irises that blends into the decoration, most likely exhibited at the Paris Exposition.

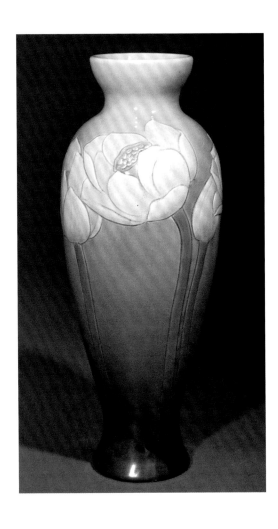

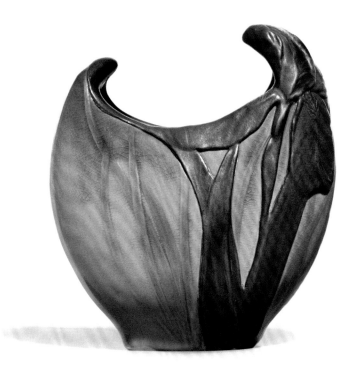

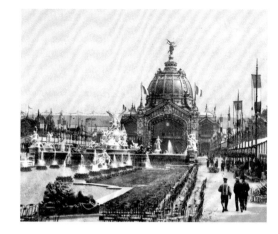

Top
The Exposition Universal
(1900) in Paris

Left
The famous "Uranus"
Tiger Eye vase created by
Albert Valentien. Standing
18½ inches (47 cm) tall,
the vase has an incised
design of cranes in flight.
However, the most import-
ant aspect is the incredible
Tiger Eye effect, displaying
an almost liquid quality.
Nothing like it had ever
been seen before, leading
to multiple wins at world's
fairs and exhibits. The date
Valentien created the vase
is obscured by the glaze,
but it was probably for the
1889 Paris Exposition,
then exhibited later at
other events.

Below
A Standard Glaze vase by
Shirayamadani featuring
large orchids and standing
15 inches (38.1 cm)
tall (1900).

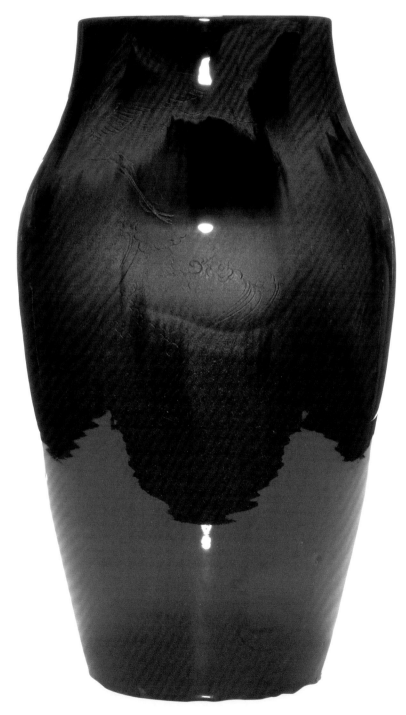

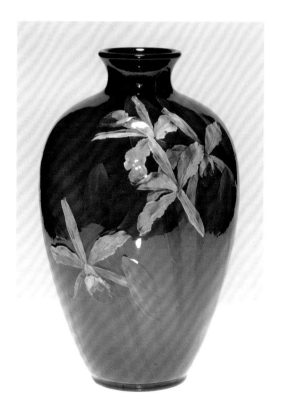

After a decade in the new factory and studio perched on Mount Adams overlooking the growing Cincinnati skyline and deep into Kentucky across the Ohio River, Rookwood served as a kind of living museum, Queen City showcase, and artist retreat. People trekking to the factory made a 200 foot (60.9 m) climb in rail cars on an electric incline, resulting in a brilliant panoramic view.

People flocked to Rookwood, as well as the Cincinnati Art Museum, one of the later stops on the rail line. According to a 1903 pamphlet, Rookwood was "visited yearly by over 10,000 persons, interested in its wares and the place and matter of their production." The factory buzzed with excitement, only closing for the Saturday afternoon and Sunday.

Taking its role as emissary for the city seriously, Rookwood's guests included celebrated actors, diplomats, politicians, and notable residents eager to catch a glimpse of the magic taking place on the bluff. After the factory tour, visitors might peruse the impressive, large gift shop, as well as an accompanying museum of handcrafted and decorated pieces put on display to provide a physical correlation between the global accolades and what viewers saw housed there in oversized glass cases.

The international awards, particularly the 1889 and 1900 Paris achievements, heightened curiosity and brought ever-larger crowds to Rookwood's doors. Journalists and writers heaped on praise, not only for its wares, but the pottery's incredible international showing. Pride in Rookwood equated to pride in American manufacturing and America itself.

Media relations and direct outreach to influencers were two parts of Rookwood's evolving marketing efforts. The pottery also helped retailers plan and create advertisements, particularly for newspapers.

Like so many aspects of modern business life in the early 1900s, the advertising industry developed quickly to grow and fulfill consumer demand, as well as the manufacturers' desires to get new products into the marketplace. In previous decades, a company may have simply plastered its name onto every flat space in and around a factory, but as the ad industry grew in sophistication, its leaders determined that they and their clients could use the visual and textual power of ads to create an idea regarding what a consumer needed or possibly desired.

Taylor appreciated that Rookwood must broaden its consumer base, but the reliance on art pottery made it difficult to sell outside its own stores or those of a select group of national retailers. In an age dominated by the Sears catalog, which sent a virtually unlimited number of manufactured goods into the marketplace, Rookwood attempted its own mass appeal, publishing *Rookwood Pottery*, a lavish, forty-seven-page booklet with black-and-white images of art and architectural faience in 1902 and 1903.

Two years later, in 1904, the company published *The Rookwood Book*, a shorter catalog, but one that contained a limited number of color photos. The new marketing piece also had a price guide in an attempt to prompt customers to possibly order by mail. Yet, unlike Sears and other companies that excelled at offering mass-produced items, Rookwood faced numerous challenges as a mail-order business.

The Rookwood Book emphasized the unique beauty of its handcrafted wares, but often prices were given in a range, based on the artist, glaze, and size of the piece (though the catalog did not promote individual artists within its pages). Furthermore, the text also warned that a specific piece pictured might not even be available when the customer placed the order. These difficulties in selling Rookwood's individual wares flew in the face of the mail-order process and what buyers expected. The process was supposed to seem easy for the consumer, but Rookwood's system was a challenge.

The most expensive piece listed was a 14½-inch (36.8 cm) Iris Glaze vase decorated with orchids that cost $100 to $150 (which calculates to a range of about $3,000 to $4,500 in current value). Most products in the catalog, which included lamps and electroliers, were well under $20, with some of the production

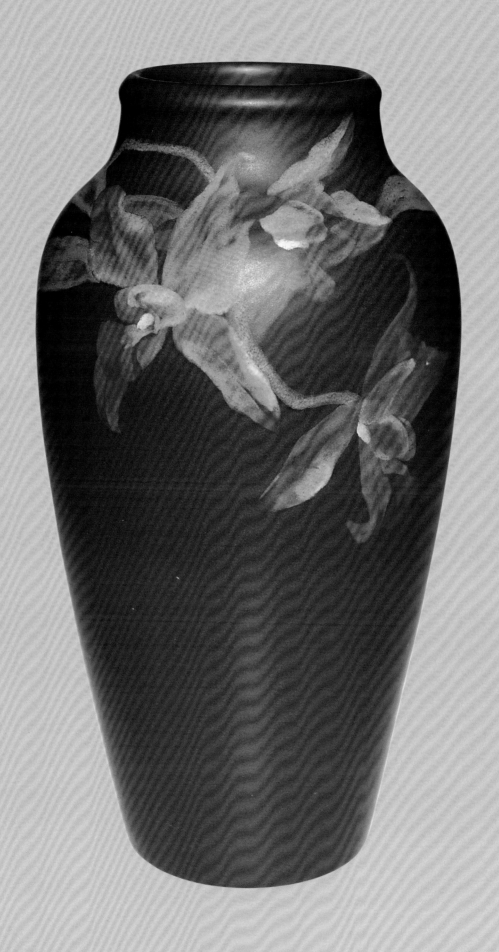

In contrast to the glossy nature of Iris Glaze, Harriet Wilcox's 1903 elegant red Painted Mat vase reveals how the production team worked with decorators to create a range of colors and compositions.

pieces and small vases at $1 to $5 (about $30 to $150 today).

With Rookwood offering production pieces in the catalog, a case could be made that it deliberately undercut its own status as a brand. Was Rookwood a luxury goods company or simply a supplier of middle-class home goods?

Although Rookwood struggled as a mail-order agency, it maintained its dominance in competitions. Under Taylor's watchful eye, Rookwood continued to focus on international awards and securing a place for its pieces in museums, which in turn, could then be utilized in advertising and marketing campaigns.

After the major 1900 Paris accomplishment, Rookwood entered expositions in Buffalo, New York (1901), St. Petersburg, Russia (1901), Charleston, South Carolina (1902), and Turin, Italy (1902). Although lauded at this series of events, the goal was to astonish the art world at the 1904 St. Louis World's Fair, which event organizers had pledged would be the largest ever undertaken.

Bottom left
Matt Daly's Sea Green vase was exhibited at the St. Louis World's Fair. The deep seawater is contrasted with the hand-painted lifelike fish, one in a striking golden hue. Taylor loaned this piece to the Cincinnati Art Museum after the fair.

Bottom right
A 13½ inch (34.3 cm) Iris Glaze oil lamp base decorated by Carl Schmidt in 1904 and exhibited at the 1904 fair. The piece is in the artist's careful detail, making the irises seem to come alive, the white and purple petals elegantly blending with the light background and dark top.

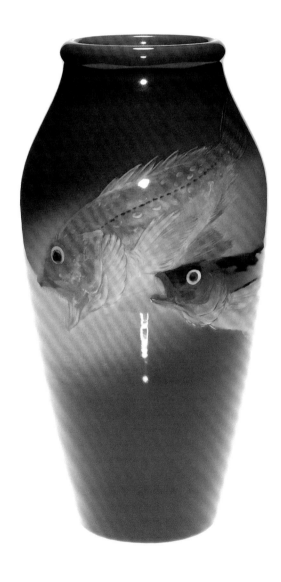

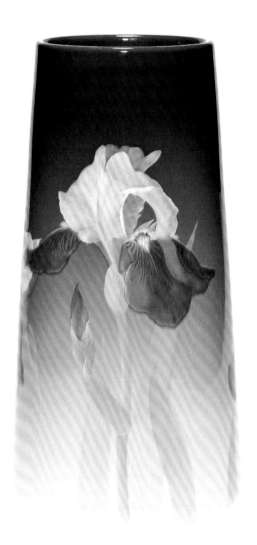

Expanding Glaze Lines

The collision of art and commerce grew increasingly important as the nineteenth century faded into memory and the twentieth exploded onto the scene. There were competing ideas, however, about how art should address the societal transformations taking place.

The Arts and Crafts Movement centered on a reaction against the drudgery of machine life, hoping to provide an escape from the seeming inevitability of mechanization. At the same time, the dawn of the new century and its exuberant embrace of technology transformed the way consumers viewed the modern world.

Rookwood, celebrating its twentieth anniversary in 1900, had been driven by the idea that its artists would produce handcrafted, one-of-a-kind works of art based on the union of hand painting, color, and form. Individual artists would make decisions about what pieces looked like, while the factory as a larger entity would also manufacture items for everyday use. According to art historian Carol Boram-Hays, "The general goal of purveyors of modernism in the decorative arts was to make objects of high style and efficient design an affordable part of most homes." The guiding mission centered on beautifying people's homes and fulfilling the need for daily wares that were both functional and eye-catching.

Taylor and the executive team had to delicately balance the various aspects that had won Rookwood accolades for art pottery with the ever-increasing need to introduce new technology and scientific advancement into the ceramics process. As the twentieth century began,

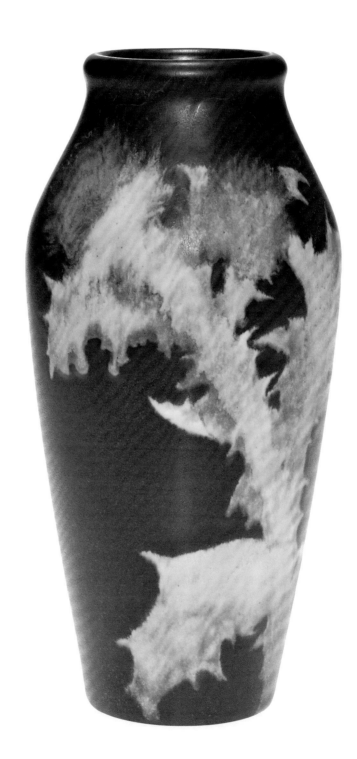

A 1903 Olga Geneva Reed painted Mat vase with impressionistic pink and green thistles against a flat black background.

a reaction against agrarian and rural dispositions led to technology catching on as an idea across fashion, décor, and daily life. The Arts and Crafts Movement collided headfirst with an increasingly industrialized society.

Mesmerized by a new vision of the future and emboldened by the bombastic Theodore Roosevelt, American consumers turned to machine-produced goods, along with other advancements that made their lives easier. A burgeoning middle class, perhaps for the first time in history, had more time for leisure and an increase in discretionary money to spend on those activities.

Rookwood's nod to modernization had begun at the end of the previous century when Taylor asked Stanley Burt, the production supervisor and master chemist, to experiment with glazes that might be used for architectural tile. As the nation's cities grew both in size and skyward, Taylor realized Rookwood could provide a product better than its competitors. The new Mat Glaze lines straddled two worlds: the subtlety and subdued vibe of the Arts and Crafts Movement, while simultaneously enabling Rookwood to supply the growing architectural and construction industries.

Always on the lookout for a splashy promotion that would gain attention in the newspapers, Taylor had Rookwood introduce a new glaze line at the 1904 St. Louis World's Fair. Dubbed "Vellum," it featured a mat glaze that gave pieces a mystical, milky feel, almost a sense of added depth or perspective.

Sara Sax, Sallie Coyne, Edward T. Hurley, and other decorators quickly crafted pieces that used the sensuality of Vellum to its best advantage. The new line seemed a perfect marriage of hand-painting skill, while also showing off the new glaze. An eager marketplace responded, making Vellum one of Rookwood's bestselling glazes during the first several decades of the twentieth century.

Historian Nancy E. Owen views Vellum as Rookwood's "greatest technical achievement in mat glazes." In particular, Vellum's use in creating landscapes provided decorators with the ability to paint round ceramic forms in the popular style made famous by James McNeill Whistler and George Inness and the photography of Edward Steichen and Alfred Stieglitz.

An early 1905 Vellum landscape, one of the few painted by Albert Valentien, created a winter scene with towering trees in the foreground in evocative greens and muted blues, while the background is a mystical forest. The tonalist style conjures a dreamlike setting. Yet the depth of the trees and forest are juxtaposed by a variety of green leaves at the base of the trees. A heavenly snowfall gives the piece added depth and an immaculate sense of place.

W. P. Jervis, one of the era's top ceramics authorities, noted that Vellum remained "soft and close in texture," with its main benefit that the glaze "greatly enhances the work of the artist, the effect being . . . tender." In examining the glaze, he proclaimed Vellum "is undoubtedly a great ceramic achievement, and when first exhibited at St. Louis in 1904 was pronounced by competent judges to be the only novelty in ceramics at the exhibition."

A rare early Vellum Glaze landscape decorated by Albert Valentien in 1905. The icy demeanor makes the viewer nearly shiver.

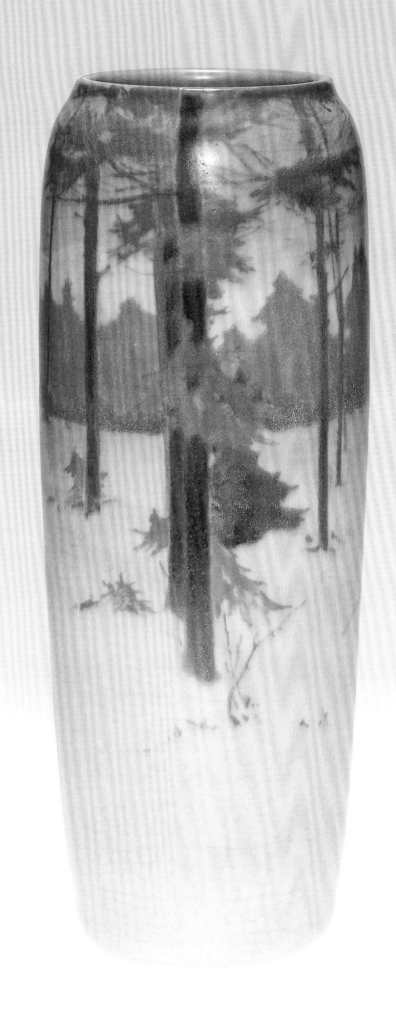

Birth of Art Tile

In the early years of the twentieth century, art critics and journalists heaped accolades on Rookwood, almost as if in shock that an American company could compete with its European counterparts. International awards continued to stack up.

Taylor, eternally searching for new markets to offset what he considered the "disregard of taste" at many retailers that sold the company's wares, launched a campaign to gauge the interest of the architectural and builder communities in utilizing Rookwood tile. According to observers at the time, Rookwood scientists had launched research into tile manufacturing in 1893.

More than chief executive, Taylor excelled in the role of primary marketer. He realized that tile revenues could more than make up for the often-slipshod sales efforts by retailers, which he could urge on, but not control. Since Rookwood essentially "loaned" its artworks to retailers, the company did not have the revenue on hand until the final sale. This practice was unlike traditional manufacturing practices—the sales exchange between producer and seller. Taylor hoped architectural work would bring Rookwood larger projects and increase cash flow.

Mat glaze lines served as the focal point of the leap into tile. In the pottery line, Mat most frequently had no decoration under the glaze, so decorators worked the clay body itself, mixing colors and incising the piece with interesting shapes and patterns. Adding carved or modeled elements combined with the kiln work produced stunning artworks that marked a noticeable shift away from Rookwood's traditional hand-painting ethos.

One of Twenty-six Faience Lunettes
in the Suburban Passenger Concourse and Restaurant
of the New Grand Central Terminal, New York City
Warren & Wetmore and Reed & Stem, Asso. Architects

Executed by the Rookwood Pottery Company

Main Office and Works
Cincinnati, Ohio, U. S. A.

Eastern Branch Office
1 Madison Ave., N. Y. City

Mat glazes were noted for soft coloring. From a strategic standpoint, Taylor could see that the transition from high-gloss to Mat glaze created an opportunity for Rookwood to fall in lockstep with the latest urban building craze. Initial research revealed that architects had few outlets for quality tile—none with Rookwood's reputation.

Taylor dove in headlong, as he had in virtually every aspect of production, instructing company scientists to experiment with new glazes and bodies. Architectural tile necessitated a different series of compounds and mixes to ensure strength and durability. Taylor reported to the board of directors that the architectural division would soon be the "highest importance" for the company's future.

After two decades in business, Rookwood faced increased competition from other art potteries, such as Grueby and Newcomb, who were also eager to launch tile divisions. The emphasis on new Mat glazes, according to one historian, enabled the company to "diversify its artistic output and to stay ahead of competitive imitators."

The downside to creating an architectural faience division was that it took up so much of Taylor's time. He needed senior-level help to efficiently run the growing company. As a result, he negotiated a deal with the Cincinnati Art Museum to hire its director, Joseph H. Gest, to work every afternoon at Rookwood after spending the morning at the museum. Gest was also an accomplished painter, which gave him added insight into the work and lives of Rookwood's decorating team. The two Queen City institutions had a longstanding relationship that made the odd arrangement viable.

The Rookwood board had no reason to doubt Taylor's strategies. In 1901 the company had a robust financial year, posting revenues of $89,500 (an estimated $89.1 million in current dollars) and net profits of $12,500 ($11.4 million). Within a year, Gest had been promoted to vice president, while the architectural design team had created a series of mantel facings and tile panels to show the board.

Demonstrating the talents of the decorating team, the tiles were primarily the design of three of its top artists—William P. McDonald,

Top
Rookwood created many architectural tile accents for New York City's immaculate Grand Central Terminal, including twenty-six faience lunettes like the one in this 1913 advertisement.

Above
A Mat tile 6 × 6 inches (15.2 × 15.2 cm) embossed with purple mag-nolia blossom and turquoise leaves on a pink background.

Opposite
A rare Art Nouveau Mat Glaze tile by Valentien (1902) depicting a young woman with the sun behind her head, breathing in the fragrance of a large group of Easter lilies. The decorations are all outlined in black by slip trailing, certainly to keep the colors in place. The large tile is 21 × 15 inches (53.3 × 38.1 cm).

Albert Valentien, and Sally Toohey—along with the chemistry and technical advancements led by Stanley Burt.

McDonald headed the architectural division, with Toohey running the glaze shop for tile. John Wareham became the chief of the decorating department, yet over the ensuing years he would also play a key role in designing large-scale tile installations.

The Rookwood tile division commenced alongside a critical growth phase in America's large metropolitan areas. In New York City, for example, building took place hundreds of feet (meters) above and below ground. In each case, Rookwood had a hand in the expansion: decorative faience that would adorn several of the new subway stations and Grand Central Station, while also delivering tile for numerous skyscraper builds and luxury hotels, including the Vanderbilt Hotel. The early efforts resulted in a $5,650 contract in early 1903 to create decorative faience for 23rd, 79th, 86th, and 91st Street stations of the New York City Subway line (later altered to 77th and 96th).

Taylor anticipated further success in New York and other East Coast cities, so he sent long-time decorator Sturgis Laurence to the Big Apple to open an office in the Metropolitan Building at One Madison Avenue. Back home, the company purchased eighteen lots north of the Mount Adams complex to add a dedicated factory for the tile division, which McDonald headed.

Once Rookwood acquired the additional land north of factory, it expanded the architectural tile and administrative offices. Initially, the Board of Directors issued $60,000 in new stock to finance the effort, then later increasing the amount when demand rose. Taylor's design would create about 22,000 square feet (2,000 sq m) of working space, with construction commencing in October 1903. After exceeding the budget enough to cause the stock dividend to be waived, the operation was in effect a year later. One of the central features of the tile wing was a "room two stories clear height," where "the finished product is laid out on the floor, or erected against the wall, bringing all parts of the design together as a whole

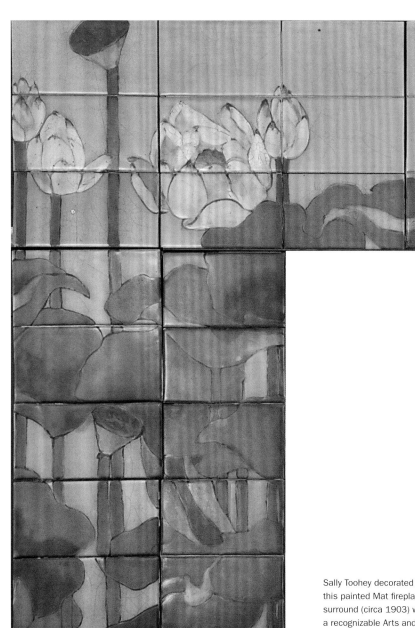

Sally Toohey decorated this painted Mat fireplace surround (circa 1903) with a recognizable Arts and Crafts pedigree, including life-size lotus blossoms, stems, and lily pads. A popular object in residences, it measures 55 × 85 inches (239.1 × 215.9 cm).

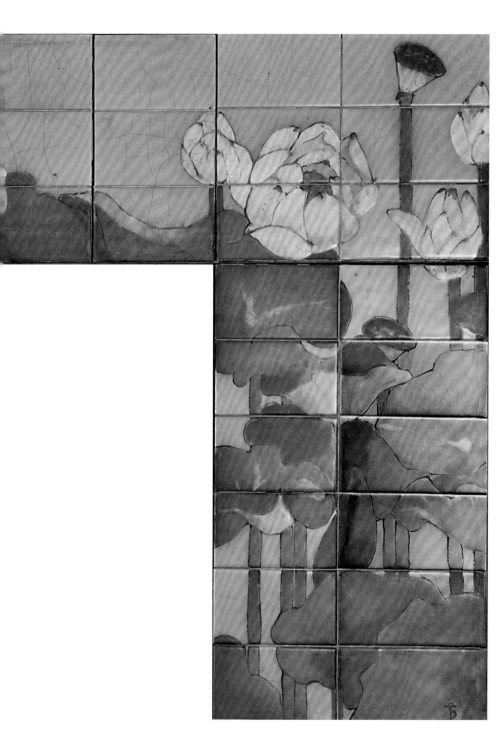

as nearly as possible." The large space allowed MacDonald and other designers to inspect the piece, with the goal "to turn out nothing that cannot pass the test of a work of art."

The 1902 and 1903 Rookwood catalogs—forerunners to the mail-order business—also featured information on the new division with photos of a fountain and fireplace mantel. The glaze was the hook: "in all the combinations in which the architect or the decorator delights to use" for "beautiful effects of color attainable in this glaze."

A 1905 *Architectural Record* article looked at the early tile work, calling it "a bold, fearless, free treatment, which thoroughly preserves the character of the material . . . more consistently than is the case where the designer is not a clay worker." Melding technical and artistic elements enabled the company to create functional objects that were usually ignored—like drinking fountains—and turn them into art. One writer noted that under Rookwood's care, an ordinary drinking fountain became "a beautiful example of the highest art in ceramics."

The crowning achievement came when judges awarded Rookwood the Grand Prize in architectural faience at the 1904 St. Louis World's Fair. This victory strengthened an education and awareness campaign designed to show architects that industrial tile would provide permanent color to buildings better than terra-cotta or other options.

Building a new division from scratch was costly, resulting in tile straining company resources in its early incarnation. In 1906, the need for cash to run the studio and tile department necessitated another stock sale for an additional $60,000, bringing the total capitalization to $180,000. On the bright side, though, officials in New York were pleased with the subway work and placed another substantial order.

In December 1905, shortly after Rookwood celebrated its 25th anniversary, a Brooklyn newspaper brought to readers' attention that longtime retail outlet Davis Collamore and Co. had "a collection

of Rookwood vases to dream over," calling one piece, "the most beautiful Rookwood vase ever made." At the same time, hundreds of ads from Montana to Mississippi proclaimed: "Every Piece Is an Original Painting On Pottery . . . there will never be a duplicate." Others trumpeted the studio's standing as the best in the world and its unique value.

Such accolades were not exactly commonplace and maybe not even entirely true, but what is undeniable is that the foundation of it all was Rookwood's commitment to experimentation. Sturgis Laurence estimated that by the time the pottery celebrated twenty-five years in business, its scientists, production employees, and chemists had conducted more than 2,000 trials in color and quality of color alone.

Rookwood launched into the new century with its 1900 Paris Expo prize and solidified that high honor with further wins and accolades at a series of exhibitions, culminating with the 1904 St. Louis World's Fair. With Taylor at the helm mapping the future strategically, Rookwood launched into new markets and created an architectural faience division to capitalize on a flourishing marketplace as American technology and industrial might pushed buildings skyward and stretched its urban centers. Rookwood adapted to the new world by introducing stunning glazes, technical innovations, and new ways to expand its consumer and architectural trajectory.

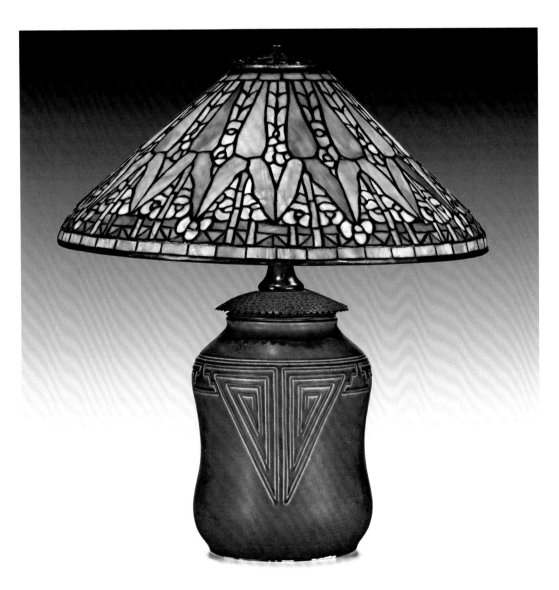

Above
A December 1906 Tiffany & Co. newspaper advertisement featuring Rookwood and its new glazes for the holiday season.

Left
This 1906 Tiffany/Rookwood partnership pairs a Tiffany Arrowroot shade on a Mat Green production lamp base. This work of art may have been created for professional interior design in an office building or other public space.

Art Nouveau

The Art Nouveau movement, literally "new art," paralleled the expertise and abilities of Rookwood's skilled decorators. Using nature as inspiration, particularly Wareham's deep-rooted interest—a professional horticulturist—and Shirayamadani—whose delicate work seems drawn from nature itself—Rookwood embodied the philosophy of new styles that represented humanity's yearning for freedom and the individual desire to live an unfettered life.

Shirayamadani, Wareham, Albert Valentien, Matt Daly, Lenore Asbury, Carl Schmidt, and others had been inspired by Japanese art (as had Maria Storer), as well as the Arts and Crafts doctrine of "art for art's sake." Looking at a precise flower or evocative carving in a Rookwood piece, the viewer is drawn to the spirit and an uplifting coexistence with nature that stood in stark contrast to the humdrum consequences of the factory or assembly line.

Many Rookwood Art Nouveau pieces employ the Iris Glaze, which emphasized the intricate twists and bends in plant life, while adding a brilliant sheen. Carvings often accentuated or deepened the symbolism of Art Nouveau pottery. Wareham, for example, carved a pink cyclamen into an 1899 vase that features stems growing and twisting around the vessel.

Rookwood's Art Nouveau wares captured the aura inspired and magnified at the 1900 Paris Exposition Universelle, where it gained a huge following and ultimately a Grand Prix award. By bringing the inspiration of green spaces into people's homes, artists believed they could manifest mental and physical health and well-being. As technology became more pervasive, Art Nouveau offered a perspective recognizing one's union with nature.

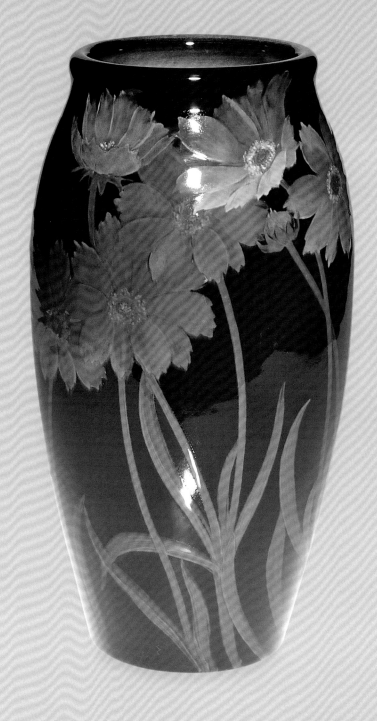

A rare carved Standard Glaze vase with Art Nouveau flowers that swoop up the side and then wrap around the rim is the work of Ed Diers (1900).

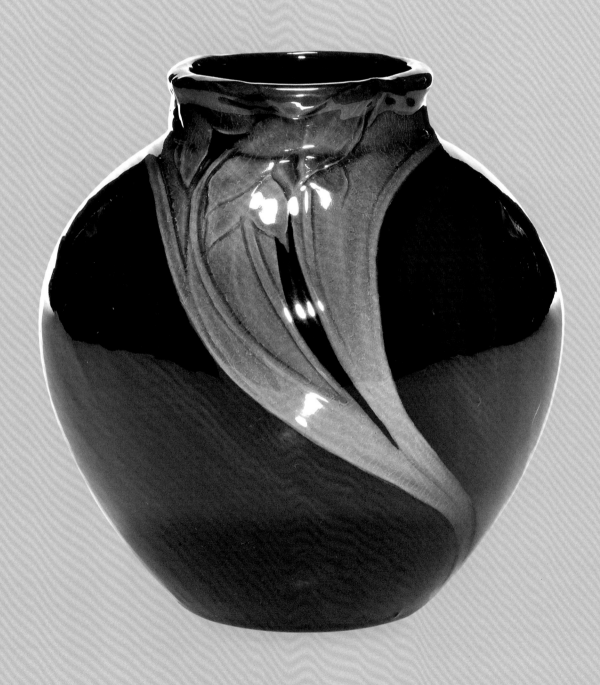

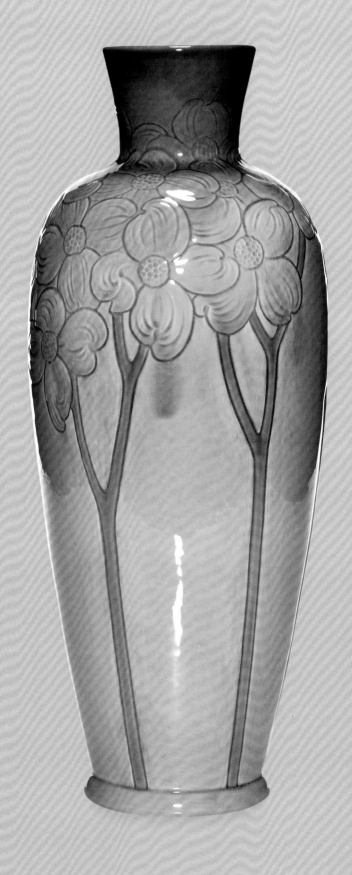

More than 15 inches (38.1 cm) tall, this Sea Green vase by Albert Valentien (1899) is decorated with carved dogwoods that encircle the piece.

Tile at the St. Louis World's Fair

The 1904 World's Fair in St. Louis officially entertained 19.7 million people, creating an astounding, global cultural center in the heart of America. The sheer size and number of displays contained in 75 miles (120 km) of walkways and roads and more than 1,500 buildings meant that it took more than a week to even casually get a sense of the Fair's totality. The cultural ramifications were even more lasting, still felt by attendees and participants for decades afterward.

For Rookwood's architectural department, the 1904 World's Fair was a grand introduction to the wider world, extending the global accolades it had received as an art pottery. A reporter called it a "tour de force." The St. Louis display intensified interest commercially and, according to one observer, "many pilgrims from the Exposition stopped at Cincinnati on their return to see the work in its birthplace." Calling the tile work "the natural and gratifying culmination" of its work, "Rookwood leads the ceramic world in America."

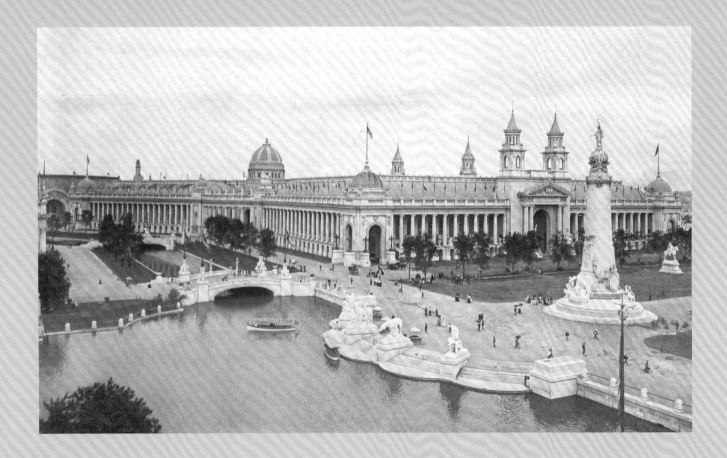

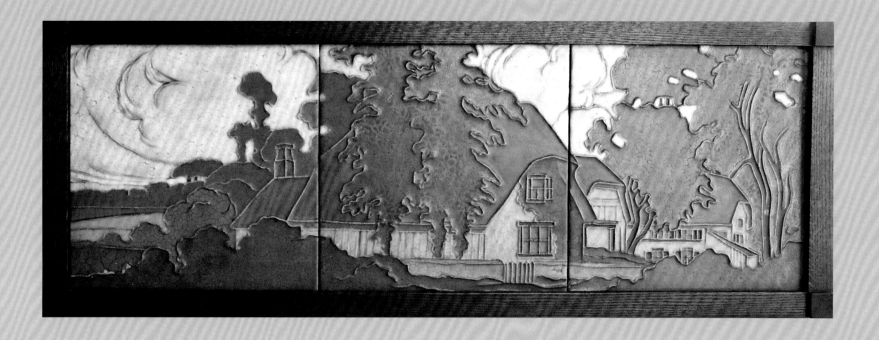

Top
The Mat Glazes and craftsmanship (three 16 inch [40.6 cm] tiles) enabled Rookwood to create intricate pastoral scenes—such as this thatched-roof cottage—that gave viewers a sense of nostalgia and connection to nature.

Right
A large 12 × 12 inch (30.5 × 30.5 cm) architectural faience tile depicting a landscape with mountains, lake, and trees in polychrome *cuenca* technique, meaning the piece has raised sides within the mold so the colors do not mingle.

Opposite top
The 1904 St. Louis World's Fair Grand Prize.

Opposite bottom
The Palace of Varied Industries at the 1904 St. Louis World's Fair.

4 Simplicity and Style

Fame and international accolades paved the way for Rookwood to build an architectural division. Yet factory expansion costs and a shaky American economy dampened Taylor's enthusiasm and cut into profits, but the pottery department offset the losses by hitting an artistic stride on the wings of innovations in glaze lines. These day-to-day efforts came to a screeching halt on November 12, 1913, when William Watts Taylor unexpectedly passed away. A new Rookwood would emerge.

In 1912, Cincinnati historian and bestselling novelist Charles Frederic Goss summed up the remarkable success Rookwood had achieved, noting that Maria's pottery "has made our city famous wherever in the whole world the beauty of exquisite form and coloring in the manufacture of pottery is adequately appreciated."

The Queen City had hit its stride as well; city leaders estimated that its manufacturers sold about $200 million worth of goods annually. Trade via the Ohio River and railway turned the city into an economic power, particularly in clothing, machinery, shoes, meatpacking, and grains.

Rookwood had long been one of Cincinnati's crown jewels. Visitors streamed to the factory, hoping to catch a glimpse of the magic that had made it one of the best in its industry in the world—and for that stunning view from the top of Mount Adams!

Since Maria's time running the studio, decorators had a significant freedom in expressing themselves. This idea had aided the pottery's march into the upper echelon of the art pottery world. Yet styles never really had definitive lifespans, so many art movements overlapped and drew from one another. All the while, Taylor tried to anticipate consumer tastes and gently push his artists toward wares that would sell.

In the early twentieth century, competing ideas symbolized by the factory and nature warred as technological progress marched forward. Americans beamed with pride over the nation's bright future, but also looked back fondly to an idealized past. For a company that had to consider what customers desired—and would purchase—these were times fraught with challenges. Do decorators adapt, for example, to Art Nouveau ideas that harkened back to a stylized natural world, or does the company concentrate on architectural faience or production wares that were handcrafted, but less expensive to produce?

The Art Nouveau movement accentuated natural forms, but critics railed against its newness as too extreme and too modern. The line between art and commerce—what Rook-

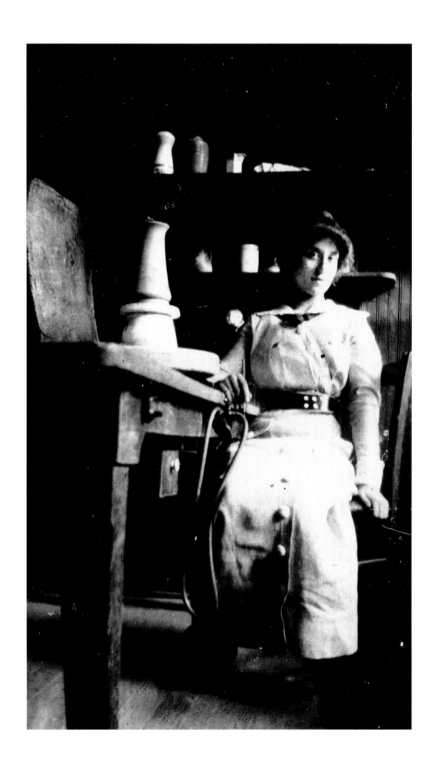

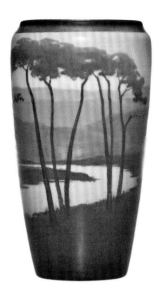

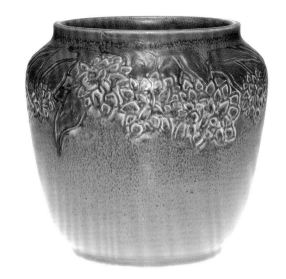

Top left
Lorinda Epply created this meandering river scene in 1911. The rolling hills provide depth and the hazy Scenic Vellum Glaze heightens Epply's frequent use of blue and gray shades.

Top right
A William Hentschel Mat Glaze (1914) speaks to his abiding interest in nature, particularly evident in the delicate flowers and leaves carved into the piece.

Right
Kitaro Shirayamadani's photo-realistic style is accentuated by the Black Iris Glaze used as background in this vase (1907). The details of the barn swallows flying through boughs of English ivy are precise, down to individual feathers, tiny feet, and eyes.

Opposite
Mary Grace Denzler trained at the art academy, then joined the decorators in 1913. Her work is in a museum in Canton, Ohio.

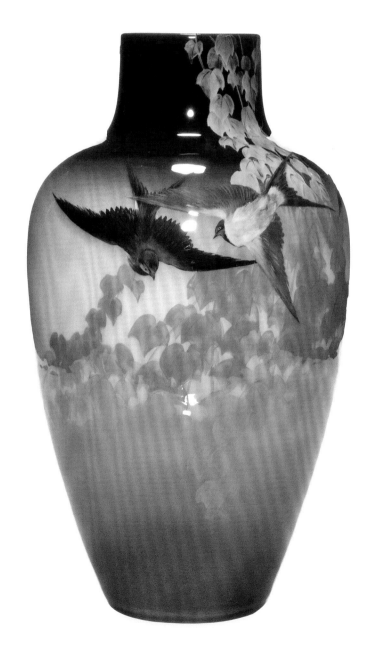

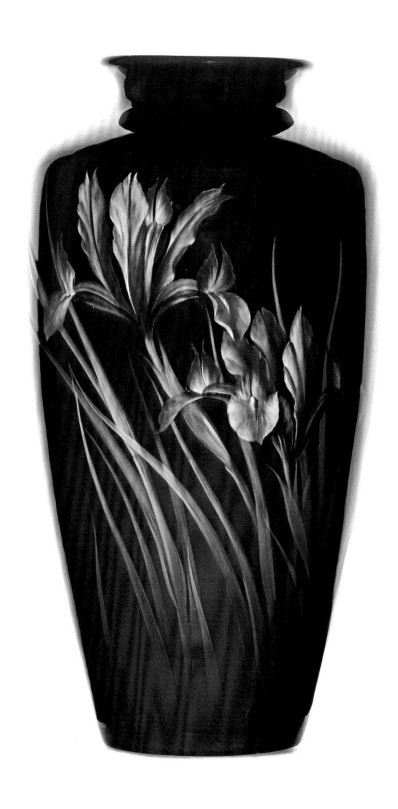

An extraordinary 14 × 7 inch
(35.6 × 17.8 cm) Black
Iris Glaze vase decorated
with irises by Carl Schmidt
(1910). This work is similar
to one in the collection of
the Newark Museum.

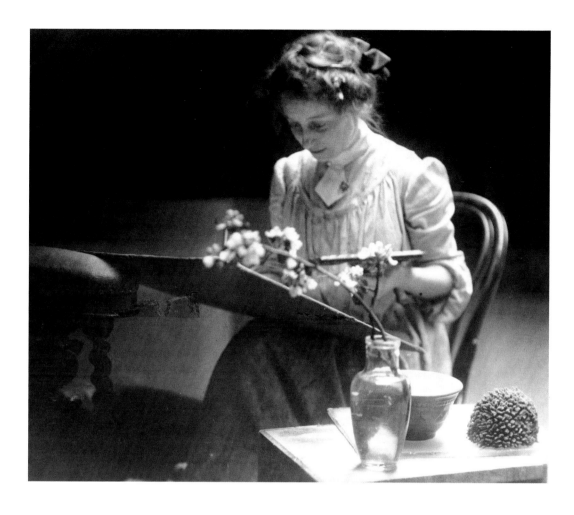

wood artists wanted to create, based on artistic vision and what could sell to a predominantly conservative American middle class—again caused minor rifts between the decorators and management. For Taylor, the Arts and Crafts emphasis on traditional flowers and landscapes seemed a more prudent option. The senior artists were given latitude to create what they desired, but the junior members of the team were more overtly directed by management to stick to wares that would sell.

Given its international awards, commentators and art critics approached Rookwood with a mix of reverence and wonder. From the outside, it seemed as if commercial success meant little, particularly set against artistic superiority. Many writers set Rookwood firmly in contrast with the inhuman elements of the modern factory system, rooting for the handcrafted nature of superior ceramics.

As one writer carefully noted, the artist/decorator "composes with brush and India ink the design carefully thought out . . . adapting to the shape a motive suggested by one of the thousands of studies in the Rookwood Library." The result is "always an individual expression of the artist's creative sense, never a soulless or mechanical repetition." At Rookwood, the decorator had artistic freedom that included selecting glaze lines, manipulating the body of the vase through incising or slip painting, and other physical exertions on the ware itself.

Growing a Brand

This Arts and Crafts scene of mountains, a lake, stately pines, and wild roses was most likely created by Sally Toohey, circa 1910. The architectural faience piece (22¾ × 42½ inches [57.8 × 107.9 cm]) was created to go over a mantel and is deeply carved and colorful, emphasizing nature's beauty.

Opposite left
Seafaring and Norse-inspired tiles were popular, particularly as Rookwood created the famous "Norse Room" in Pittsburgh's Fort Pitt Hotel.

Opposite right
Three 8 inch (20.3 cm) tiles cast with large purple irises and green leaves against a sky-blue backdrop.

Rookwood's arrival in New York City architectural circles certainly did not surprise art aficionados in the burgeoning skyscraper mecca. Architects and designers were well aware of the company, not only for pottery, but the faience division's high honors at the 1904 World's Fair. The early work for the New York City Subway—one of the highest-profile construction projects in American history—certainly heralded Rookwood's vaunted place among tile manufacturers. Given its heritage as an art pottery, much of the company's initial faience work was in decorative installations, beautifying steel and cement structures.

In a high-profile January 1907 article by Sturgis Laurence in the *Architectural Record*, Rookwood's decorator-turned-New-York-sales-executive outlined the most important virtue of faience, describing, "the accumulated experience of a staff of highly trained artist-craftsmen working in close association with scientific technicians who have created their own precedents in the technology of ceramics."

From his office on Madison Avenue, Laurence talked to architects and delivered presentations determined to elevate tile over the less expensive and more utilitarian terra-cotta by appealing to the artisanship that architectural faience represented. For Rookwood, it came back to science and glaze. The scientific portion meant that tile was as durable and sturdy as terra-cotta, while its color options were plentiful, including a wide range of textures that could replicate marble or bronze or add crystalline features.

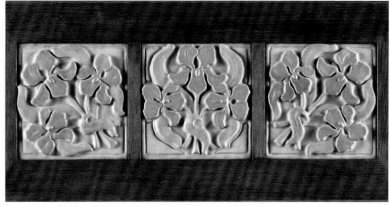

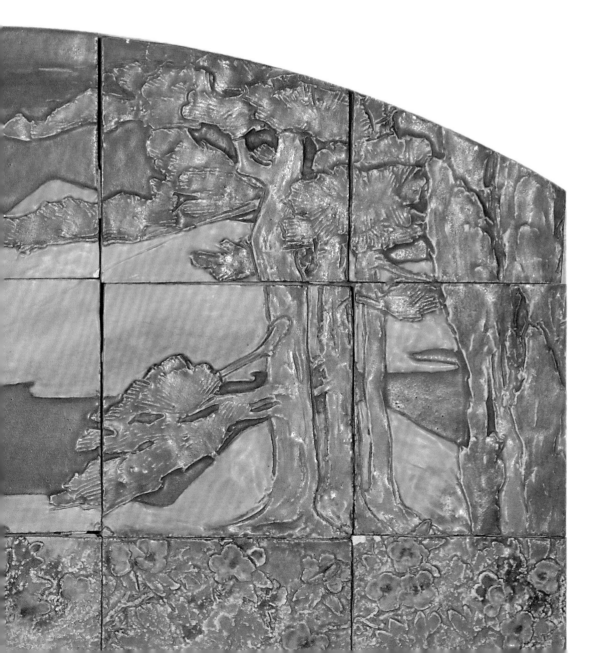

In August 1907, Rookwood published its first architectural tile catalog, a massive publication with some 200 photographs and illustrations. Although the number of commercial projects had been increasing, the timing of the catalog coincided with the Panic of 1907, a national recession that severely curtailed business expansion. Countless companies and small businesses faltered or went bankrupt in the ensuing recession caused by duplicitous trading in Montana's copper market. Rookwood's fate was less severe. Taylor's gamble on the architectural division actually helped the company recover sooner.

Looking back, all that Taylor had anticipated started to unfold. As a prestige brand, Rookwood helped major hotels establish themselves as luxury names in the early twentieth century. Many businesses used the company's prestige as a way to differentiate themselves from competitors. The big-name hotels helped the pottery weather the recession, because they kept on building in that highly competitive market.

The most elegant establishments created entire "Rookwood rooms" to become synonymous with sophistication. This two-pronged approach helped both Rookwood and the hotel. First, the latter could then associate itself with beauty in an era when more travelers were moving between large cities. Second, the tile artworks were essentially permanent advertisements for Rookwood in locations across the nation where the nation's elites and growing wealthy class trafficked.

As hotels vied for added prestige, Rookwood installations moved from fireplaces, mantels, and surrounds to Rookwood-filled rooms, and then to immense cafes, dining rooms, and lobbies complete in a ceramic faience. The Norse Room in Pittsburgh's Fort Pitt Hotel is an example of a mammoth dining room decorated from floor to ceiling in Rookwood tile. Hard to imagine in today's world of prefab, cookie-cutter hotels catering to quantity over quality, the grand palaces of the early twentieth century were showcases of sophistication and elegance. The Norse Room featured a stunning set of nine murals designed by John Wareham based on Longfellow's "Skeleton in Armor." The 1841 poem recounted a Viking warrior's trip to America: "Speak! speak! thou fearful guest!"

The Sinton Hotel in Cincinnati opened in 1907. The Sinton Hotel was connected to the famous Taft family. Anna Sinton Taft—wife of Charles P. Taft, brother of former president William Howard Taft—was the only child of David Sinton, a Civil War profiteer. When her father died, Anna Sinton inherited an estimated $20 to $30 million—immediately becoming one of the largest landowners in the Queen City.

At night, the hotel lit up the evening sky with an explosion of color emanating from the high arching windows. Inside, the ornate lobby stretched upward several stories. The ceiling was framed in handcrafted, gilded designs that made it seem like a French castle. Interior hallways high above the floor enabled guests to look down on the hustle and bustle below.

Rookwood faience was one of the luxury points of the Sinton. At groundbreaking in 1905, a reporter described the grand touches:

A cafe of unsurpassed grandeur, finished in rare marbles and Rookwood pottery panels, with a great spreading dome above, rising 55 feet (16.8 m) above the marble floor, is to be the great feature of the new Sinton Hotel.

Comparing the Cincinnati gem with the famous Waldorf Astoria in New York City, the *Cincinnati Enquirer* proclaimed that the Rookwood dining room, soaring to a great dome 55 feet (16.8 m) high and 8,100 square feet (752.5 sq m) "will make the new hotel one of the notable places of the country."

Below left to right
Luxury hotels created postcards with iconic images, like the Fort Pitt Hotel's Rookwood "Norse Room," displaying the intricate detail of the columns and grand seafaring murals.

Cincinnati's Sinton Hotel had one of the finest Rookwood Rooms in the nation. The Grand Café was a central dining room with soaring archways and ornate columns, certainly a breathtaking experience for one of America's "notable places."

The Sinton also featured a "Kneipe" room (meaning "pub" in German) in the basement, a Norwegian oak-lined bar and billiard room that had multicolored Rookwood tile and other accents throughout.

Opposite
The popularity of the Norse Room led to Rookwood offering it as a residential unit.

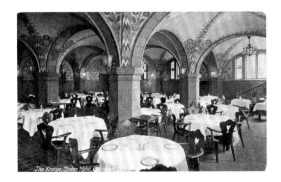

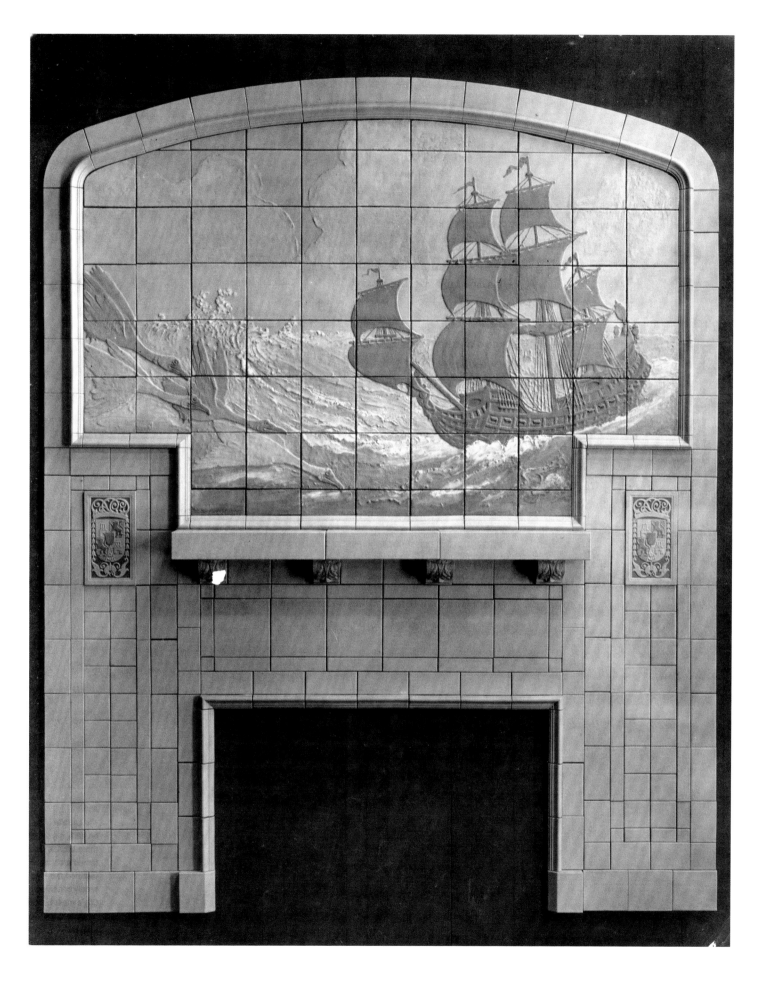

Sturgis's work in New York City paid dividends when Rookwood became part of the Vanderbilt Hotel on the west side of Park Avenue between 33rd and 34th Streets. Named after the famed family of Italian sculptors, the Della Robbia Room and Bar was a soaring temple of ceramic art. Polychrome tiles stretched skyward, topping out in oversized archways, while looming columns covered in tile stood guard, each topped with decorative faience. Summing up the era's demand for ornate, spectacular hotel palaces, writer William Hagerman Graves noted:

The lobby ofttimes rivals the atrium in the house of a Roman noble, rich with spoils of conquered provinces, while the dining room outshines the gilded and mirrored throne room at Versailles . . . The Della Robbia room . . . is an example of the most successful work of the kind that has been accomplished by American potters.

A 1910 article in the widely read *Scribner's Magazine* examined the use of colored tile in architectural projects, which had only been done for about twenty years. The author quoted Sturgis Laurence, who noted "their richer and more sympathetic qualities of color," comparing the scientific advances equal to that of Luca della Robbia, the Italian sculptor who invented terra-cotta faience in 1440 CE.

The consistent challenge for the architecture division centered on cost efficiency. The intricacies of Rookwood's faience lines made production pricey and labor intensive, gobbling up resources and time. Taylor searched for practices to save time and money in other areas, without sacrificing the hand-decorating that had won the company so much global acclaim. Writing about the commercial line in *The Forensic Quarterly*, the Rookwood president explained, "Commercial wares must be produced at low cost . . . all the risk possible must be eliminated so to insure rapid and cheap production."

Nothing, however, was fast or inexpensive in tile. Further challenging cost efficiency, Rookwood did not have the operating capital to keep a large inventory at the factory, so each order had to be created after the department received the order. "Simple orders for stock design usually took three weeks to complete, whereas the execution of original designs and elaborate schemes took from five weeks to several months," one historian explains. Tile necessitated an element of teamwork between clients and the subcontractors that projects demanded, from interior designers and architects to installers and technicians.

Initially, Rookwood offered two classes of colors (thirty in total), which determined the price of an individual tile. The other deciding

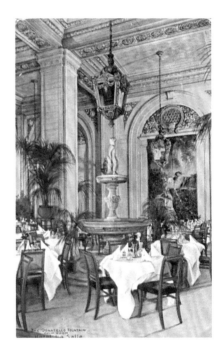

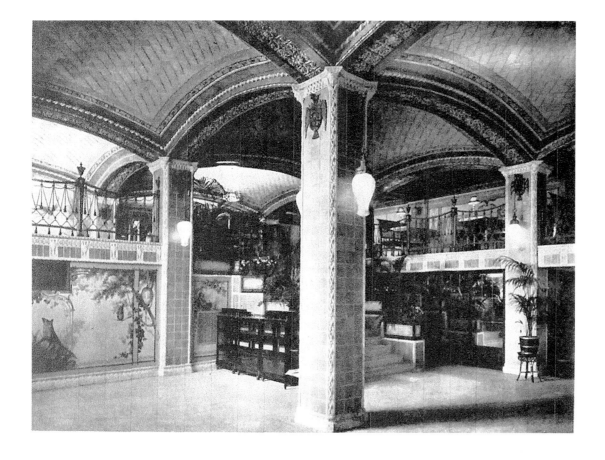

factors were size and design. The more unique or stylized colors and designs resulted in more expensive installations. By 1912, the color choices increased to forty-six. The fact that Rookwood's glaze required two kiln firings meant a higher production cost versus its competitors. The commitment to quality came at a price.

Examining the 1907 catalog, the most popular decorations ranged across landscapes, flowers, animals, plants, seascapes, and mountains, as well as subjects based on literature or folklore, including knights, Vikings, and Greek myths. "Much to the dismay of the decorators," art curator Kenneth Trapp muses, "the most persistent tradition was dictated by the public's insatiable appetite for anything floral." Rookwood responded with a dizzying array of flowers, lilies, wooded scenes, and landscapes filled with bright greens, pinks, whites, and blues.

Rookwood's interior faience, whether featured in public spaces or in private homes, often centered on rustic ideals and scenes glorifying the agrarian past. A kind of reaction to the aggressive mechanization of American society, people found comfort in filling their home lives with beautiful colors and romanticized portraits.

A Mat Green glaze fireplace surround, for example, evoked the calming influence of the forest, while a majestic mountain range frankly invited viewers to equate nature with happiness. In some ways, a Rookwood tile installation could be more lifelike and natural than nature itself, the deep glazes adding depth and strength to flat surfaces and intense colors, projecting an aura of comfort directly into one's private spaces.

By 1911, ceramics authority W. P. Jervis claimed that Rookwood had "perhaps the most extensive palette of mat glaze colors in the world." Again, turning ordinary objects into art, Jervis, explained: "The unsightly radiator has even been provided for . . . covered with a grille of pierced tiles becomes a thing of beauty."

Left
Lafayette-South Side Bank
in St. Louis opened in April
1916, drawing some 40,000
onlookers. Trade papers
called it the best-looking
bank in the Midwest and the
only one "finished with the
Rookwood." August A. Busch,
president of Anheuser-Busch,
was president of the new
financial institution.

Top
Another section of the wall
honoring Lafayette's former
executives.

Above
The teller space and lobby
at Lafayette used Rookwood
faience, as did a wall
dedicated to the bank's
early leaders.

ROOKWOOD FAIENCE : MANTELS

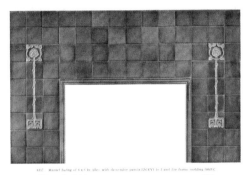

Left
Two Rookwood mantel surrounds using flowers and floral accents as a way to meet consumer demand in the early 1900s.

Below
Pages of hand-drawn sketches of 16 × 16 inch (40.6 × 40.6 cm) tile inserts.

The Rookwood team utilized technological advances in art pottery as well. Underglaze painting, which demonstrated the decorator's artistry, necessitated that the artist understood how different colors would change when fired. In other words, the colors used by the decorator on raw clay would be transformed under intense heat to something completely different. As a result, Rookwood artists were, in some respects, professional scientists as well as painters.

Changes in technology and consumer interest also pushed Rookwood decorators deeper into realms that did not involve hand-painting, or limited painting to some degree. It is not as if these skills weren't already in practice. The decorating team had a long history of innovative skills, from adding metal to pieces to creating texture and 3-D elements. From an outside perspective, however, the move seems radical, at least from the kind of painting that had won universal acclaim.

Science was never that far away from process. Journalist Marie J. Adams contrasted the challenges in making ceramics with the ultimate payoff. "Tremendous losses are made in the firing, but in the pottery everything is sacrificed to perfection." If the pieces could be fired with more reliability or created less expensively—hand-painted versus incised and glazed—then profitability would increase.

The experimentation continued in the glaze lines as well. In 1910, Rookwood brought out the Ombroso glaze, which highlighted a new direction in colors. Rather than painting under the glaze, the decorator typically incised the clay body that would highlight Ombroso's mat style. In skilled hands, the use of complementary colors in the carvings would pair with or contrast well with the glaze's mat gray or brown, though the colors could range to include shades of blacks and blues.

Two 7 inch (17.8 cm) production vases. Left, a two-handled ware (1912) in shaded pink and green Mat Glaze. Right, bluish-green Mat with embossed medallions (1915).

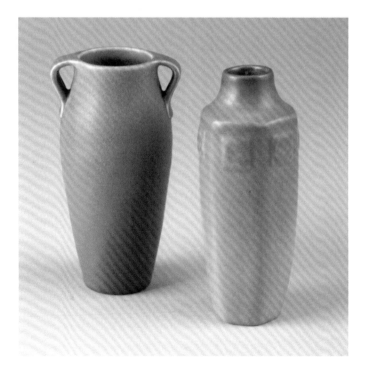

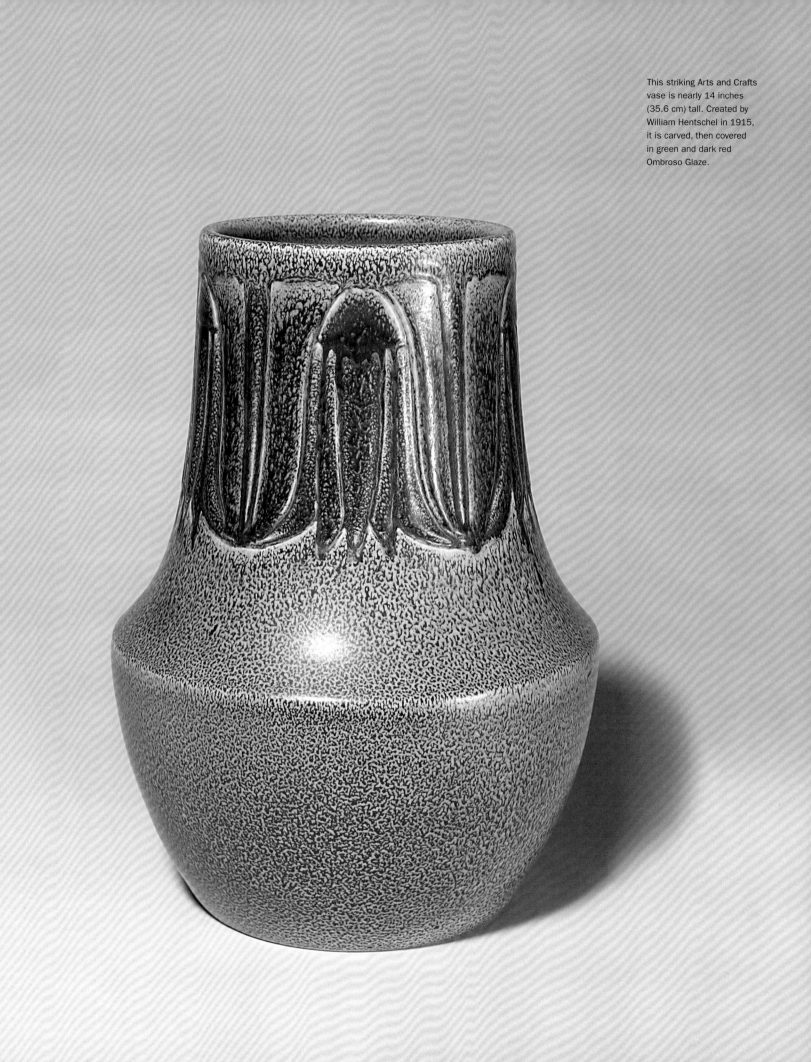

This striking Arts and Crafts vase is nearly 14 inches (35.6 cm) tall. Created by William Hentschel in 1915, it is carved, then covered in green and dark red Ombroso Glaze.

Rookwood also introduced new versions of old classics as additional refinements were made. Although Vellum debuted at the 1904 St. Louis Fair, Stanley Burt continued to tinker with the glaze composition. He brought out a version in 1905 that seemed completely new. Although it took ten years to perfect Vellum, Adams noted, "It is the first type of Rookwood that has pleased everyone."

Albert Valentien created the first Vellum-inspired landscape piece (soon dubbed "Scenic Vellum"), which demonstrated its unique qualities. Scenic Vellum pieces fit neatly within the tonalist style that grew in popularity from the 1880s through the early years of the twentieth century. Tonalism emphasized subtlety and the use of color tones that were pleasing and restful on the eyes. The glaze projected a sense of deep connection to nature, as well as abstract ideas that the natural world embodied. In the mystic landscapes and foggy seasides, artists such as Carl Schmidt and E. T. Hurley presented the art world with an innovative way to look at pottery.

In the hands of Rookwood's master painters, Vellum created a dreamy canvas for artists to create pieces that had the look and feel of impressionistic works. Many Rookwood artists used Vellum in decorating large tiles meant to be hung like traditional canvas paintings in wooden frames. Schmidt and Hurley used the large wall plaques as means of expressing themselves outside the company's traditional forms, while emphasizing their vision of wistful landscapes and harbor scenes.

In 1911, author W. P. Jervis published *A Pottery Primer*, labeling Rookwood's Vellum glaze, "a great departure . . . soft and close in texture and greatly enhances the work of the artist, the effect being somewhat similar to the Iris, through much more tender." Rookwood had the pieces framed and then sold them as pieces of art.

The mysterious qualities of Vellum did pose some challenges for decorators. Company lore recounts that Hurley and Rothenbusch, two highly talented painters, were basically forced to use Scenic Vellum based on the popularity of the dreamy landscapes. "Hurley's deep love of nature is manifest in his photographic treatment of trees, streams, and light, which he translated into landscapes on vases and plaques," explains Trapp. The artist revered plants, and the veiled look Vellum produced worked in parallel with his aesthetic.

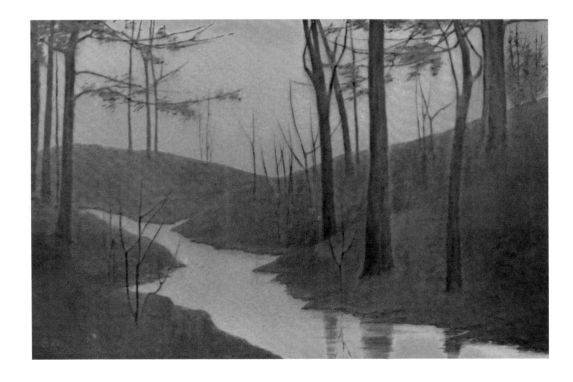

An Arts and Crafts Scenic Vellum plaque by Sara Sax (1914) that brings an enchanted fall countryside to life at dusk. The dark orange sky throws a shimmering haze over the winding creek and sparse, tall trees.

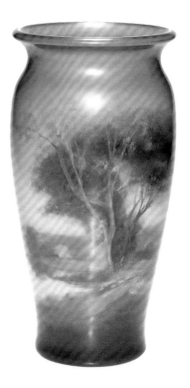

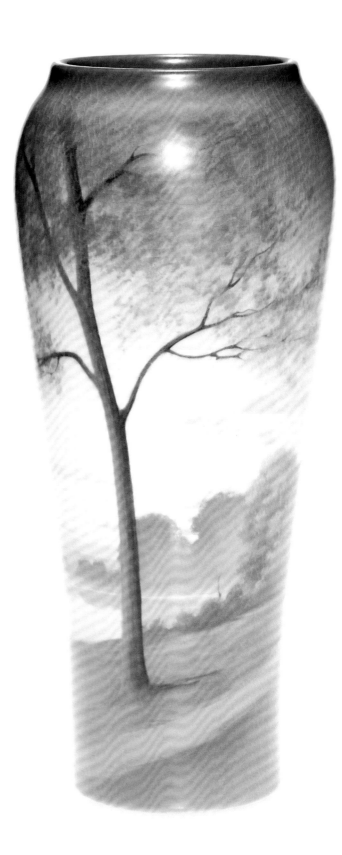

Although Rookwood remained a bustling tourist destination and museums continued to buy pieces for their growing collections, selling art pottery to consumers with wildly different ideas about what constituted art was still a challenge. In retrospect, Taylor's practice of granting exclusive sales rights to individual retailers did not work in application. Essentially loaning the wares to retailers handed over too much power to the stores. Without selling them upfront with the concurrent revenue, strategic planning and efficient production remained elusive.

Retailers, such as The A. Schachne Co., in Dayton, Ohio, controlled the point of sale and advertising related to marketing efforts. When a customer visited, store clerks might direct them to Rookwood, but the locations usually stocked a wide variety of luxury goods from many different companies. Schachne, for example, also sold "Fine Art Good and Bric-a-Brac" designed to appeal to consumer tastes, not just Rookwood wares.

Many challenges with retail establishments fell outside Taylor's control, but the pottery division remained the profit center. His focus on the international awards truly set Rookwood apart. Within the company, though, management realized that the debt burden taken on in expanding the architectural division and the mounting costs of creating commercial tile dragged at profits.

In 1912, for example, sales eclipsed $126,000 (equivalent to $68.7 million today), with two-thirds coming from pottery. The architectural division still ran at a loss, even though the number of institutions it served had increased. Creating tile installations that replicated the artisanship of the pottery department was a costly venture.

The decorating team dealt with another blow during this era when Kitaro Shirayamadani left Cincinnati, allegedly returning to his native Japan. This episode is shrouded in mystery, however, because the ultra-private Shirayamadani left no records of why he decided to leave. The exact dates of his leave are even mysterious, though it is generally acknowledged that he was overseas from 1911 to 1921.

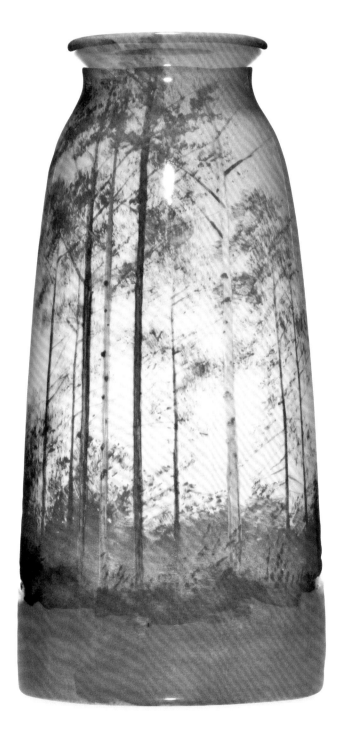

This 1911 Iris Glaze vase may be among the last works Kitaro Shirayamadani painted before his decade-long return to Japan. Although he usually did not tackle scenic panoramas, his typical photo-realist style turns the morning sunlight illuminating the woods below into a masterful piece of art.

The End of an Era: William Watts Taylor

William Watts Taylor died suddenly on November 12, 1913, from a heart condition at sixty-six years old. Working long hours, Taylor had rarely taken vacations, instead opting to dedicate his life to running the pottery. The sad news hit Rookwood and the ceramics world like a bolt of lightning.

The American Ceramic Society memorialized Taylor, thanking him for what he had achieved with Rookwood, "which has done so much to place America in the very front rank as a maker of the best in art pottery." The editor noted: "He combined a charming personality, a wonderful tact and an unfailing loyalty to high ideals of attainment which are but rarely found." Other accolades poured in. W. P. Jervis rightfully claimed that Taylor was the person to "shape Rookwood's destiny and uphold its prestige . . . much of the artistic and commercial success of Rookwood is due to him."

The *Cincinnati Enquirer* reported that his friends and associates thronged the Walnut Hills funeral service and that the "sorrow over his death is profound." Among the pallbearers were Taylor's boyhood friend (and Maria's husband) Bellamy Storer and Rookwood colleagues Joseph H. Gest, Stanley Burt, and John D. Wareham. During the ceremony, one speaker said: "Few men in Cincinnati will be more missed. He was an ideal citizen . . . a perfect gentleman. No one came in contact with him without being touched by his simple, lovable spirit."

Rookwood's board of directors collectively explained, "An adequate memorial . . . would recite the history of Rookwood," particularly

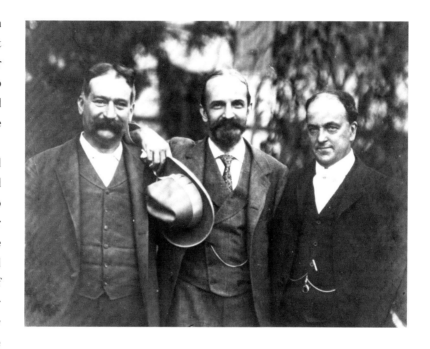

ROOKWOOD POTTERY, CINCINNATI, OHIO 7A-H1444

when Maria gave him "the task of organizing and building up the great art industry." Yet Taylor himself was loathe to take credit. The board related the comment he often repeated, "his was the master mind under which it grew by the help of the many others whom he gathered about him." Taylor's greatest trait, they said, was generosity of spirit: "setting up of standards of excellence in the heart of each individual."

Taylor's will granted his entire Rookwood stock portfolio to a board of twelve trustees (including Gest, Burt, Wareham, and other board members and close associates). They would choose from among themselves five directors to oversee the income, only dropping from the group upon death. Then, twenty-one years after the death of the last trustee, the stock and profits remaining would be turned over to the Cincinnati Museum Association, which oversaw both the Cincinnati Art Museum and the Art Academy.

Taylor hoped his decisions would keep the pottery in steady hands in perpetuity. In his will,

he wrote that he wanted to "secure continuous employment for the artists and craftsmen" so that Cincinnati would continue to benefit from the pottery's "artistic success."

Taylor also left $2,000 to be disbursed among current Rookwood employees who had been there more than five years. He also gave $500 to Sallie Coyne and $250 to Carrie Steinle, former members of the decorating team. The twenty-two-year-old Coyne had started at the pottery in 1891 when she was just fifteen. She continued to work at Rookwood until 1936, retiring at sixty-three. Steinle's mother had been a French tutor at Maria's Rookwood estate, where Carrie lived. She also started at the pottery at age fifteen, becoming a decorator at twenty-one. Leaving Rookwood in 1925, Steinle joined the nunnery, passing away in 1944.

"The greater part of my business life has been spent in developing and endeavoring to perfect that kind of ceramic ware which is commonly known as Rookwood," Taylor wrote in the will. "It has always been my aim to promote . . . what

may be styled the artistic side of the business, even at the expense of immediate commercial profit." He believed Rookwood was "an important factor in the education of the community, in matters of art and taste."

The prestige and influence of a leader of Taylor's stature would leave a gaping hole in the pottery. The immediate question on the lips of the art world was whether Rookwood would remain a significant player on the American art scene.

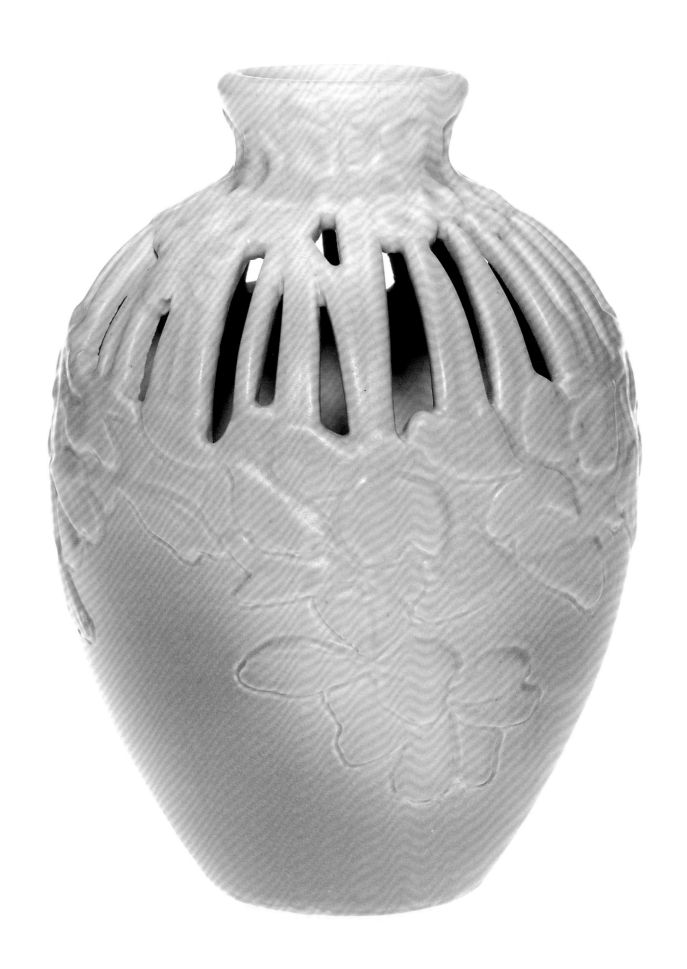

Sara Sax and the Floral Explosion

Sara Sax (1870–1949) launched a thirty-five-year career as a decorator in 1896, well after Rookwood had achieved global accolades. Yet Sax's work with floral motifs during the Arts and Crafts movement elevated the pottery's standing and redefined the role of flowers used as decoration in American homes.

Like the venerated Kitaro Shirayamadani, Sax excelled at every aspect of pottery decoration, including precise glaze calculations that enabled colors to burst forth. Her style continued to evolve with her growing command of the ceramic process. Sax would add 3-D carving into her work, as well as use fabric to create intricate surface patterns.

What set Sax's work apart, however, was her combination of hand painting and creativity. Sax excelled as a painter, bringing together composition and execution in an almost breathtaking fashion. Sax works of art are frequently marked by striking colors that seem beyond what could be manufactured to attain an ethereal, mystical quality.

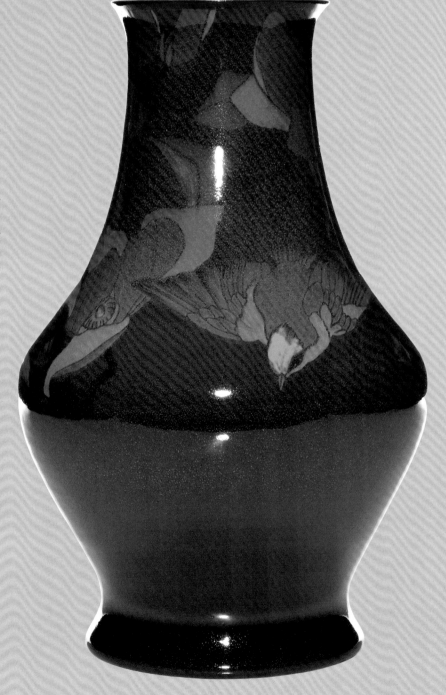

An exotic floral decoration and a single diving bird in Turquoise Blue painted by Sara Sax (1917). The exquisite design accentuates the glaze, paired with the porcelain form.

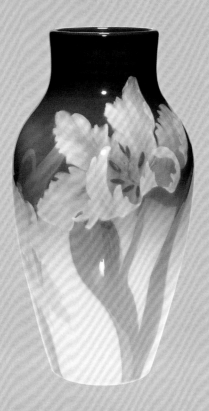

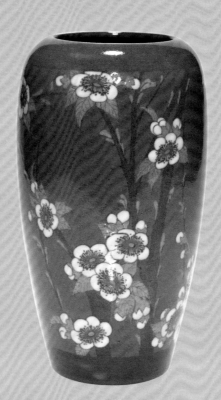

Left
A 1903 Iris Glaze by Sara Sax with parrot tulip decoration in striking yellow, which contrasts with both the long, sinewy green stems and dark top.

Right
This 9 inch (22.9 cm) Sara Sax porcelain vase (1918) demonstrates her creative use of colors, depicting blue and white blossoms on a medium blue ground, all framed in dark borders at the top and bottom.

Below
Sax remained at the forefront of new styles that emerged later. In 1923, she created this French Red vase with overlapping sprays of red and blue flowers with green and orange leaves and black stems. The swirling motion of the stems and the pattern at the foot of the vase marry art styles pervasive in the 1920s.

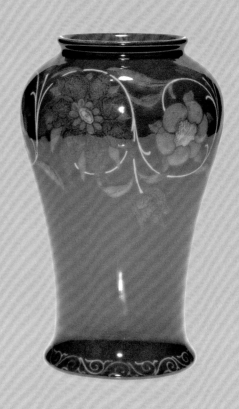

The Rathskeller at Louisville's Seelbach Hotel

"THE PLACE where EVERYBODY MEETS EVERYBODY"

Louisville's magnificent Seelbach Hotel opened in 1905 with 25,000 people pushing through its doors. Many among the throngs were seeing wonders like nothing they had viewed before: imported European marble, French bronzes, and the finest Irish linens available in the world. The French Renaissance-inspired hotel grew so fast that it had to be remodeled in 1907.

Considered one of the most luxurious establishments in the South, Louis and Otto Seelbach decided to create a Bavarian-inspired rathskeller in the hotel's lower level, bringing some of their German homeland to Kentucky. The entire room would be created using Rookwood faience.

The grand opening gala on December 30, 1907 included 300 attendees from Louisville's elite. The Rathskeller was an immediate hit, called "beautiful, unique, fascinating . . . extravagant . . . conjuring up the impression of some Old World castle." Inside, Rookwood covers nearly every inch of the 80 foot (24.3 m) room, including columns and arches, "in every essential, artistic detail, a reproduction of the underground drinking and council hall of one of the famous castles on the Rhine."

Another immense faience piece was the Rathskeller's towering floor-to-ceiling clock that greeted visitors in the vestibule. Rookwood designers declared it "the masterpiece of the many beautiful and artistic things which have come from the pottery." Like Rookwood rooms of the early twentieth century, the Rathskeller is a visual treat and architectural marvel.

Left
The Rathskeller in Louisville's Seelbach Hotel brought a Bavarian feel to Kentucky and provided a charming escape for travelers and sightseers.

Right
The mosaics, curved surfaces, and detailed features, such as the intricate coats-of-arms and pelicans, make the Rathskeller one of the finest Rookwood rooms ever created.

5 Evolution of Form and Style

During Rookwood's World War I era, the pottery and tile divisions took on somewhat separate identities. The decorating team diligently—often quietly—went about its business, hardly slowing in the transition from William Watts Taylor to the team of J. H. Gest and John D. Wareham. In architectural faience, Rookwood continued working on high-profile installations, marrying design efforts with tile production and glaze science.

In March 1914, months before the Great War broke out in Europe, decimating a generation, a grand building devoted to solving humankind's physical challenges through medical practice and research opened in Rochester, Minnesota. Called a "monument of architectural beauty" and the "most remarkable institution of its kind in the world," the building served as the new home of the Mayo Clinic.

Embodying the impulses of the age, the Mayo Clinic building brought together the most advanced scientific knowledge with the idea that people suffering from physical or emotional ailments should be surrounded by beauty and grace, which aided in healing.

Along with its rooftop greenhouse and an in-house museum, the Mayo Clinic also contained the largest Rookwood tile installation in the nation, which had been designed by John D. Wareham. Befitting the idea that a serene environment gave people hope and comfort, the gigantic lobby—finished in Rookwood tile—covered some 17,300 square feet (1,600 sq m)

and soared upward four and a half stories. Rookwood created the centerpiece of the massive space, a grand double stairway, as well as the accompanying elaborate water fountain that provided patients and their families a steady, calming purr. Palms, plants, and flowers from the rooftop garden filled the lobby, bursting with sunlight from large skylights.

Wareham also designed other parts of the medical institution, including several of the upstairs floors housing the editorial department, administrative staff, and research facilities. He created murals for the bathrooms, one featuring children at play in billowy flight and a legion of fish, tying the space to nature and its calming influence.

In an era about to be filled with devastation and toil, Rookwood faience and art pottery was designed to bring elegance and beauty into people's lives. In private residences and public spaces, Rookwood presented a vision of the natural world meant to convey harmony and grace.

Above
An oversized tile (18 × 18 inches [45.7 cm]) decorated using the *cuenca* technique, which used deeply impressed patterns with raised sides to prevent the different paints from mingling, with trees and a landscape in polychrome Mat Glazes.

Below
Designed to stimulate serenity and comfort, the 1914 Mayo Clinic building had Rookwood faience covering just about every space, which one observer said gave the building "a bright and cheerful look, while keeping it very refined and delicate."

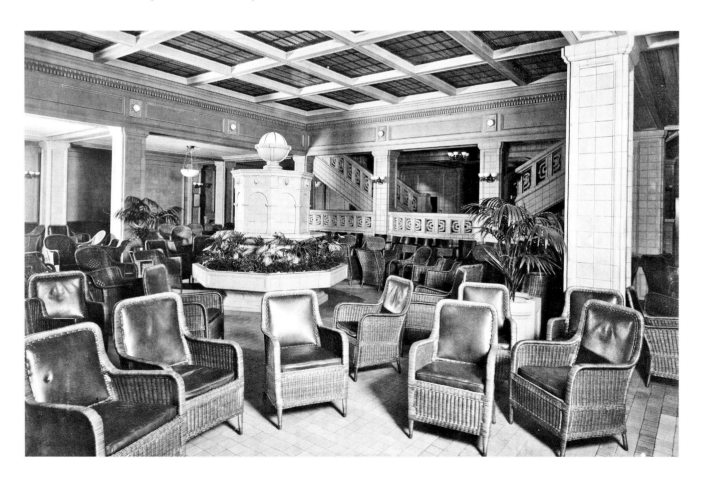

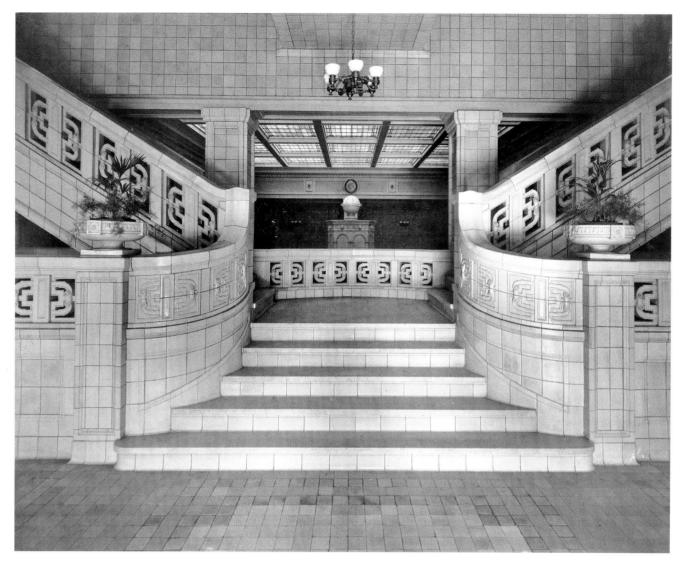

Left
The grand Rookwood entranceway staircase.

Below
A popular four-tile frieze decorated in *cuenca* featuring three tall ships sailing across calm waters and blue green skies.

Discovering a New Path

William Watts Taylor entrusted Rookwood to his longtime friend and confidante, fifty-four-year-old Joseph Henry Gest, the executive he had personally recruited to join the pottery in a part-time arrangement with the Cincinnati Art Museum. Gest's elevation to chief executive led company directors to name John Dee Wareham vice president, while longtime board member Edward Goepper became the new treasurer. Goepper was president of the Herman Goepper & Company, a longstanding hop merchant. The politically connected and wealthy Goepper also served on several important boards, including those of the Cincinnati Railway and the Cincinnati and Suburban Bell Telephone Company.

Although beloved in Cincinnati for his inspirational efforts in elevating the Art Museum, Gest was not the hands-on leader that Taylor had been. Taylor lived and breathed Rookwood, as if he held deep personal responsibility for fulfilling Maria's vision of what the pottery could be. Gest would steer a different course, relying on longtime Rookwood managers to guide the company.

According to historian Herbert Peck, "Business at the pottery went on much as it had before." Gest continued to divide his days, spending 8:30 a.m. until noon at the Art Museum. He frequently dined with Wareham or Burt at the Queen City Club for lunch. In the afternoon, he went to his office on top of Mount Adams and worked on "broad policy matters," including "details of advertising and sales promotion."

Wareham and Burt ran Rookwood on a day-to-day basis. They had been Taylor's top lieuten-ants, so the arrangement probably seemed about the same for employees. Wareham was also active as a designer for tile installations, using his painting and drawing skills to map out what a project might entail. "His sketches would be enlarged photographically to actual size to serve as full-scale blueprints from which the clay tiles were planned and fitted to exact measurements," Peck explained.

Naturally, Burt took over management of production and research. The daily supervisory work fell to Otto Metzner, promoted to plant superintendent. It is difficult to compare Gest's efforts versus Taylor's overall, but there was a difference in style (as well as time, because Gest continued to work half-time at the museum). In an informal report to the board in early 1916, Gest noted, "The business of the company was proceeding normally, and in a satisfactory manner," while he paid down outstanding debt to its "usual small amount."

Under Gest, Rookwood's marketing campaigns remained similar to what Taylor put in place. An April 1915 ad, for example, announced that Rookwood had developed "an entirely new type of ware designed in color and for the holding of flowers." Rookwood would continue to emphasize its traditional strengths: form, function, and color.

The pride Cincinnatians felt for Rookwood is reflected in the October 1916 gift the Hughes High School presented to President Woodrow Wilson and his wife Edith when they made a stop in the Queen City. "The president's carriage," according to the *Cincinnati Commercial Tribune*,

"will be stopped long enough to allow the presentation of a fine piece of Rookwood pottery which has been purchased by the students." The students "felt a piece of Rookwood pottery was a very good reminder of the excellent products of Cincinnati."

Although the war in Europe and America's entry in 1917 would have a cataclysmic influence on the twentieth century, the conflict did not have a major impact on Rookwood itself. The xenophobia and violence against Germans and German-Americans, however, would have critical consequences on the Queen City and the region, given its extensive and vibrant German communities. Incidents ranged from discrimination against businesses run by people of German descent to the city changing street names from German names to those that seemed more "American."

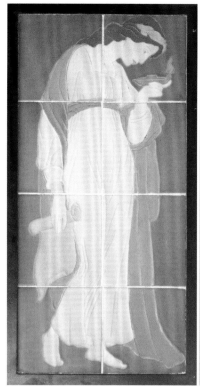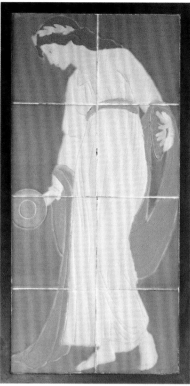

ROOKWOOD FAIENCE: FRIEZE AND WALL PANELS

Top
Although existing examples are rare today, Rookwood used these kinds of tiled panels in many interior design projects. Using Greco-Roman ideas, these muses symbolize whimsy, wisdom, and song.

Right
Wall panels, particularly of landscapes and adventure scenes, remained popular.

Opposite
Portrait of Joseph Henry Gest.

The architectural faience division continued to expand, landing a series of high-profile installations. The company had success with high-end retailers that wanted to be associated with the Rookwood brand. In Pittsburgh, sculptor Clement J. Barnhorn designed a towering fountain for the downtown Kaufmann's Department Store, a powerhouse retail hub run by philanthropist Edgar J. Kaufmann, later owner of Fallingwater, the modern architectural masterpiece designed by Frank Lloyd Wright. Barnhorn, a professor at the Cincinnati Art Academy and one of America's most famous sculptors, created many works for Rookwood's architectural department. Lord & Taylor in New York City added a fountain in its flower department, giving Rookwood another installation in one of the nation's most important retailers.

In the Queen City, the cornerstone was placed on April 11, 1915, for the $500,000 Western & Southern Life Insurance building at Fourth and Broadway. Some 500 local business leaders attended the event, where company officials announced that Rookwood would be used to cover the walls, ceiling, and floor of the lobby.

Rookwood focused marketing efforts on industry trade magazines read by the nation's top architects, construction companies, and interior designers. Many of the prominent installations became the centerpieces of the ads, often in full color.

A 1913 ad in *Architectural Review*, for example, showed an oversized faience panel from the Fort Pitt Hotel's Norse Room. The arresting mural featured a Viking longship fighting its way through glistening waves rocking the ocean, portrayed in a series of blues and whites. A flock of geese fight against gusts of wind in the foreground, providing a level of depth one might find unimaginable in a tile mural. The perimeter of the piece showed the level of detail, with Viking shields adorning the pink and gray tiles, really emphasizing Norse power visually.

Accompanying text stressed the ideas at the heart of Rookwood, marrying the art and tile sides of the company for the reader: "The

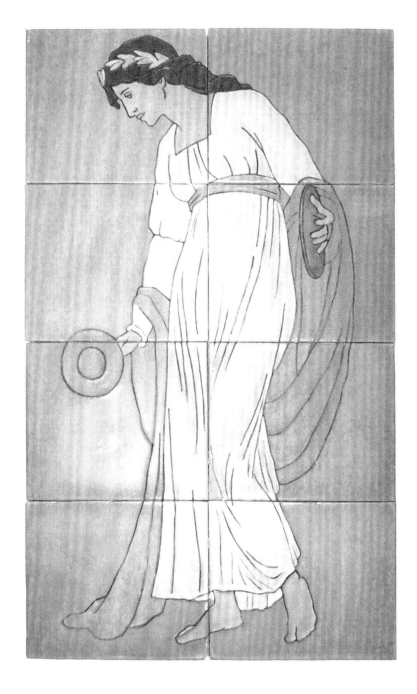

An eight-panel tile sequence (32 × 19 inches [81.3 × 48.3 cm]) of an elegant, barefoot maiden playing the cymbals in blue, white, red, and green Mat Glazes.

Mat Glazes developed by Rookwood, through thirty years' experience in the manufacture of Faience, embody a technical perfection which is recognized as the standard of American workmanship." Rookwood's edge, the ad highlighted, centered on the variety of colors the designer could employ, "a palette practically unlimited." Ironically, on the next page, Grueby had a full-page ad showing its flooring in Philadelphia's Bellevue-Stratford Hotel. The Boston-based company (founded in 1894) declared itself the "oldest manufacturers of Faience tile in America," and had emerged as one of Rookwood's primary rivals.

Above
A 12 inch (30.5 cm) square architectural tile featuring the popular tall sailing ship image.

A rare 6 inch (15.2 cm) Mat Glaze tile with an Arts and Crafts poppy, stamped "Rookwood Faience."

Right
A 1919 ad in *The House Beautiful* targeting luxury consumers who might be tempted by the novelty of the "endless colors and patterns" of an indoor pool, quite different than what Rookwood had been producing prior to that point.

A Rookwood Room: Fantastic Tile Installations

GEORGE HIBBEN

In 2010, Rookwood was tasked with a nearly impossible feat: restore tile in Chicago's famed Monroe Building that had recently been uncovered and make the new tile seem like it had been made when it was initially installed in 1912. Using precise glaze calculations developed a century earlier, Rookwood was able to make the grand first floor lobby look new/old again!

In the early 1900s, Rookwood's burgeoning architectural division, headed by William P. McDonald, designed and manufactured entire "Rookwood Rooms," essentially floor-to-ceiling installations with nearly every inch (centimeter) covered in the pottery's faience. Giving America's grandest hotels an added touch of sophistication and elegance,

Rookwood rooms could soon be found coast to coast.

Today, Rookwood's Architectural Tile department works with architects, interior designers, and consumers to design and manufacture tile installations, ranging from new hotels and restaurants to private residences in historic districts to the latest homebuilding trends.

As it has historically, Rookwood's glaze technology enables architects and builders to create countless looks based on Mat Glazes to Gloss and Crystalline. The Rookwood legacy, combined with modern production methods, makes handcrafted tile accessible again for any space.

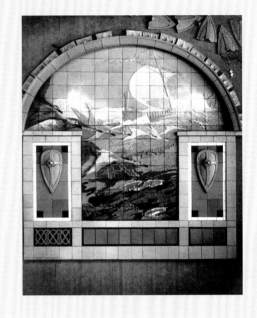

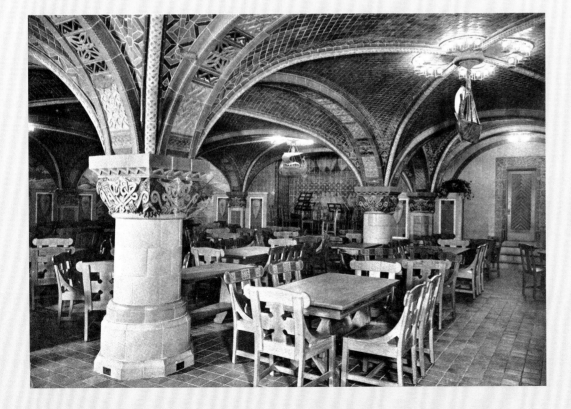

Above
Close-up of the Norse Room in the Fort Pitt Hotel in Pittsburgh.

Left
The Norse Room decked out and ready for the evening's crowd.

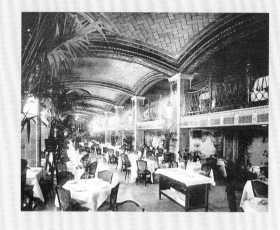

Above
The multilevel Della Robbia
Room in New York City's
Vanderbilt Hotel. Rookwood
faience added to the luxury
ambiance, including the
crests at the top each pillar.

Left
William P. McDonald, the
decorator who took over the
architectural department.

A Foot in the Past, a Move Toward the Future

Most of Rookwood's stellar decorators were dedicated artists—often across mediums—spending their time away from the pottery engaged in other forms of creativity. Some of them freelanced and supplemented their salaries via outside work. The very best put on exhibitions and shows, and simply reveled in artistic expression—true artists following their calling.

In 1917, E. T. Hurley published *For Old Acquaintance*, a small book of etchings. His reputation had steadily grown and his artwork hung in several museums. Often, he walked the grounds around the Mount Adams factory with his sketchpad, capturing scenes of the employees and studio. The first edition of Hurley's book included commentary from his fellow decorator Sara Sax.

Sax pinpointed the majesty of Hurley's sketches, particularly their focus on the Queen City, explaining that if the Rookwood factory "were situated on a busy street, it would never have become so interesting." Yet it is transformed "perched on the brow of a hill overlooking the busy town, but far above its noise and smoke." Hurley's nostalgic Cincinnati, according to Sax, is filled with the ideas and inspirations of bygone days, "the things he has seized with his etching needle, and kept for us all."

During the World War I era, Rookwood was in a kind of nostalgic place, despite Taylor's sudden death. Perhaps with Wareham at the helm, moved up to vice president and department chief, the team took on some of his personality—steady, dedicated, artistic, and disciplined. Maybe it was the influence of the Vellum Glaze, which had remained so popular, with its emphasis on tone, reflection, and mood. Countless changes occurred all around Rookwood, but the tenor of the decorating team was calm, quietly going about its work, and certainly in contrast to the many years prior when the pottery chased down award after award.

A toned-down aura, however, did not equate to uninspiring work or innovations. Slow and steady meant something different at Rookwood, a pottery dedicated to a level of excellence that most organizations could never achieve.

In 1915, for example, after years of ceramic research and experimental firings, Rookwood launched the Soft Porcelain vessel body, which the company publicized as an "interesting departure" in a promotional booklet. Curator Anita J. Ellis explains, "Beginning in 1915 with its new porcelain body, Rookwood looked to the Chinese for inspiration."

Company lore told that the new work resulted from Stanley Burt attempting to replicate the popularity of Chinese pottery styles. He certainly would have been familiar with Asian examples, as would company decorators, who had seen the extensive collection of Chinese pottery owned by Cincinnati magnate Charles P. Taft, William Howard Taft's half-brother, and husband of Anna Sinton, heiress of the Sinton family fortune.

A 13¾ inch (34.9 cm) Porcelain Glaze vase decorated with a trio of bluebirds perched among crabapple branches by Lorinda Epply in 1919. The outline is bordered by an intricate flower design that offsets the thoughtful blue background.

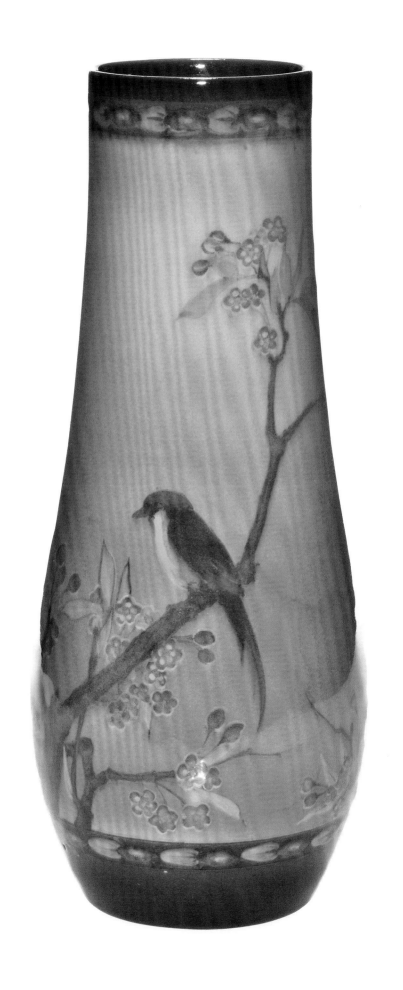

E. T. Hurley: An Artist's Artist

RILEY HUMLER

An E. T. Hurley original etching of Cincinnati's Mount Adams Incline, with the Rookwood factory at the top left. Close inspection reveals intricate detail, including expressive people on the streets, children, and bounding dogs.

E. T. Hurley was perhaps the most productive artist to ever work at Rookwood. Among his achievements outside the pottery were etching (for which he was made an associate member of the National Academy of Design in 1930), oil painting, book publishing, bronze work, and the creation of a line of oil pastels that he marketed under his name.

It is impossible to quantify the number of etchings done by Hurley, but we can speculate the number to be more than five hundred, with minor modifications adding to that number. A lover of his hometown, many of his works dealt with Cincinnati-area architecture and points of interest. Hurley also created scenes from Florida and Chicago. Local markets, including Cincinnati's famous Findlay Market (which is still active as a market and tourist attraction) were favorites.

Hurley's bronze works consisted of items he designed and carved, then cast. Many featured seahorses, including boxes, ashtrays on stands, bells, lamps, letter openers, and candlesticks. Most were cast across the Ohio River in Newport, Kentucky, though he brought the new casting to his home on St. James Place to be finished and to patinate. His daughter, Joan Hurley O'Brien, told me he would get piles of castings from the foundry, which he would grind and polish to his satisfaction, making a terrible racket in the process.

Hurley's oil paintings are less common. Although there are many famous pieces in the Cincinnati Art Museum, one that many love and comment on is Hurley's *Midnight Mass*. The sensual, dark painting depicts a snowy Mount Adams cathedral with the only light coming from the windows during service.

As a Rookwood artist, Hurley was also prolific. Employed there from 1896 to 1948, his work shows growth and maturity over the years. Hurley's love for sea creatures is apparent. Some of Rookwood's best aquatic scenes from the turn of the last century featuring fish and lobsters were created by Hurley. Tonalistic landscapes from around 1910 show his ability as a plein air painter. These pieces are highly prized by Arts and Crafts collectors.

In the early to mid-1920s, Hurley produced an interesting subgenre featuring bright colors with exotic flowers and birds (with the occasional aquatic scene for good measure). These pieces are some of Hurley's most lavish, done on porcelain with bold color and expression. Not his most exacting work by design, these are sketch-like, but the overall effect is perhaps his best. During Rookwood's reincarnation in the 1940s, Hurley produced many vases and plaques in Vellum Glaze showing beech trees and lakes during different seasons. Many of these are repetitive, but consistently well-done, despite his advanced age.

I asked Hurley's daughter, Joan, how the artist could have produced so much work over his lifetime. She did not know for sure but explained that being a widower with two children, he had little choice.

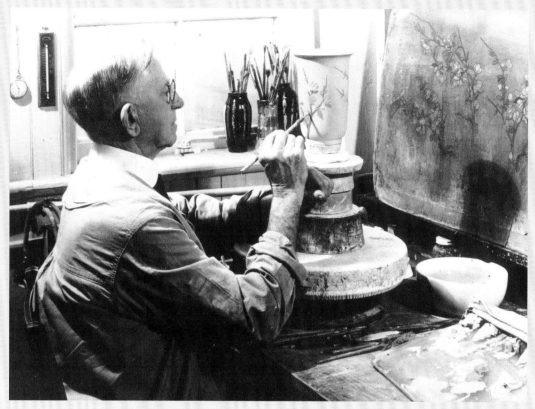

Top left
A 1946 Scenic Vellum plaque
(10 × 12 inches [25.4 × 30.5 cm])
depicting a tree-lined lake in
a mountainous landscape,
highlighted by vibrant pink,
blue, green, and sandy tones.

Above
A Hurley etching plate (1915)
showing a view of Cincinnati's
Mount Adams neighborhood
with the Church of the Immaculata
crowning the hilltop, as well as two
bridges spanning the Ohio River,
including the famous Roebling
Bridge in the background.

Top right
Working in several genres, Edward
Timothy Hurley gained internation-
al acclaim as an artist. He pro-
duced thousands of pieces in his
career at Rookwood, 1896–1948.

Right
Heavenly white geese fly amid
the clouds in a dreamy candy-
colored butterscotch sky on this
vase (1903). The Iris Glaze brings
the birds to life, their wings metic-
ulously highlighted in gray.

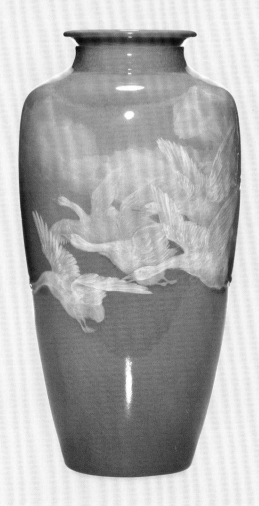

Rookwood used Soft Porcelain to capitalize on the craze for creating flower arrangements, thereby bringing nature's beauty into closer communion with the increasingly technical world. Labeling Rookwood's glazes on Soft Porcelain "quiet," company literature claimed "colors as well as the shapes have been carefully studied with reference to their value in the display of flowers in a new and beautiful setting."

Despite the way Rookwood characterized its new wares, the glazes decorated on Soft Porcelain bodies were frequently anything but quiet. In fact, the flowers and plants burst from the vessel surface, the glaze offsetting the somewhat muted effects of the body type.

Arthur P. Conant was particularly skilled in decorating Soft Porcelain, melding arresting colors with delicate painting to create the kind of craftsmanship that pushed Rookwood ahead of competitors (and, increasingly, imitators). Even at a company where "one-of-a-kind" became kind of the catchphrase, Conant's work was unique and unlike that of his colleagues on the decorating staff.

Rookwood's new leadership team helped smooth the transition from William Watts Taylor's strong personality to a new era by exuding a calmness and rededication to exquisite work across its architectural and art pottery divisions. Although the Great War would exert incredible strain on its combatants, Rookwood ably maintained its place atop American potteries.

Yet as the company prepared for its fortieth anniversary in 1920, there were indicators that competitors were squeezing into the marketplace. Both faience and art pottery were becoming crowded, with competitors hoping to capitalize on Rookwood's innovations, as well as newcomers that could make ceramics more quickly and less expensively. As the nations of the world flung off the existential and physical damage of World War I, Rookwood grappled with the challenges of being an established power in a highly competitive arena.

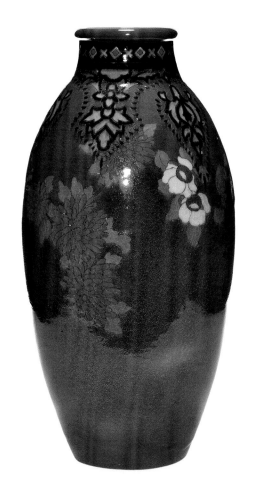

Left
Demonstrating his wide-ranging talent, Arthur Conant decorated this striking purple vase with numerous flowers accentuated by a dripping blue tint (1917).

Right
A Conant porcelain vase (1918) with colorful floral decoration and pattern.

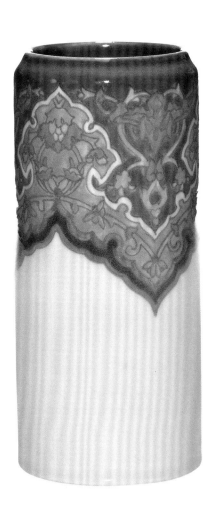

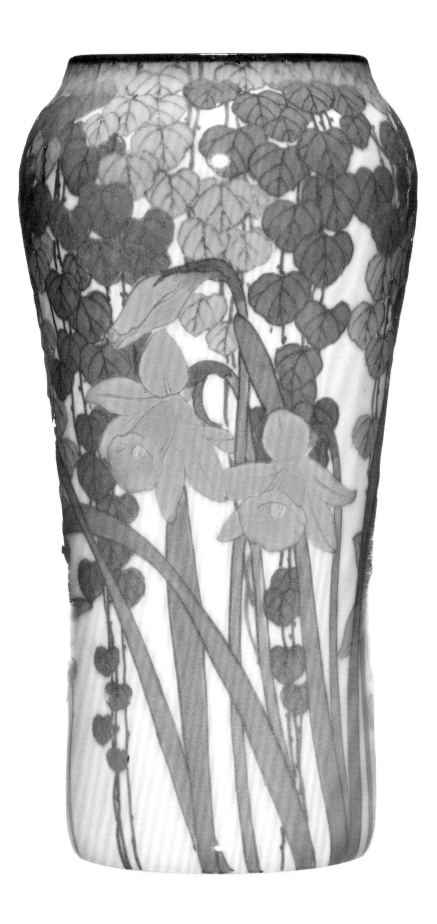

A yellow-tinted porcelain vase by Kitaro Shirayamadani (1922) features cascading English ivy in shades of blue, red, and green interspersed with bright yellow jonquils. The petals, veins, and stems are outlined in black for added definition.

Arts and Crafts Movement at Rookwood

GEORGE HIBBEN

This 1922 Sara Sax French Red is another example of her artistry. According to Riley Humler, "The ovoid form has first been glazed inside and out with a lime green glaze over which is applied the decoration and the French Red color." The stylized black flowers are "decorated in gold and maroon in several different patterns."

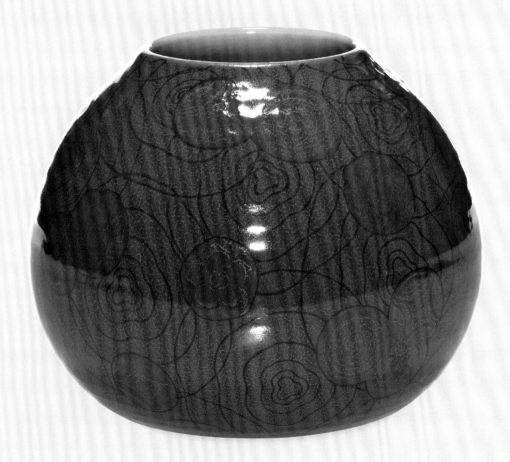

A common misconception about Rookwood is that the pottery is primarily an Arts and Crafts company. Although Rookwood had an Arts and Crafts design phase, perhaps lasting from about 1900 and into the next decade, in actuality Rookwood's top decorators and artists were well attuned to the fluctuations and innovative ideas that emerged in the broader arts community.

Certainly Rookwood's decorating team engaged with new ideas, ushering in new styles as older concepts waned. About every ten years a new design style emerged, sometimes completely different, as did innovations in glaze lines based on ceramic chemistry and ensuing breakthroughs.

Mat Glazes were in vogue for the first several decades of the twentieth century, fitting well with the Arts and Crafts aesthetic, which focused on quality craftsmanship and reverence for naturalistic themes. Earth tones, plants, animals, and incised carvings dominated the style when applied to art pottery. Common tile uses ran the gamut, from geese and birds featured on fireplaces and surrounds, to the use of earth tone glazes in Rookwood Rooms created exclusively for the era's grand luxury hotels.

Sara Sax, for example, utilized Arts and Crafts ideas in many Mat Glaze vases she created in the first decades of the twentieth century. Sax often used flowing lines and hand-painted flowers or other plants to create an artwork that seemed to refocus the viewer's eye on how the object rhythmically danced with the muted glaze.

Top left
This leading-edge Arthur Conant porcelain vase (1916) is exotically decorated with colorful flowers, grasses, and fruits beneath a black sky. "Some of the plants seem to be sprouting from sandy areas," said Humler. "How Conant accomplished this, we do not know but we believe he was ahead of his time and there definitely is a sandy texture near the base."

Bottom left
A 1927 production vase in Caramel Mat Glaze shows how Rookwood's artists straddled Arts and Crafts and ensuing styles. This 10 inch (25.4 cm)-tall piece, with dripping surface and simple mat coloring is counterbalanced by the intricate pattern at its neck and shoulder..

Bottom right
A Kitaro Shirayamadani Black Opal vase (1921) that demonstrates his melding of craftsmanship, glaze, and hand painting. The purple-pink flowers burst from the vessel, offset by detailed yellow flowers and green foliage. There is even an homage to Art Deco at the top of the piece, contrasted with the marriage of blue and green at the foot.

6 Rookwood in the Jazz Age

A 1921 French Red with incised and painted tulips, mixing High Gloss and Mat Glazes. The pattern on the stylized neck and body background must have been made from a fabric design, set off by the Art Deco-ish rectangular pattern at the neck.

With two hundred employees and fifteen kilns, Rookwood hit the Jazz Age with momentum from forty years of research, experimentation, and success. The pottery pushed into new designs, produced wares that met consumer demands, and was unwilling to simply rest on past accolades. Across a range of traditional styles and new innovations, company artists created ceramics for a wide range of consumers and the architectural marketplace that met demand and the height of artistic expression.

In a February 3, 1920 ad, the Joseph Horne Co. in Pittsburgh, one of the city's finest and oldest retailers (dating back to 1849), announced new shipments of Rookwood pottery had just arrived, refilling its shelves after the holiday rush. Housed in Horne's "Floor of Ideas" suite on the third level, the notice validated what Rookwood meant to consumers in the 1920s:

"To add a touch of delightful personality to a Home!"

In practical terms, the "Floor of Ideas" featured the latest colors and design ideas that would appeal to consumers (mainly female, the primary shoppers for home goods): "blues and greens so typically Rookwood . . . soft rose-grays . . . as if they had caught a cloudy sunset . . . warm, sunshiny yellow."

For middle- and upper-class Americans, Rook-wood—represented by stellar glaze lines and soothing shapes—had become synonymous with luxury. Having Rookwood in one's home equated to a heightened sophistication—the owner had style. For those shoppers in Pittsburgh and at other retailers across the nation, Rookwood was offered at numerous cost points, from $1.50 to $3.50 and "more expensive pieces, of course, all the way to $150." Picking out a piece of Rook-wood equaled grace.

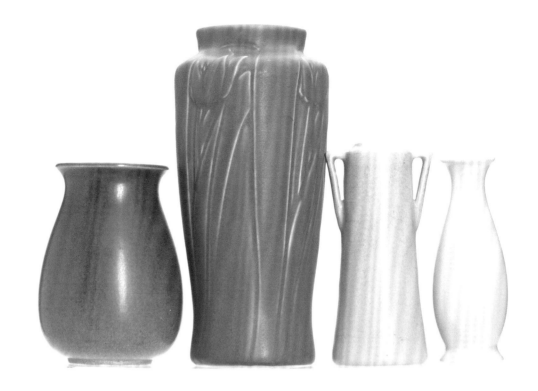

Top
Shown are four production pieces in a range of colors designed and sold in the early twentieth century to appeal to new styles and fashions.

Bottom
Elizabeth Barrett looks to a variety of floral illustrations while painting in her studio. At Rookwood from 1924 to 1931, she left after marrying fellow decorator Jens Jensen but did occasional work through 1943. Her work was influenced by Art Deco and modern styles.

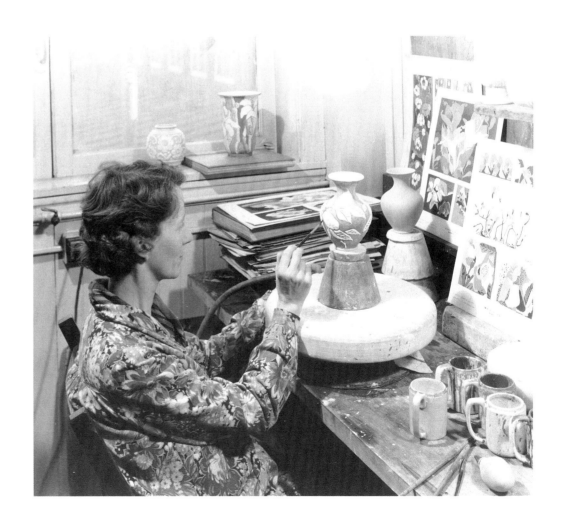

Barrett created a dramatic scene of Valkyries on this Turquoise Blue vase (1935). The warriors carry weapons and shields, the intensity strengthened by the black-on-blue painting. She was the only decorator who worked in this style. Perhaps this is a tribute to her husband's Viking roots.

Fast-forward a decade or more, as the Jazz Age ground to a halt, Rookwood and its retailers moved away from the "traditional" message, instead angling toward the "modern." Pottery was, they exclaimed, like in the Hudson's holiday ad in the December 23, 1931, *Detroit Free Press*: "The Oldest gift in the World! Well-Beloved by 'We Moderns'!"

With the Great Depression gripping the country, Hudson's wisely highlighted a "hand-moulded" bowl in its black-and-white, hand-drawn advertisement, "with an interesting grape design, tinted in a subtle mauve," which sold for $3.50. A nod to the modernist style that had swept in with the Roaring Twenties, but at a price still (somewhat) affordable, aimed primarily at elite consumers (equivalent to $353 today). Rookwood had spent the 1920s adapting to the styles prevalent in the broader art world, but also delicately balanced the more conservative nature of many of its consumers.

The blurry edge between modernism and the idealized past (often featuring styles based in rural/pastoral nostalgia) had consequences for Rookwood as a commercial entity. Contrasting views of modernity would also cut across culture—think about the differences in attitude, fashion, and belief systems on a Jazz Age flapper versus her mother, born as the nineteenth century ended or the twentieth began. In the 1920s, culture transformed at breakneck speed, the pent-up explosion in a world that felt it had just barely avoided annihilation.

Although the United States emerged from the conflict as the world's most powerful nation, Americans had to recover from the existential scars brought on by the "war to end all wars." World War I continued to exert influence long after the fighting ceased. For Rookwood, the era had been less tumultuous than for many other companies. The pottery did not have to substantially change its business or lose many

of its workers to the military. People lived in a world tracking toward mechanization.

Rookwood's changes had been internal, so the war years gave the pottery a brief pause. With the changing of the guard after William Watts Taylor's untimely death, the relative calm of the late war years gave the entire organization time to transition to its new leadership. The continuity from Taylor to the triumvirate of Joseph H. Gest, John D. Wareham, and Stanley Burt at the top was less disruptive than if Taylor would have sold his majority interest, thereby risking someone from the outside taking over his precious life's work. Taylor's prudence, combined with the lengthy experience of the new team in charge, enabled the managerial shift to sort out gradually.

Adapting to new modernist styles, William Hentschel created this large piece in 1927. More than 1 foot (30.5 cm) tall, the Art Deco vase shows the impact of nature on the artist's perspective, a gazelle leaping through a fantastical forest covered with blue and tan Mat Glaze, which brings out the contrast between animal and nature.

This 17½ inch (44.5 cm) extravagant vase by John Dee Wareham shows how an artist of his caliber can unify timeless and contemporary in one work of art. This 1924 piece is encircled with intertwined grapevines, leaves, and large blue and purple grapes, set against a mottled maroon background with black tendrils dripping from the rim.

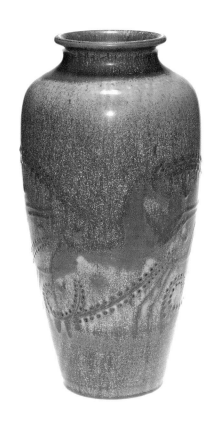
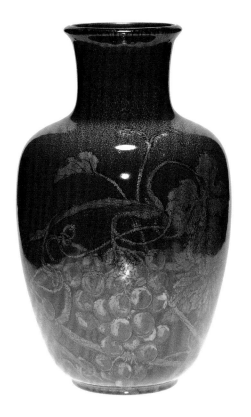

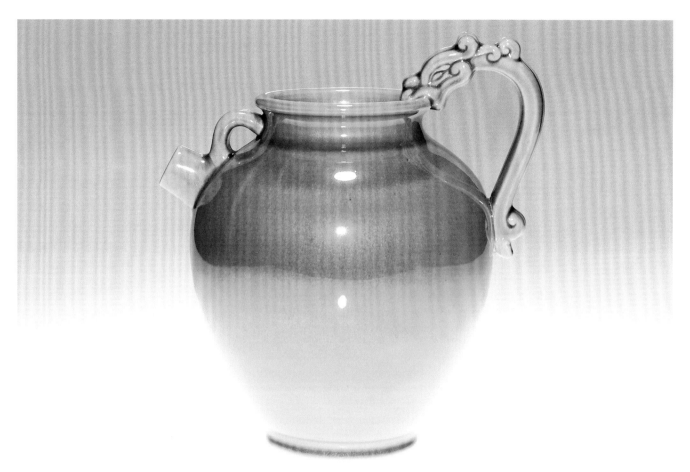

R O O K W O O D

aims at a constant freshness while maintaining the high traditions of an art as old as time. Examine our products which are carried by an exclusive representative in your locality or write direct to us.

THE ROOKWOOD POTTERY COMPANY
Monastery Place, Cincinnati, Ohio

R O O K W O O D

The Rose of Sharon and the traditions of pottery making are our heritage from a romantic past.

Rookwood has added new force to the ancient traditions by developing distinctive qualities of color, design and texture.

Our distributor in your locality may help you in your selection of a piece for the home, or as a gift. We invite direct inquiries.

THE ROOKWOOD POTTERY COMPANY
Celestial Street, Cincinnati, Ohio

Simultaneously, though, those breakneck societal changes were creating havoc. The fighting in Europe had stopped, but fear became a central facet of people's worldviews. One might interpret topics such as immigration, Prohibition, communism, or technology as ills encroaching on traditional American strengths. For these folks, progress was not desired or welcomed. In contrast, for people who looked at the new socioeconomic trends optimistically, the new age brought with it innovations in technology that had far-reaching consequences on how people lived, worked, and played.

Rookwood not only had to respond to these stimuli, but itself had already more or less split into several linked entities: the legacy art pottery studio, an architectural faience manufacturer, and a factory that produced a wide range of wares, from small vases to garden accessories, molded and then decorated, but not usually signed by a member of the decorating team.

The Jazz Age, so coined by novelist F. Scott Fitzgerald to encapsulate the gaudy spree that swept across postwar America, gave Rookwood a chance to not only solidify its place atop American art potteries, but to explore new motifs and influences. The decorators and tile designers employed a range of inspirations from the ideas percolating around them, from the geometric, precise Art Deco to the ancient patterns and styles of China and Persia. Rookwood experienced an explosion of creativity. Its artists moved beyond the long-established reliance on nature as the primary subject (a sea of flowers, plants, and landscapes) to the very ideas at the forefront of the global art scene.

Demonstrating how advanced and sensitive to changes in art writ large, often even before these ideas were crystalized—such as Art Deco—Rookwood artists had already caught the zeitgeist. They were keen on what was happening around them, studying new styles, and prided themselves on being innovative. For example, the fundamental tenets of Art Deco are evident in many of Sara Sax's pieces well before the impulse had been formally recognized in 1925.

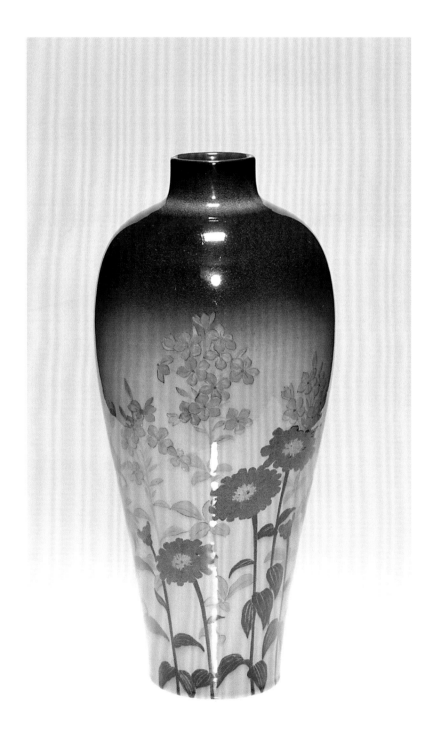

Shirayamadani's painting and mix of brilliant colors—from the detail in the flowers to the maroon interior glaze—kept his work fashionable in 1925, even as art and architecture moved toward a more mechanical, modern style.

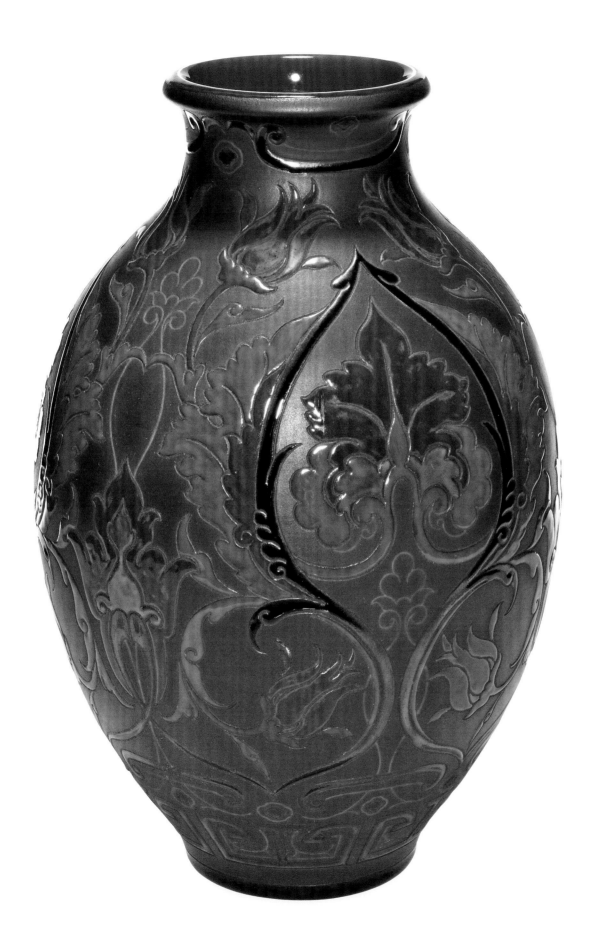

It is as if Sara Sax had a divining rod, creating a new brand of modernism by combining a unique ability to physically manipulate clay, as well as use Rookwood's most stunning French Red Glaze to create intricate artwork that screamed Roaring Twenties. More than 14 inches (36.6 cm) tall, the vase decoration is complex and mixes patterns, styles, and carvings that make this one of the most impressive pieces in Rookwood history.

Art Deco Production Pieces

RILEY HUMLER

The depth of talent among Rookwood's decorating team is nearly unfathomable. The company had a number of skilled designers and sculptors capable of working in, and excelling at, the Art Deco Style, including Arthur Conant, Louise Abel, David Seyler, Kitaro Shirayamadani, Jean Reich, and William Hentschel.

Unlike the hand-painted art pottery, the production pieces were usually much less expensive and not signed by a decorator. However, the shape had to be created and various colors employed in an attempt to appeal to consumers who wanted a piece of Rookwood, but might not be able to afford the costly signed works.

Conant is best known for his bookend designs, including replicas of Cincinnati's famous Union Terminal, Rooster, and Turkey. He also created bird and cat paperweights. Abel designed a triangular covered box detailing transportation in the early twentieth century, as well as several ceramic figures, including dancers and nudes. Seyler, while a student at the Cincinnati Art Academy, designed paperweights in the guise of sailors, radio singers, plump fairies, and at least two masks. Kitaro created several different playful paperweights in the form of mice, elephants, bunnies, fish, seals, snails, several birds, and ladybugs. Jean Reich produced only one Rookwood figural, a polychrome fisherman, proudly holding a long fish in his right hand. Hentschel produced a very exotic cat paperweight and one of the most unusual (and rare) bookends—the sleeping man—few of which have ever come on the market.

Five production pieces from the mid-1920s through early 1930s all done in Mat Glaze.

Six production vessels
from the 1920s in various
shapes and shades of blue.

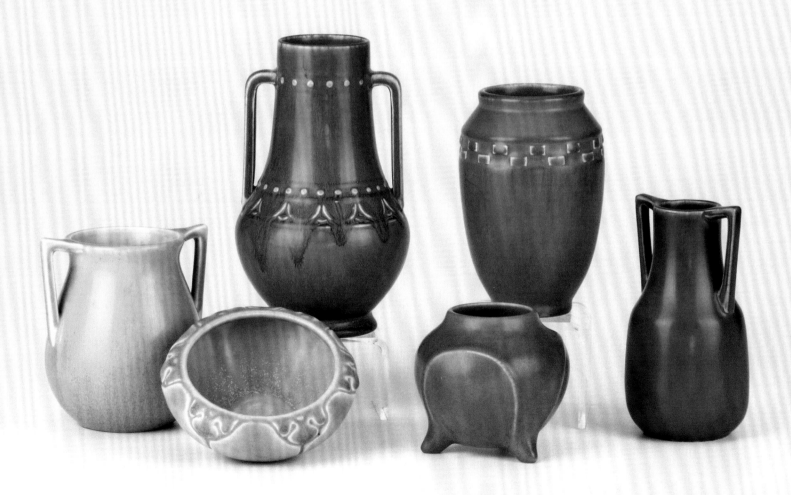

Uniting Art and Science

The marriage of technology and art powered Rookwood during the Jazz Age as it had from its earliest years. Continued expansion at the Mount Adams facility put fifteen kilns in operation as the 1920s began, while the employee roster grew to about 200. The increased production capabilities really powered the architectural division.

Throughout the decade and into the 1930s, the company fulfilled several large tile installations. The arcade in Cincinnati's new Carew Tower, an innovative city-within-a-city office complex, hotel, and marketplace, had a soaring tile mosaic, towering some two stories. A local reporter proclaimed, "The Rookwood work used in the Arcade is the most expensive piece of faience tile ever done in the world."

Glazes, in particular, benefited from four decades of research and constant experimentation. Rookwood chemists created colors across the spectrum: brilliant reds, deep blues, lush greens, and varieties of black as deep as a well or as vast as the nighttime sky. "The company was as sophisticated in its technology as any ceramic manufactory in the world," explains Kenneth R. Trapp. It is estimated that Rookwood had hundreds of glazes to draw from in creating artware in the early twentieth century.

Appraising what the company had achieved through the end of the 1920s, Trapp maintains that Rookwood "kept in stock over five hundred glazes, hundreds of decorating colors, and clays from which several different bodies could be composed." These new bursts of color were difficult to create and manufacture, which demonstrated the way the pottery's chemists built on previous work to create new, innovative processes.

This collective knowledge after forty years of experimentation, trials, and scientific study set Rookwood apart. "The artistic development which has taken place would not have been possible," said writer Arthur Van Vlissingen, Jr., "without the technical proficiency and chemical control." If a decorator or artist had a specific idea about a form, glaze, or firing technique, he or she could consult Rookwood's vast library to create the piece desired. Four decades of meticulous recordkeeping, dating back to when Taylor managed the factory, gave Rookwood a scientific edge.

Sara Sax's use of French Red Glaze is indicative of the collective knowledge Rookwood and its decorators had gained over the preceding decades. As a technical artist, Sax utilized ideas drawn from the Art Deco movement to create imaginative designs that fit perfectly with the burgeoning aesthetic.

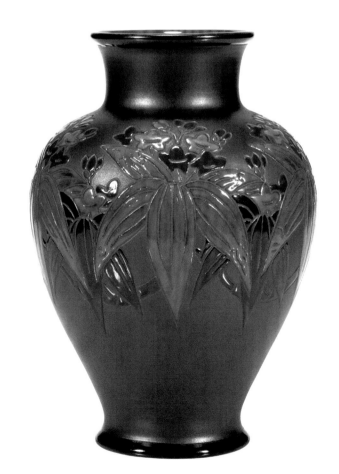

The 1923 French Red has five overlapping sprays of red and blue flowers with green and orange leaves and black stems incised and painted. The vase is first incised with the outlines of the flowers and then the colors are applied, with the carved areas keeping it in place. The interior is also lined in the rich French Red Glaze.

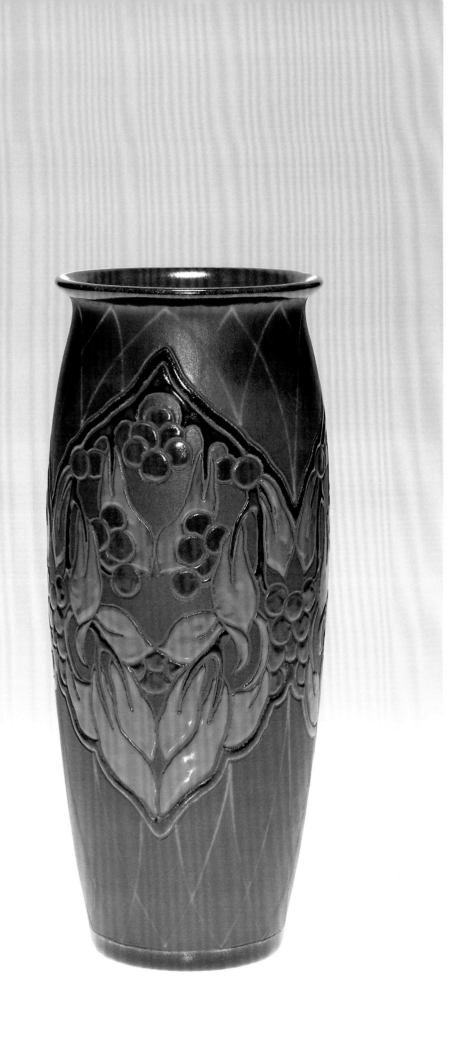

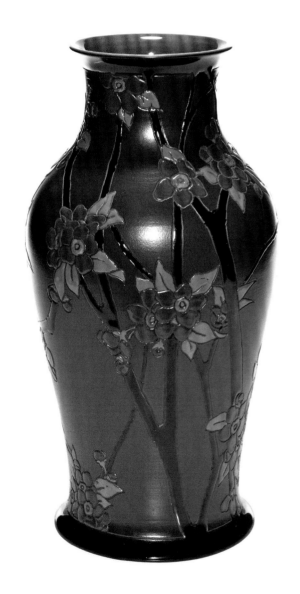

Left
Just under 8 inches (20.3 cm) tall, this Sax French Red (1921) again fuses art styles (notice the geometric background pattern) as the artist utilizes a combination of Mat and Gloss Glazes with incised outlines to highlight the stylized leaves and berries. A new take on French Red, Sax creates a new purple color and then uses orange to contrast the mix.

Right
Sax again mixes influences, drawing from Art Nouveau and Art Deco ideas in this French Red (1922). The dark green Mat finish is the perfect color to emphasize the multicolored cherry blossoms.

She also physically manipulated vases, carving them and filling spaces with patterns and shapes that intensified the artistic expression. She drew ideas from unique patterns, such as textiles and steelwork. Perhaps most impressive, the French Red wares mixed Mat and Gloss Glaze applications, a technical advance that curator Anita J. Ellis called "a remarkable design achievement." This era was the culmination of innovations in production and ceramic technology. Rookwood decorators then united these forces to create distinct and masterful art pottery.

In 1920, Rookwood achieved what many ceramic industry insiders believed impossible—re-launching the vaunted Tiger Eye Glaze line. Company chemists had run countless experiments to reconstruct the famous glaze effect, but none of the trials worked as well as management had hoped. As the Jazz Age kicked off, however, a new version of the crystalline glaze appeared in a variety of colors.

One of the benefits, in terms of cost savings, was that the "new" Tiger Eye might bypass the need for hand-painting, instead being thrown or cast and then glazed. The departure raised the importance of the glazer and hand thrower, but Rookwood's decorator-centric culture prevented these individuals from signing the wares they created.

Introducing new styles was not a negative for many Rookwood artists. As a result of the technical advances, the decorating team had multiple methods for expressing craftsmanship. Some—including Sax, Shirayamadani, and Hurley—could work across motifs, creating art that mixed forms, colors, and styles, while others continued to focus on underglaze painting. As a whole, the artists utilized glaze innovations to transform clay into works of beauty and transcendence. The technological improvements and innovations gave Rookwood's artists more options for showing the world what a great art pottery studio could produce.

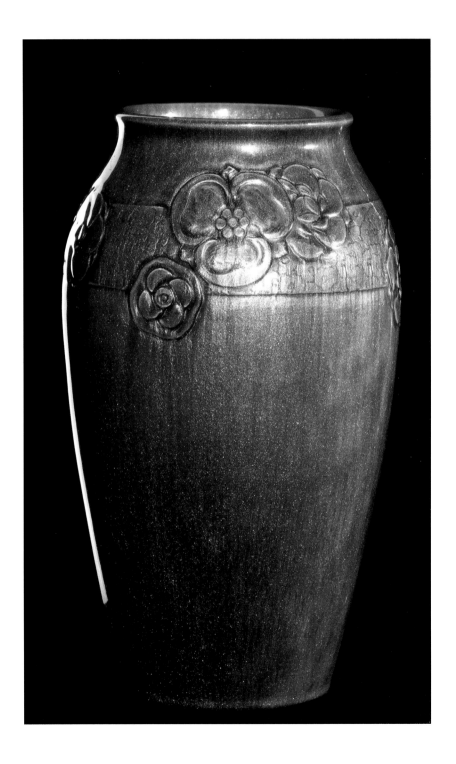

The 9½ inch (24.13 cm) Adventurine Glaze (also called "Later Tiger Eye") by Sara Sax (1922) has stylized roses around the shoulder over a ribbon of floral highlights. The interior gives way to a modish aqua blue. The true significance, however, is the Tiger Eye sparkles that burst from the vase as if lit from within.

Beauty, Commerce, and Adapting to the Roaring Twenties

Dating back to its founding, when Maria Longworth Nicolas Storer decorated in the latest Japanese-influenced styles that were all the rage in the 1880s, Rookwood's artists responded to movements in the arts, particularly when an innovative wave such as modernism swept the scene. Maria had set Rookwood up for this success by creating a company culture that emphasized originality and artisanship across design, form, and color. Maria had experimented with the budding science around ceramics, as well as painted objects that were influenced by the impulses she saw around her.

Forty years later, at the dawn of a new era, the Machine Age took on new meaning for artists around the world, particularly in France, which often led the way as innovative ideas jumped from artist to artist. At the height of the Jazz Age, the 1925 Paris Exposition showcased a new modern style, highlighted by geometric forms and provocative technology-influenced artwork. This new movement has broadly been labeled "Art Deco," a style within the larger wave of modernism.

Rookwood's creative team was not only susceptible to new artistic movements, but also progressed with the times, quickly interpreting how to apply these concepts to clay. "Rookwood evolved a spirited modernism manifest in unique glazes and decorative treatments, brilliant colors, and more expressionistic interpretation of decorative subjects," noted art scholar Kenneth Trapp.

From architecture to hairstyles and automobiles, the Roaring Twenties were marked by a growing demand for exciting products that eager buyers would lap up almost instantly. For Rookwood, the changing style meant that sharp-looking, shiny glazes were back in fashion. According to art historian Ellis: "Commercial wares thrived during this period with high gloss lines such as Celadon, Chinese Turquoise/Turquoise, Ming Yellow, Catawba, Colonial Buff/Buff and Pomegranate."

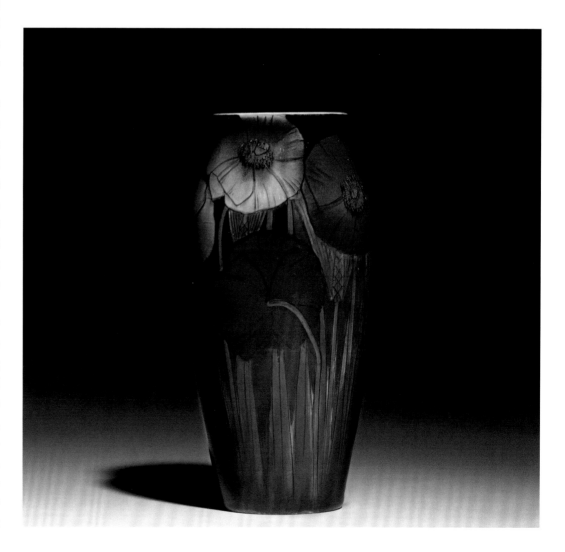

A 10½ inch (26.7 cm) tall Flambé/Black Opal porcelain vase painted by Shirayamadani (1929) demonstrates the intricacies of 1920s glaze artistry.

The company was known for shifting with the times, sending its skilled decorators overseas to study with European masters and adapting new styles to its tile manufacturing output. Many of Rookwood's most accomplished employees were noted artists across other disciplines. William Hentschel, for example, not only demonstrated Art Deco influence in his oil paintings on canvas, but in creating textile installations at area galleries.

At times the fluctuating art movements would create some discomfort for Rookwood executives. They had the arduous task of attempting to reconcile the artistic interpretations of their in-house decorators with the particular shapes, styles, and colors they believed would sell to the general public—often a more conservative audience, and not necessarily in step with the latest, cutting-edge Parisian styles. The bottom line demanded that Rookwood tend to its commercial side. Its life as a company depended on mass-producing thousands of products that were beautiful, functional, and also affordable.

Sometimes the commitment to a style that seemed outdated simply played to a decorator's strength and the artist stayed in that area. Although Rookwood had an inordinate number of creatives who could work across styles, disciplines, and mediums, not everyone had the ability of Sax, Hentschel, Kitaro, or Hurley.

While art pottery kept Rookwood in the headlines, the architectural division continued to grow. As the Jazz Age roared to life, observers could see influences of the Art Deco movement on Rookwood's household goods, as well as its architectural faience and garden pottery.

The architectural division faced many of the same dilemmas that the decorating team tackled, particularly how to meet changing tastes and react to new ideas. In the early 1920s, many faience projects harkened back to earlier times and eras before the Great War. For example, the Mills Restaurant in Cincinnati opened on August 18, 1921, with a goal of becoming the Queen City's top restaurant, one that would stand above all others east of New York City. On opening day, J. O. Mills—in a flashy show of the era's blossoming opulence—unlocked the door in front of a throng of newspaper reporters and a large crowd, giving the solid gold key to his wife, "to remain permanently in her possession."

The owners had the entire main dining room decorated in Rookwood tile. Including the other spaces that used faience, the installation totaled some 40,000 pieces. The project featured Dutch blue, striking panels of birds and fruit, and quaint scenes of Holland, utilizing the Mills's trademark windmill as a prop in one landscape. At the center of the room stood a Rookwood fountain, while the entrance featured an ornate Rookwood ceramic clock. Even the ventilation grills were covered in tile.

The idea of the Roaring Twenties centered on fantastical parties at Gatsbyesque mansions rolling in blaring jazz and rivers of booze. Much of this idea came directly from Fitzgerald, who lived a decadent, headline-grabbing, liquor-infused lifestyle in the 1920s with his flapper wife Zelda. The novelist rendered the era beautifully in his 1925 novel *The Great Gatsby*. Rookwood had a direct connection to the Jazz Age, as many residential installations were launched at the request of wealthy elites who wanted to accentuate their mansions with Rookwood faience.

Julius Fleischmann Jr., the heir to the Fleischmann flour and distilling fortune, began building an estate in the posh Indian Hill suburb of Cincinnati in 1924 before his father's unexpected death from a heart attack in February 1925 while playing polo in Miami. The older man had been mayor of the Queen City from 1900 to 1905 and was famous for philanthropy and participating in sporting events—almost a perfect model for Jay Gatsby's nemesis Tom Buchanan.

The younger Fleischmann's 2.5-square-mile (6.5 sq km) property, which he called "Winding Creek Farm," showcased a Norman-style mansion. The house featured an indoor Rookwood-lined pool and many of the architectural department's nautical sculptures. Fleischmann was an enthusiastic foxhunter, building Winding Creek toward that end. Also an art lover, he could not resist using Rookwood throughout the home, particularly its nine bathrooms, which had colored Rookwood tile, making the home one of the first in the nation to use colored tile in a private residence.

R O O K W O O D
POTTERY AND TILES

During all the ages, tiles have been used by every people and today, their judicious use is equally suitable for the small house or the palace.

THE ROOKWOOD POTTERY COMPANY
Celestial Street, Cincinnati, Ohio

R O O K W O O D

Columbus Caravel Plaque modeled in five inch relief and having an approximate diameter of 26 inches. It is suitable for an insert over the mantel or in other places, and can be had in colored glazes to meet special requirements.

THE ROOKWOOD POTTERY COMPANY
Rookwood Place, Cincinnati, Ohio

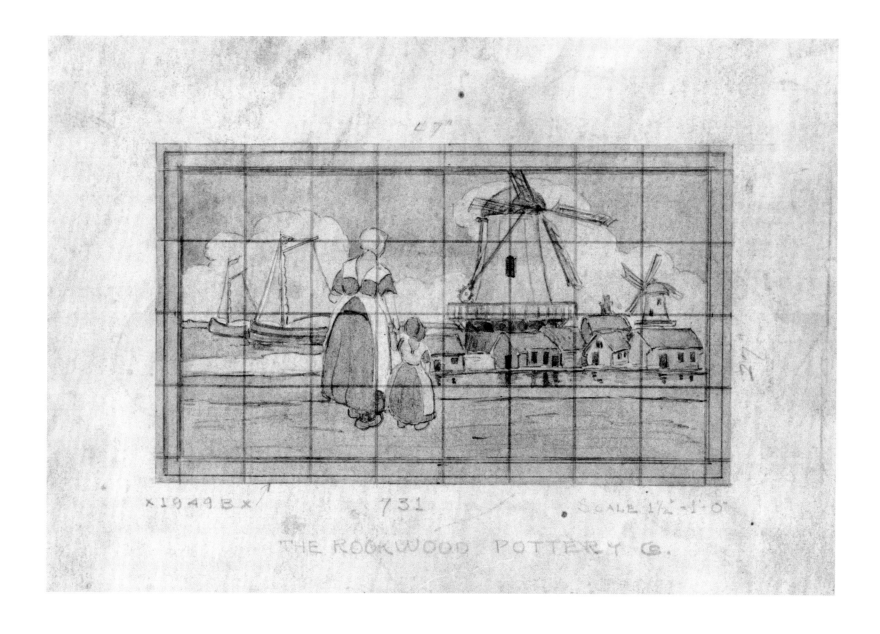

Opposite left to right
Rookwood touts tile in this
1923 ad: ". . . suitable
for the small house or the
palace."

One of Rookwood's most
intricate and detailed faience
works, the Columbus Caravel
Plaque harkened back to
earlier styles, despite the
modernism of the 1920s.

Above
An original architectural de-
partment draft for a Dutch
faience layout.

The entire project took an estimated three to four years to complete. A local newspaper called the property, with acres of gardens, thoroughbred stables, kennels, and water features, "one of the show places of Southern Ohio."

Although Rookwood put significant resources into the tile department, including factory expansion, staff additions, and marketing campaigns, it is impossible to determine the division's conclusive financial picture because documentation from that era no longer exists. The lack of a paper trail has led to mixed ideas about the tile division. Some observers argued that the architectural department had gone from breaking even to actually being quite profitable. Others disagree. Herbert Peck, for example, declares, "The contribution to net profit was negligible even in the best years, as a result of the much narrower profit margins on the architectural products."

A counterargument can be made, however, that although tile most likely was not the financial windfall that Taylor and the board of directors anticipated, there were associated benefits that should be factored into its overall significance.

The architectural division, from the early 1900s through the early 1930s, for example, helped Rookwood market and promote the company as a premiere pottery manufacturer. The list of luxury hotels that had Rookwood installations stretched nationwide, from the Oregon Hotel to the Vanderbilt Hotel in New York City. The fact that so many of these establishments were the finest, most prestigious hotels in a metropolitan area meant that business leaders and elite families would associate Rookwood with refinement.

The Mills Restaurant serves as a case study in attempting to piece together how one might think about Rookwood's architectural division. The architects boasted that 40,000 pieces of Rookwood tile were used in the installation. If only at $2 per tile (a conservative underestimate), that $80,000 would have been $30,000 more than the entire net profit for 1922. Without documentation, it is nearly impossible to calculate how much it cost Rookwood to manufacture those 40,000 tiles or establish a verifiable return on investment, just as it is impossible to assess the marketing gain from being in America's grand palace hotels.

While the massive Rookwood public installations are important in understanding the pottery from a financial and reputational perspective, the magnitude of the private residential work has never been compiled. Like the Fleischmann Winding Creek Farm mansion, many spectacular examples of Rookwood's influence on home architecture and interior design have faded from the public view. A Rookwood fireplace, mantel, or bathroom had the same kind of clear-cut impact on building awareness from a marketing perspective. The prestige factor remained high, with realtors listing Rookwood features when selling and reselling homes. Putting a dollar figure on this effort, however, is not practical.

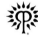

Contemporary minds see the Roaring Twenties as one long party fueled by booze made illicit because of Prohibition. However, this basic conception is riddled with holes. The transition from war to a peacetime economy led to challenges for many businesses, creating an indifferent market in 1920 and 1921. A return

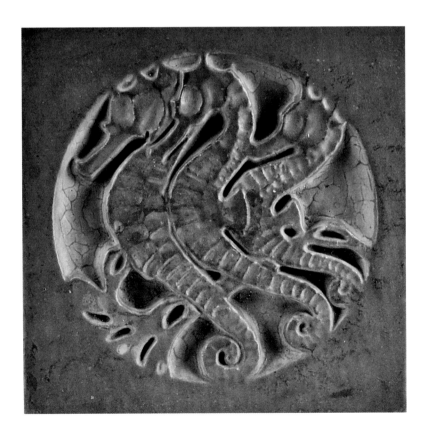

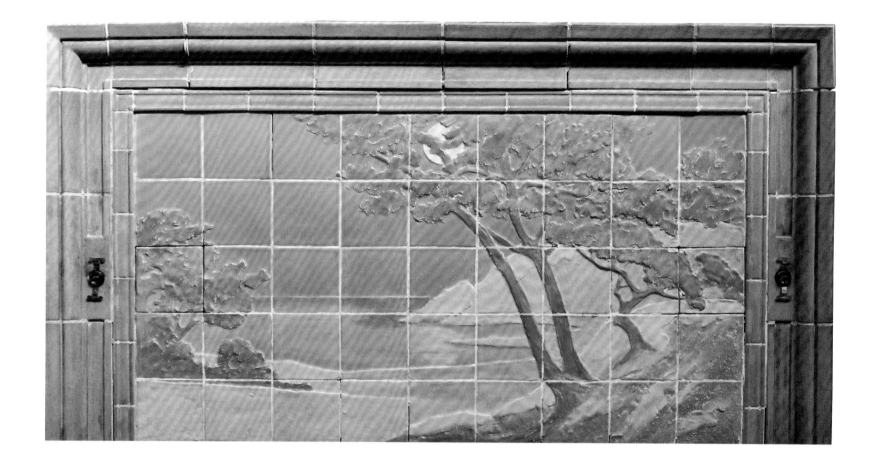

to a peacetime system gradually improved the economy. By the fiscal year that ended in January 1923, Rookwood posted a record profit topping $52,000 (the equivalent of $12.4 million today).

Just when Rookwood seemed to be becoming a juggernaut, a dispute with the government over how the company dealt with its retail consignments led to a hefty tax bill of $25,000. The old scheme for selling Rookwood, essentially loaning pieces to retailers until they sold, had bedeviled William Watts Taylor while he ran the company. Now, under Gest's leadership, the ax would fall. Company officials estimated, according to Peck, "the pottery now had an inventory of unsold merchandise valued at nearly $250,000 distributed among approximately 150 'agents' throughout the country."

In 1923, the net gross profit was $42,200, an ominous drop considering the large fine. The following year, Rookwood's accountants recommended the company file a loss of $19,900.

Rookwood fought the fine for years. Gest and Burt went to Washington, DC, many times to argue against the ruling, but the courts ultimately denied the company's appeal in 1928. Rookwood owed income taxes amounting to about $20,000, forcing the board of directors to raise $15,000 of their own funds to cover the necessary bond.

The timing could not have been much worse. The loan by the trustees drained company coffers that might have helped it stave off the economic chaos brought on by the Wall Street crash in October 1929.

Pictured above is a massive surviving faience installation consisting of forty-five center tiles depicts a sweeping seaside landscape with towering mountains and large trees in Mat Glaze. Three sets of brown border tiles frame the piece, making this an epic example of Rookwood's architectural prowess.

Opposite
A rare 8 inch (20.3 cm) faience piece is embossed with a medallion of seahorses in brown and green on a turquoise and green ground. Many Jazz Age homes were filled with Rookwood's aquatic and seascape tiles.

Rookwood's Jazz Artist: William Hentschel

William Hentschel "produced work which was a real inspiration," according to Delia Workum, who joined Rookwood in 1927. A wizard with Mat Glaze, he demonstrated how an artist could apply Art Deco influences to ceramics. Hentschel worked for Rookwood from 1913 to 1932 and taught at the Cincinnati Art Academy from 1921 to 1957.

For Art Deco inspiration, Hentschel—called Billy by his friends—looked to his first wife, ballerina Halina Feodorova, a Russian dancer who opened a ballet studio in Cincinnati to train young people in her native style. Feodorova became a prominent instructor, placing students in major New York productions, like the famed *Ziegfield Follies*. Ballet's sleek lines and movements seemed replicated in Hentschel's designs.

Although best known for his vases, Hentschel also designed architectural projects. The largest were the towering ceramic arches in Cincinnati's Carew Tower, an innovative "city within a city" complex completed in 1931. The design is of repeating bouquets of thick flowers that soar some two-stories high in rich greens, reds, yellows, and whites.

Hentschel also designed the famous Rookwood Tea Room at the Cincinnati Union Terminal, a $41 million stately train station, one of the last of its kind built in the United States. An homage to Art Deco influences, the 1933 building soared from the railways in one of the largest half domes ever created in that era. Hentschel's design for the Tea Room featured mint green, mauve, and gray colors with dragonflies and flowers throughout.

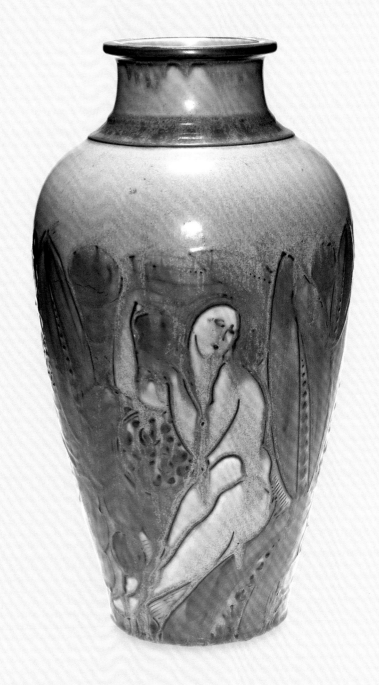

This Hentschel masterpiece features a trio of female nudes among the flowers, perhaps washing their hair in the flowing stream. Created in 1927, the 16⅝-inch (42.2 cm) vase was decorated using a squeeze bag, which enabled the blue and browns to cascade and blend.

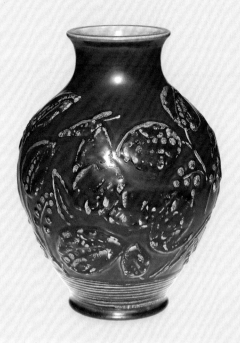

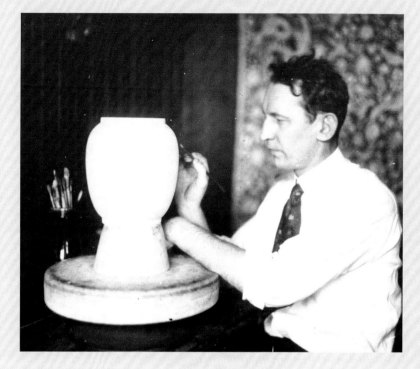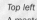

Top left
A master of colors and Art Deco forms, Hentschel created this Wax Mat vase in 1929. The deep crystalline blue and heavy slip decoration bring out hints of white and orange, which highlight the leaping gazelles in fields of leaves and berries.

Top right
Hentschel, Rookwood's jazz impresario and Art Deco specialist, worked at the pottery from 1913 to 1932.

Bottom left
In 1929, at the apex of the Art Deco movement, Hentschel created this 14 inch (35.6 cm) Wax Mat vase featuring a large deer running briskly through a floral field. The animals and the plants blend together, the deer's spots matching the blooms, while the circular bottom evokes images of sunlight and life-giving essence.

Bottom right
A highly stylized, large Faience Garden Urn (25½ inches [64.8 cm]-tall) was crafted by Hentschel in the late 1920s. The oversized vessel features images of baby Jesus and Mary. Hentschel's distinctive style is accentuated by heavy carving, which gives the urn depth, and is glazed in a stunning array of blues, greens, and golds that bring the piece to life.

7 The Weight of the Great Depression's Crushing Blow

Pictured is a glaze effect vase (1932) with striated brown High Gloss Glaze dripped artistically over a purple Mat Glaze.

The Great Depression transformed consumer culture across the globe. American stalwarts, such as Tiffany glass and Rookwood pottery, were viewed as luxuries by families struggling to make ends meet on a daily basis. As a luxury brand, Rookwood stock fell as dramatically as Wall Street's, despite the quality of the pottery and tile produced during the long era of economic collapse.

On October 30, 1929, Baltimore retail company Hutzler Brothers, which had invented fixed-price shopping sixty years earlier, ran an advertisement in the *Evening Sun*. Obviously the retailer placed the ad before the stock market crash the day before had brought a sudden, explosive panic to Wall Street and the world.

On that fateful next day, when America awoke to an economic collapse that would mire the nation for more than a decade, the Hutzler Brothers' ad promoted Rookwood, comparing its "Master craftsmen" with "those old artists and artisans of the Dresden and Milanese kilns." Each piece was dubbed "an individual work of art." Consumers could choose from a variety of wares, ranging from $1.50 to $65.

Suddenly—literally overnight—given the uncertainty of what had taken place on Wall Street, scared consumers had to make every penny had to count. The $1.50 for a Rookwood production piece (equivalent to $22 to $45 today) might feed a family of four. Moreover, $65 ($954 to $1,950) is more than most families paid in a typical month's rent or mortgage. Most of the households that could, up to that time, afford Rookwood products hastily reassessed, worrying instead about meeting basic day-to-day needs. Companies such as Hutzler Brothers, Rookwood, and other manufacturers and retailers across the nation were forced to limp along at the whim of consumers who had watched their discretionary income vanish.

For Rookwood's management team, with Joseph H. Gest, John D. Wareham, and Stanley Burt at the top, flagging sales compounded the looming crisis. In addition, infrastructure costs and repairs had forced the company to invest heavily (and take on increased debt) to stay afloat. The heady days of the Roaring Twenties had come to an abrupt halt. The stock market collapse created a new economic reality.

The crash could not have come at a worse time for Rookwood. Like many companies shocked by the collapse, the pottery had little cash on hand. In its attempt to recover from the federal government's $20,000 income tax penalty, Rookwood's trustees put up $15,000 of their own money as collateral for the bond that would pay off the fine. At the same time, holiday sales slumped as panic-stricken consumers lost confidence in the economy. On top of those challenges, Rookwood had the constant need for new equipment, purchasing raw materials, and keeping up with maintenance costs.

In flush times, Rookwood might have been able to weather the downturn more effectively. Just as consumers turned away from luxury goods, most of its assets consisted of $250,000 in merchandise scattered in retail operations across the country. These issues came to a head when Wall Street tanked, causing a perfect storm that left the pottery on its sickbed.

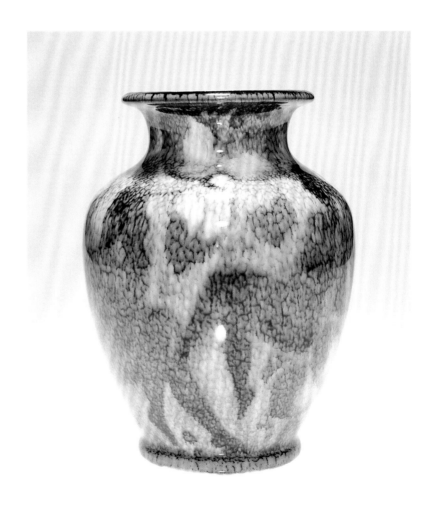

Oppposite top
Four production vessels designed to appeal to middle-class consumers. From left: teal bud vase (1934), double-handled cabinet vase with geometric decoration (1930), bulbous vase with fish design (1937), and rose vase with full-length scrolls (1927).

Opposite bottom
An example of Depression-era high art, this is a 1933 Jens Jensen Porcelain vase with three languid blue nudes almost floating among gigantic maroon and cream-colored flowers. The neck and upper rim are done in Rookwood's 50th Anniversary Glaze, which grows slightly iridescent farther down.

Above
A masterful Scenic Vellum plaque by Ed Diers (1929) displays an early morning view of Venice with buildings, boats, and people under a redolent, cloudy blue sky. The large structure beyond the sand bar, surrounded by boats, is a religious shrine maintained and frequented by those who make their livings at sea.

Glaze in the 1930s

GEORGE HIBBEN

Continually evolving through experimentation, Rookwood achieved new glaze looks in the 1930s. Despite the gloomy economic picture—in America, and deeply felt at Rookwood—colors were becoming more vibrant. An example of the change is at Cincinnati's Carew Tower, where William Hentschel created a massive architectural tile installation of flowers in tight bunches using exquisite, glossy colors. Even though the times were difficult, the subdued earth tones of the Mat Glazes were fading away.

Earth tones yielded to Wax Mat and Butterfat Glazes that seemed to curdle and run, giving interesting abstract effects to hand-painted art on vases. Reflecting a mid-century modern shift in style, these glazes were artfully utilized by such artists as Jens Jensen in his typical abstract style.

With colors popping, turquoise, deep blues, greens, and yellows could all be found on Rookwood forms, often with a complementary interior color to a vase or bowl. The two-toned effect was popular among consumers (then and now), but did little to help Rookwood emerge from its financial death spiral.

A new formulation of the famous Tiger Eye Glaze also appeared, often called Later Tiger Eye, and then Coromandel. A similar version in green was called Empire Green (nicknamed "Aventurine"). This glaze line has been again reinvented today as Rookwood's Nebula Glaze. Common to all these glazes are glistening microcrystals, which sparkle in strong lighting.

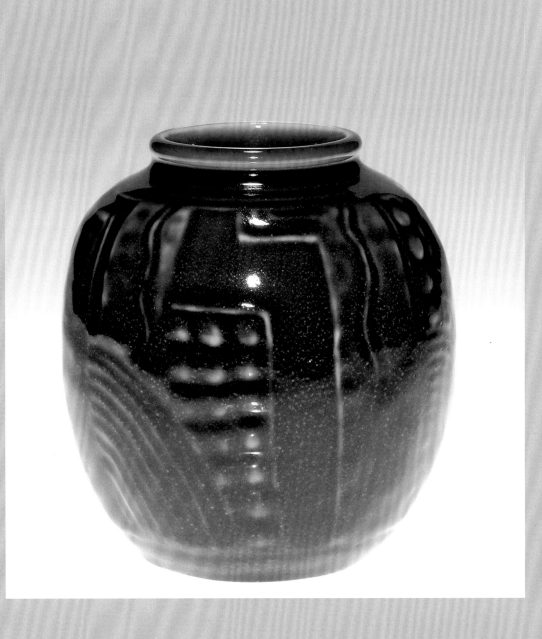

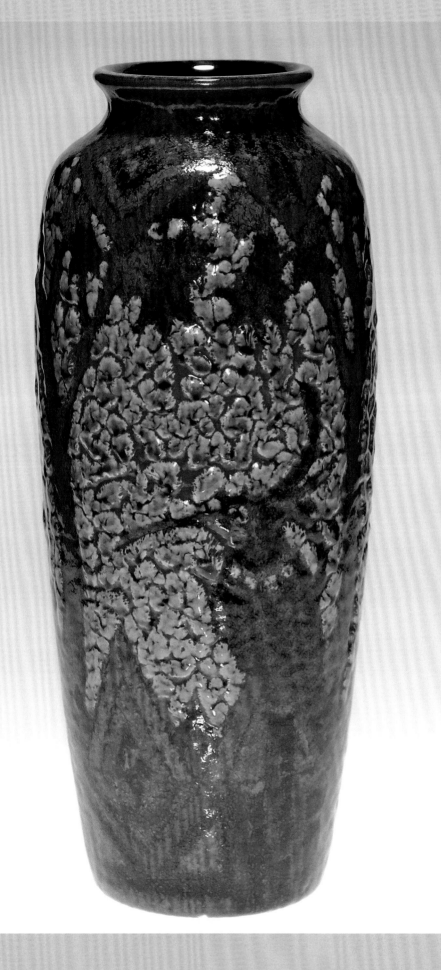

Elegance Amid Uncertainty

The pressures mounted from the start. Rookwood's 1929 holiday sales, which had in previous years accounted for about 35 percent of its total annual revenue, abruptly dropped. Sales for 1929 sank to $268,000 (about $55 million today, based on total economic share measured over time), down nearly 15 percent from $313,000 the previous year.

The bad news was not about to let up, as a matter of fact, getting worse as the reality of the initial stock market crash reverberated across the nation and around the globe. Rookwood suffered substantial sales losses and an almost complete halt of its architectural faience business. The 1929 and 1930 losses were offset by bank loans in January and September 1930 totaling about $75,000. Financing such a large credit line was an act of desperation on management's part, but essential in keeping some kind of hope alive. Rookwood, like other small businesses, listened to President Herbert Hoover and national leaders who implied that a solution was in the offing.

The company faced a quagmire of loan repayments and sagging revenues. Gest did what he could, but he was primarily an artist with a creative mentality, not a hard-hearted business-man. His first step was logical. Gest authorized an urgent sales effort, abandoning the pottery's longstanding decree regarding each city or region having just a single retailer. Instead, Rookwood quickly signed on new stores in an attempt to breathe life back into the market. Gest hoped that a fresh batch of retailers might develop innovative marketing campaigns to generate revenue, which in turn could be ploughed back into operations.

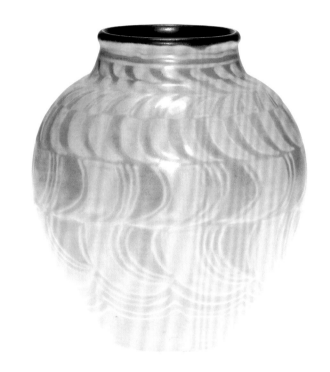

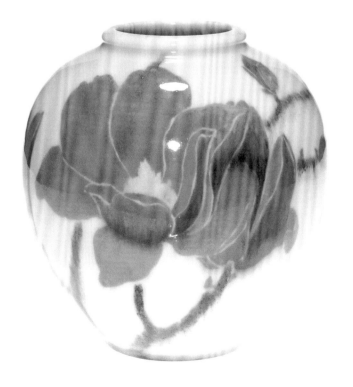

Above
A 6 inch (15.2 cm) Mat Glaze piece by Wilhelmine "Willie" Rehm (1931) incised and painted in Art Deco style. The meticulous decoration led to an impressive vase that captured the essence of popular art.

Below
Harriet Wilcox decorated this porcelain vase in 1930 with pink and purple magnolias against a cream background.

Wilhelmine Rehm, shown in her studio surrounded by flower illustrations, skillfully adds depth by chiseling the vase. She worked at Rookwood from 1927 to 1935 and then from 1943 to 1948.

On a snowy Thanksgiving Day in 1930, Rookwood celebrated its 50th anniversary by inviting a small group of stockholders and guests to the factory to see a special kiln drawn. About 100 visitors showed up, with Gest and Wareham acting as featured speakers. The party's honored guest was former decorator Clara Chipman Newton, Maria Longworth Nichols Storer's close friend and colleague who had so ably helped the founder run the company in its early days.

Pieces from the kiln were marked with a special anniversary logo and Newton received first choice on a piece from that collection. Guests also visited the Rookwood showroom museum, the company's internal collection of its most prized wares. What had been a gloomy day to celebrate a momentous date at least had a small silver lining. About two months later, Wareham reported that most of the remaining items from the anniversary kiln had been purchased.

Even the embattled Hoover joined in on the celebration. The Cincinnati Chamber of Commerce had sent a piece of the collection to the president and his wife as a gimmick to demonstrate the value of airplane delivery service. A "newsreel movie film" publicizing the event, according to historian Herbert Peck, was shown all over the country.

If only Rookwood could have stamped a couple thousand more pieces with the 50th anniversary kiln logo . . . Yet nothing could actually stave off the loss of revenue and mounting loan repayment fees. In 1931, sales further dipped to $196,000, which led to a net loss of $47,000. Rookwood's relentless demand for raw materials, chemicals, and the resources needed to run a manufacturing plant kept expenses high.

The board of trustees scrambled to keep the pottery afloat, taking on additional loans (totaling more than $83,000), and then attempted to raise money by selling another 1,200 shares of common stock. None of these measures made much of a difference. The loan balances piled up with no concurrent sales on the horizon. Gest and Wareham were unwilling or unable to face the new economic reality, holding out hope that something would turn the situation around.

Additional credit options dried up. With no further financing available, the board decided in October to briefly shut the company down "as long as necessary to balance the budget." Within days, management—desperate to find a counter solution—slashed art pottery prices another 30 percent across the board. It also upped the commission retailers would earn in hopes of driving demand.

ROOKWOOD
America's Contribution to the Fine Arts
FOUNDED IN 1880

ITS HISTORY
AND ITS AIMS

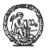

THE WORLD'S EXCLUSIVE
PRODUCERS OF JEWEL PORCELAIN

ROOKWOOD POTTERY
CINCINNATI

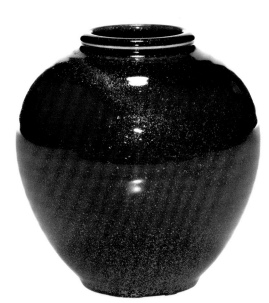

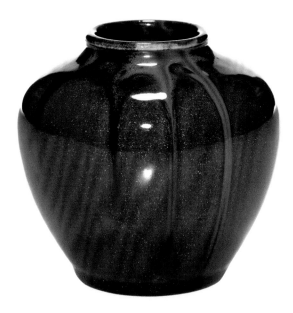

Above
A Rookwood catalog from the era emphasizing status and exclusivity in an attempt to encourage sales by elevating the brand.

Bottom left
A 1930 production vase, about 4 inches (10.1 cm) tall, features the Coromandel Glaze, clearly an Art Deco–inspired piece loaded with copper crystals, and from the 50th Anniversary kiln.

Bottom right
Gest and Wareham hoped creating less expensive production vases would help spur sales. This 1932 piece has an interesting glaze effect with bluish gray color dripped over Coromandel Glaze that highlights its deep gold crystals.

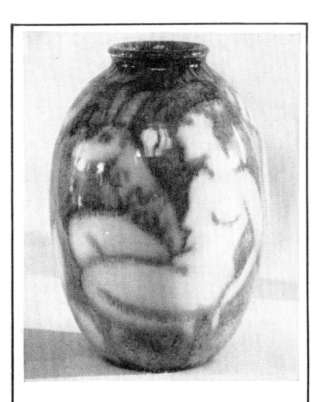

ROOKWOOD

Rookwood, always producing vitally new things, is suitable when you are considering beauty for your own home or choice gifts for your friends. Rookwood's range in design and prices is from conservative to ultra.

Rookwood may be found at the following stores: *Tiffany and Co., Jewelers, New York City; B. Altman and Co., New York City; Frederick Loeser and Co., Inc., Brooklyn; Marshall Field and Co., Chicago; Strawbridge and Clothier, Philadelphia; Schervee Studios, Inc., Boston; L. B. King and Co., Detroit; Brock and Co., Los Angeles; Dulin and Martin, Washington, D. C.; Frederick and Nelson, Seattle. A store of similar quality represents the pottery exclusively in your city. We invite your direct inquiry.*

ROOKWOOD POTTERY
CINCINNATI

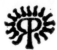

All Rookwood Bears This Imprint

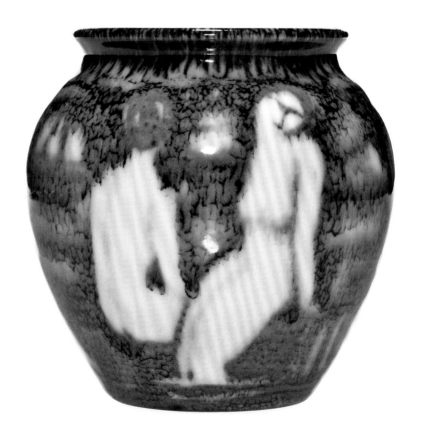

While Gest, Wareham, and the trustees battled to stave off bankruptcy, bad news came in from France. On April 30, 1932, amid the growing Depression back home, Maria Longworth Nichols Storer died at her daughter's home in Paris at eighty-three years old. Given the problems at Rookwood, the halcyon days of the 1880s seemed far away. The Rookwood founder had few ties to the Queen City. When in Cincinnati, Maria and Bellamy (who had passed away a decade earlier) had lived in an elegant "apartment" at the St. Ursula Convent and Academy, but she had basically been out of the country since World War I had ended.

Maria's obituaries noted Bellamy Storer's longtime diplomatic service, including four years as ambassador to Austria-Hungary in the Theodore Roosevelt administration. The papers also reported on the falling out that occurred between the Storers and the former president over her support of Catholic policies and subsequent diplomatic entanglements. In Maria's final years, according to her daughter Min, her thoughts centered on the Queen City. "She lives a lot in Cincinnati, even though she is always in her Paris, France, apartment," the young woman explained. "She lives scenes of her girlhood over and over, talks of her father and mother . . . old time, old art, and old music are the best."

Back on the hill in Mount Adams, economic collapse kept Gest and the board from carrying more than a skeleton staff, basically glaze engineer Harold Bopp, head potter Reuben Earl Menzel, and kiln manager John Reichardt, who worked three days a week. Remarkably, given the skill of the remaining employees, they were still able to make some exceptional pottery. When members of the American Ceramic Society visited Rookwood in early 1934, art critic Mary L. Alexander wrote, "Nowhere during the present era have the artistic possibilities that lie within materials been set forth with more taste and feeling for that material than at Rookwood."

Decorators were paid intermittently, only when work orders came in. Most were forced to find outside employment or left the company altogether. According to company lore, Kitaro Shirayamadani—well past retirement age—continued to report to his studio each day with little more than hope on his side.

Management was not shielded from the cuts. Salaries dropped as the forecast remained gloomy. In 1933, John Wareham went from $8,500 annually to $5,667, but actually was only paid $1,465 of that lesser amount. Hats in hand, Gest and Wareham continued their efforts to save the pottery. They obtained some short-term loans from prominent local Cincinnati business leaders to keep Rookwood operating at the bare minimum, but they had no real plan to emerge from the economic spiral. The crippling economy baffled business leaders nationwide; Rookwood's team had no answer.

In 1933, sales dropped to $64,000—one-fifth the revenues prior to the Depression—but losses continued to accelerate, reaching about $50,000. Gest, no longer able to cope with the mounting pressure, resigned in July 1934. Although he would no longer head Rookwood, Gest had a significant financial stake in the company. As such, the trustees designated him with a new "chairman" title.

Wareham, then sixty-three years old, was the only logical successor, capping a forty-one-year career at Rookwood. Sadly, the moment centered on an act of desperation, rather than as a crowning achievement for a man who had devoted his career to Cincinnati and its arts community. Wareham had begun his career in the waning days of the nineteenth century and had become one of the art pottery world's most heralded decorators. In any other era, his rise to the presidency would have been wildly celebrated. During the economic chaos, there was little left of Rookwood to run. Unfortunately, his skills as an artist, creating new vessels, glaze mixes, and clays could provide no relief. There were simply no faience orders and so few sales.

Instead, Wareham faced a dire situation. According to Herbert Peck: "He inherited a sick business . . . his two major problems were

The Rookwood showroom
on Mount Adams (circa 1930).

the management of an unmanageable debt and the securing of new executive talent—without the money to pay for either." The debts at Rookwood continued compounding, reaching about $135,000 by 1935.

The community recognized Rookwood's plight, and gracefully lauded its leaders. Two days after Wareham became president, the *Cincinnati Enquirer* published an editorial praising both him and Gest, the latter for upholding the "highest traditions of art for the sake of art." Rookwood, according to the newspaper, presents "one of the tangible evidences that Cincinnati has an artistic and cultural as well as an industrial side." Both men were artists with "high ideals" thus, it continued, "Cincinnati is fortunate to have two such men . . . where art and beauty are the only things which count."

Wareham, not willing to see the pottery fail after giving his entire adult life to Rookwood, battled to find a way out of the crisis, but the economic chaos had swamped men with much deeper business experience, leaving the pottery

perishing. One Rookwood executive told Peck "the pottery operated an average of one week a month during the five years from 1932 through 1936, and then only at a fraction of capacity." Several of the greatest artists in art pottery history were basically reduced to sitting on their hands. "Shirayamadani, Hentschel, and Hurley decorated a few vases," Peck said, "but were not regularly paid."

In 1936, unable to stop the hemorrhaging, Rookwood's board of directors secretly searched for a buyer without Wareham's knowledge, thinking that the news would break the man's spirit. Several inquiries were made, including an overture to the famous Corning Glass Works, but nothing materialized. Rookwood was too costly a venture, particularly in such uneasy times. The board also looked for someone to manage the pottery financially. One candidate reported that Tiffany had "50 pieces but they are mostly vases and do not sell very well," while Davis Collamore agents claimed "Rookwood did not keep abreast of changes."

Above
Portrait of John Dee Wareham.

Right
Despite the economic catastrophe, Shirayamadani and other artists created attractive works. This 9¾ inch (24.8 cm) vase (1936) is encircled with finely detailed cactus flowers that seem to blur into a desert dreamscape. Unfortunately, no records survive that provide a glimpse into the lives of the decorators during the Depression.

Opposite
Another attempt at marketing the famous Rookwood name, this rare "Potter at the Wheel" paperweight (1935) utilized Coromandel Glaze and was aimed at factory visitors, who still viewed the pottery as a main tourist destination.

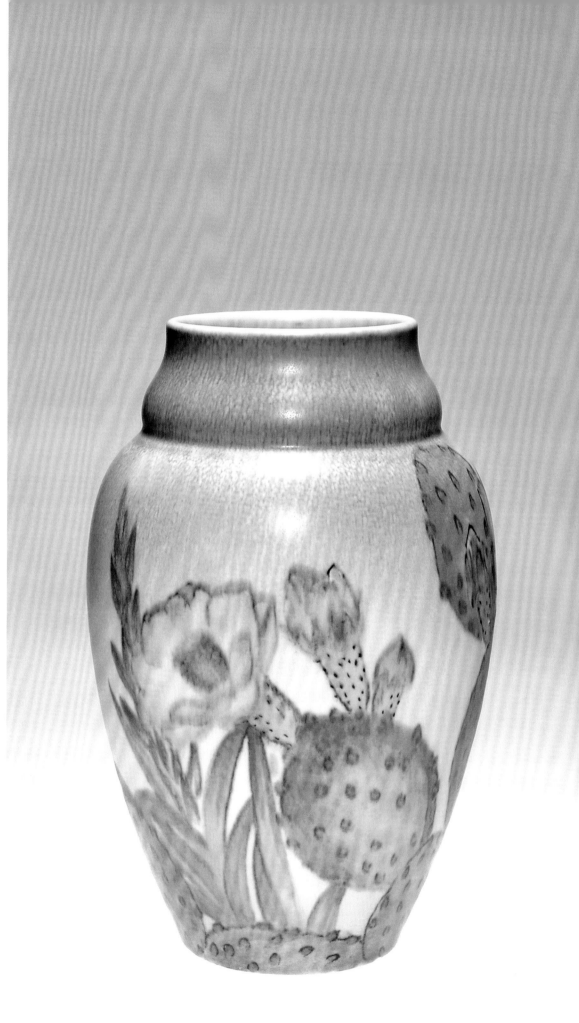

Rookwood's Picasso: Jens Jensen

RILEY HUMLER

Jens Jensen has always been one of my favorite Rookwood artists because of his style. There are two qualities that show up in his work. First, Jensen displays an incredibly modern treatment of flowers, animals, and women. Second, born in Denmark, he holds a Scandinavian penchant for overdecoration. Jensen's vases are usually quite bold and typically decorated from top to bottom and side to side.

Jensen's work is bold, colorful, and daring. My favorites have always been his female nudes, which tend to be Rubenesque. Large and robust female figures were his specialty.

During the early 1930s, when little else was happening at Rookwood, Jensen produced some of his best work. He also possessed amazing technical production skills that, combined with his decorating, made for wonderful and enchanting pottery. Jensen's bizarre animals are second only to his human figures, and although often not enthusiastically lauded by collectors, his floral pieces are simple and elegant.

Jensen felt he was never given full credit for his abilities. He mentioned to me that his friend (and through-the-mail chess opponent), Nobel Prize–winning playwright and author George Bernard Shaw considered him to be the "Picasso of America." However, Jensen's flirtation with modern design at Rookwood did not put money in his pocket, nor give him recognition among his peers.

It was only in the 1970s, when Jerry and Josie Amspaugh, a young Cincinnati couple, went to visit Jens and Betty that Jensen's full range of work became clear. They discovered that he had been painting for years and had produced dozens of wonderful paintings in his modern style. The Amspaughs arranged for a show of Jensen's work at Frame House Gallery in Louisville, which helped him both financially and spiritually. Jensen had another subsequent show in the Detroit area and posthumous shows in Cincinnati at Closson's Art Gallery and, most recently, at Cincinnati Art Galleries.

Jensen finally got the rewards he deserved, though he did not live to relish them.

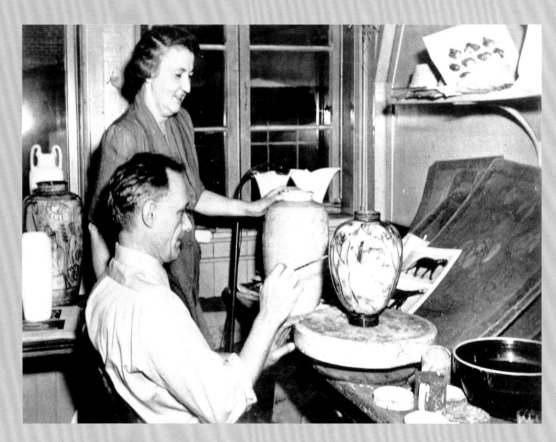

Left
In this undated oil on paper portrait of a pensive female nude, the ode to Picasso is palpable.

Bottom left
A Jensen vase featuring three Rubenesque nudes and large blue flowers. The rim and interior are covered in Rookwood's 50th Anniversary Glaze.

Bottom right
This striking tribute to Pablo Picasso by Jensen in 1948 was created on a 6⅛ inch (15.6 cm) vase, which is completely encircled with dramatic faces.

Opposite
Jens Jensen and Wilhelmine Rehm in his studio, filled with illustrations for inspiration and several Jensen pieces in the background.

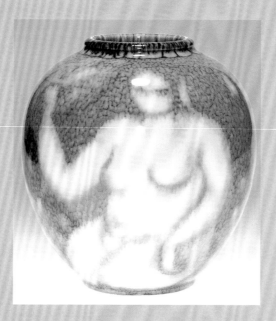

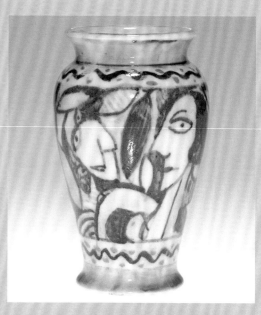

Close of a
Golden Age

By the late 1930s, the war in Europe had already ensnared the United States. President Franklin D. Roosevelt struggled with maintaining an aura of neutrality while weighing difficult decisions about the United States' role in the conflict. Meanwhile, economic calamity still rocked the American economy. It seemed as if the future of humanity rested in the balance.

In this turbulent era, the humble struggle of a single ceramics company, even one as vaunted as Rookwood, might simply be swept out of existence. Art itself may have appeared on the verge of extinction, particularly as news of atrocities in Europe compounded. Yet Rookwood stood for more than just a point of hope against financial strain and global disarray.

Rookwood faced a conundrum in the late 1930s. Regardless of new glaze lines, innovative decorations, and interesting production wares, the pottery could not escape the larger economic crash. The architectural division, with no orders to fill, shut down as the construction and building industries faltered.

With nowhere else to turn, Wareham looked to past marketing campaigns in hopes of gaining a bit of traction. Earlier, the pottery solidified its relationships with luxury retailers by offering special exhibits on-site at the retail store. The shop and the pottery would both benefit from using Rookwood's heritage and global accolades to boost sales, while customers would get exclusive access to the special artworks.

In March 1936, the company sent this kind of exhibit-as-marketing display to Charles Mayer and Co., in what a newspaperman called "perhaps, the most important collection of Rookwood pottery ever assembled in Indianapolis." After giving a quick overview of the company's history, the writer made a turn to what was next at Rookwood, claiming "they have their eyes on modern trends," and even saying one piece (most likely by Jens Jensen) "looks as if Pablo Picasso might have had a hand in it."

In the nation's capital, the Woodward & Lothrop shop announced that Rookwood was now exclusively at its location on 10th and F streets. The ad in the *Evening Star* harkened back to the pottery's heyday, claiming, "Fashioned by artists allowed free rein in their choice of design and colors—Rookwood Pottery is a highly individual, exceptionally lovely contribution to American art." Many retailers continued to run similar ads without fully comprehending Rookwood's diminished status.

Rookwood had been battered by the Great Depression, but forces rallied in an effort to remind consumers of its masterful wares. A September 1939 essay in the *Chicago Tribune* placed by the city's venerable Marshall Field's compared Rookwood with John Keats's famous Grecian urn, its pottery "waiting only for someone like another Keats to transpose their inimitable loveliness into language." Calling Rookwood "the very poetry of pottery," the retailer noted "its perfection of form, color, decoration and finish—the four-fold standard of all ceramic fineness." The glaze lines, in particular, were deemed "superlative."

The article is clearly an effort by Marshall Field's to encourage sales at one of its flagging lines, but it also provides a deeper look into the sales downturn. Although a great placement

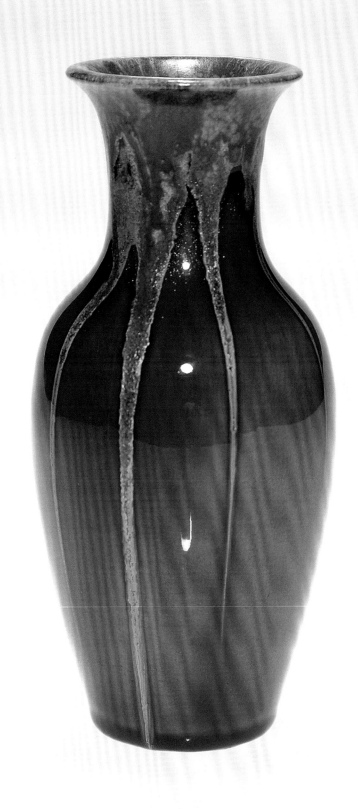

A semimetallic glaze is dripped over the stylish Coromandel Glaze and then into the interior of the piece in this 1932 production vase.

in a leading newspaper by a popular retailer, Rookwood pottery was just one of many products advertised. With a smaller total portion of the consumer's spending going to luxury goods, the pottery could not compete, even in its own category.

Ironically, the vast majority of advertisements never referenced or mentioned the economic calamity. Perhaps slightly toned down, campaigns still featured luxury goods and wealthy-looking people attracted to them. Simultaneously, though, ads in this era pushed the product to take the focus off the consumer. This helped Rookwood, because the stars of its ads were its heritage and art pottery pieces.

Although advertising and marketing campaigns were risky during the Great Depression, as consumers did not have the money to spend on unnecessary home goods, Rookwood remained a Cincinnati institution. Despite all the challenges the pottery faced, it endured as one of the Queen City's primary tourist destinations.

In June 1938, for example, the National Association of Retail Grocers hosted 5,000 visitors at the Netherland Hotel downtown. The factory was a highlight of the group's weekend festivities. Regardless of its popularity, and quick burst of sales, the overall financial picture grew darker. Visitors purchasing tchotchkes at $1 or $1.50 per piece could not keep the pottery financially viable, especially considering its heavy debt load.

A year later, in 1939, a Cincinnati reporter marveled at the "flurry" of visitors—though "not extraordinary"—that visited Rookwood in one weekend, including two guests from Germany and one from India. Attempting to drum up business by focusing on its handcrafted tradition, the article noted, "Never interested in mass production, the pottery works slowly, firing only from one to four kilns a month." The *Cincinnati Enquirer* article formally claimed that thirty-five people still worked at Rookwood. Two months later, however, Wilber Kendall, an Indiana reporter on a family visit to the factory disclosed that he only saw "four or five persons" on staff.

Most items, the reporter estimated, were priced at "a dollar or so and up," certainly a reflection of the Depression.

Waterlogged by debt and pushing the limits of its creditors, Rookwood's options—and hopes—for the future were sliding away.

Despite its intact reputation and secure status as a significant tourist destination, Rookwood's financial challenges remained daunting. Much of the challenge must be placed outright at the feet of the Depression. The crisis demoralized Americans and only grew worse when national unemployment rates reached 25 percent or more in the early 1930s. The psychological toll caused high levels of stress and anxiety.

Before the Wall Street crash, Rookwood had essentially become a holiday gift retailer, while its architectural division battled to become profitable. There were enough high-end retailers then carrying Rookwood across the nation that the brand name had status, which led to profitability. The combination of the income tax debacle and debt load, however, hurt it at a time when sales were about to implode. Plus, it had an albatross around its neck, some $250,000 worth of old ceramics that its retailer partners could not sell.

When war broke out in Europe in 1939, basically cutting off the natural flow of goods, some observers thought Rookwood would benefit because it could manufacture everyday ware for household and business use. On January 6, 1940, Wareham publicly told the *Cincinnati Enquirer* that Rookwood "could not do it successfully because of the higher labor and manufacturing costs in this country." Although Wareham told the paper that 1939's holiday season sales totals topped the previous year, privately, he knew that Rookwood was little more than a three- or four-person skeleton of its former self. The pottery could not fill the need for everyday ceramics because it was weakened to its core. The skeleton crew could only turn out a small number of pieces, and no financial institution would have financed Rookwood's rebirth.

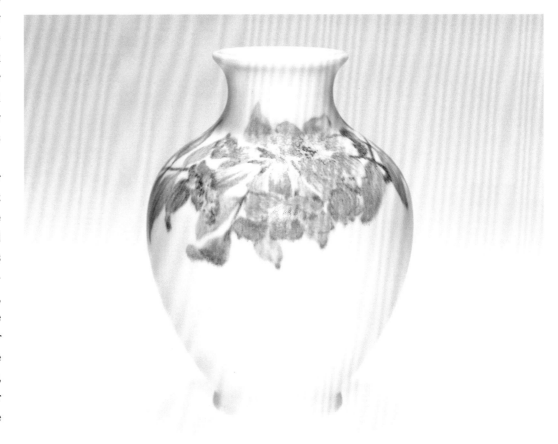

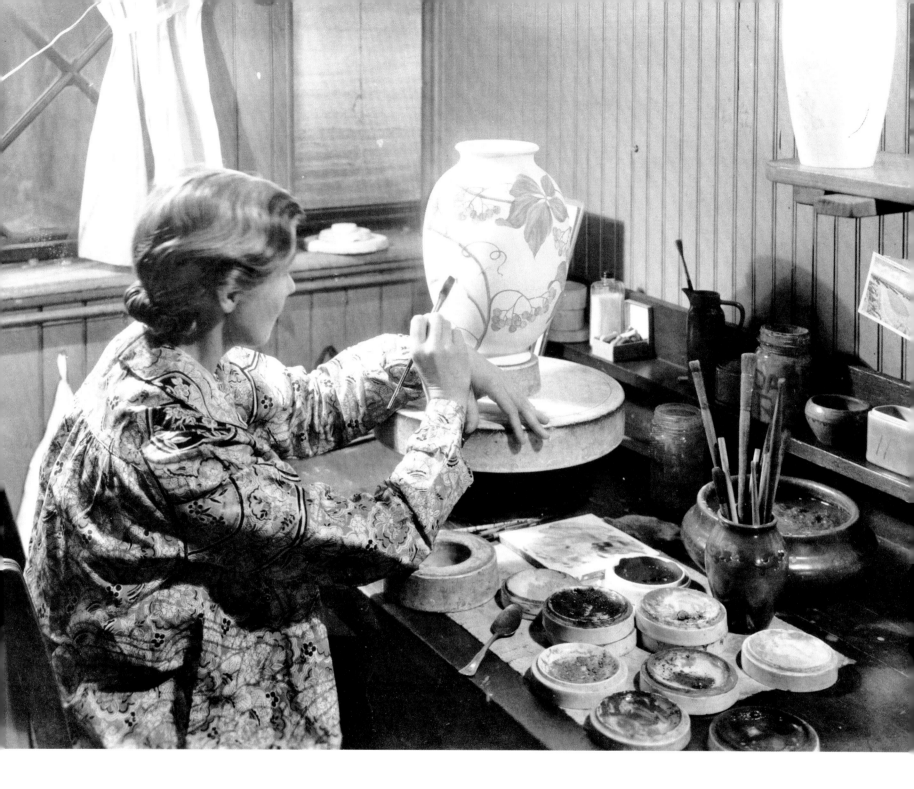

Helen McDonald, daughter of William P. McDonald, in her airy studio, circa 1940. She worked at Rookwood from 1913 to 1948, meaning a member of her family had been making pottery from 1882 to 1948.

Opposite
A 6½ inch (16.5 cm) Mat vase decorated with trumpet creepers encircling the shoulder by McDonald (1940).

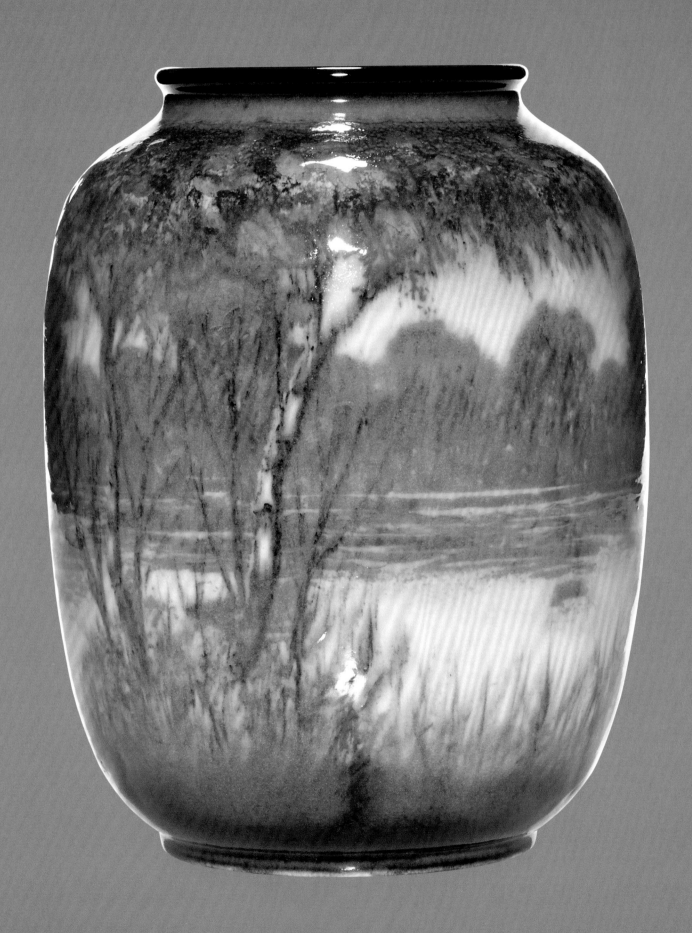

8 Desperate Measures to Save an Icon

Rookwood faced numerous financial challenges as a result of the Great Depression, including a debilitating debt burden. The transformation to a wartime economy did little to help the pottery. Not even postwar prosperity would pull Rookwood from its financial instability. Cincinnati business leaders made desperate attempts to save Rookwood based on civic pride. Despite decades of machinations, its last local owner ultimately moved Rookwood to Mississippi, eventually shuttering operations.

The destruction of American small businesses during the Great Depression could not be understated. As if a wave of plague had swept across the land, owners and managers fought desperately against the onslaught, but eventually succumbed to its relentlessness, like a wave beating against the rocks.

John D. Wareham, who had dedicated his entire life to Rookwood and the art scene in Cincinnati, tried in vain to find new paths toward financial stability. The board of directors launched its own initiatives, sometimes without his knowledge, in a last-ditch effort. Finally, however, Wareham could not keep them from throwing in the towel.

On April 17, 1941, Rookwood announced that it filed for bankruptcy in U.S. District Court.

The final nail in the coffin was the two-headed monster it had been fighting for more than a decade: a drop in consumer demand for ceramic art and no working capital. Wareham made a public plea to Cincinnati business leaders to save the vaunted enterprise.

Sadly, Wareham was lauded in a news story two months later about the remodeled Central Trust Bank, one of the final architectural faience clients that employed Rookwood. Mary L. Alexander called Wareham "a really great designer who has a creative imagination that is controlled by excellent taste." The accomplishment had to be bittersweet for the longtime Rookwood chief. The project had started while the pottery still existed, but came to fruition during its darkest hours, post-bankruptcy.

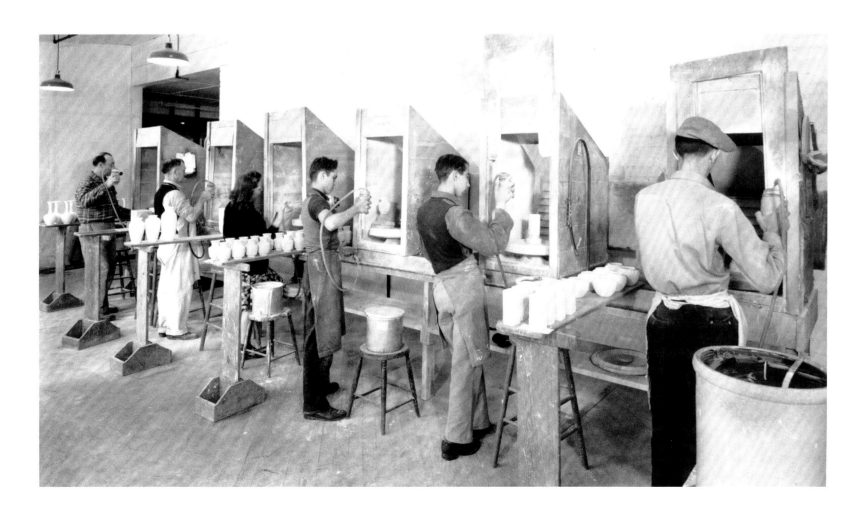

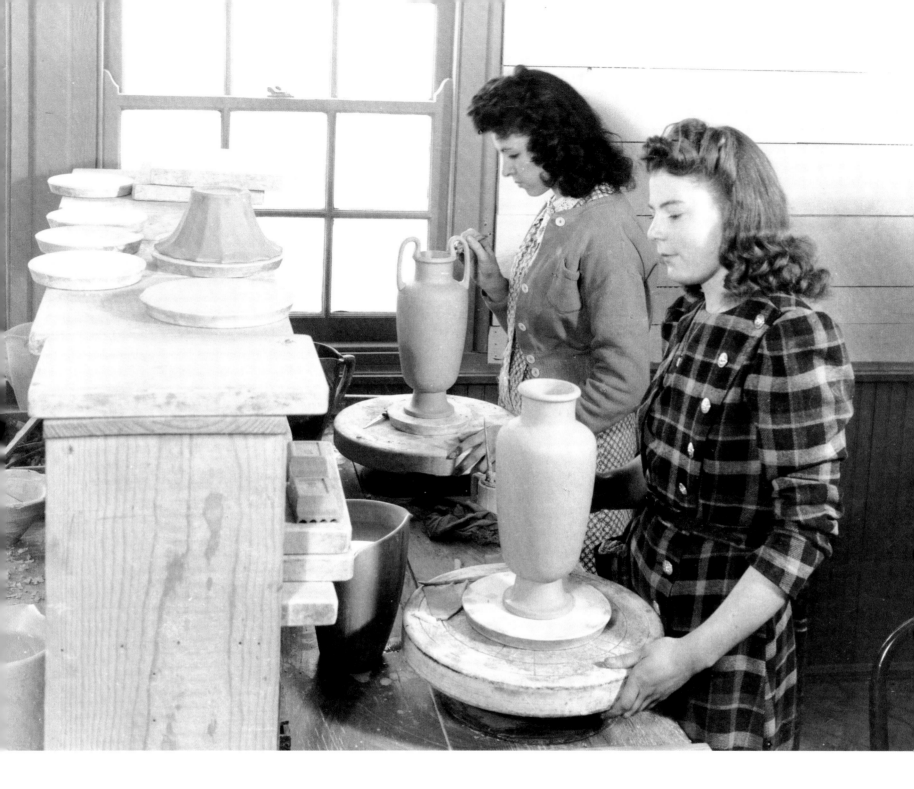

Above
Two female employees
search for imperfections
(circa mid-1940).

Opposite
Workers spray glaze
on production pieces
(circa 1940).

Ownership Change and Struggle

In mid-1941, court appraisers valued Rookwood at nearly $68,000 (equivalent to $10.8 million today), with much of that total tied to its real estate and finished pieces or wares from its own special collections. Typically, in bankruptcy cases in that era, the company had to be sold, so reorganization efforts were denied. The September 30, 1941, sale was widely publicized, but only two bids were submitted.

When the two offers were compared, the court ruled that a Cincinnati-based team that offered $60,500 won the auction. The new owners were automotive tycoon Walter E. Schott and his wife Margaret, his brother Harold C. Schott, attorney Lawrence H. Kyte, and Charles M. Williams (Western & Southern Life president and son of Charles F. Williams, a former Rookwood board member).

The next day, an editorial in the *Cincinnati Enquirer* called the sale "Indeed good news to Cincinnati." Kyte, who negotiated the deal, told the paper that the new management team "will put adequate capital into the institution to enable it to regain its former enviable position." He also said that the longtime staff "will be returned to duty virtually intact."

The first important step the new owners took was to retain Wareham as president. Next, they named ceramics veteran W. E. Mackelfresh, Jr. as sales manager. Launching an extensive advertising campaign, the new owners hoped Rookwood would be "rejuvenated" and "function again as a . . . modern industry without sacrificing the quality of the ceramic art for which it is noted."

During the shutdown, Wareham explained, the factory would be redecorated and repaired, leading to it emerge "more beautiful than ever." As Rookwood had recalled all the pottery on sale at its retail affiliates when it declared bankruptcy, Wareham said, "we probably have the largest stock of finished merchandise on hand now that we have ever had." The new owners planned to build a better retail outlet at the Mount Adams factory to take advantage of the surplus. As always, Wareham remained optimistic.

The first anniversary celebration under the Schott ownership team (sixty-first overall) was "a thrilling occasion" according to a local society page, featuring a "brilliant reception and tea" and "civic pride" as the pottery formally reopened. A special kiln was fired and a "61"

mark created, with each piece inscribed for the occasion. Wareham hosted the reception, which featured on display a selection from Rookwood's company museum. Less than two months since the new owners took over, enthusiasm and optimism were at a fever pitch.

The World at War

The December 1941 bombing of Pearl Harbor drew America into the global conflict. With the United States at war, Rookwood's travails seemed minor in comparison. Yet, after more than a year under new ownership, its financial situation still seemed bleak.

Looking back, there is an air of desperation wafting from the Schott team. The major ad campaign that they hoped would replenish Rookwood's coffers tactically played out as little more than a wholesale fire sale, more like Schott's roots in selling cars than how one might successfully market a luxury brand. Perhaps the Schott group was too caught up in the prestige of the brand name or civic pride to comprehend just how far the pottery had fallen in more than a decade. Selling works of art at slashed prices was not going to put the company on solid footing.

One of the strangest moves the new owners made was recalling the remaining artwork loaned to the Cincinnati Art Museum through 1916. According to Herbert Peck, some of the original 2,292 pieces had been "recalled by the pottery during the 1930s and early 1940s," prior to the bankruptcy. Without correlating Rookwood company records, which are not known to exist, one can only speculate on the rationale for the retrieval before the Schott team took over.

What is known, however, is that in the *New York Times* on March 22, 1942, B. Altman & Co. ran an ad announcing: "Tomorrow Altman will hold one of the most unique sales in its history/three thousand pieces from America's famous ROOKWOOD POTTERY." Though this must have stunned readers, imagine an art collec-

tor's delight in reading that the sale consisted of "All individual pieces ... far below their original prices." Astonishingly, the massive sale consisted of Rookwood's internal museum, the collection of inspirational wares its artists had collected over the decades, and the remaining pieces that had been housed at the Art Museum.

The Altman sale was over the top, and an event from the pottery's history that can only be looked back on in sorrow. A more typical approach by the Schott team—but not nearly as gut-wrenching—is symbolized in an April 1942 ad run in the hometown *Cincinnati Enquirer*. The headlines shouted that Rookwood was being sold cheaply, "offering for quick disposal," including "odds and ends and discontinued models" in its spring "housecleaning." This was hardly the kind of cutting-edge marketing needed to revive the struggling company. Nevertheless, the war effort soon proved all-inclusive, impacting Rookwood in unforeseen ways.

With the fate of the Western world hanging in the balance, the American economy turned to wartime production. As a result, many Rookwood raw materials, primarily chemicals, were placed on the government's list of products only available for military purposes.

With few orders and reduced output, Rookwood basically again stalled out as a pottery. Schott though, searching for a way to contribute on the home front, sought war contracts. He also allowed sister companies that he owned to utilize space at the factory. Next, Rookwood "began turning out wooden pipes for use at army air bases ... [and] became a subcontractor

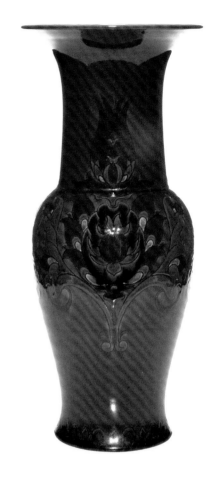

Opposite left
The Rookwood factory when the company declared bankruptcy.

Opposite right
The March 22, 1942, *New York Times* ad for the infamous B. Altman Rookwood sale.

Above
The overt artistry of Sara Sax made her a collector favorite. This 1925 18 inch (45.7 cm) Black Opal vase features three identical interlocking flowers done in blue red, yellow, black, and green against a maroon ground. Each leaf and petal is carved, presumably to keep the different colors from intermingling. In the Rookwood museum vault, this Sax piece was first sold in Cincinnati during the infamous B. Altman sale. The purchaser bought ten pieces. According to Humler, "the original price for the ten was $510 but that figure was discounted to $170 plus tax." The new owners were desperate to recoup their losses after buying Rookwood from bankruptcy.

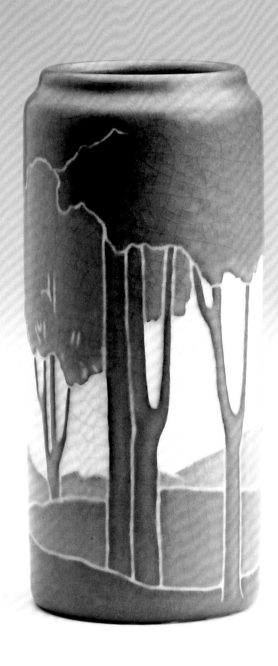

making parts for proximity fuses," according to historian Herbert Peck.

The wooden pipes were a pedestrian—but much-needed—utilization of Rookwood's capabilities. However, the work on proximity fuses was both top secret and critical to the Allied victory. Experts considered the fuse the third most important invention during the war, behind the atomic bomb and radar. Cincinnati industrialist Powel Crosley Jr., who had made a fortune in auto parts, became a pioneer in the radio industry and later owned the Cincinnati Reds and a production facility in Cincinnati that developed and improved the proximity fuse.

The proximity fuse had a trigger mechanism that enabled explosives to be detonated at a predetermined time or distance, thus a bomb only had to get close to a target, not hit it head-on. American researchers improved a British prototype and several corporations began making them, Crosley manufacturing more than any other company. This connection to production facilities in Cincinnati most likely led to Rookwood's role as a subcontractor. Rookwood employees, along with those at Schott's other firms, probably had no idea what they were working on. A July 1942 article vaguely reported that Rookwood was engaged in "making certain products essential to the war effort." When early tests proved fruitful, government contracts for proximity fuses escalated, reaching $450 million by the last year of the war.

Government officials credited the fuse with helping stave off Japanese Kamikaze attacks—in the Pacific Theater they were called the "Buck Rogers fuse"—and thwarting German Luftwaffe raids on England. Perhaps most notably, Allied forces employed the device to win the Battle of the Bulge in late 1944. General George S. Patton, commenting on the ferocity of the devastation, claimed that its use would require a complete overhaul of land-based warfare. "Those who had a hand in the assembling of these remarkable little devices were playing a useful role in the gigantic effort that finally brought victory," the *Cincinnati Enquirer* reported when news of the "super-secret" project, "assembled in the plants of the Crosley Corp." became public.

One sad outcome of aerial warfare was the number of cultural institutions that were bombed. Countless Rookwood treasures acquired by these organizations before the fighting broke out were eventually lost. Many collections were completely destroyed during the fighting, including those of the Musée du Luxembourg in Paris, City Museum of Dortmund in Germany, and nearly a dozen more stretching from Central Europe to Japan.

On January 1, 1943, seemingly out of the blue, Cletus A. Miller, dean of the Institutum Divi Thomae Foundation, an arm of the Catholic diocese, announced that some of Rookwood's buildings and land had been donated to that organization, primarily to help with "war research activities…cancer and wound healing." These areas were the chief aims of George Sperti, the famous researcher who set up a for-profit arm of the Catholic organization under his own name, Sperti, Inc. Although not mentioned in the announcement, Sperti's efforts "are of a secret nature . . . related to essential war instruments and drugs." For the pottery: "It is probable that research in ceramics, vital to the war effort, will also be conducted there."

Sara Sax (1908) carved this 7½ inch (19.1 cm) Vellum vase with an abstract landscape in blue-gray and ivory. It was one of the artworks taken from the Cincinnati Art Museum and sold in the B. Altman auction.

With Rookwood's future looking bleak, this "donation" actually turned out to be the Schott group "gifting" the pottery to the Roman Catholic Archdiocese of Cincinnati. Rookwood's land and buildings would be controlled by Institutum Divi Thomae, a graduate school and research facility, while Sperti took over its commercial affairs. John W. Millet was named manager, while Wareham continued to run art and production.

George Sperti was a polymath research scientist and entrepreneur. Once his organization took over, things moved quickly at Rookwood. During the 1940s, Sperti, Inc. expanded into the Rookwood building atop Mount Adams, moving its drug and cosmetic divisions there, as well as parts of its Faraday manufacturing business and the Sperti holding company offices.

By June 1943, the Sperti and Rookwood divisions seemed merged. A newspaper article reported: "Recently acquired by Sperti Inc., Rookwood Pottery uses the latest scientific research methods in its production." According to one writer, "It wasn't long before day creams and night lotions were on the market in pale blue and rose Rookwood containers."

Even as the world focused on the harrowing events in Europe, it seemed as if all Cincinnati pulled for Rookwood. Late in 1943, after the company had solemnly celebrated its sixty-third anniversary, an editorial in the *Cincinnati Enquirer* urged the region to rally, using the company's incredible heritage as a key message. "The Rookwood Pottery became a Cincinnati institution," the paper exclaimed, "A symbol of beauty in design and excellence in craftsmanship."

As the editorial explained, "It is heartening to see this old institution taking a new lease on life after a period of discouragement and business difficulty." The Sperti ownership group seemed poised to provide a kind of rebirth, introducing new products and firing techniques. Hope was in the air. "Once the war is over and free passage of goods returns to the world," the writer declared, "Rookwood again will carry the name of Cincinnati to the four corners of the earth."

Yet, in the midst of global warfare, consumers were uncertain of Rookwood's status as an art pottery. Years of challenges, including negative publicity as a result of the bankruptcy and poor handling of the company afterward, made Rookwood's outlook as a pottery ambiguous, but at least with Sperti it seemed as if some kind of future might exist.

Rookwood struggled to find its way under Sperti management, however, as just one of many subsidiaries competing for attention and

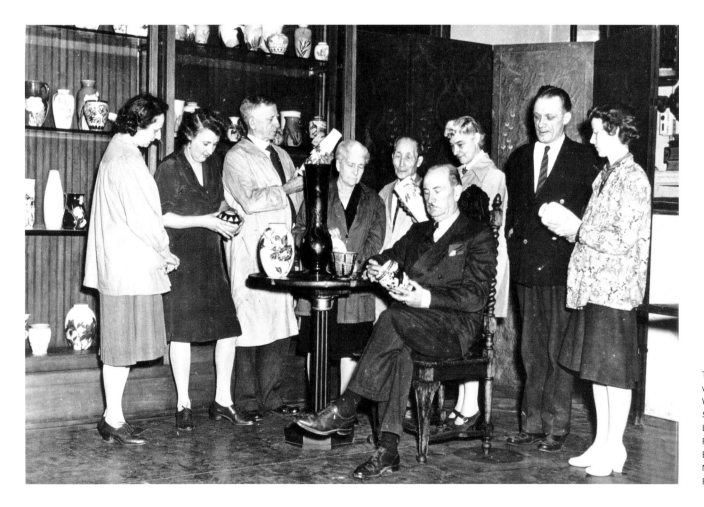

The decorating team with President John Dee Wareham (sitting) in 1943. Standing (left to right): Loretta Holtkamp, Wilhelmine Rehm, E.T. Hurley, Lorinda Epply, Kitaro, Margaret McDonald, Jens Jensen, and Elizabeth Barrett Jensen.

Left
A scenic fall woodland plaque (1943) by E. T. Hurley is characterized by his typical birch trees lining a small, meandering creek. There are patches of bright red leaves reflected in the stream. The piece measures 11⅝ by 8⅝ inches (29.5 × 21.9 cm).

Below
Despite Rookwood's financial woes, Jens Jensen continued producing high-quality work, such as this Wax Mat vase featuring three human figures, including a woman who appears to be holding a cat, a man in a floppy hat, and a Gandhi-like figure holding a spoon. The decoration is done in heavy gray slip against the white porcelain body.

Above
Pictured are production
vases cast in 1942 and
1943. Both are covered
in Wine Madder Glaze and
have blue and green high-
lights that draw attention
to the floral decoration.

Right
Four high gloss production
vases (circa 1945 to 1950).

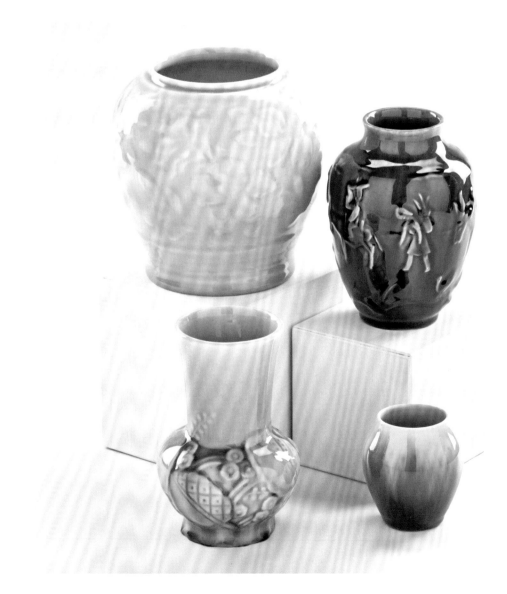

resources, yet people still rallied to honor what the pottery had meant to Cincinnati history. On November 25, 1945, in celebration of Rookwood's sixty-fifth anniversary, some 5,000 people attended an open house and exhibit, which included Yuletide decorations and tours of the factory. Kicking off the celebration, Cincinnati Mayor James G. Stewart declared:

> *"No other institution—outside of religion itself—has performed a greater service to this community than Rookwood. Not only here, but throughout the world, its name has become synonymous with a great love of culture."*

With an eye on past accomplishments, but also attempting to steer consumers toward other products, the exhibit featured hand-decorated vases, but also "articles suitable for all purses and tastes," including urns, ashtrays, and small production vases. Sperti President Ralph A. Lostro led a contingent of city leaders through the factory in a show of support for its struggling division.

The ensuing years did nothing to stave off financial disarray. The year 1948 proved incredibly difficult for Rookwood. After many attempts to bring the pottery back to name-brand recognition, Sperti decided to pull the plug. Not only were further efforts halted, but many on the decorating team were summarily fired. "The public was no longer interested in buying new art pottery of the quality of Rookwood and at the price that had to be charged for it," explained Peck.

Evan more heartbreaking for the art world at large, Kitaro Shirayamadani, who had worked at Rookwood since 1887, died after a short illness on July 19, 1948, at 10:30 a.m., never fully recovering from a head injury sustained when he fell down the stairs at his Rookwood studio preparing for a television appearance earlier in the year. Wareham, who worked with the Japanese artist his entire adult life, said that his friend was "sweet and gentle in character, understanding, with a keen sense of humor, and a mind of high culture."

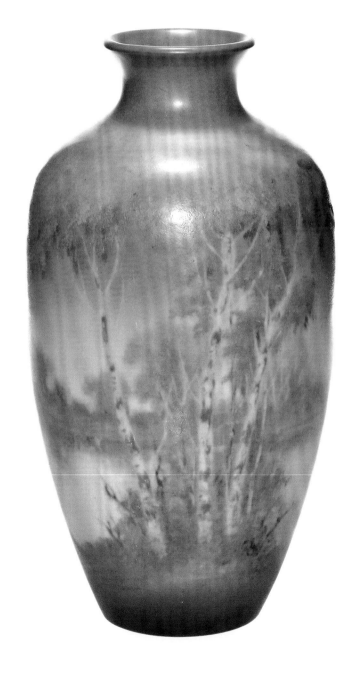

Hoping that the earlier popularity of Scenic Vellum might rekindle interest in Rookwood, E. T. Hurley painted a majestic lakeside scene with a peach and blue sky and trees that frame the image (1945).

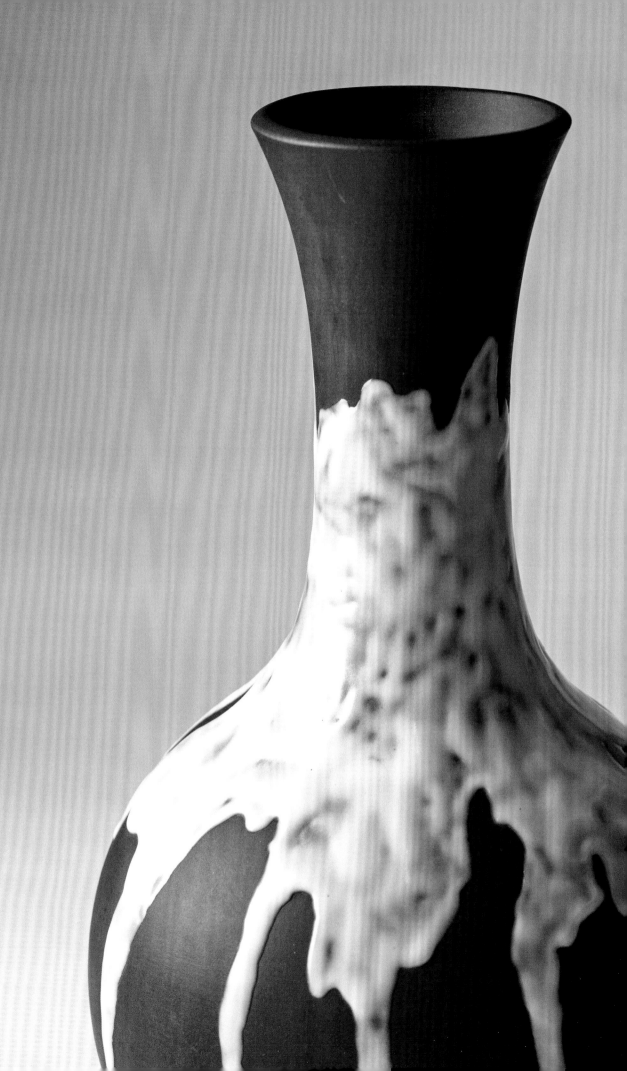

A 1959 Cirrus Glaze
vessel was a late attempt
at appealing to new upper
middle-class consumers.

Sperti relented to some degree, but even with the tumult at the ownership level, the decorating team and production personnel still worked on new colors that might appeal to postwar consumers. In 1949, for example, the Cirrus Glaze was introduced, but used more frequently in the early 1950s. Like much of the company's output during this era, the glaze itself is the decoration, with a thick layer applied to the dark surface to create an almost tapioca-like effect, as if the color is about to drip off. Curator Anita J. Ellis described it as Rookwood's last notable glaze line. "The gloppy unctuous glaze offers a sensuous contrast with the mat black ground."

A new aura of beauty emerges around Rookwood's seventieth anniversary in 1950, despite the vast contrast with earlier hand-painted artworks. Actually, the line between potter and decorator blurred as well. Cost savings necessitated that the firm focus on production pieces that were less expensive to create. Despite these concerns, many beautiful glazes appeared, such as the flowing Seaweed, the brown Nepturian, and Vista Blue, which appears almost like granite to the naked eye, with deep crevices of white and hints of tan.

On April 25, 1954, John Dee Wareham died from a heart condition. Although Rookwood was then not the company it had been during most of his vaunted career, Wareham's death seemed to be a final exclamation on Rookwood's better times. In the company's early years, Wareham had been one of its most celebrated decorators, and then later designed many forms that went on to great acclaim. If Kitaro might be acknowledged as Rookwood's soul, then Wareham embodied Rookwood's beating heart.

As the 1950s continued, Rookwood's outlook increasingly shrank. In January 1955, with expansion plans underway for creating, manufacturing, and licensing products from the lab of George Sperti and for new acquisitions, the Sperti Products board of directors announced that it intended to sell Rookwood. Initially, four bids were under review.

On December 30, 1955, Sperti management decided to spin Rookwood off as an independent entity. The newly formed corporation was led by William A. Shea, who served as president and CEO. Edgar M. Heltman became vice president, while Richard G. Jensen was named secretary/treasurer.

A high-powered New York City attorney, Shea concurrently sat on the board of Gruen, a Cincinnati-based watch company that had also recently entered the postwar military defense industry. Several years later, Shea would go on to help Major League Baseball expand, adding the New York Mets in 1962, which earned him significant accolades. When the team built a new stadium in Queens, they called it Shea Stadium in his honor.

Publicly, Shea viewed independence from Sperti as a way to regain the pottery's national prominence. Privately, though, Rookwood remained attached to Institutum Divi Thomae through Sperti Incorporated, one of many such entities, including Sperti-Faraday (signaling systems), Sperti Drug Co. (drugs, food, orange juice), and Schock, Gusmer & Co. (brewery equipment and machinery). George Sperti had incorporated the Institutum Divi Thomae Foundation in 1955 to serve as the holding company for these many businesses derived from his research interests.

Sperti promised that Rookwood would remain both a pottery and cultural institution, but Shea's vision for Rookwood took a curious turn. He announced to the local media "a plan by which leading ceramic artists in America and Europe will make unusual ceramic designs for reproduction in Rookwood pottery."

Below top
A glossy vase decorated by Kay Ley (1946) brings to life the brilliant red magnolias and the lighter green at the bottom. The flowers were created via heavy slip, which was then covered with Wine Madder Glaze.

Below bottom
A 1946 production vase almost 7 inches (17.8 cm) tall featured a molded flower and berry design, which was then covered with a blue High Glaze.

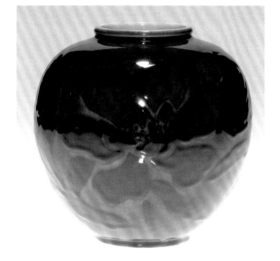

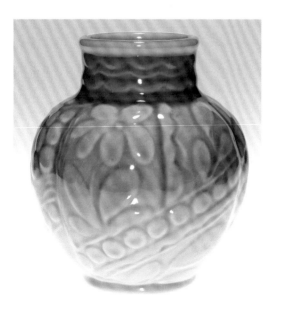

This new strategy would have marked Rookwood's end as an art pottery after seventy-five years. However, a week later, before Shea's ideas could even take hold, Cincinnati business leaders James M. Smith and William F. MacConnell bought the company for $100,000 (equivalent to $4.5 million today). The new owners promised Sperti that they would keep the pottery operating. Their primary interest, though, focused on the physical assets, particularly the Mount Adams factory and offices that Sperti had remodeled and expanded.

Smith and MacConnell viewed the facility as part of a larger citywide effort to turn the bluff into, as one newspaper reported, "A 'Left Bank'—Center for the arts in Cincinnati." Ironically, the sale put an interesting project on hold—a proposed Taylor-Wareham museum of ceramic arts dedicated to the memory of the two former Rookwood presidents.

Smith and MacConnell formed Rookwood Realty two months later to remodel and then lease space to area businesses and artisans. The first significant change focused on placing large picture windows in offices to take advantage of the view overlooking the Queen City. K & S Films, a production company that made television commercials for national ad agencies, was an early tenant. The new Rookwood owners told the *Cincinnati Enquirer* that they purchased the factory because "they needed office space and they had always admired Mt. Adams." They continued gobbling up area properties, including the site of the former incline in late 1957.

The new owners noted that Rookwood Pottery leased a portion of the building to continue operations. They retained Reuben Earl Menzel, the master potter who had been with the company since 1896, to run the business, as well as become its head decorator. He oversaw a small staff, which focused primarily on filling commemorative and commercial orders and production wares.

Rookwood further slipped from relevancy, despite many interesting pieces coming from Menzel's wheel. Some newspapers even lamented that the "pottery has been closed down," a bleak circumstance for an enterprise attempting to stay afloat. Yet, simultaneously, Rookwood continued to be a city tourist attraction, particularly for visiting civic groups eager to relive nostalgic feelings of the pottery's exalted past. Without much emphasis on new production, however, Rookwood shambled along.

On June 3, 1959, *Cincinnati Enquirer* readers woke to surprising, front-page news:

"Cincinnati's world-famous Rookwood Pottery has been purchased for an undisclosed price by a group representing another world-famous prestige name—Herschede Hall Clock Co."

For generations of ceramics aficionados, the news came as a relief, with Herschede claiming that "they intend to breathe new life into the prestige of Rookwood Pottery and into the company's sales." MacConnell and Smith retained the buildings, but the intellectual property and trademarks went to Herschede.

Robert Herschede, vice president of the luxury brand, became president of the new Rookwood Pottery, established as a separate corporate entity. He told reporters that the addition went "hand in hand with the prestige of our clock lines." John G. Hoyt III was named operations general manager.

In hopes of drumming up business and spreading awareness, the new president named the Richard F. Peck Agency as Rookwood's advertising agency of record, the same firm that the parent company employed. "What we're interested in is regaining the front of the prestige market for pottery and ceramics," Herschede announced.

Despite the cheery public face, however, Rookwood remained on a severely curtailed production schedule, overseen by Menzel, the venerable potter whose own father had been master potter when Rookwood opened in 1880, making it nearly eighty continuous years that a Menzel had worked there. Though Herschede tried to jump-start flagging interest, Rookwood consisted primarily of a showroom in its old factory and a "Rookwood Gallery" that served as a quasi-museum and retail space. There were only about ten employees still on the payroll.

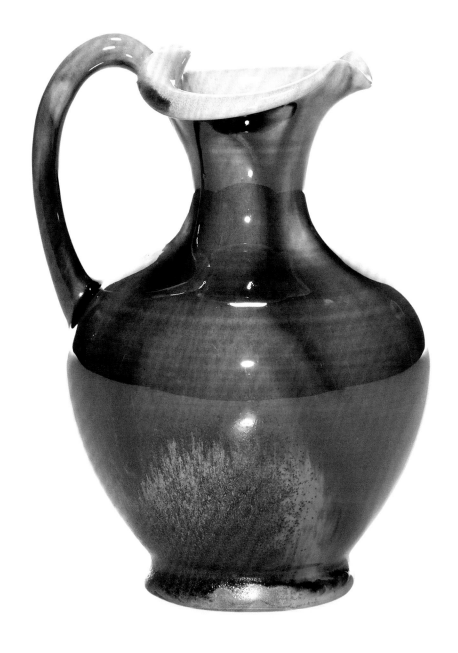

Opposite
Architectural plot plan
for the first floor of the
redesigned Rookwood
Building, October 1956.

Right
A nearly 6 inch (15.2 cm)-
tall porcelain pitcher by
Reuben Earl Menzel (1959)
featuring his characteristic
playfulness with glazes,
dripping green glaze over
a blue base color, offset by
lighter colors on the handle
and interior.

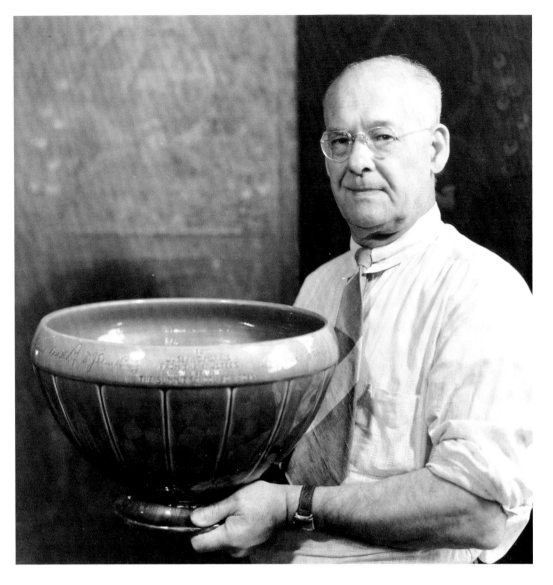

Despite the optimistic tone, trying to revive Rookwood came at a price. Fewer than eight months later, the front-page story in the February 22, 1960, *Cincinnati Enquirer* leapt starkly from the page:

World-Renowned Names To Forsake Queen City

Both Herschede and Rookwood, Walter J. Herschede announced, would be leaving Cincinnati to take up operations in Starkville, Mississippi. The southern city promised Herschede tax breaks and other incentives to move there. "We must find lower operating costs," Herschede told reporters. Moving operations would ultimately save money via tax abatements and lower utility costs.

William T. Glass, who had taken over in 1959 when Menzel retired, went south to Mississippi to operate the pottery business. Though the factory still stood on Mount Adams, a large majority of remaining shape molds and company documents were either discarded or auctioned as the vaunted pottery left the Queen City.

Glass attempted to keep Rookwood operational in Mississippi. He created new shapes

Top
Menzel with one of the oversized vessels typical of his work, with characteristics such as fine glazes and design.

Right
This advertising sign was made after Rookwood moved to Starkville, Mississippi, dated 1965.

and experimented with various design styles. "Starkville, Miss" was added to many of the new wares produced during this era. Despite these efforts, consumer demand continued to fade.

In the six or so years that Rookwood operated in Mississippi, during the tumultuous era of the Vietnam conflict, with rioting in the streets and mass protest, operations were at a minimum, dropping the famed pottery further from the mainstream. Rookwood was considered an antique, a relic of bygone days that most modern consumers would rather forget.

On May 3, 1967, a group of Starkville executives who ran the Howard Furniture Manufacturing Co. announced that they had purchased an 80 percent share in the Herschede Hall Clock Company, which included Rookwood. Howard Furniture Manufacturing, run by John Robert Arnold, a Starkville business leader, had just completed a 63,000-square-foot (5,850 sq m) factory housed in the city's new industrial park. The new ownership group suspended operations at the pottery, which had barely clung to life for several years. Arnold, however, kept Herschede as part of his portfolio. By early 1973, the conglomerate pulled in more than $20 million, making Arnold's outfit one of the fastest growing in the South.

Although the Herschede family had high hopes in moving south, ultimately they could not outrun consumer interest—or in this case, lack of interest—in pottery. The 1960s demanded new, different, and exciting. Antiques and collectibles were out of style, and Rookwood was out of chances.

A 1965 Herschede Coaster featuring its clock manufacturing heritage.

John Dee Wareham:
A Lifetime in Pottery

RILEY HUMLER

John Dee Wareham served a remarkable sixty-one years at Rookwood. He launched his career in 1893, and his talent was quickly recognized and lauded. His artworks helped Rookwood win several early international awards.

Wareham also served as art director, vice president, and president. A respected arts leader in the local Cincinnati community, Wareham is the only Rookwood employee to have a street named after him. Wareham Drive is in the Mount Adams area near the factory and studio location.

Although an impeccable dresser, "Dee" was known to show up at Rookwood with muddy shoes after spending time in the gardens he tended at the Clifton estate of Samuel Taft. He grew a surfeit of flowers and roses, and created his favorite—hybrid irises. An accomplished painter, he was well-known for his oil paintings and murals. According to one reporter, Wareham worked in an old stone studio attached to the mansion, "where the trumpet vine sounds its note of summer and the gladioli and lily stand guard at the door." Wareham later inherited the estate in 1932 and lived there until his death in 1954.

During the lean years of the 1940s and 1950s, Wareham did his best to hold together a group of talented artists as production at the pottery slowed. Well-respected by the artists, his death marked the end of a long creative era at the pottery.

An Art Nouveau carved Iris Glaze vase features a 3-D pink cyclamen created by Wareham in 1899. Three green stems grow from the bottom and twist around the vessel, evocative of Wareham's deep interest in horticulture.

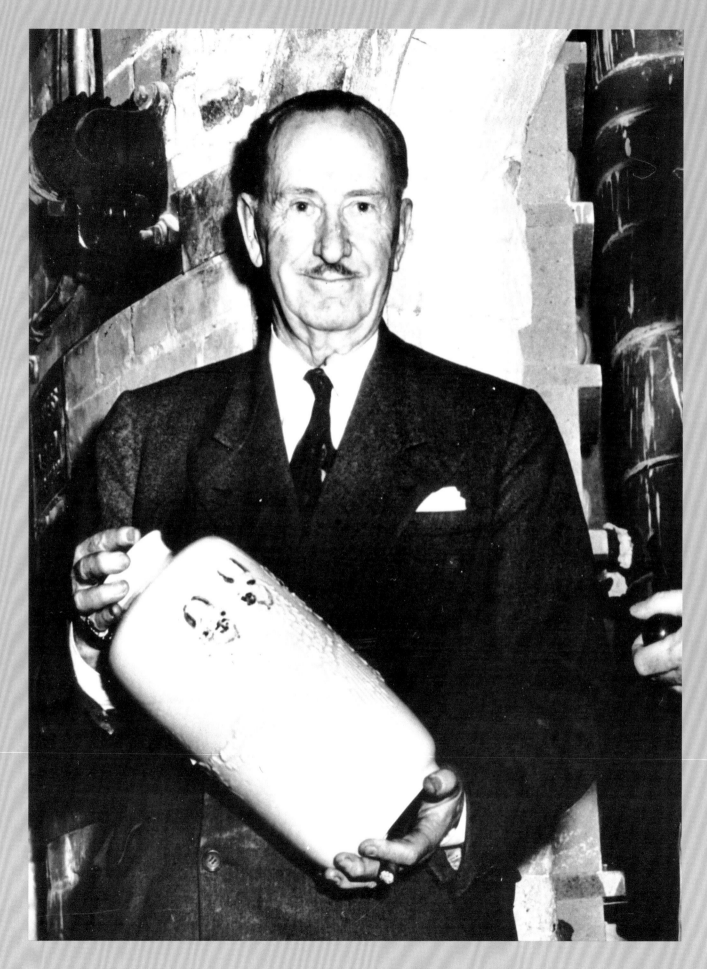

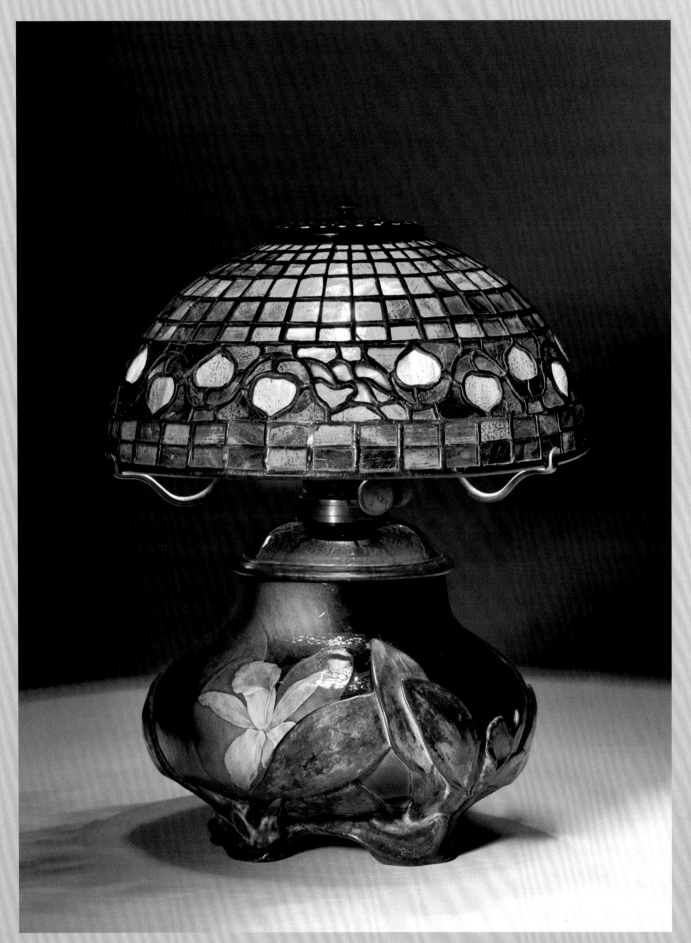

Left
Bringing together two iconic American brands, Kitaro painted this Sea Green lamp base with orchids (1901). Most likely, his Japanese colleague, Ito, created the metal overlay in a leaf design to match Tiffany's lampshade with its single pink blossom.

Opposite
Kitaro Shirayamadani lived with Ellen McKeown and her family at 942 Morris Street in Cincinnati, where McKeown ran a boardinghouse. Here, Kitaro poses with members of the McKeown family (circa 1908), before returning to Japan.

Kitaro Shirayamadani: Rookwood's Soul

"It must be perfect," Kitaro Shirayamadani explained when a journalist asked why he would spend a full day and a half painting one small clay jar. Then he turned, resuming his work. The delicate strokes barely touched the vase, each precise movement made with care.

The artist himself didn't like the media attention. He wondered about the fuss, but his work had gained global recognition. Reporters wanted to know more about the modest artist and his work. In addition, during his lifetime, he was a curiosity. Shirayamadani was one of a small number of people from Japan then living in bustling Cincinnati. Although the city had been a melting pot of nationalities, his Asian heritage made him a wonder. Kitaro had

been the first Japanese person to live in the city when he moved there in the late 1880s.

Kitaro's cluttered design studio was tucked away in the attic of the Rookwood factory, up a dozen or so rickety stairs. He slipped in among his paints and brushes, a thin film of powered clay dust covering most spaces. Company folklore recounts that he had a pet mouse and that it eventually became the model for a popular figurine he designed. The thick wooden shutters, built to keep out the winter chill, let in a flood of sunlight in warmer months. Below the window stood row after row of brightly colored flowers, opulent in full bloom. Rookwood's artists kept up the garden and used the flowers as models. The lawn stretched to the edge of the

hill, a path to where the hillside fell and opened to a magnificent view overlooking downtown, the rushing Ohio River, and the hills of Kentucky rising up from the far shore.

In the studio, Kitaro meticulously carved intricate, tiny strokes into the soft clay and would next paint flowers on the smooth surface in a drab slip glaze that would come to life when fired. What looked like thin, muddy water in the small jar might transform into a deep red or bright orange. A pair of large round glasses perched on his nose as he inspected the piece, noting the details and aligning them with the vision of the finished product that filled his mind. "Accomplished as a decorator and amazing as a carver and modeler, he also excelled in his work with electroplating copper, silver and occasionally gold on carved Rookwood surfaces," explains *Antiques Roadshow* expert appraiser Riley Humler.

The intensity of Shirayamadani's demand for flawlessness belied his true spirit. Rookwood visitors and the media frequently referred to the artist as "dignified." He centered his life on quiet compassion and a fervent commitment to craftsmanship. Although the outside world might wonder how the Japanese artist had arrived in Cincinnati, some 6,000 miles (9,650 km) from home, inside Rookwood he was less enigmatic.

His friends and colleagues at the factory called him "Shiry." They watched him work in awe—the paintbrush gliding in his skilled fingers, combined with deep scientific knowledge of how a glaze would change when baked in the kiln. Kitaro accumulated this information from decades of trial and error. What had once been painstaking experimentation now seemed effortless.

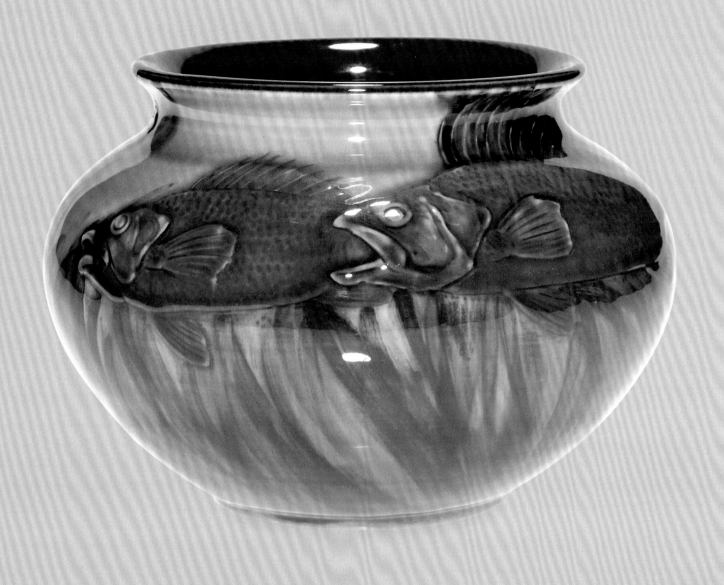

Above
A small Black Opal vase with three lightly carved fish and brightly colored aquatic plants by Kitaro in 1925. A special feature is the maroon interior coloring, since Kitaro was the only Rookwood decorator to use this glaze.

Right
Kitaro excelled at every style and duty, including designing many forms for clay bodies. This 1927 vase created from his drawing, and hand-colored by Sara Sax before being covered in Black Opal Glaze, merges the talents of two of Rookwood's most gifted artists.

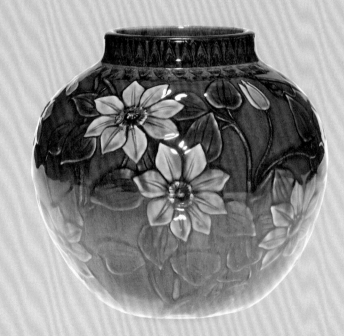

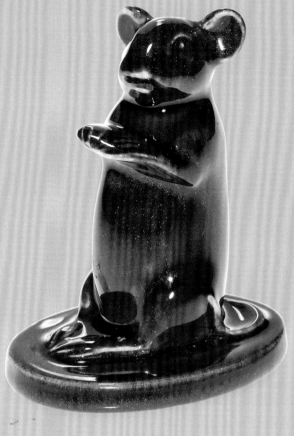

Meanwhile, as he looked down on the Queen City below, Kitaro dreamed of Japan. His family's surname meant "Pleasant White Mountain Valley" in his native tongue. The area near Tokyo had been home to his ancestors for centuries. Arriving in the American Midwest to work at Maria Longworth Nichols Storer's new pottery factory fulfilled her wish to replicate the Japanese ceramic art that she so admired. The young heiress was awestruck by the Asian exhibits at the Philadelphia Centennial of 1876, causing her to vow that she would launch a pottery, "a place of my own where things could be made."

With his arrival, Shiry made Maria's dreams come true.

In a relatively short few years, Kitaro's work would spearhead Rookwood's global fame and glory. He shunned such accolades, however, seemingly embarrassed by the pomp. "Shirayamadani is not one who talks about his work," a reporter noted. "It is sacred to him, and discoursing about it is like taking familiar liberties with something divine." Instead, Kitaro quietly continued to paint and design exquisite pieces, exuding beauty and delicacy.

Rookwood's founder was among the chorus echoing these sentiments. Maria admired what Kitaro had achieved, explaining that she believed his "delicacy of touch is unrivaled." She said simply that he produced "beautiful work," a simple, yet powerful, compliment from one talented artist to another.

Falling in love with Asian art and ceramics, Maria had dreamed of producing art that would give people the same uplifting feeling when they saw the pottery in their own homes. Her vision of what Rookwood could be came to life in Kitaro's steady, small hands.

Above
Kitaro designed this mouse (1937), allegedly modeling it after a little friend that he gave crumbs to in his studio at lunchtime. The piece is playful yet intricately detailed and covered in the tantalizing Coromandel Glaze.

Right
Kitaro Shirayamadani poses for a rare photograph in his cluttered Rookwood studio. Hiring Kitaro fulfilled Maria Longworth Nichols Storer's primary goal of bringing a Japanese artist to the pottery.

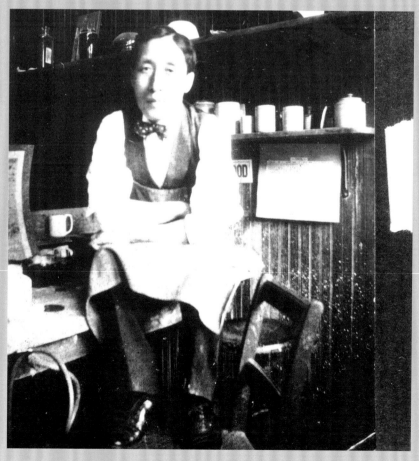

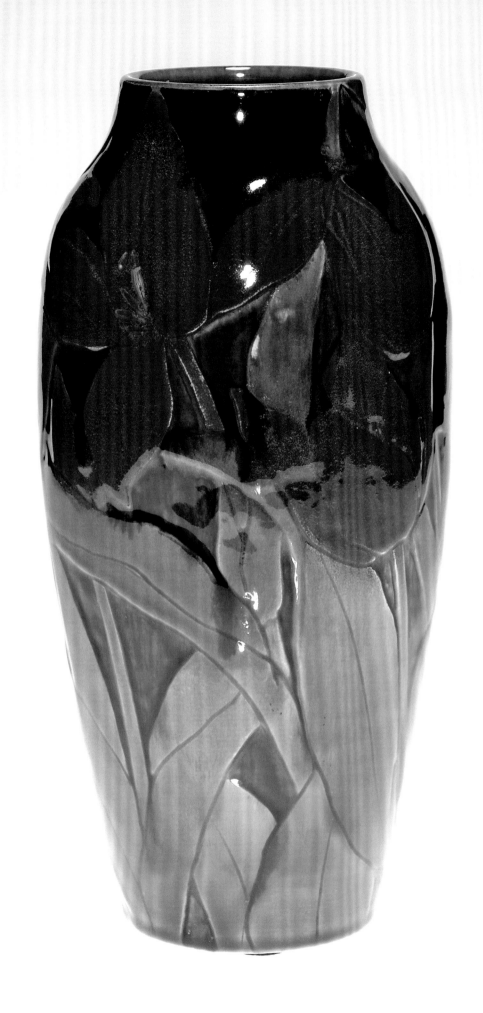

9 Collectors Seek Treasures

Kitaro Shirayamadani's talent enabled him to mix ideas within art movements and even single pieces. This 1927 vase features a stylish decoration of luxuriant red tulips, emphasizing the deep green leaves and stems. The whole object is modeled and then painted.

When Rookwood ceased production, the meaning of "Rookwood" changed from a business entity to an idea. What people meant when they considered the name Rookwood ran the gamut from "antique" and "museum" to "masterpiece." "Rookwood" transformed into a concept—its meaning continuously evolved to fit the representation imagined by the collector, curator, consumer, or auctioneer. It was once an iconic name of American art pottery that filled public spaces nationwide, but others now dictated what the brand meant.

In 1911, ceramics scholar W. P. Jervis discussed Rookwood's booming faience division. He almost prophetically saw this area as Rookwood's lasting contribution to society. "Many fine hotels and public buildings have rooms entirely decorated with Rookwood productions, and these will doubtless prove the most lasting monuments to the artistic genius of their creators." The writer, who was also an accomplished potter, held deep reverence for his industry. However, he could not have anticipated how the world would change across the rest of the twentieth century.

Rookwood's decline as a business entity anticipated its drop from the public eye. As decades passed, Rookwood became a remnant of a forgotten past. In the mid- to late-twentieth century, many of the nation's grand hotels and public buildings were deemed outdated. Entire Rookwood rooms and other large installations would fade into yesterday at the hands of wrecking balls or neglect.

For at least fifty years, Rookwood meant something to discerning art lovers and consumers. Its reputation was carefully crafted and maintained. For many people, Rookwood would be the art pottery they viewed at museums around the world. As time went on, Rookwood would reemerge as works of art that one could buy, sell, or trade. For some, Rookwood was—and may still be—an elusive treasure discovered or uncovered at a garage sale, flea market, or rummage shop.

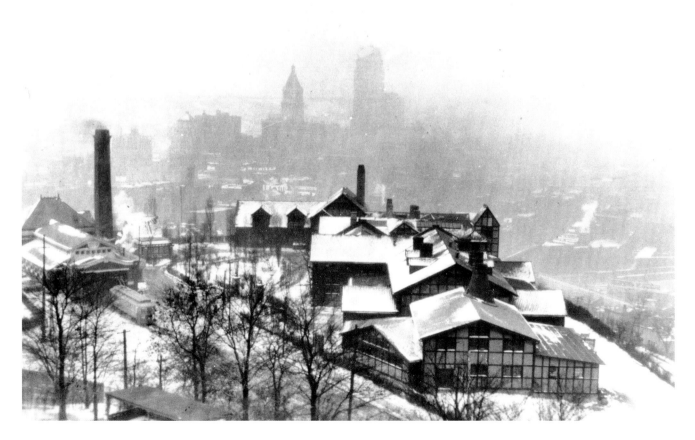

Rookwood overlooking the snowy Queen City at its full production capacity.

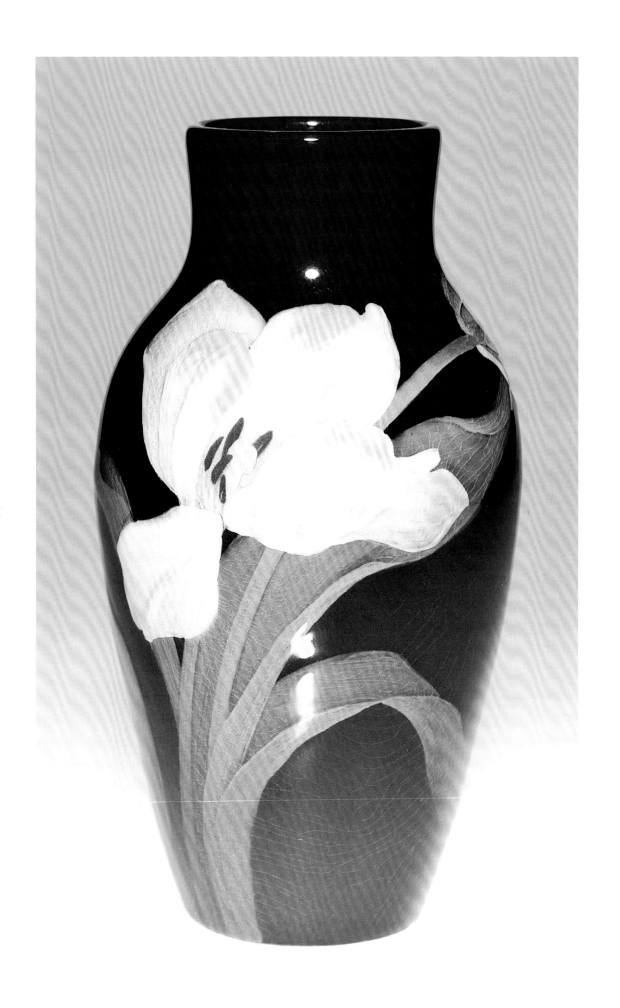

Just over 8 inches (20.3 cm) tall, a Sax Black Iris vase (1903) with pink and white tulip decoration. A single open flower is visible on the front and an opening bud to its right.

What Is Rookwood?

The distinction between old Rookwood and current or new Rookwood probably began as early as the 1940s, if not during the previous Depression-era decade. Certainly the days of winning international acclaim and purchases by museums seemed long past as the pottery fought to stay in existence.

According to Riley Humler, auction manager of Humler & Nolan Auction Gallery and twenty-year appraiser on PBS's hit television show *Antiques Roadshow*, interest in Rookwood among collectors dropped to an all-time low by the 1950s. "Modern fashion replaced earlier love for Victoriana and Art Nouveau," he explained. "Quality Rookwood and Tiffany pieces could be found in secondhand stores for pennies on the dollar."

On the other hand, Humler said, there were a few collectors who understood the old adage about quality being quality, so they began buying up pieces, assuming that interest would some-day return. These were discerning buyers, frequently with training in the arts, architects, artists, or others who had gained an appreciation for Rookwood.

Two early Rookwood collectors were David and Kay Glover, a couple who lived in Glendale, Ohio, a bucolic near-suburb of Cincinnati where members of the Proctor family (Proctor & Gamble) had mansions and estates, as did other wealthy families. The Glovers amassed what might have been the largest private Rookwood collection ever assembled. "David attempted to buy up every piece of Rookwood he found so that, in essence, he could control the burgeoning market," Humler explained. "Unfortunately, he underestimated the amount of Rookwood produced over the years, but did manage to acquire over 1,600 pieces. Mindboggling to say the least."

Humler's personal interest in Rookwood began in the 1970s, when visiting the Glovers to see the collection. The future Rookwood expert would later be reunited with the Glover collection some two decades later.

In the 1970s, art enthusiasts slowly redis-covered American art pottery, which experts loosely dated from the Philadelphia Centennial Exhibition in 1876 to around 1930. Interest in this "lost" era gathered momentum, which was accelerated when a 1972 exhibit on the American Arts and Crafts movement opened at Princeton University Art Museum, organized by Robert Judson Clark.

The next year, the exhibit traveled to Chicago and Washington, DC. The resulting publicity and exposure drew in collectors. According to one reporter, "a few people who did like to collect but had limited budgets began to get interested in ceramics." Other museums and art institutes followed suit.

David Rago, partner at Rago Auctions in Lambertville, New Jersey, and longtime appraiser on *Antiques Roadshow*, got his start collecting as a teenager in Trenton, New Jersey, buying, as he recalls, "cool household stuff, self-recorded 8-track tapes, and the occasional antique." However, Rago moved into porcelain because his hometown had been the home of art pottery, dating back even before Rookwood. In the early 1970s, he said, "The pottery market was in its puerile state, but still quite exciting and robust."

In September 1979, the public sale record for a Rookwood piece was broken by a Daly vase featuring an image of a samurai warrior, which the Robert W. Skinner gallery in Bolton, Massachusetts, sold for $10,250 to the Jordan-Volpe Gallery in New York.

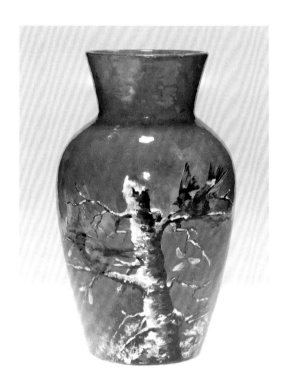

Created in 1882, this extremely rare Limoges-style piece by Albert Valentien demonstrates how early in its history Rookwood (and the artist) produced complex art pottery. It is also one of the few remaining works stamped with "Eastern Avenue."

Finding a Treasure

In 1980, Rita Reif wrote about Rookwood's upcoming 100th anniversary in the *New York Times*, explaining for a national audience largely unaware of Rookwood that the day Maria "fired the first kiln" was when "the American art pottery movement was born." Reif continued, saying, "Throughout its existence the pottery was regarded as the most prestigious and creative of all the studio workshops in this country."

Marking Rookwood's centennial year, the Jordan-Volpe Gallery at 457 West Broadway in New York City held an exhibition entitled, "Ode to Nature: Flowers and Landscapes of the Rookwood Pottery, 1880–1940." Guest-curated by Cincinnati Museum curator of education Kenneth Trapp, the accompanying catalog he authored gave Rookwood to a new audience. The splashy SoHo exhibit, according to Reif, was a "museum-quality show," the culmination of eight years of research.

The Jordan-Volpe Gallery exhibition made national headlines. Tod Volpe emphasized the idea that Rookwood should be viewed primarily as art. The exhibit featured 100 examples of pottery, along with company records, artist sketches, and photographs. "Until now," Reif assessed, "Rookwood has been as unknown to the general public as was Louis Comfort Tiffany twenty-five years ago."

Collectors, however, had been quietly pursuing the company's wares since the 1972 Princeton exhibition. Unlike many previous shows, the focus on Rookwood and its impact on American art pottery gave viewers a new way to appreciate the historical significance of the studio and its artists.

Reif mentioned many of Rookwood's artists in her *New York Times* article, but emphasized Kitaro Shirayamadani, saying that his vases were "far and away the most astonishing work in the show," noting the "variety and vigor" of his designs. An example of the way Rookwood pottery clutches at one's heart when they fall in love with a particular artist or era was when Reif gushed, "At every stage of Shirayamadani's long career, his poppies and water lilies pulse with a life that no other Rookwood artist achieved."

By the end of 1980, a Sotheby's auction drew sale prices exceeding estimates. For example, an 1898 Kitaro standard glaze vase sold for $7,000, twice its appraisal. In what seemed like a quick turnaround, the market heated up.

"A piece of Rookwood featuring a Native American portrait sold at auction in New York for $32,000 in 1980 and suddenly, the market was booming," Humler explained.

In January 1987, a syndicated newspaper article by Ralph and Terry Kovel highlighted the revival in American art pottery that pushed Rookwood back into national headlines. Collectors and buyers scrambled to find top pieces. The hunt for Rookwood was on and additional auction houses got in on the effort.

"I had began working for Randy and Michelle Sandler at Cincinnati Art Galleries in 1987, hired because I was interested in art and Rookwood and Randy was expanding his gallery," Humler remembered. They wanted to land the Glover collection while the market was hot. "We both knew about Glover, but attempts to buy his collection by Randy and others went unheeded."

Around Cincinnati and the region, people saw Rookwood most frequently in real estate listings. Each year, hundreds of home sales and rental properties would be elevated to luxury status by including "Rookwood" as a feature, whether a fireplace or an entire room. Countless newspaper profile pieces also highlighted when

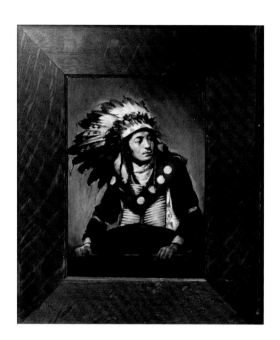

"Chief High Hawk" plaque painted by Grace Young (1903) in Standard Glaze with headdress, breastplate, and tomahawk, in its original frame, was made for the 1904 Louisiana Purchase Exposition in St. Louis. Rookwood's Native American works have become a mainstay of contemporary ceramics collectors.

local or visiting celebrities owned pieces or had some connection to the company. For example, Buddy LaRosa, a famous Queen City pizza chain magnate, was also an art collector. The *Cincinnati Enquirer* profiled LaRosa, including one of his "treasures," an 1898 Rookwood portrait vase.

In February 1991, the Cincinnati Historical Society held a special exhibit at the Union Terminal center that showcased the history of collecting in the city. One of the main features was the large wood and glass case Rookwood used at the 1900 World's Fair in Paris. Because the Union Terminal housed the Rookwood Tea Room as well, the exhibit drew many curious onlookers.

In June 1991, Cincinnati Art Galleries held what was at the time billed as the world's largest auction of Rookwood Pottery at the Queen City's Music Hall (itself with ties to founder Maria Longworth Nichols Storer and her early artistic patronage). Some 1,600 pieces were up for sale, the heart of the collection from the Glendale couple that had been collecting since the 1960s.

"Around 1990, David Glover died and we were alerted to the potential sale of the collection," Humler explained:

Negotiations followed and soon Cincinnati Art Galleries suddenly had 1,600 pieces of Rookwood Pottery to sell. It was thought that an auction might be the best way to sell the collection, giving everyone a chance to bid and buy as they wished. Randy wanted to do a sale that allowed the buyers to feel confident about what they were buying so we quickly established some rules, relatively unheard of in the auction world.

Throwing the traditional ideas about how to run an auction out the window, Cincinnati Art Galleries made the experience more customer-centric. For the Glover sale, they carefully inspected the Rookwood pieces, recording the basic description, and alerting buyers to any crackling, chips, or other damage. They also allowed potential buyers to take a look before bidding.

Cincinnati Art Galleries took some heat from other dealers who thought putting so much Rookwood

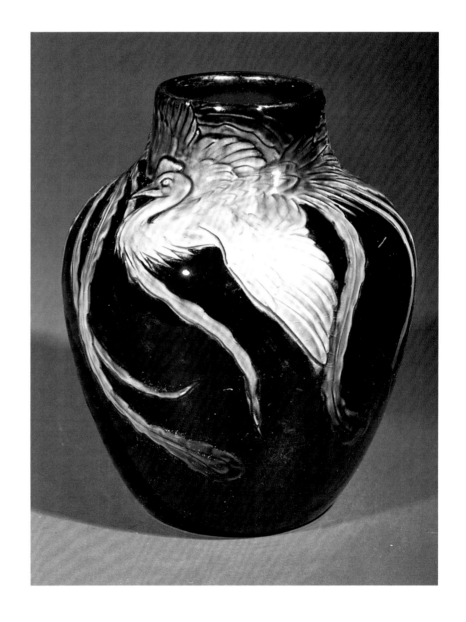

Above

An exceptional Scenic Vellum plaque by Ed Diers (1927) of Yosemite's majestic El Capitan in colorful pink, lavender, brown, and green, including the mercurial Merced River. It sold for $58,750 in early 2004.

Opposite

Renewed interest in Rookwood in the early twenty-first century drove higher prices. Black Iris Glaze pieces were particularly fruitful, such as this 1899 carved, bulbous vase (8¾ × 7 inches [22.2 × 17.8 cm]) by Matthew Daly featuring blue and white birds-of-paradise against a deep black background. In early 2004, Rago Arts sold this vase, estimated at $30,000, for just over $44,000.

on the market would depress the demand, but according to Humler, the opposite occurred. "Before the Internet, it was nearly impossible to find Rookwood for sale unless you frequented antique shows or pursued the few antique weekly newspapers available. There were collectors out there, but none of us knew each other, and no one had any idea how many collectors there were."

Instead of kicking the bottom out of the market, the June 1991 Glover Collection sale by Cincinnati Art Galleries demonstrated that the pent-up demand for Rookwood would blow the roof off. The auction started strong, and prices increased over the three-day period. "One piece brought $198,000, shattering the Record for Rookwood or any American Art Pottery," Humler said. "Rather than flood the market, it seemed like we could have gone on with another 1,600 pieces with no slowdown in sight. All of a sudden, the Cincinnati Pottery that nobody wanted in 1940 was the darling of the antique world." Cincinnati Art Galleries had proven Rookwood's place in American art. Not bad for a company that had set out to do one auction and then shut down. They continued to do Rookwood sales for another thirty years.

In early 2003, the Cincinnati Art Museum took a bold step, opening the Cincinnati Wing, an 18,000-square-foot (1,670 sq m) gallery dedicated to the art history of the Queen City. The permanent exhibit highlighted the region as an epicenter of the nineteenth-century marriage of art and industry, a complex topic that the nation still confronts today. Both then and now, the Cincinnati Wing reveals the intricate relationship between artists and art patrons. The Longworth family, which had such a central role in shaping Cincinnati's creative past, held a central role in the exhibit. One observer noted that without Nicholas Longworth's "generosity to local artists . . . Cincinnati's art world would not have attracted the attention it did in the nineteenth century."

Given its illustrious initial fifty years, then rocky survival through the late 1960s, Rookwood stood as a case study across many styles

on display in the Cincinnati Wing, from the precarious dance between art and commerce to ever-changing consumer tastes and desires.

Ironically, several of the societal events that transpired against Rookwood in the 1930s and beyond would come back and take a bite out of the collector's market in the late 2000s, including a series of national economic calamities and topsy-turvy consumer tastes. "After the 2008 crash of the stock market, the decline began and it has not abated," Humler noted. "Values are half or less from the 1990s and it is a buyer's market again and definitely not a seller market."

An additional challenge is generational and the eternal give-and-take of age and entropy. As the massive Baby Boomer generation ages and passes away, the sizeable Millennial generation has not valued collecting.

"If people understood Rookwood, and other pottery, for what it really is, that might rekindle the love and enthusiasm of fifty years ago," Rago added. But it is a difficult process that has no easy levers to trip that internal wire in what people think:

Where people see a pretty vase, I see a fingerprint of a place and a time that, in its way, captures—like a photograph—the uniqueness of the moment. That pot simply wouldn't look like it does, were it created at another place, in another era. [Appreciation of history] attempts to instruct beyond the skin-deep beauty of the artwork.

"The group of collectors that made the Glover Collection such a success have grown older and either faded away or lost interest," said Humler. "Yes, there are still serious Rookwood collectors but we are a dying breed." Anticipating the future of collecting Rookwood, he added, "I can only say that 'quality will always be quality,' so it remains to be seen what future generations will feel about the golden years of Rookwood, America's Finest Art Pottery."

The Most Expensive Piece of Rookwood

RILEY HUMLER

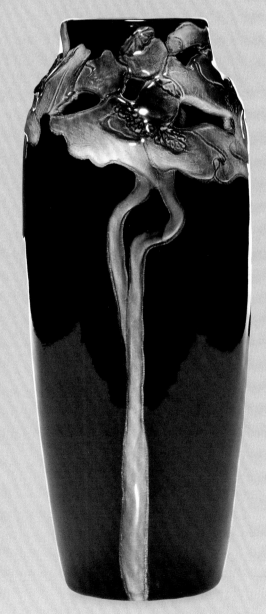

Another highly artistic Black Iris Glaze vase in comparison to the record-setter. Unlike other decorators, Wareham made cutouts in vases with the carving heightening the thick red-orange flowers and balancing the narrow green stems (1901).

On June 6, 2004, Cincinnati Art Galleries set a record for both Rookwood and American art pottery, selling a Kitaro Shirayamadani vase for $350,000. The Rookwood record has yet to be broken and, arguably, might never be topped.

I was fortunate to be involved with selling the most valuable Rookwood piece ever, a Black Iris Glaze vase with electroplated silver and bronze mounts. Created by Kitaro Shirayamadani, the piece was quite possibly sent to the 1900 Paris Exposition with other important artworks that helped the pottery win international acclaim.

The vase itself featured several white cranes in flight on a rich black ground, with the base consisting of carved and electroplated vines and stems, the whole measuring 14½ inches (36.8 cm) tall. The Kitaro piece is clearly one of the most striking examples of Rookwood ever made. The vase also had wonderful credentials, in addition to its intrinsic value. The piece played a starring role in the Cincinnati Art Museum's seminal exhibition of Rookwood, "The Glorious Gamble."

I had been approached by Truett Lawson, the owner of the vase, a year or so before we sold it. I advised him to wait a bit before selling. The market was in a slight downward mode and I felt it better to see if that trend corrected itself, which it did. We agreed on estimates and a reasonable reserve price and scheduled its entry into the June auction in Cincinnati.

There were countless hopeful bidders interested in the Shirayamadani masterpiece. Many phone lines were requested and one very important absentee bid left with me. In the final moments, despite the excitement and extensive bidding, there were only two going tooth and nail at the end. The undertaking had come down to the eventual owner and myself. I was bidding for the Cincinnati Art Museum.

The Art Museum had left that significant absentee bid, which I felt would surely win. However, the private bidder had other plans and, while on the phone, bid the next increment past the museum's high amount. I was shocked, but that is what makes an auction interesting! Certainly the excitement and high bids makes the seller and the auctioneer happy.

As it turns out, the private bidder was also a patron of the Cincinnati Art Museum. Discovering that he had bested his favorite place to visit, the new owner decided to donate half the value of the vase to museum, which allowed the institution to buy it at far less than it was prepared to spend. It was a wonderful bit of largess on the part of the private bidder and a great boon to the museum.

Now the vase is proudly on display at the Cincinnati Art Museum for all to see. The artwork remains one of my favorites, as well as perhaps the most beautiful example of Rookwood ever made.

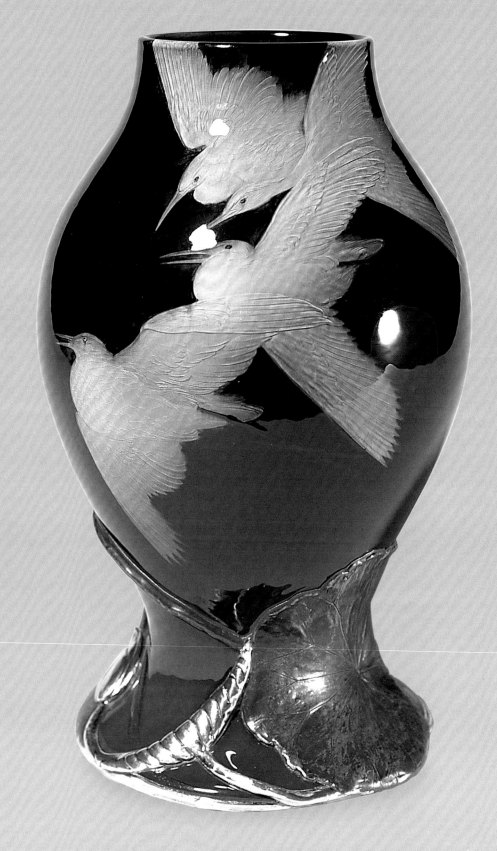

A rare glaze vase created by Shirayamadani in 1900, most likely explicitly for exhibition at the Paris World's Fair, which Taylor determined would be a showcase for Rookwood. The 14½ inch (36.8 cm) vessel is accentuated with electroplated silver and copper metal mounts. The hand-painted decoration features caramel-colored flying cranes gliding through a sea of black clouds.

Dr. Townley Saves Rookwood

GEORGE HIBBEN

Art and Rita Townley became enamored of Rookwood Pottery, first as collectors, then as the stewards of the pottery from 1982 until 2005. Hearing of a possible purchase by an Asian company when the Herschede family decided to find a buyer in the late 1970s, the Townleys withdrew their life savings and purchased the assets of the Rookwood Pottery Company. Knowing little of pottery production, they focused on using some of the 3,200 archival molds to re-issue numerous pieces, including animal figurines, the Union Terminal Bookends, small vases, and a handful of others.

The wares looked somewhat amateurish at first, due to hand-brushed glazes—airbrushing created a more pristine product. At least fourteen different animal forms were issued, with a limited mark (e.g, 14/250), often scratched into the bottom. This crudeness may have been why the Townley Era was often misspoken of as reproduction Rookwood—not true, but rather a different ownership group in a family operation of six people. This "Present Day Rookwood" was also marked either in a sticker or decal.

The Townley Era represented a labor of love for the pottery and its heritage, which culminated in the sale of Rookwood in 2005, based on Art's health issues and an investor group willing to relocate Rookwood back to Cincinnati. The Townleys wanted Rookwood to return to where it had all begun. The search for a set of Union Terminal Bookends began the discussion that ended in Rookwood returning to its hometown.

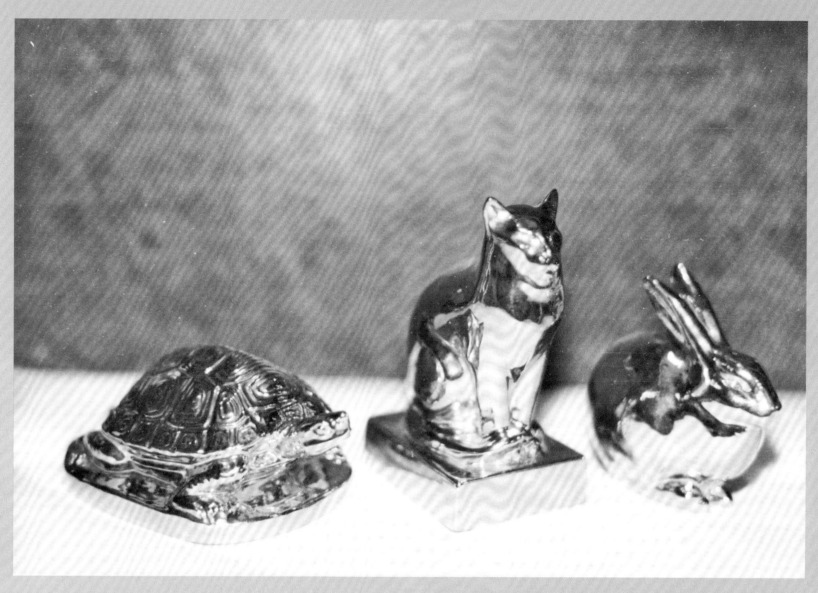

Above
A photo of three animal paperweights that Dr. Townley sent to prospective buyers and antique dealers.

Right
Historic pottery molds kept in Art Townley's workshop.

Opposite
An advertisement that Dr. Townley created for three of the popular gold-plated paperweights he created from historic Rookwood molds.

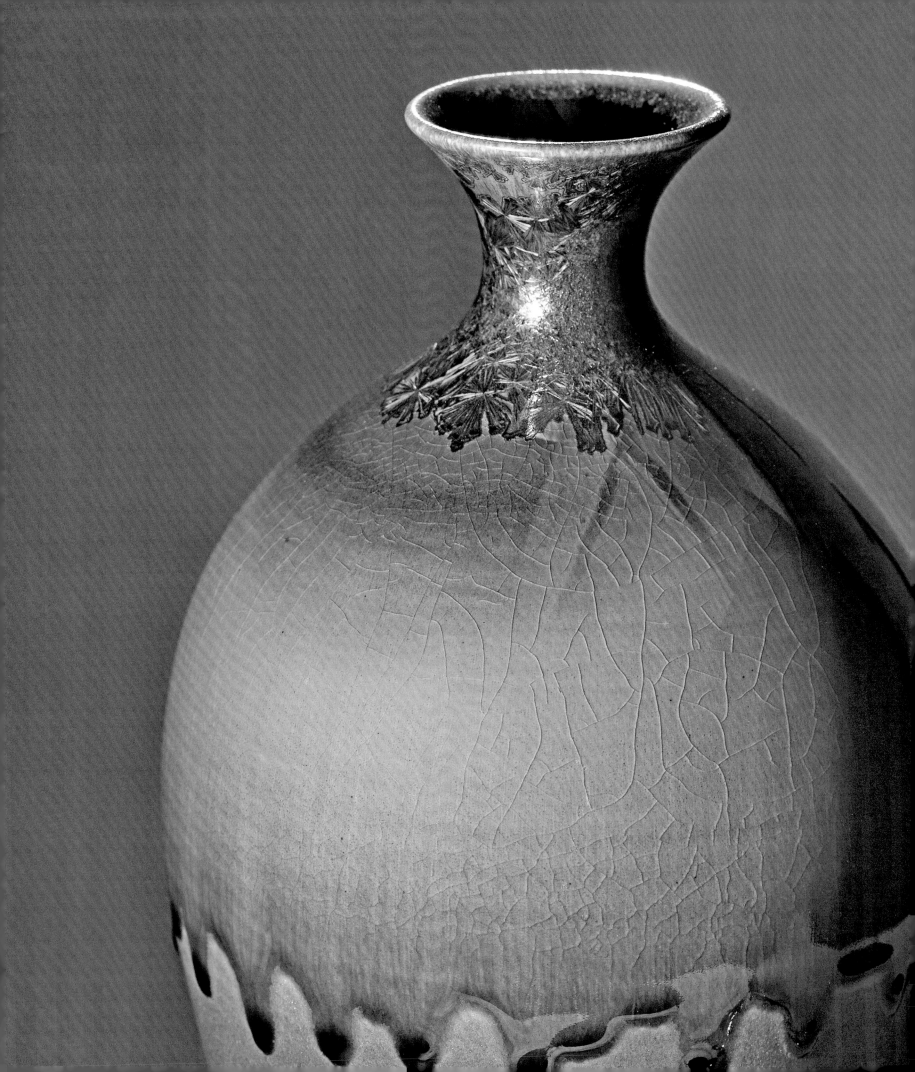

10 Rediscovery and Revival

In the twenty-first century, consumers have returned to classic ideals—valuing things that symbolize quality and authenticity while shifting to handcrafted, unique products made by people, not by machines. A resurgence in the appeal of craftsmanship has emerged, even as—perhaps in contrast to—the tech-based world that grows more interconnected every moment. Since returning to Cincinnati, Rookwood has embraced these values, creating handcrafted art pottery and tile that bring beauty and elegance into people's daily lives.

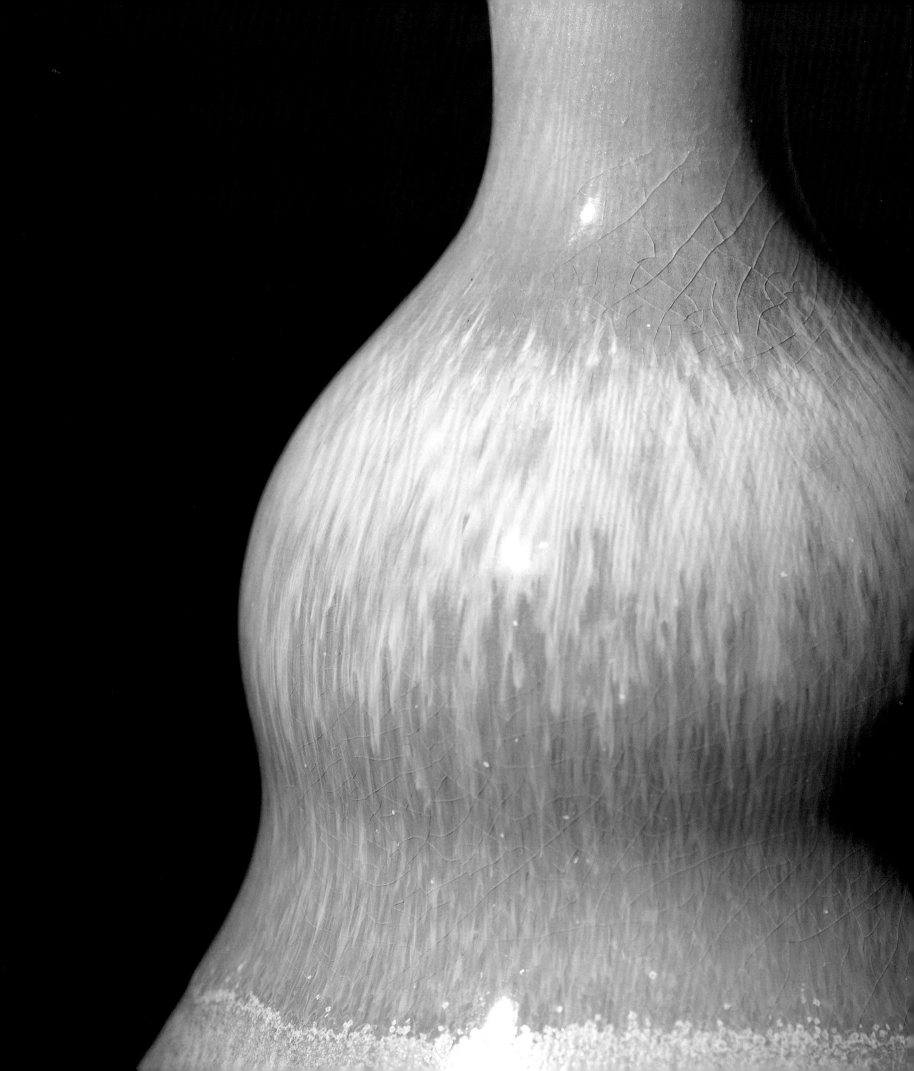

"Glazes have personalities," explained Ashley Neumeister, Rookwood's lead glaze technician. "Sometimes they react to one another in interesting ways, while other times they just want to be by themselves." As a result, while it might seem counterintuitive, glaze chemistry is actually both science *and* art. The most stunning glazes are often the most difficult to create. "Chemical instability keeps us constantly testing and refining what is successful," Neumeister said.

The link between science and art—and the amazing results of that connection—is the most enduring tie across Rookwood's history. From the earliest days to its newest pieces, unique glazes have been the defining aspect of Rookwood . . . its very lifeblood.

Examining new crystalline glaze samples under a microscope, Micah Carroll, Rookwood president and chief executive, points to the deep fractures within the glaze that, in turn, produce stunning, one-of-a-kind tiles. "We've been creating products like this for more than a century, but the harmony of color, form, and design frequently leads to new surprises." The commitment to research and refining its glaze lines has always been Rookwood's priority. "It's been said that every Rookwood kiln ever opened contained some experimental pieces," Carroll said. "Today we benefit from that knowledge and use it to create functional works of art for modern consumers."

Left
Molokai Glaze, a crystalline glaze in a palette of bold greens and blues. Based on both the contours of decorative tiles and hard versus soft edges on the tile perimeter, the microscopic crystals will thin or concentrate. Hard edges tend to concentrate crystal formation, while soft edges allow the background color to dominate. The beauty is the variability and elegance in each individual piece.

Opposite
Today's Rookwood is a combination of shape and color, here an innovative glaze pattern moving from tan and orange through variations on blue, purple, and violet.

From hand thrown vases to architectural tile, Rookwood is constantly extending what glaze can achieve. The chemists of one hundred years ago would marvel at what the current team creates. The science and experimentation have enabled the company to move light-years ahead of what was fashioned in the early part of the twentieth century.

Art pottery helped define how consumers would view everyday luxury as the era of the consumer began in the 1880s and has continued—and intensified—well into the twenty-first century. As one would imagine from a company that played such a pivotal role in creating American art, Rookwood has become synonymous with luxury.

In the early years, Rookwood's role in beautifying people's lives meant creating ceramics that were functional and attractive. Americans were just beginning to realize that creating pleasant surroundings at home would have additional positive benefits. This tie between art and life still drives Rookwood today.

Consumers want to be regarded as individuals, not a collection of data or sales points. Self-expression has also led to a closer examination of the products they use to beautify their everyday surroundings and add meaning to their daily routines. "The real test of an object's worth lies not in its efficiency, novelty, or even beauty," explained art curator and writer Glenn Adamson, "but in whether it gives us a sense of our shared humanity."

Self-expression via the objects we surround ourselves with is a central facet of people's worldviews. What people value is constantly shifting and evolving. What has meaning for people living in a high-tech world? Though Rookwood is rooted in its history, it delivers on these consumer needs to reconnect with thoughtful gift-giving and inspired surroundings.

"Our history is important to us," explained Marilyn Scripps, Rookwood's owner, "but included in this link to the past is a commitment to the future by bringing together a team of artists to make handcrafted, artisanal products for today's lifestyle." When it comes to maintaining an iconic brand, Scripps said, "We are caretakers, but in the same instant, we're really focused on the future. I think it is important that Rookwood also inspires future generations as well."

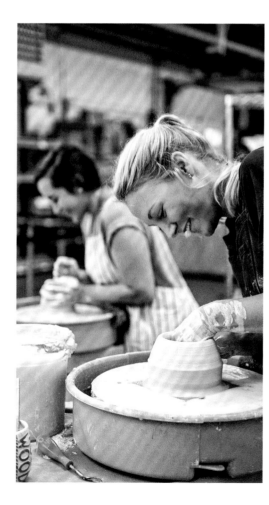

Left
Rookwood artists Lauren Thomeczek, left, and Morgan Willenbrink, right, create hand thrown works, as potters have been doing for millennia.

Right
A daring display of what modern glazes can produce. This hand thrown vase features a variety of crystalline facets, as well as an incised lower half.

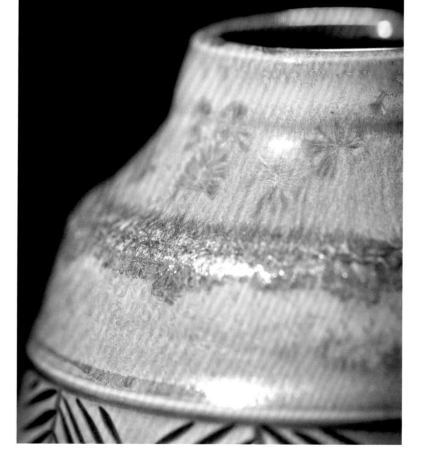

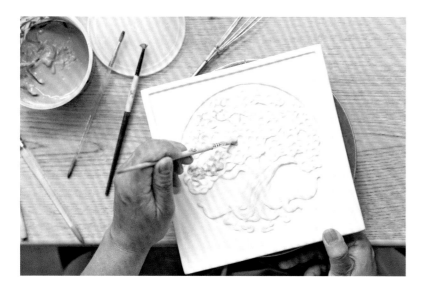

Top left
Members of the Polychrome team paint architectural tiles, like the popular Tree of Life, each meticulously glazed by hand.

Top right
Glaze technology is precise and demands constant testing and experimentation, which has always been at the heart of Rookwood's products.

Left
Production team member Harmony Denlinger in the Over-The-Rhine factory.

Above
The fanciful swirling Rhapsody tile makes any space stand out from the crowd.

Return to the Queen City

Art and Rita Townley continued manufacturing Rookwood pieces from their workshop in Michigan. They faithfully kept the trademark active and also marketed to antiques dealers through articles in periodicals such as *Antiques Weekly*, an important publication in the pre-Internet era.

In 2000, David Pittinger, a fifth-generation Cincinnatian and lifelong Rookwood collector, hunted for a set of elusive Union Terminal bookends, the originals designed by artist Arthur Conant to commemorate the Art Deco train station that opened in the Queen City in 1933. Pittinger started collecting Rookwood at garage sales when he was in elementary school and later became fascinated with trains. The bookends were the culmination of his two hobbies. The search led Pittinger, along with his friend Patrick Rose, to Townley. Not only was he remaking the bookends, but the two heard that Townley might soon look to sell the company as he got closer to retirement.

With little but a wing and a prayer, Pittinger and Rose wrote Townley a letter asking about the possibility of buying Rookwood. Pittinger envisioned the company back in Cincinnati, where it had been during its heyday. Although Townley initially turned down their offer in November 2003, some three years later, they received a phone call out of the blue inviting them to Michigan to chat with the owner and take a look at his workshop and pottery collection.

"I was like a kid in a candy store," Pittinger recalls. Townley's basement space was filled with Rookwood history, from thousands of original molds for production wares to rare photographs and company documents. Pittinger remembers it kind of like Santa's workshop, the clay "like bags of flour scattered on the ground." Townley's broad smile grew even larger as he talked about the company and particularly his role as "caretaker, never owner." Rose and Pittinger shared this belief. "We feel like Rookwood needs to come back to Cincinnati," Pittinger said. "It's part of our fabric, part of our city."

Returning to Ohio, Rose received a call the next day from the Rookwood owner. "The molds spoke to me," Townley explained. "I decided that you are the right people to bring the company back to Cincinnati." Within several months, a semitruck full of Rookwood molds more than a century old, priceless documents, and materials were on their way to the Queen City.

More like launching a new startup than a venerable return, Rookwood grew into its new role. In 2006, Marilyn Scripps purchased the company after a meeting with potter Allan Nairn and chemist Jim Robinson, who were concerned with the direction management took after Pittinger and Rose left. They asked her, in their words, "to step in and save the company." Later, Marilyn explained, "Rookwood is part of Cincinnati, it's integral to the whole city—to let it disappear—that just wasn't possible."

The "new" Rookwood coincided with a revitalized sense of civic and cultural pride in Cincinnati. Much of the city's resurgence began with the renaissance of the historic Over-The-Rhine (OTR) neighborhood, once the home of Cincinnati's thriving German community. These new efforts caught the public's imagination, resulting in OTR's rebirth as a cultural cornerstone.

Settling into a historic factory at 1920 Race Street, Rookwood looked at the shifting consumer landscape and realized that it essentially faced

Above
Handcrafted detail is added to each mold.

Opposite
Rookwood's Over-The-Rhine factory and headquarters. The mural, created by artist Christian Dallas, is a project by ArtWorks, a public art program. Each design element (flowers, birds, and insects) references Rookwood pottery and tiles, influenced by the Revival Bird Tile Series. The floral pattern represents how Rookwood draws on its history, while moving toward a vibrant future.

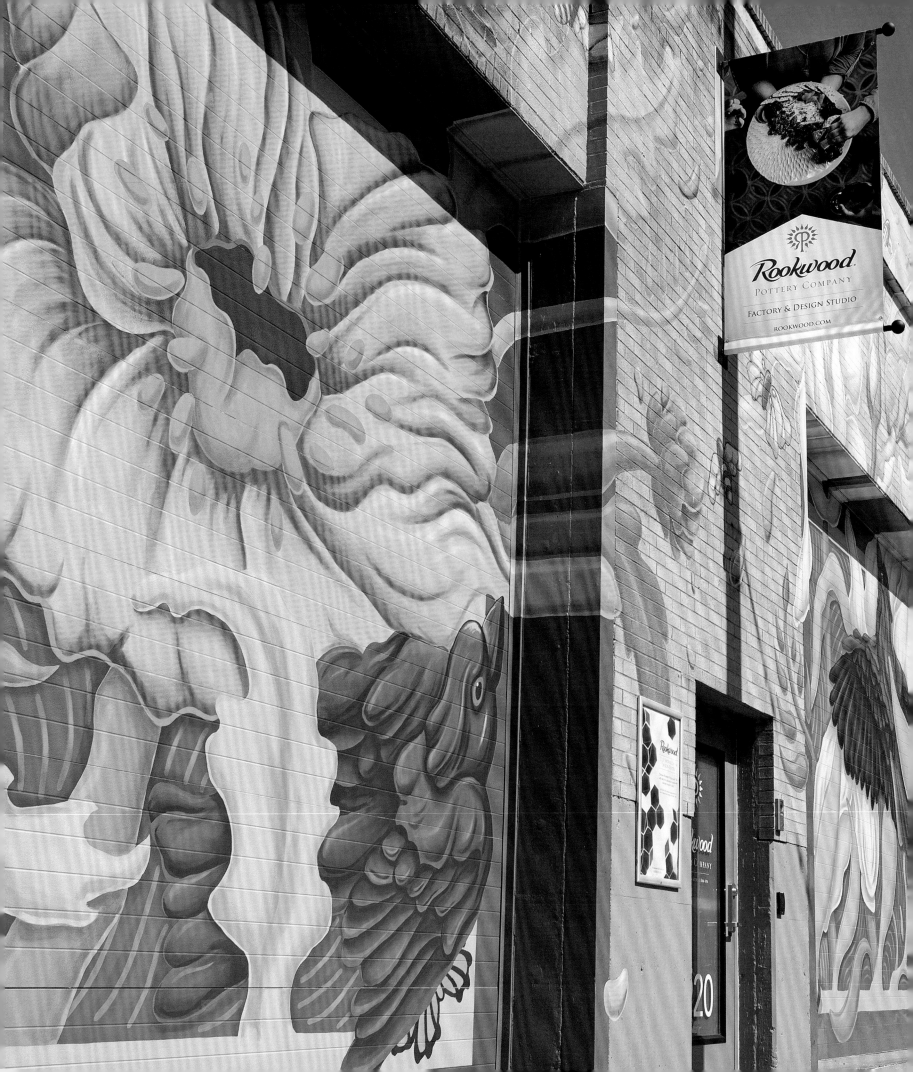

the same challenges that Maria discovered when she launched the company in 1880—the creation of home art and architectural tile that would meet the demand of today's consumer.

Rookwood launched a curated line of new products, including adapting and reintroducing historic glaze lines to creating architectural tiles that were both timeless and trendsetting. Several thousand production molds had been passed down from Townley to Rookwood ceramicists and technicians, enabling them to revitalize products using designs that dated back to the company's earliest days. According to one reporter, the Townley sale included "more than 1,000 molds, thousands of glaze recipes and corporate notes."

Even more important, historic glaze recipes were included in the company assets. Although contemporary environmental regulations made some of the old glazes obsolete, Rookwood

scientists began reformulating the old recipes. Much of the early efforts fell to potter and glaze chemist Jim Robinson. He served as the modern-day equivalent of Karl Langenbeck, the pioneering Rookwood glaze mastermind who was the industry's first industrial chemist.

Critical research and development took place to formulate modern glaze lines. As a result, Robinson and his colleagues were able to create colors that were near-perfect examples of past glazes, while simultaneously developing new innovations. Mat and Gloss Glazes, for example, were a nod to past colors. Others, such as Alkaline and glazes with micro-crackle were new additions to what Rookwood could offer current consumers. Nebula, a deep green glaze that attracted people's attention right away, mixed old and new, actually updating Rookwood's famous Tiger Eye, which had been such an important part of it winning so many international awards.

Another link to Rookwood's past is the continuing evolution of craftsmanship through dedication to research and experimentation. Since 2006, the company has conducted more than 50,000 tests to develop its architectural tile glaze collections.

If the connection to Cincinnati and commitment to research and experimentation are two legs in Rookwood's heritage, then the final attribute is dedication to employees. The people at Roowood are a collection of forward-thinking creatives, committed to manufacturing world-class, handcrafted products. The tie here links directly back to Maria, William Watts Taylor, Kitaro Shirayamadani, John Wareham, Sara Sax, and the generations of Rookwood employees motivated by the drive to craft the highest quality ceramics possible.

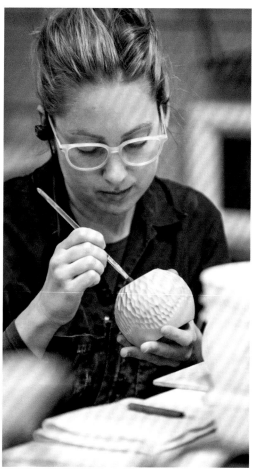

Architectural Tile and Crystalline Glazes

GEORGE HIBBEN

The Architectural Tile line was reborn in 2006 when Rookwood returned to Cincinnati. Each year, new patterns, shapes, colors, and styles are introduced, as well as many of the heritage designs that would appeal to modern audiences, whether an architect, an interior designer, or a customer remodeling a residential living room, kitchen, or bathroom.

Mat, Gloss, Crackle, Crystalline, and Studio Glazes have been developed with new recipes for modern applications. From traditional Arts and Crafts to geometric contemporary designs, Rookwood emphasizes design trends suited for a range of styles.

One of the most elegant and unique glazes is Rookwood's Crystalline Glaze line. This is definitely not a historic look—Rookwood's chemists created a recipe that utilizes minerals to create crystals in breathtaking colors.

Rather than a uniform look, the Crystalline Glaze produces variable effects. These variations take place chemically and in the firing process, based on microscopic crystalline formation and the contour of the form on which the glaze is applied.

As a result, the idea that Crystalline is one-of-a-kind takes on a whole new meaning. Rather than just a single piece being unique, each tile in an installation can be completely different based on miniscule variations of microscopic crystalline formation. The intensity of Crystalline is part of the beauty of Rookwood glaze art as it evolves to bring twenty-first-century luxury into people's daily lives.

Top
A unique backsplash at a bar and eatery, Zing is shown in a variety of bold Studio Glaze lines.

Bottom
Close-up of the playful crackling created by Crystalline Glaze innovations.

Opposite
An inspiration board showing a variety of Rookwood architectural tiles.

Rookwood in the Twenty-First Century

"Taking our legacy and making it new again."

– MICAH CARROLL, ROOKWOOD PRESIDENT AND CEO

Rookwood has come full circle in its long journey. The first manufacturing company founded by a female, Rookwood today is woman-owned, under the passionate vision of Marilyn Scripps. Although the factory helped change business and societal norms in the late nineteenth century by employing women, the company's workforce is now more than 70 percent female, unique in the manufacturing sector. Then, as now, Rookwood is a prominent force in American-made ceramic art across decorative pottery and architectural tile.

When Rookwood returned to Cincinnati, it again became something more than art pottery viewed in museums around the world and architectural tile in landmarks across America—it reemerged as a modern lifestyle brand.

This merger of historic and contemporary influences is precisely what Carroll sees as the power of the company's legacy in the twenty-first century. Bridging the past and future provides an opportunity to "stay true to Rookwood's innovative core," he explained, "both building on the past, and looking to what might be next as consumers search for ways to implement functional beauty into their everyday lives."

Philadelphia Museum of Art curator David Barquist hinted to a similar future strategy: "Rookwood was one of the biggest success stories in the art pottery movement, and it attracted a diverse group of very talented artists and decorators," he said. Capitalizing on the talent and handcrafted products was also a Rookwood specialty. "It also produced such a large volume and was excellent at marketing and getting national distribution of its wares."

As America's premiere art pottery of the twentieth century, Rookwood will always be more than a thriving business, linking art connoisseurs, collectors, and aficionados to the ideal of art pottery itself. From this vantage, Rookwood in the twenty-first century also has a role in museums and as collectible art. For example, in 2018, painter and art patron Robert A. Ellison Jr. donated more than 300 pieces of American art pottery to New York City's Metropolitan Museum of Art. At the time of the donation, a writer remarked on Rookwood's place in the collection, saying that the company became "virtually synonymous today with the phrase 'art pottery.'" The Met's collection grew when Barrie A. and Deedee Wigmore donated pieces from their Rookwood collection in late 2019.

The Cincinnati Wing at the Cincinnati Museum of Art continues to display about 100 Rookwood wares, both vases and architectural installations. In June 2018, Rookwood gifted a new fireplace designed by its artists to the museum. Included on the surround are inspirational "ceramic heroes" portraits,

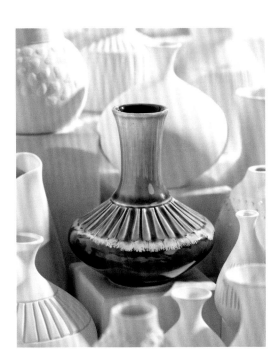

Above
A mini vase that accentuates the artistry of the glaze and hand thrown teams, resulting in a brilliant blue over tan and brown backgrounds on a unique form.

Opposite
The Emilia Share Board from pressed form to its glazed, finished outcome after being touched by a dozen artisans along the way.

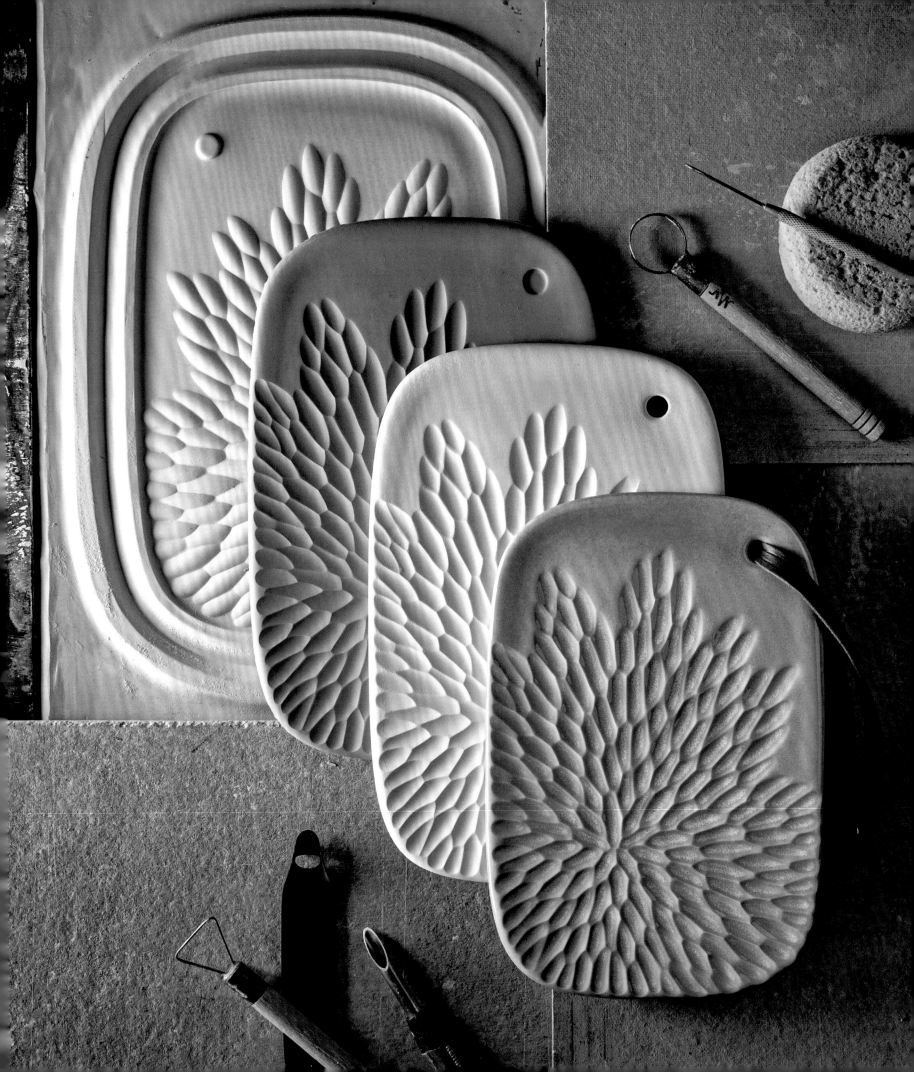

including Maria Longworth Nichols Storer. Amy Dehan, curator of decorative arts and design, told a reporter that the fireplace "has a wonderful connection to our historical collections and brings those collections to life in a way that makes them interesting for visitors today."

The museum continues to utilize its collection in new and inspiring ways. For example, in late 2019 and early 2020, it debuted an exhibit called "Women Breaking Boundaries," a showcase of female artists across geographic lines and art genres. The show features a large early vase (1882) decorated by Maria Longworth Nichols Storer in her essential style, including gold netting in a 3-D effect, daring use of color, and a bright school of fish thrashing about.

The Cincinnati Museum Center, opened in the renovated 1933 Cincinnati Union Terminal, converted its Rookwood tearoom—one of the last, great Rookwood Rooms created by William Hentschel—into an ice cream parlor run by Cincinnati's legendary Graeter's Ice Cream. Now, countless visitors enjoy a sweet treat while learning about local history in the restored train terminal, one of the largest Art Deco, half-dome historic landmark buildings in America.

Because of its deep ties to Cincinnati's roots, Rookwood remains profoundly valuable to local organizations, realtors, and others interested in the city's heritage. UC Health, for example, opened the $68 million Gardner Neuroscience Institute in April 2019, a 114,000-square-foot (10,590 sq m) facility housing some 125 specialists. A centerpiece of the institute was the donation of fifty-two pieces of Rookwood, opened as a gallery in the lobby. The Gardner family collection consists of American Indian wares, formerly exhibited at the Cincinnati Art Museum.

In the late Gilded Age, Rookwood benefited from two foundational ideals. The first: America needed its own homegrown art and artists, sep-arate from the hegemonic influence of Europe. The second: Americans across the economic and cultural spectrum would greatly benefit from a closer connection with art and beauty in their daily lives.

Today's Rookwood proudly carries forward the principles it adopted from its inception, but continues to evolve, utilizing both handcrafted artistry and state-of-the-art technology to create awe-inspiring products. Much has changed since the heyday of the late nineteenth and early twentieth centuries, but the commitment to craftsmanship remains. That is a trait that cuts across the ages and defines a company's soul.

Ultimately, it is only through this dedication that Rookwood makes one-of-a-kind, treasured ceramics that are the perfect harmony of exquisite color, unique form, and eye-catching design. At the core of Rookwood's character, these ideas enable the pottery to bring functional works of art into people's lives.

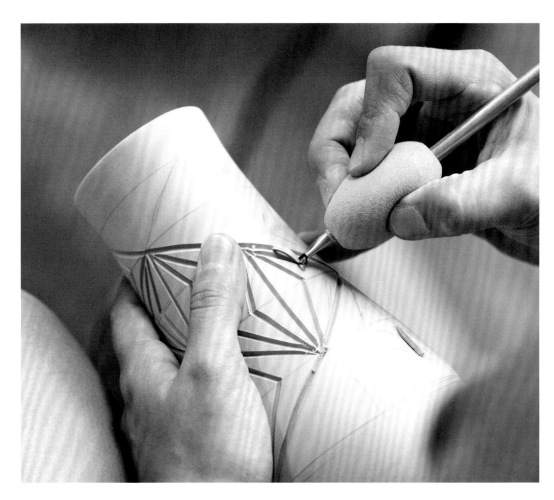

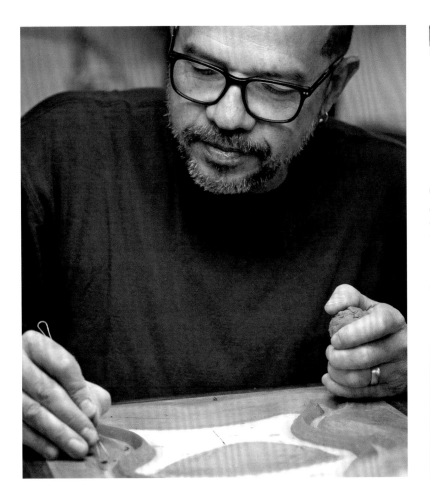

Top left
Luis Laya, a Mold Team member, works on a new design.

Top right
James Acoff using the 90-ton press to create the Emilia Charcuterie Board. After a day, wet trimming and sanding will detail the piece before it dries.

Left
An array of architectural tile glaze samples show a range of Rookwood's artisanal colors.

Opposite
Applying detailed carving features to a hand thrown vase.

Hand Thrown Art Pottery

GEORGE HIBBEN

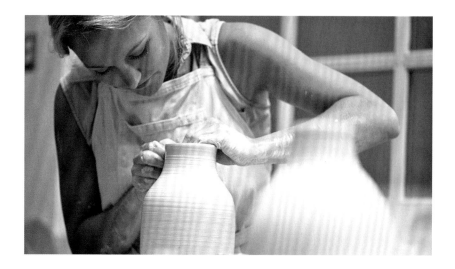

The heart of Rookwood's success has always been its one-of-a-kind art pottery, whether going back to Maria's earliest work, the era of global awards and accolades, or the hand thrown artists today. Rookwood potters Morgan Willenbrink and Lauren Thomeczek create hand thrown and carved vases that are inimitable. This kind of pottery appeals to customers because each piece is unique and made by hand. The pieces showcase the immense talent it takes to throw a beautiful shape, as well as Rookwood's immaculate glazes.

A combination of elegant forms and beautiful carvings merge to create this type of premium art pottery. Once the piece is completed and bisque-fired, Rookwood's glaze artists apply their expertise. The process as a whole accentuates the elegance of both form and carved designs with Rookwood's proprietary glazes.

Top
Lead potter Morgan Willenbrink
shapes a vase on the wheel.

Bottom
Morgan marks the bottom of the vase
with her "MW" cipher, the pottery term
for signature, affixed just below the
Rookwood logo along with other identifi-
ers, such as date, shape, and glaze.

Opposite
Art pottery has changed significantly
since Rookwood's achievements in the
late nineteenth and twentieth centuries.
The focus on hand-painting has shifted
to emphasize unique glaze colors,
shapes, and carvings. Craftsmanship
and authenticity, however, have remained
central to Rookwood's artistry.

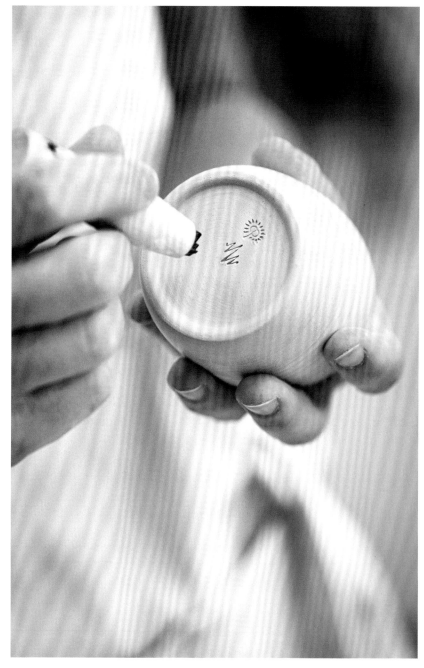

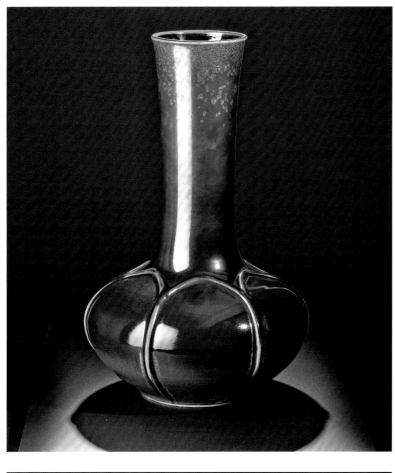

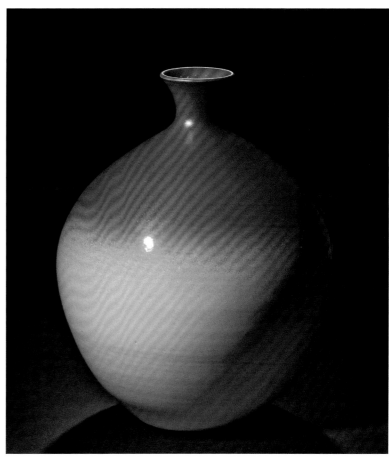

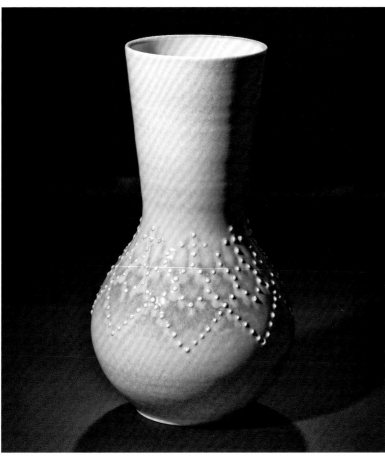

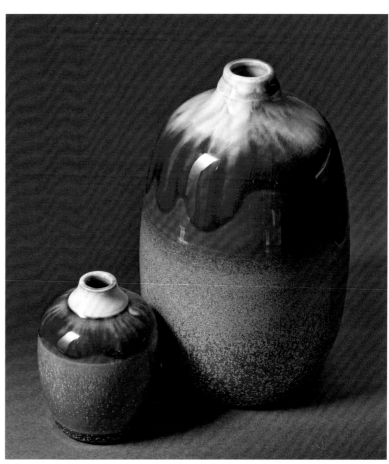

Endnotes

Chapter 1: The Birth of American Pottery

p. 15 "proudly exclaimed . . . will be turned by woman-power.": Maria Longworth Nichols Storer, *History of the Cincinnati Musical Festivals and of the Rookwood Pottery* (Paris: Printed by the author, 1919), np.

p. 15 "Its designs . . . shall be the goal.": Storer.

p. 16 "The main object . . . make cheap ware pretty.": MLNS to Mrs. Keenan, January 29, 1881, Quoted in Sue Brunsman, "The European Origins of Early Cincinnati Art Pottery: 1870–1900," (M.A. Thesis, University of Cincinnati, 1973), 112–13.

p. 16 "establish a footing . . . and the staff she assembled.": Comparing value over time is a difficult calculation that has befuddled economic historians. The website MeasuringWorth, created by noted Miami University professor emeritus Samuel H. Williamson, enables comparison of historic value over time based on commodity, income, wealth, or project. Throughout the book, I use numerous examples of "then versus now" to provide context for the figures. For more information, please see Samuel H. Williamson, "Seven Ways to Compute the Relative Value of a U.S. Dollar Amount, 1790 to Present," MeasuringWorth, 2020, www.measuringworth.com/uscompare/.

p. 17 "The greatest . . . is the pottery.": "Ceramics in Cincinnati," *Daily Leader*, May 12, 1888, 3.

p. 17 "Previous historians . . . bulldozed others with her wealth.": Storer had a tireless work ethic and unbounded energy, which some found offensive in Gilded Age America when women—particularly upper-class females—were supposed to quietly run their households and raise children. Well-educated, based on the opportunities available to women in that era, Maria spoke five languages, sang, played piano at a near-professional level, and preferred to lead, not follow, others. Her intensity was looked at as negative, and her high-profile run-ins with others led to a negative view of her personality and many anecdotes passing into "acknowledged" history. For example, her disputes with ceramics rival M. Louise McLaughlin almost uniformly paint Maria

as a dilettante, or even underhanded in their dealings. See the 1893 exchange, reprinted in Herbert Peck, *The Book of Rookwood Pottery* (New York: Crown, 1968), 47–49; and Anita J. Ellis, *The Ceramic Career of M. Louise McLaughlin* (Athens, OH: Ohio University Press, 2003), 69–70, 94–96, 101–105.

p. 17 "Obviously . . . male workers there.": "High Art," *St. Louis Post-Dispatch*, September 14, 1880, 2.

p. 18 "the idea . . . a place of her own.": Edwin Atlee Barber, *The Pottery and Porcelain of the United States* (New York: Putnam, 1893), 285.

p. 18 "Her attitude . . . usually negative or ambivalent.": Brunsman, 32.

p. 18 "Her wares . . . a prolific inventive faculty.": "High Art," 2.

p. 18 "Of these . . . a large purchaser.": "High Art," 2.

p. 18 "A specialty . . . a variety of other patterns.": Barber, 286–87.

p. 19 "Cincinnati . . . considerable attention.": Quoted in "Mrs. Nichols' Pottery," *Cincinnati Commercial*, April 25, 1881, 4.

p. 19 "Real beauty . . . this very reason.": "Mrs. Nichols' Pottery."

p. 19 "The showroom . . . in surprising variety.": "Mrs. Nichols' Pottery."

p. 19 "She evidently . . . artistic excellence.": "Mrs. Nichols' Pottery."

p. 19 "suitable work . . . a center of activity.": Elizabeth Williams Perry, "Decorative Pottery of Cincinnati," *Harper's New Monthly Magazine*, May 1, 1881, 844.

p. 19 "These women . . . room for hysteria.": Perry, 844.

p. 20 "the crowning . . . by a woman.": Perry, 844–45.

p. 20 "the simplest . . . of beauty.": Perry, 845.

p. 20 "The work . . . uncommon rapidity.": Perry, 837.

p. 20 "Mrs. Maria . . . eventually be found.": Perry, 845.

p. 22 "a great movement . . . children.": Charles Frederic Goss, *Cincinnati, the Queen City*, 1788–1912, Vol. 1 (Chicago: S. J. Clarke, 1912), 234.

p. 22 "wild ceramic . . . hysteria.": "Aesthetics," reprinted from the *Boston Journal of Education*, *Cincinnati Enquirer*, November 22, 1881, 4.

p. 22 "Enthusiasm . . . financial resources.": *Rookwood Pottery* (Cincinnati: Procter & Collier, 1894), 14.

p. 22 "empirical knowledge . . . international authority.": Kenneth R. Trapp, "Rookwood Pottery, the Glorious Gamble," in *Rookwood Pottery: The Glorious Gamble*, edited by Anita J. Ellis (New York: Rizzoli, 1992), 12.

p. 24 "On May 10 . . . in Rookwood's history.": "Fire in the East End," *Cincinnati Enquirer*, May 11, 1881, 4.

p. 24 "Albert Robert Valentien . . . Art Academy of Cincinnati.": Young Albert Valentine (the artist) may have changed the spelling of his name to "Valentien" to differentiate himself from a nearby Dayton resident of the same name and age who lost an arm in a gruesome paper mill accident on April 12, 1880, and then later turned to a life of petty criminality. A more traditional interpretation is that the Valentines changed it after their trip to Europe, but no motive is given. See "Suburban," *Cincinnati Daily Star*, April 13, 1880, 5; Bruce Kamerling, "Anna and Albert Valentien: The Arts and Crafts Movement in San Diego," *Journal of San Diego History*, 24, no. 3 (1978).

p. 25 "Commentators . . . burgeoning pottery industry.": "Limoges," *Cincinnati Daily Star*, June 17, 1880, 8.

p. 25 "article proclaimed . . . artist in the West.": "Cincinnati School of Design," *Cincinnati Daily Star*, June 10, 1880, 10.

p. 25 "Valentien . . . culture in this city.": "Limoges," 8.

p. 25 "By some . . . prices in New York.": Perry, 841.

p. 25 "Soon . . . including Matt A. Daly.": "Temple Decorations," *Cincinnati Enquirer*, August 23, 1881, 8.

p. 26 "In July 1881 . . . to house the academy.": "American Art Chronicle," *American Art Review 2*, no. 9 (1881): 136.

p. 26 "Kiln after kiln . . . world's ceramics.": *Rookwood Pottery* (1894), 10.

p. 26 "The idea . . . biscuit with a glaze.": Waldon Fawcett, "The Production of American Pottery," *Scientific American*, November 10, 1900, 296.

p. 28 "He never . . . on a piece of ware.": Quoted in Peck, 16.

p. 28 "was the conception . . . herself and the community.": Barber, 297.

p. 28 "Her niece lamented . . . home at lunch.": Quoted in Constance J. Moore and Nancy M. Broermann, *Maria Longworth Storer: From Music and Art to Popes and Presidents* (Cincinnati: University of Cincinnati Press, 2019), 46.

p. 29 "It was a woman . . . give us an art.": W. P. Jervis, *A Pottery Primer* (New York: O'Gorman Publishing, 1911), 175.

p. 29 "The harmony . . . to touch it.": Jervis, 176.

p. 29 "Taken in . . . one-person operation.": Storer, np.

p. 29 "She sent . . . for his presentations.": Peck, 13.

p. 29 "She has accumulated . . . a larger purchaser.": "Mrs. Nichols' Pottery," *Democrat and Chronicle*, September 18, 1880, 5.

p. 31 "The costly enterprise . . . ($26.5 million today).": Peck, 21.

p. 31 "Unskilled workers . . . a 60-hour workweek.": United States, Bureau of Labor Statistics, "History of Wages in the United States From Colonial Times to 1928: Bulletin of the United States Bureau of Labor Statistics, No. 604" (Washington: United States GPO, 1934), 235.

p. 31 "In the beginning . . . artistic progress.": Storer, np.

Woman Power . . .

p. 21 "conceived . . . the old world.": "Rookwood Pottery," *The Arts* 3, no. 5–6 (December 1894): 168.

p. 21 "a regular . . . enterprising pottery.": "High Art," 2.

p. 21 "wished . . . which to work.": "Mrs. Nichols's Pottery," *Democrat and Chronicle*, September 18, 1880, 5.

p. 21 "Many woman . . . got married.": "Women as Potters," *Cincinnati Commercial Gazette*, March 20, 1883, 8.

p. 21 "The big . . . a woman's hand.": "Ceramics in Cincinnati," *Daily Leader*, May 12, 1888, 3.

p. 21 "Implementing . . . into people's lives.": Storer.

p. 21 "Improving . . . domestic ceramics.": *High Art*, 2.

Oscar Wilde . . .

p. 30 "Area newspapers . . . the English writer.": "Oscar Wilde," *Boston Globe*, January 1, 1882, 10; Greg Hand, "When Oscar Wilde Visited Cincinnati, Everybody Freaked out about It," *Cincinnati Magazine*, June 21, 2016, www.cincinnatimagazine.com/citywiseblog/take-oscar-wilde-tour-cincinnati.

p. 30 "Today I drove . . . can be done for art.": "Oscar Wilde," *Cincinnati Enquirer*, February 21, 1882, 4.

p. 30 "He did not . . . ('ugly, ungainly-looking man').": "The Aesthete," *Cincinnati Enquirer*, February 24, 1882, 5.

p. 30 "I saw some work . . . beautiful and delightful.": "The Aesthete," 5.

Chapter 2: The World's Foremost Design Studio

p. 34 "only . . . their view.": "The Deluge," *Cincinnati Enquirer,* February 15, 1883, 1.

p. 34 "happened . . . Dallas Pottery.": Maria Longworth Storer, *History of the Cincinnati Musical Festivals and of the Rookwood Pottery* (Paris: Printed by the author, 1919), np.

p. 38 "One historian . . . faience.": Sue Brunsman, "The European Origins of Early Cincinnati Art Pottery: 1870–1900," (M.A. Thesis, University of Cincinnati, 1973), 123.

p. 38 "The workmen . . . celebrity.": Edwin Atlee Barber, *The Pottery and Porcelain of the United States* (New York: Putnam, 1893), 292.

p. 40 "Peck . . . experiments.": Herbert Peck, *The Book of Rookwood Pottery* (New York: Crown, 1968), 34.

p. 40 "in an entry . . . clay to biscuit?": Walter S. Christopher, "Experiments Made at Rookwood Pottery," December 28, 1885–December 31, 1886, 165. Rookwood Archives, Cincinnati, Ohio.

p. 40 "Over the . . . not at all pleasing.": Christopher, 185.

p. 40 "Taylor . . . consultant.": Walter S. Christopher married Henrietta Wenderoth on December 25, 1884. She had been one of the earliest female decorators at Rookwood, originally hired in 1881. Several of her pieces were in the original collection at the Cincinnati Art Museum. Christopher later became a famous pediatrician, winning national acclaim for a study of children in the Chicago public school system. He was elected president of the American Pediatric Society in 1902.

p. 42 "In early 1888 . . . sacrificed to quantity.": "Ceramics in Cincinnati," *Daily Leader*, May 12, 1888, 3.

p. 42 "Although . . . in business.": Peck, 38.

p. 47 "among . . . ceramic art.": Advertisement, Duhme & Co., *Cincinnati Enquirer*, December 9, 1887, 8.

p. 47 "none facilitated . . . 1880s and 1890s.": Jack L. Lindsey, "A Question of Merit: Edwin AtLee Barber, Rookwood, and the Pennsylvania Museum," in Nancy Owen, *Rookwood Pottery at the Philadelphia Museum of Art* (Philadelphia: Philadelphia Museum of Art, 2003), 15–16.

p. 47 "It is safe . . . American institution.": Barber, 285.

p. 47 "The founding . . . of a woman.": Barber, 280.

p. 47 "Maria being . . . patrons of art.": Barber, 285.

p. 49 "For Taylor . . . pieces sent overseas.": Peck, 39.

p. 49 "The Europeans . . . and decoration.": Kenneth R. Trapp, "Rookwood Pottery, the Glorious Gamble," in *Rookwood Pottery: The Glorious Gamble*, edited by Anita J. Ellis (New York: Rizzoli, 1992), 18.

p. 49 "Rookwood asserted . . . manufacture and dedication.": *Rookwood Pottery*, (1903), 9.

p. 50 "A newspaper . . . not surpassed anywhere.": Eliza Putnam Heaton, "China that is Costly," *Topeka State Journal*, February 19, 1890, 7.

p. 50 "As . . . to Taylor.": The terms of Storer's "gift" to Taylor were never disclosed and have not been uncovered in existing documentation.

p. 50 "The direction . . . friendly criticism.": *Rookwood Pottery* (Cincinnati: Procter & Collier, 1894), 16.

p. 54 "For the . . . $64,630.": Peck, 46.

p. 54 "Today . . . in the land.": Barber, 297.

p. 54 "Out of . . . the United States.": Quoted in Edwin J. Kircher, Barbara Agranoff, and Joseph Agranoff, *Rookwood: Its Golden Era of Art Pottery, 1880–1929* (Cincinnati: Printed by the authors, 1969), np.

p. 54 "The actual . . . and Japanese.": Kircher, Agranoff, and Agranoff.

Native American Portraits . . .

p. 44 "Masterful . . . or complex.": Anita J. Ellis, "Rookwood and the American Indian," in Anita J. Ellis and Susan Labry Meyn, *Rookwood and the American Indian: Masterpieces of American Art Pottery from the James J. Gardner Collection* (Athens, OH: Ohio University Press, 2007), 112–13.

Rookwood and Electroplated Metal . . .

p. 56 "In the . . . at the pottery.": Peck, 52.

Mark Twain: Rookwood Aficionado . . .

p. 58 "Twain's . . . with Twain.": Mark Palkovic, *Wurlitzer of Cincinnati: The Name that Means Music to Millions* (Charleston, SC: History Press, 2015), 53.

p. 58 "Attorney . . . tour stop.": Robert Pack Browning, Michael B. Frank, and Lin Salamo, eds., *Mark Twain's Notebooks & Journals*, Vol. 3 (Berkeley: University of California Press, 1979), 96.

p. 58 "The . . . out of the kiln.": Mark Twain quoted in Browning, Frank, and Salamo, 87.

Chapter 3: Melding Art and Industry in the Twentieth Century

p. 62 "I have . . . from elsewhere.": Quoted in Herbert Peck, *The Book of Rookwood Pottery* (New York: Crown, 1968), 66.

p. 64 "In . . . Émile François Loubet.": Peck, 66–67.

p. 64 "It is . . . in the world.": Quoted in Peck, 67.

p. 64 "as artistic . . . in pottery work.": Waldon Fawcett, "The Production of American Pottery," *Scientific American*, November 10, 1900, 296.

p. 66 "visited . . . their production.": *Rookwood Pottery*, (1903), 5.

p. 69 "The general . . . most homes.": Carol Boram-Hays, *Bringing Modernism Home: Ohio Decorative Arts, 1890–1960* (Athens, OH: Ohio University Press, 2005), 5.

p. 70 "greatest . . . in mat glazes.": Nancy Owen, *Rookwood Pottery at the Philadelphia Museum of Art* (Philadelphia: Philadelphia Museum of Art, 2003), 67.

p. 70 "In particular . . . Alfred Stieglitz.": Owen, 68.

p. 70 "soft . . . tender.": W. P. Jervis, *A Pottery Primer* (New York: O'Gorman Publishing, 1911), 177.

p. 70 "is undoubtedly . . . the exhibition.": Jervis, 177.

p. 72 "According . . . in 1893.": "Pottery's History," *Cincinnati Commercial Tribune*, April 2, 1909, 5.

p. 73 "The emphasis . . . imitators.": Kenneth R. Trapp, "Tiles of the Rookwood Pottery," *Flash Point* 6, no. 4 (Oct.–Dec. 1993): 1.

p. 74 "room . . . work of art.": A. O. Elzner, "Rookwood Pottery," *Architectural Record* 17, no. 4 (April 1905): 304.

p. 75 "in all . . . this glaze.": *Rookwood Pottery* (1903), 39.

p. 75 "a bold . . . clay worker.": Elzner, 299.

p. 75 "One writer . . . in ceramics.": Elzner, 303.

p. 75 "a Brooklyn . . . ever made.": "Fads and Fashions," *Brooklyn Life*, December 23, 1905, 13.

p. 76 "Every . . . a duplicate.": Advertisement, Walbridge & Co., *Buffalo Morning Express*, December 23, 1905, 5.

p. 76 "Sturgis . . . alone.": Sturgis Laurence, "Architectural Faience," *Architectural Record* 21, no. 1 (January 1907): 65.

Tile at the St. Louis World's Fair . . .

p. 80 "A reporter . . . in America.": "Louisiana Purchase Exposition Ceramics," *Keramic Studio* 6 (1904–1905): 194.

Chapter 4: Simplicity and Style

p. 84 "has made . . . appreciated.": Charles Frederic Goss, *Cincinnati, the Queen City, 1788–1912*, Vol. 1 (Chicago: S. J. Clarke, 1912), 235–36.

p. 87 "composes . . . repetition.": Nicholas Hungerford, "The Work of American Potters," *Arts & Decoration* 1, no. 4 (February 1911): 161.

p. 88 "the accumulated . . . ceramics.": Sturgis Laurence, "Architectural Faience," *Architectural Record* (January 1907): 65, 67.

p. 90 "A café . . . Sinton Hotel.": "Cafe of Marble and Pottery," *Cincinnati Enquirer*, August 22, 1905, 5.

p. 90 "will make . . . the country.": "Cafe of Marble and Pottery," 5.

p. 92 "Named after . . . faience.": Christopher Gray, "Does a Far-From-Pristine Remnant Rate Protection?" *New York Times*, April 4, 1993, R7.

p. 92 "The lobby . . . American potters.": William Hagerman Graves, "The Use of Tile in the Interior Finish and Decoration of Hotels," *Architectural Review* 2, no.4 (1913): 44, 46.

p. 92 "their richer . . . 1440 CE": William Walton, "Contemporary Architectural Sculpture in Color," *Scribner's Magazine* 48, no. 3 (September 1910): 383.

p. 92 "Commercial . . . cheap production.": Quoted in Edwin J. Kircher, Barbara Agranoff, and Joseph Agranoff, *Rookwood: Its Golden Era of Art Pottery, 1880–1929* (Cincinnati: Printed by the authors, 1969), np.

p. 92 "Simple . . . several months.": Kenneth R. Trapp, "Tiles of the Rookwood Pottery," *Flash Point* 6, no. 4 (Oct.–Dec. 1993): 13.

p. 93 "Much to . . . anything floral.": Trapp, "Tiles," 12.

p. 93 "perhaps . . . the world": W. P. Jervis, *A Pottery Primer* (New York: O'Gorman Publishing, 1911), 177.

p. 96 "Tremendous . . . perfection.": Marie J. Adams, "Pottery's History," *Cincinnati Commercial Tribune*, April 2, 1909, 5.

p. 98 "It is . . . pleased everyone.": Adams, 5.

p. 98 "a great . . . more tender.": Quoted in Kircher, et al., np.

p. 98 "Hurley's . . . plaques.": Kenneth R. Trapp, *Ode to Nature: Flowers and Landscapes of the Rookwood Pottery 1880–1940* (New York: Jordan-Volpe Gallery, 1980), 36.

p. 100 "Fine Art . . . wares.": Advertisement, The A. Schachne Co., *Xenia Daily Gazette*, May 11, 1907, 2.

p. 101 "which has . . . rarely found.": "William Watts Taylor," *Transactions of the American Ceramic Society* 16 (1914): 49–50.

p. 101 "shape . . . due to him.": Jervis, 178.

p. 101 "thronged . . . spirit.": "Autos Only," *Cincinnati Enquirer*, November 15, 1913, 5.

p. 101 "An adequate . . . individual.": "Resolution and Memorial to the Late W. W. Taylor," *The Book of Corporate Minutes*, 124–25, Rookwood Archives, Cincinnati, Ohio.

p. 102 "secure . . . success.": "Will," *Cincinnati Enquirer*, November 20, 1913, 5.

p. 102 "The greater . . . and taste.": "Will," 5.

The Rathskeller at Louisville's Seelbach Hotel . . .

p. 106 "Louisville's . . . in 1907.": Larry Johnson, *The Seelbach Hilton: A Centennial Salute to Louisville's Grand Hotel* (Louisville: Butler Books, 2018), 25–29.

p. 106 "beautiful . . . Old World castle.": "The Seelbach Rathskeller," *Clay-Worker*, Vol. 55–56 (1911), 66.

p. 106 "in every . . . the Rhine.": "The Seelbach Rathskeller," 66.

p. 106 "the masterpiece . . . pottery.": "The Seelbach Rathskeller," 66.

Chapter 5: Evolution of Form and Style

p. 110 "monument . . . the world.": "New Home for Mayo Clinic," *Winona Daily News*, March 9, 1914, 5; "A Day in Rochester, Minnesota," *Hotel Monthly* 25 (1917): 57.

p. 110 "a bright . . . delicate.": "Rookwood Faience," *Mantel Tile and Grate Monthly* 9, no. 9 (1915): 28.

p. 112 "Business . . . promotion.": Herbert Peck, *The Book of Rookwood Pottery* (New York: Crown, 1968), 101.

p. 112 "His sketches . . . measurements.": Peck, 102.

p. 112 "The business . . . small amount.": "President's Informal Report," Board of Directors Meeting, *The Book of Corporate Minutes*, 131–32, Rookwood Archives, Cincinnati, Ohio.

p. 112 "an entirely . . . flowers.": Advertisement, Rookwood Pottery Company, *Cincinnati Commercial Tribune*, April 3, 1915, 3.

p. 112 "The president's . . . Cincinnati.": "To Present Rookwood Vase," *Cincinnati Commercial Tribune*, October 26, 1916, 4.

p. 114 "In the . . . the lobby.": "Insurance Men," *Cincinnati Commercial Tribune*, April 11, 1915, 3.

p. 115 "The Mat . . . unlimited.": Advertisement, Rookwood Pottery Company, *Architectural Review*, April 1913, xix.

p. 115 "oldest . . . in America.": Advertisement, Grueby Faience Company, *Architectural Review*, April 1913.

p. 118 "Sax pinpointed . . . us all.": Sara Sax, "Comments," in E. T. Hurley, *For Old Acquaintance: Prints from the Etchings of E. T. Hurley* (Cincinnati: St. James Press, 1917), np.

p. 118 "the company . . . booklet.": *Soft Porcelain* (Cincinnati: Rookwood Pottery Company, 1915), np.

p. 118 "Beginning . . . inspiration.": Anita J. Ellis, ed., *Rookwood Pottery: The Glorious Gamble* (New York: Rizzoli, 1992), 145.

p. 122 "quiet . . . setting.": *Soft Porcelain*, np.

Arts & Crafts Movement at Rookwood . . .

p. 124 "The ovoid . . . patterns.": Riley Humler, Personal interview with the author, January 18, 2020.

p. 125 "How Conant . . . near the base.": Humler.

Chapter 6: Rookwood in the Jazz Age

p. 128 "blues . . . yellow.": Advertisement, Joseph Horne Co., *Pittsburgh Press*, February 3, 1920, 13.

p. 128 "more . . . $150.": Advertisement, Joseph Horne Co., 13.

p. 130 "The Oldest . . . Moderns'!": Advertisement, Hudson's, *Detroit Free Press*, December 23, 1931, 7.

p. 130 "hand-moulded . . . today).": Advertisement, Hudson's, 7.

p. 136 "The Rookwood . . . world.": "Glimpse into Store Given," *Cincinnati Enquirer*, October 2, 1930, 11.

p. 136 "The company . . . world.": Kenneth R. Trapp, "Rookwood Pottery, the Glorious Gamble," in *Rookwood Pottery: The Glorious Gamble*, edited by Anita J. Ellis (New York: Rizzoli, 1992), 37.

p. 136 "kept . . . composed.": Trapp, "Glorious," 37.

p. 136 "The artistic . . . control.": Arthur Van Vlissingen, Jr., "Art Pays a Profit," *Factory and Industrial Management* 79 (February 1930): 302.

p. 138 "a . . . achievement.": Anita J. Ellis, ed., *Rookwood Pottery: The Glorious Gamble* (New York: Rizzoli, 1992), 146.

p. 139 "Rookwood . . . subjects.": Kenneth R. Trapp, *Toward the Modern Style: Rookwood Pottery, The Later Years, 1915–1950* (New York: Jordan-Volpe Gallery, 1983), 13.

p. 139 "Commercial . . . Pomegranate.": Anita J. Ellis, *Rookwood Pottery: The Glaze Lines* (Atglen, PA: Schiffer, 1995), 10.

p. 140 "On opening . . . her possession.": "A Gold Key," *Cincinnati Enquirer*, August 14, 1921, 8.

p. 142 "one of . . . Ohio.": "In Society," *Cincinnati Enquirer*, October 1, 1927, 3; Owen Findsen, "Buy Relic," *Cincinnati Enquirer*, May 5, 1996, D10.

p. 142 "The contribution . . . products.": Herbert Peck, *The Book of Rookwood Pottery* (New York: Crown, 1968), 163.

p. 143 "the pottery . . . the country.": Peck, 107.

p. 143 "In 1923 . . . fine.": "President's Report," Board of Directors Meeting, April 17, 1924, *The Book of Corporate Minutes*, 147, Rookwood Archives, Cincinnati, Ohio.

Rookwood's Jazz Artist: William Hentschel . . .

p. 144 "produced . . . inspiration.": Quoted in Peck, 109.

Chapter 7: The Weight of the Great Depression's Crushing Blow

p. 148 "Master . . . $65.": Advertisement, Hutzler Brothers, *Evening Sun*, October 30, 1929, 9.

p. 152 "The pressures . . . previous year.": Revenue figures listed in Herbert Peck, *The Book of Rookwood Pottery* (New York: Crown, 1968), 111. In comparison, retailer Marshall Field's was the forty-first largest corporation in 1929, with revenues of $180 million. The average middle-class wage earner made about $1,000 annually.

p. 154 "newsreel . . . the country.": Peck, 112.

p. 154 "As long . . . the budget.": Quoted in Peck, 112.

p. 156 "She lives . . . the best.": Quoted in Constance J. Moore and Nancy M. Broermann, *Maria Longworth Storer: From Music and Art to Popes and Presidents* (Cincinnati: University of Cincinnati Press, 2019), 240.

p. 156 "Nowhere . . . Rookwood.": Mary L. Alexander, "The Week in Art Circles," *Cincinnati Enquirer*, February 11, 1934, 5.

p. 156 "In 1933 . . . amount.": Peck, 113.

p. 156 "Wareham . . . run.": "Presidency," *Cincinnati Enquirer*, July 10, 1934, 10.

p. 156 "He . . . 1935.": Peck, 117.

p. 158 "the latter . . . which count.": "Deserving of Honor," *Cincinnati Enquirer*, July 12, 1934, 12.

p. 158 "the pottery . . . paid.": Peck, 117.

p. 158 "One candidate . . . of changes.": Quoted in Peck, 118.

p. 162 "perhaps . . . hand in it.": Anton Scherrer, "Important Collection of Rookwood Pottery," *Indianapolis Times*, March 24, 1936, 3.

p. 162 "Woodward & Lothrop . . . art.": Advertisement, Woodward & Lothrop, *Evening Star*, June 22, 1936, B5.

p. 162 "compared . . . superlative.": Caleb, "Could Keats Have Seen," *Chicago Tribune*, September 6, 1939, 10.

p. 164 "flurry . . . month.": "Pottery Attracts," *Cincinnati Enquirer,* July 4, 1939, 21.

p. 164 "Two months . . . on staff.": Wilber L. Kendall, "Condensed Statements," *Rushville Republican*, September 2, 1939, 1.

Chapter 8: Desperate Measures to Save an Icon

p. 168 "Wareham . . . enterprise.": "Rookwood Pottery Asks Cincinnati for Financial Aid," *Courier-Journal*, April 17, 1941, 3.

p. 168 "a really . . . taste.": Mary L. Alexander, "Week in Art Circles," *Cincinnati Enquirer,* July 27, 1941, 6.

p. 170 "In mid-1941 . . . submitted.": Herbert Peck, *The Book of Rookwood Pottery* (New York: Crown, 1968), 121.

p. 170 "Indeed . . . intact.": "Good News," *Cincinnati Enquirer,* October 2, 1941, 4.

p. 170 "an extensive . . . noted.": "Rejuvenation is Ahead for Noted Pottery," *Cincinnati Enquirer,* November 9, 1941, 20.

p. 170 "During . . . optimistic.": "Pottery to Reopen Soon," *Cincinnati Enquirer,* October 11, 1941, 16.

p. 170 "a thrilling . . . fever pitch.": "In Society," *Cincinnati Enquirer,* November 20, 1941, 44.

p. 171 "recalled . . . bankruptcy.": Herbert Peck, *The Second Book of Rookwood Pottery,* (Tucson: Herbert Peck Books, 1985), 31.

p. 171 "Tomorrow . . . prices.": Advertisement, B. Altman & Co., reprinted in Peck, 30.

p. 171 "offering for . . . housecleaning.": Advertisement, Rookwood Pottery Company, *Cincinnati Enquirer,* April 5, 1942, 22.

p. 171 "began turning . . . fuses.": Herbert Peck, *The Book of Rookwood Pottery* (New York: Crown, 1968), 123.

p. 173 "The wooden . . . and radar.": "Proximity Fuse Secret Weapon," *Shreveport Journal*, October 3, 1945, 2.

p. 173 "making certain . . . war effort.": "Pottery Head," *Cincinnati Times-Star*, July 8, 1942.

p. 173 "Those . . . public." "The Proximity Fuse, *Cincinnati Enquirer,* September 22, 1945, 4.

p. 173 "One sad . . . to Japan.": Peck, 157.

p. 173 "war research . . . conducted there.": "Institutum to Expand Activities," *Cincinnati Enquirer,* January 1, 1943, 1.

p. 174 "this donation . . . production.": Peck, 123.

p. 174 "George Sperti . . . offices.": "Rookwood Pottery, Division of Sperti, Inc., Employer and International Union, United Automobile Workers of America, American Federation of Labor, Petitioner, Case No. 9-RC-711, Decided May 16, 1950, *Decisions and Orders of the National Labor Relations Board*, Vol. 89, March 28–May 31, 1950, Washington, DC: Government Printing Office, 1951, 1351.

p. 174 "Recently . . . production.": "Visitors Tour," *Cincinnati Enquirer,* June 20, 1943, 9.

p. 174 "It wasn't . . . containers.": Robert McKay, "The Amazing Dr. Sperti," *Cincinnati Magazine*, August, 1982, 50. Though Rookwood may have made prototypes for Sperti products, there is no direct evidence or existing containers that demonstrate the veracity of this claim.

p. 174 "urged . . . craftsmanship.": "Rookwood Pottery," *Cincinnati Enquirer,* November 28, 1943, 6.

p. 174 "It is . . . the earth.": "Rookwood Pottery," *Cincinnati Enquirer,* 6.

p. 177 "No other . . . culture.": "Thousands See Show," *Cincinnati Enquirer,* November 25, 1945, 10.

p. 177 "articles . . . vases.": "Thousands See Show," 10.

p. 177 "The public . . . charged for it.": Peck, 127.

p. 177 "Wareham . . . high culture.": "Aged Rookwood Artist Dies," *Cincinnati Enquirer,* July 21, 1948, 12.

p. 179 "Rookwood's last . . . black ground.": Anita J. Ellis, *Rookwood Pottery: The Glaze Lines* (Atglen, PA: Schiffer, 1995), 192.

p. 179 "the Sperti . . . under review.": Andy Sparke, "Sperti Directors," *Cincinnati Enquirer,* January 24, 1955, 32.

p. 179 "one of many . . . interests.": John A. Heitmann, "Doing 'True Science': The Early History of the Institutum Divi Thomae, 1935–1951, *Catholic Historical Review* 88, no. 4 (October 2002): 719.

p. 179 "A plan . . . pottery.": "Another Move," *Cincinnati Enquirer,* December 31, 1955, 17.

p. 180 "However . . . $4.5 million today).": Dick Havlin, "Along the Business Front," *Cincinnati Enquirer,* January 6, 1956, 35.

p. 180 "newspaper reported . . . in Cincinnati.": "Mt. Adams: A Stimulating Influence," *Cincinnati Enquirer,* August 12, 1956, 37.

p. 180 "they needed . . . Mt. Adams.": "Mt. Adams: A Stimulating Influence," 37.

p. 180 "pottery . . . afloat.": Nellie Bower, "Ohio Woman," *Miami News,* December 1, 1957, 26.

p. 180 "Cincinnati's world-famous . . . company's sales.": "Herschede Group," *Cincinnati Enquirer,* June 3, 1959, 1.

p. 180 "hand . . . lines.": "Herschede Group," 1.

p. 180 "What . . . announced.": "Herschede Group," 1.

p. 182 "World-Renowned . . . told reporters.": Dick Havlin, "World-Renowned Names," *Cincinnati Enquirer,* February 22, 1960, 1.

p. 183 "On May . . . included Rookwood.": "Starkville Firm Changes Owners," *Greenwood Commonwealth,* May 4, 1967, 8.

p. 183 "Howard Furniture . . . the South.": "Starkville Firms Merge," *Clarion-Ledger,* January 14, 1973, F6.

John Dee Wareham: A Lifetime in Pottery . . .

p. 184 "an old . . . door.": "In Society," *Cincinnati Enquirer,* June 20, 1915, 14.

Kitaro Shirayamadani: Rookwood's Soul . . .

p. 187 "It . . . clay jar.": Norine Freeman, "Creates More Designs for Rookwood Pottery," *Cincinnati Post,* November 10, 1941, 3.

p. 187 "Accomplished . . . surfaces.": Riley Humler, Personal interview with author, January 18, 2020.

p. 189 "a place . . . be made.": Maria Longworth Storer, *History of the Cincinnati Musical Festivals and of the Rookwood Pottery* (Paris: Printed by the author, 1919), np.

p. 189 "Shirayamadani . . . divine.": Freeman, 3.

p. 189 "delicacy . . . to another.": Storer, np.

Chapter 9: Collectors Seek Treasures

p. 191 "He almost . . . creators.": W. P. Jervis, *A Pottery Primer* (New York: O'Gorman Publishing, 1911), 177–178.

p. 194 "by the 1950s . . . the dollar.": Humler interview, December 18, 2019.

p. 194 "David . . . the least.": Humler interview, December 18, 2019.

p. 194 "a few . . . ceramics.": Elisabeth Stevens, "Precious Pottery," *Baltimore Sun,* January 25, 1980, B1.

p. 194 "cool household . . . robust.": David Rago, Personal interview with author, January 8, 2020.

p. 195 "the day . . . this country.": Rita Reif, "Rookwood Pottery Marks Its First 100 Years," *New York Times*, May 4, 1980, D32.

p. 195 "museum-quality . . . research.": Reif, D32.

p. 195 "Until now . . . years ago.": Reif, D32.

p. 195 "Far and . . . achieved.": Reif, 42.

p. 195 "A piece . . . booming.": Humler interview, December 18, 2019.

p. 195 X "a syndicated . . . top pieces.": Ralph and Terry Kovel, "Art Pottery Made in America is in Demand," *Courier-Journal*, January 11, 1987, H5.

p. 195 "I had . . . unheeded.": Humler interview, December 18, 2019.

p. 196 "In June . . . the 1960s.": Frank Loomis IV, "Rookwood Roundup," *Cincinnati Enquirer*, February 23, 1991, B1.

p. 196 "Around 1990 . . . auction world.": Humler interview, December 18, 2019.

p. 197 "just the . . . collectors there were.": Humler interview, December 18, 2019.

p. 197 "One piece . . . thirty years.": Humler interview, December 18, 2019.

p. 197 "Longworth's . . . century.": Paul Breidenbach, "The Cincinnati Wing: The Story of Art in the Queen City: A Permanent Exhibition at the Cincinnati Art Museum," *Ohio Valley History* 4, no. 1 (Spring 2004): 65.

p. 197 "After . . . market.": Humler interview, December 18, 2019.

p. 197 "If people . . . beauty of the artwork.": Rago interview, January 8, 2020.

p. 197 "The group . . . America's Finest Art Pottery.": Humler interview, December 18, 2019.

Chapter 10: Rediscovery and Revival

p. 205 "Glazes have . . . successful.": Ashley Neumeister, Personal interview with author, February 4, 2020.

p. 205 "We've been creating . . . modern consumers.": Micah Carroll, Personal interview with author, December 12, 2019.

p. 206 "The real . . . humanity.": Glenn Adamson, *Fewer, Better Things: The Hidden Wisdom of Objects* (New York: Bloomsbury, 2018), 9.

p. 206 "Our history . . . generations as well.": Marilyn Scripps, Personal interview with author, February 4, 2020.

p. 208 "I was like a kid . . . part of our city.": David Pittinger, Personal interview with author, February 14, 2020.

p. 208 "Rookwood is part . . . wasn't possible.": Marilyn Scripps, Personal interview with author, February 4, 2020.

p. 208 "Settling . . . consumer.": Rookwood's 88,000-square-foot (8,175 sq m) production facility at 1920 Race Street had previously housed a vegetable wholesaler. Earlier in its existence, the manufacturing plant housed W. T. Wagner's Sons soda and seltzer company (early 1900s through midcentury). Although mostly forgotten, Wagner's made "Snap" ginger ale and other sodas, at one time a major competitor of Coca-Cola and other iconic brands.

p. 211 "the Townley . . . notes.": Lisa Cornwell, "Rookwood Reborn," *Dayton Daily News*, September 5, 2006, A8.

p. 214 "Rookwood was . . . its wares.": Quoted in Cornwell, A8.

p. 214 "the company . . . 'art pottery.'": Isabella Smith, "The Art and Craft of American Pottery," *Apollo* 11 (February 2019), www.apollo-magazine.com/american-art-pottery-metropolitan-museum.

p. 216 "Amy Dehan . . . today.": Erin Couch, "A Milestone in the Revival of a Famous Cincinnati Name," *CityBeat*, June 12, 2018, www.citybeat.com/arts-culture/visual-arts/article/21009000/a-milestone-in-the-revival-of-a-famous-cincinnati-name.

p. 216 "The Cincinnati . . . Ice Cream.": Chris Mayhew, "Rookwood Room Reopens with Graeter's Ice Cream at Cincinnati Museum Center," *Cincinnati Enquirer*, December 23, 2018, www.cincinnati.com/story/news/local/cincinnati/2018/12/23/cincinnati-museum-center-union-terminal-rookwood-tea-room-ice-cream-parlor-opens-graeters-remodel/2401974002.

p. 216 "UC Health . . . Museum.": Mitchell Parton, "UC Health Opens $68 Million Neuroscience Building," *News Record*, April 12, 2019, www.newsrecord.org/news/uc-health-opens-million-neuroscience-building/article_d16343b6-5d29-11e9-9eea-8bdc340e2069.html.

Image Credits

Bob Batchelor: pages 6 (second from bottom), 23 (top), 37, 65 (top right), 73 (left), 80 (bottom), 82, 121 (bottom left)

Cincinnati Art Museum: pages 6 (third from top), 60

David Pittinger: page 201 (bottom)

The Family of Margaret McKeown Brand: page 187

Humler & Nolan, photography by Mark Mussio: pages 6 (second from top), 7 (top four), 17 (bottom right), 18 (bottom), 20, 24, 27, 30 (bottom left and right), 32, 39, 42-44, 45 (left), 46, 54 (bottom), 55, 57, 58, 65 (left and bottom right), 67-69, 71-72, 74-75, 77-79, 85, 87 (right), 88-89, 89 (top left), 97-100, 103-105, 119, 121 (bottom right), 122-126, 129-130, 131 (top), 132-133, 136-137, 144, 145 (top left and bottom row), 146, 148 (bottom), 149-152, 154 (bottom row), 155 (right), 158, 159 (right), 161-164, 166, 171, 175, 176 (top), 177, 179, 181, 182 (bottom), 184, 188, 189 (left), 190, 193-194, 198-199

Library of Congress: pages 22, 23 (bottom), 106 (left)

Mary R. Schiff Library & Archives, Cincinnati Art Museum, Cincinnati, OH: pages 2, 116 (top)

Mayo Foundation for Medical Education and Research: pages 110 (bottom), 111 (top)

Metropolitan Museum of Art, Gift of Marcia and William Goodman, 1981: page 29 (top)

Napoleon Sarony, Photograph, Library of Congress Prints and Photographs Division: page 30 (top)

Prints and Photographs Division, Library of Congress: page 59

Private Collection: pages 94, 95 (bottom), 120, 141, 180

Public Library of Cincinnati and Hamilton County, Genealogy & Local History Department: pages 17 (bottom left and middle), 35

Public Library of Cincinnati and Hamilton County, Joseph S. Stern, Jr. Cincinnati Room: pages 21 (top), 38, 40 (middle), 170 (left)

Rago-Wright auctions/Lambertville-Chicago: pages 19, 25, 41, 50 (bottom), 56, 64 (bottom left and right), 73 (right), 76 (bottom), 81, 86, 89 (top right), 96, 110 (right), 111 (bottom), 113 (top), 114, 115 (top row), 121 (top right), 128 (top), 134-135, 138-139, 142-143, 148 (top), 172, 176 (bottom), 186, 195-197

Riley Humler: pages 6 (top), 12, 15 (top right), 16, 62 (bottom right), 168, 189 (right)

Rookwood: pages 6 (bottom), 7 (bottom), 8, 10, 14 (top), 15 (bottom), 17 (top left), 28, 29 (bottom), 31, 47 (bottom), 48-49, 51, 62 (left), 63, 64 (top and middle right), 76 (top), 80 (top), 90-93, 95 (top), 101 (bottom), 102, 108, 113 (bottom), 115 (bottom), 116 (bottom), 117 (top), 131 (bottom row), 140, 154 (top), 155 (left), 169, 170 (right), 174, 178, 183, 192, 200, 201 (top), 202, 204-206, 207-220, 240

Suzette Percival: pages 106-107

Ursulines of Cincinnati Archives: pages 36 (top right), 52-53

Virgina Raymond Cummins Collection, Courtesy of Humler & Nolan: pages 14 (bottom), 15 (top left), 18 (top), 21 (bottom), 26, 36 (top left and bottom), 40 (top and bottom), 45 (right), 47 (top), 50 (top), 54 (top), 62 (top right), 84, 87 (left), 101 (top), 112, 117 (left), 121 (top right), 128 (bottom), 145 (top right), 153, 157, 159 (left), 160, 165, 182 (top), 185

About Riley Humler

Riley Humler has been a dealer and collector of American and European art pottery for more than thirty-five years. He was gallery director of Cincinnati Art Galleries, LLC, and coordinated the art pottery and art glass auctions there for more than twenty years and now manages his own auction gallery, Humler & Nolan, in Cincinnati. Riley has also been an appraiser on *Antiques Roadshow* for more than twenty years and lectures on a regular basis about his lifelong relationship with American art pottery, particularly Rookwood. Married for twenty-eight years to his wife Annie, they are the parents of five and have too many grandchildren to count. Riley is a native of Louisville and now resides in Pleasant Ridge, Ohio.

About George Hibben

George Hibben, Rookwood resident historian and tour coordinator, is a lifelong Cincinnati resident and has been at the pottery since 2008. Starting in the mold room, George has carved various works over the years, doing custom work as director of stein sales and development and retail sales. He later transitioned to history and tours and tends to always have an interesting anecdote about Rookwood.

Well acquainted with the collecting side of Rookwood's history, George began his pottery journey in 1988 when a friend told him the story of a fifty-cent Rookwood purchase at a Cincinnati yard sale that was later appraised by The Cincinnati Art Museum for $5,000 and became part of the Cincinnati Art Museum's Glorious Gamble Exhibit. This amazing find started a self-education process, which then continued at Rookwood and elsewhere, including throwing his own pottery beer steins.

George has written several articles on Rookwood for *Prosit*, *Journal of Stein Collectors International*, and *The Journal of the American Art Pottery Association*.

Acknowledgments

Rookwood speaks with pride about how each product has been touched by more than a dozen hands in its manufacturing process, resulting in each piece being truly handcrafted. *Rookwood: The Rediscovery and Revival of an American Icon* shares that vibe as books are also a collective effort, particularly for a richly illustrated artwork. We have certainly moved well past a dozen hands.

First and foremost, I would like to thank everyone at Rookwood and owner Marilyn Scripps. So many artisans there have unfailingly answered my questions about their work, discussed the company's rich heritage at length, and made me feel welcomed. In particular, Micah Carroll granted access to Rookwood's archival materials, including the mold vault, which gave the project a hands-on feeling. His discussion of Rookwood's legacy added greatly to this book.

A special note of recognition is due to Beth Johnson for her wonderful work in creating the book cover and interior design work. She is a great friend and an incredibly talented artist. Thanks also to Tracy Doyle for taking many of the photographs included in this book. The help from the creative team at Rookwood was a constant source of inspiration. Thanks to my friend Ian Burt, director of sales, who shared architectural tile archives and was one of the earliest readers of the manuscript draft.

Rookwood historian George Hibben deserves special thanks, not only for the many hours we spent discussing Rookwood's wonderful past, but also for helping me gain a greater understanding of glaze science and artistry. George also wrote several sidebars, which provide keen insight and wonderful nuance.

This book would not have been possible without the striking photographs. In an age when everyone carries a camera, it would be easy to mistakenly assume that images readily exist. Thankfully for my work—and for future researchers—Riley Humler has been cataloging Rookwood images throughout his career. Riley, who also graciously accepted my invitation to write several sidebars, is certainly the world's leading expert on Rookwood. Most of the images in this book are from his collection. His archives contain a wealth of historical works as well, which added

great depth to this book. Riley has been a constant source of inspiration and I have learned so much about Rookwood from our discussions.

I am also extremely lucky to have benefited from an interview with and insight from David Rago of Rago-Wright Auctions/Lambertville-Chicago. He is one of America's great appraisers and thought leaders in the field of twentieth and twenty-first century design. I deeply appreciate that David and his team provided many fantastic photos for this book. Thanks also to Suzanne Perrault, who supported the project and provided insight and analysis.

I would like to thank Amy Dehan, curator of decorative arts and design, and everyone at the Cincinnati Art Museum (CAM) for all that the institution and its people have done to showcase Rookwood. CAM is a treasure! Thanks to Jill Beitz, manager of reference and research at the Cincinnati History Library and Archives in the Cincinnati Museum Center, for research assistance and support. Historians are forever indebted to the institutions that make content available. *Rookwood* has benefited from numerous collections and repositories, including The Public Library of Cincinnati and Hamilton County, the Library of Congress, Miami University Libraries, The Lane Libraries, the Smithsonian, the Mayo Foundation for Medical Education and Research, and newspapers.com.

A special thanks to David Pittinger for insight, good humor, and a deep knowledge of Rookwood's rebirth. Dave also shared photos and documents from his personal archive. Anyone who loves or appreciates Rookwood should thank Dave for his role in saving the company and bringing it back to Cincinnati. Thank you, Dave!

Thanks to Nancy Broerman, one of the world's leading experts on Maria Longworth Nichols Storer, not only for hosting us at the Saint Ursula Academy archives, but also for obtaining permission for me to use photos of the collection in this book. Nancy also read the book in its draft stage and provided wonderful insight! Thanks to her husband Steve for constant good cheer and for helping with archival photo work. A special thanks to Sarah Ditlinger from the Taft Museum of Art. Sarah has been a great supporter and advocate of this book from the beginning based on her deep knowledge of art history. Thanks to Jeff Gardner, who produced an excellent mini-documentary of Maria. Our work on that project helped strengthen this book. I appreciate San Francisco Rookwood and art expert/scholar Isak Lindenauer sharing his thoughts.

Special thanks to Peg O'Hagan for granting permission to use her family photo of Kitaro Shirayamadani. Also, thanks to Bill Glass for granting me an interview. A renowned artist, Bill was the last artist at Rookwood before it folded in Mississippi. His insights improved this book.

The entire team at Quarto has been a pleasure to work with! Special thanks to Joy Aquilino, Anne Re, and Meredith Quinn for guiding this book from idea to publication and beyond. Thanks as well to Mary Ann Hall, an early advocate and initial editor. It has been fantastic to learn from the great professionals at Quarto.

There aren't enough words to recognize the contributions made by my wife Suzette Percival. I don't know anyone who loves Rookwood more and her fingerprints are on every idea and every page. I deeply appreciate Suzette's faith in my work. Her support means everything to me and has been priceless in this book. I imagine Maria looking down and smiling at *our* work. Our teenage daughters are at the center of our little team. Kassie and Sophia bring us joy, love, and laughter.

My inspiration for *Rookwood* centered on the generations of artists and artisans who turned a small pottery into one of the world's great brands. I feel indebted to the memory of Kitaro, Valentien, Wareham, Hentschel, Jensen, Sax, Hurley, and everyone who had a hand in Rookwood's history. Hopefully this book lives up to their example.

About the Author

Bob Batchelor is a critically-acclaimed cultural historian and biographer whose work explores contemporary American culture. His book *The Bourbon King: The Life and Crimes of George Remus, Prohibition's Evil Genius* won the 2020 Independent Press Award for Historical Biography. He also wrote the bestselling *Stan Lee: The Man Behind Marvel*, which was translated into half a dozen languages.

In addition, Bob has written books on Bob Dylan, *The Great Gatsby*, *Mad Men*, and John Updike. Bob's work has appeared in *Time* magazine, *The New York Times*, *The Washington Post*, and the *Los Angeles Times*. He has appeared as an on-air commentator for The National Geographic Channel, *PBS NewsHour*, and NPR.

Bob earned his doctorate in English Literature from the University of South Florida and has taught at universities in Florida, Ohio, and Pennsylvania, as well as Vienna, Austria. Bob lives in Cincinnati with his wife Suzette and their teenage daughters.

Index